THE GRACE OF THE ITALIAN RENAISSANCE

The Grace of the
Italian Renaissance

Ita Mac Carthy

PRINCETON UNIVERSITY PRESS
PRINCETON & OXFORD

Published by Princeton University Press
41 William Street, Princeton, New Jersey 08540
6 Oxford Street, Woodstock, Oxfordshire OX20 1TR

press.princeton.edu

Library of Congress Control Number: 2019948963
ISBN 978-0-691-17548-5

British Library Cataloging-in-Publication Data is available

Editorial: Ben Tate and Charlie Allen
Production Editorial: Nathan Carr
Jacket/Cover Design: Pamela L. Schnitter
Jacket/Cover Credit: Raphael, *The Three Graces*. Red chalk over stylus underdrawing.
20.3 x 25.8 cm. Sheet of paper. Royal Collection Trust / © Her Majesty Queen Elizabeth II, 2019
Production: Brigid Ackerman
Publicity: Alyssa Sanford and Katie Lewis
Copyeditor: Anita O'Brien

This book has been composed in Miller

Printed on acid-free paper. ∞

Printed in the United States of America

10 9 8 7 6 5 4 3 2 1

For Richard, Beatrice, and Alexander, with love

CONTENTS

Plates follow page 80
List of Illustrations · ix
Acknowledgments · xi

PROLOGUE	Three Graces	1
CHAPTER 1	A Renaissance Keyword	12
	Amazing Grace	15
	Meanings and Methods	17
	Narratives	26
CHAPTER 2	Grace Abounding: Four Contexts	30
	Humanist Revivals	31
	Religious Debates	35
	Christian Classicism	38
	The Language Question	44
CHAPTER 3	Grace and Favour: Baldassare Castiglione and Raphael	50
	A Courtier's Grace	51
	Two-Way Grace	58
	Raphael's Three Graces	65
CHAPTER 4	Grace and Beauty: Vittoria Colonna and Tullia d'Aragona	76
	Grace without Beauty	79
	Beauty without Grace	92
	A Grace of Her Own	100

CHAPTER 5 Grace and Ingratitude: Lodovico Dolce
and Ludovico Ariosto 114

The View from Dolce 116

A Portrait by Ariosto 128

CHAPTER 6 Grace and Labour: Michelangelo
Buonarroti and Vittoria Colonna 142

Michelangelo's 'Most Graceful Grace' 143

The Achievement of Grace 148

God-Given Grace 160

Conclusion · 181
Notes · 189
Bibliography · 221
Index · 237

LIST OF ILLUSTRATIONS

Fig. 1 (Plate 1)	Francesco del Cossa, *Allegory of April*, ca. 1469	xvi
Fig. 2	Domenico di Paris, *Fides*, ca. 1467	6
Fig. 3	Domenico di Paris, *Spes*, ca. 1467	6
Fig. 4 (Plate 2)	Domenico di Paris, *Caritas*, ca. 1467	6
Fig. 5 (Plate 3)	Raffaello Sanzio, called Raphael, *Portrait of Baldassare Castiglione*, ca. 1514–1515	56
Fig. 6 (Plate 4)	Raphael, *The Three Graces*, ca. 1504–1505	67
Fig. 7 (Plate 5)	Raphael, *Study for the Three Graces*, ca. 1517–1518	70
Fig. 8	Raphael, *Venus*, ca. 1511–1514	73
Fig. 9 (Plate 6)	Raphael, *La Fornarina*, 1518–1519	74
Fig. 10 (Plate 7)	Raphael and workshop, *Wedding Banquet of Cupid and Psyche* (detail), 1518–1519	75
Fig. 11	Francesco del Cossa, *Allegory of April* (detail), ca. 1469	127
Fig. 12	Anonymous, Emblem with bees, 1516	129
Fig. 13	Lucas Cranach the Elder, *The Honey Thief*, ca. 1526–1527	134
Fig. 14	Andrea Alciati, *Dulcia quandoque amara fiera*, 1531	136
Fig. 15	Andrea Alciati, *Ex bello pax, 1531*	136
Fig. 16	Alfonso d'Este personal coin, *De forti dulcedo*, ca. 1505	137
Fig. 17	Anonymous, Image of Ewe Suckling Wolf-Cub, 1532	141
Fig. 18 (Plate 8)	Michelangelo Buonarroti, *Pietà*, 1499	149
Fig. 19 (Plate 9)	Michelangelo Buonarroti, *Cristo di Santa Maria sopra la Minerva*, 1519–1520	155
Fig. 20	Anonymous, *Laocoön Group*, ca. 42–20 BC	159
Fig. 21	Michelangelo Buonarroti, *Colonna Pietà*, ca. 1538	161
Fig. 22	Michelangelo Buonarroti, *Colonna Crucifixion*, ca. 1538	171

IT IS A PLEASURE TO acknowledge the bounteous help I have received in the making of this book. Debts of multiple kinds were accumulated at Durham University, where my project ended and began; at the University of Birmingham, where I worked for over a decade; and in Oxford, where I lived during the Birmingham years. Special thanks for conversation, ideas, practical support, and friendship are owed to Daniele Albertazzi, Judith Allan, Clelia Boscolo, Clodagh Brook, Ben Cairns, Carlo Caruso, Rachael Dann, Paolo de Ventura, Stephen Forcer, Finn Fordham, Heather Hamill, Sean Hand, Nigel Harris, David Hemsoll, Alice Hunt, Sarah Knott, Roman Krznaric, Francesco Manzini, James McConnachie, Richard Parish, Kate Raworth, Charlotte Ross, Julia Shillingford, Kate Tunstall, Alain Viala, Annette Volfing, and Caroline Warman. Without Simon Travis, this book would almost certainly not have been written.

Collaborative research groups nourished the project during its gestation. For creating havens of collegial debate, I thank Terence Cave (director of the Oxford-based, Balzan-funded project 'Literature as an Object of Knowledge'); Alex Marr (director of the European Research Council–funded, Cambridge-based project 'Genius Before Romanticism'); and Catherine Whistler and Ben Thomas (co-curators of the Ashmolean Museum exhibition entitled *Raphael: The Drawings* and engineers of a series of workshops leading up to that event). Participation in these collectives introduced me to a great many colleagues whose reflections, perspectives, and style I am indebted to, particularly the Balzanistas Kathryn Banks, Warren Boutcher, Tim Chesters, Guido Giglioni, Neil Kenny, Kirsti Sellevold, Olivia Smith, and Deirdre Wilson; and the Genius group Raphaële Garrod, Richard Oosterhoff, and José Ramón Marcaida. Gratitude, too, to participants of the research network 'Early Modern Keywords,' which I codirect with Richard Scholar. Our collective thinking about words and what to do with them informs this book, and I am especially thankful to Alice Brooke, Colin Burrow, Emily Butterworth, Emma Claussen, Katherine Ibbett, Michael Moriarty, Kathryn Murphy, John O'Brien, Simon Park, Martino Rossi Monti, Patricia Seed, Rowan Tomlinson, and Anita Traninger.

Terence Cave's Balzan project bought me out of teaching for a term in 2012; the Fondazione Giorgio Cini sponsored a residential fellowship on

the island of San Giorgio Maggiore, Venice, in 2013; and the University of Birmingham provided a year of research leave in 2016–2017. A Leverhulme Trust Research Fellowship granted me an invaluable stretch of eighteen months (2017–2019) to finish writing the book. Sincere thanks to Pasquale Gagliardi, Maria Novella Benzoni, and Marta Zoppetti at the Fondazione Giorgio Cini; to Jerry Brotton for suggesting I apply to go there; and to each of my sponsors, whose generous support the book could not have done without. Durham University sponsored the purchase of permissions and publication rights for the images, for which I am grateful.

Archivists and librarians helped in the research process. I am particularly grateful to Martin Killeen of the Cadbury Research Library in Birmingham; Claudia Favaron, Ilenia Maschietto, and Simone Tonin of the Manica Lunga Library at the Fondazione Giorgio Cini; Gaye Morgan at the Codrington Library in All Soul's College, Oxford; and Francesca Gallori at the Biblioteca Nazionale Centrale di Firenze. Thanks, too, to the staff of the Bodleian, Taylorian, and Sackler Libraries at the University of Oxford, where I did most of my research. Ben Tate at Princeton University Press has been an engaged and supportive editor, Nathan Carr oversaw the layout and production with great care, and I am thankful, too, to Anita O'Brien for scrupulous copyediting as well as to Puck Fletcher for meticulous indexing.

The Genius group, Nicolò Crisafi, Jane Everson, Vittoria Falanca, Lucy Gwynn, Stefano Jossa, Neil Kenny, Maria Pavlova, Elena Porciani, Gervase Rosser, Heather Webb, and Boris Wiseman, are amongst those who invited me to give lectures in Europe and the United States during the research and writing of this book, while Abigail Brundin, Veronica Copello, Kathy Eden, Simon Gilson, Alex Marr, Martin McLaughlin, Luca Degl'Innocenti, Martino Rossi Monti, Angela Scholar, Paola Ugolini, and Ben Thomas read sections or all of the book, spotting errors and providing acute insights of various kinds. Each interlocutor shaped its content and form, but all remaining errors are, of course, mine.

Deana Rankin and Wes Williams fit into a number of the categories listed above, as do Patricia Palmer and John David Rhodes, whose humour, support and inspiration enlivened all stages in the making of this book. Thanks, also, to Kathy Eden for words of wisdom delivered at key moments that provided more of a boost than she can know. Martin McLaughlin has become a friend and mentor par excellence over the years, as has Gervase Rosser. I am glad of the chance to thank them publicly for their generosity of time and wisdom. I remember, with gratitude, my first academic mentor at University College Cork, Eduardo Saccone,

whose inspirational teaching of Ariosto and Castiglione set me on this track in the first place.

Mac Carthys and Scholars of all ages have shared with me the endeavours of the past decade and a half. I limit myself to naming Kathleen, Mary, Pat, Anne, Donal, Michael, Angela, Tom, and John as representatives of the intergenerational, cosmopolitan tribe I feel blessed to be a part of. Michael and Angela Scholar deserve a second mention for a decade of grandparental childcare. To them I say: take it as read. Caregiving is as fundamental to book writing as intellectual support during this stage of life, and I thank the network of au pairs, babysitters, friends, and family that has formed over the course of the past decade. *Besos* to Sara Ros Gonzáles and Ana Isabel Furquet Santamaría, *abbracci* to Giulia Ganugi, and *cead míle buíochas* to Clodagh O'Neill, Claire and Sinead Hegarty, as well as to my wonderful nephews and nieces in Ireland. Thanks, too, to Carole and Peter Lattin, and my childhood friends Karina Healy, Deirdre Mundow, and Ann O'Sullivan, who whisked the children off on day trips and sleepovers as memorable to them as they were useful to me.

I pay tribute, here, to my priest-poet-uncle, Michael Mc Carthy, who died in July 2018 as I was putting the finishing touches to my manuscript. His example and lifelong reflections on grace, poetic and divine, have informed and enhanced my thinking and writing no end.

The origins of this book can be traced back some fifteen years to a casual conversation with a new colleague in the French Department at the School of Modern Languages and Cultures, Durham. One thing led to another: the conversation carried on, fragments of thought found verbal form and became a book. I dedicate the fruits of our conversation to that new colleague turned life companion, Richard, and to our children, Bea and Sandy. You grace my life with riches no words could repay.

NOTE ON THE TEXT

Sections of chapters 3, 5, and 6 have appeared in an earlier stage of evolution in *Renaissance Keywords* (Legenda, 2013); 'Ariosto's Grace: The View from Lodovico Dolce' (*Modern Language Notes*, 2014); and 'Grace and the "Reach of Art" in Castiglione and Raphael' (*Word and Image*, 2009).

THE GRACE OF THE ITALIAN RENAISSANCE

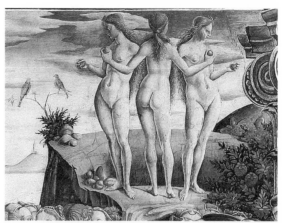

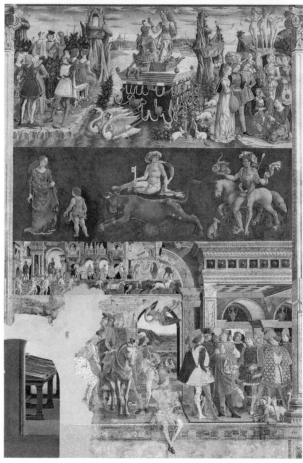

FIGURE 1. Top: detail of 3 Graces from *Allegory of April*.
Bottom: Francesco del Cossa, *Allegory of April*, ca. 1469. Fresco.
Musei di Arte Antica di Ferrara, Palazzo Schifanoia, Ferrara. © Photo Ghiraldini-Panini.

PROLOGUE

Three Graces

In Athens, the Graces stood on the way up to the holiest places. Our artists should place them over their workshops and wear them on a ring as a constant reminder and make offerings to them to make these goddesses well-disposed towards them.

—JOHANN JOACHIM WINCKELMANN, 'ON
GRACE IN WORKS OF ART' (1759)

The Greek myth attributes to the goddess of beauty a belt possessed of the power to endow the one who wears it with grace, and to obtain love. This goddess is accompanied by the goddesses of grace, or the Graces.

—FRIEDRICH SCHILLER, 'ON GRACE AND DIGNITY' (1793)

APRIL IS THE MONTH OF grace, according to the fresco of that month in the *Salone dei mesi* (Room of the months) of Ferrara's Palazzo Schifanoia. The qualities of grace are there distributed by the three Graces of classical tradition. Presiding from their grassy pedestal in the top right-hand corner of the fresco, the three sisters—Euphrosyne, Aglaia, and Thalia—infuse the classical, heavenly, and terrestrial scenes beneath them with love and beauty, poetry and music, benevolence and sociability (fig. 1, plate 1). Weaving their circular dance, they accompany Venus as she sits in triumph before Mars, kneeling chained and captive before her while two white swans bear her water-bound carriage along. Love and music entertain courting couples on the verdant river banks of that upper mythological scene, while the influence of the Graces extends to the two lower levels of the fresco as well. Together with Venus, they conspire with the zodiacal forces of Taurus depicted in the middle stratum and with the constellation of stars governing April's skies to regulate the social order

[1]

of late fifteenth-century Ferrara. Inspiring acts of charity, festivity, good leadership, and equally good citizenship, they make of Duke Borso d'Este's duchy, portrayed in the lower stratum, an idyll of generosity and civility.

Inscribed within an elaborate iconographical system, the three Graces subtly unfold the aesthetic, ethical, material, and moral virtues united in the word 'grace'. Beauty and charisma; an ability to please and to elicit appreciation in return; and a tendency towards charity and the exchange of gifts and benefits on which civilised society should depend: all these converge in the word as well as in the fresco, whose top-down action mirrors the vertical axis along which the Christian God's gift of grace is said to descend from Heaven to Earth. Deceptively simple, these Graces impart a sense of the universal appeal of the quality of grace and an image of its pervasiveness at bodily and transcendental, individual and collective levels of human experience. They also offer an impression of its subtle ineffability because, like the dance of the Graces, grace is always in motion, pleasing and benefiting certain recipients, yet eluding others at will. Like the dancers' averted gaze, it resists the demands of its beholders and bestows its lavish gifts in accordance with a law of its own. As such, grace represents an ideal that does not always chime with reality. Likewise, the image of an ideal grace-infused community immortalised on the walls of a courtly palace in Ferrara does not necessarily portray the actual lived experience of the artists, architects, and other real-life citizens who designed and executed it. Taking its cue from the complex ambiguity of the Graces in the *Salone dei mesi*, this book examines grace not as a stable repository of meaning to be decoded and defined in simple formulas, but as a mobile and multifaceted force to be traced in and around the crossroads between the ideal and the real of the Italian Renaissance.

Standard readings of the Schifanoia Graces concentrate on their ancillary role as companions of Venus, the classical goddess of love whose planetary influence governs the month of April. They tend to be considered as further incitements to reflections on love, beauty, and sensuality; their impact on human affairs is thought to be in line with other fifteenth-century Graces, such as those in Sandro Botticelli's *Primavera*. Naked and finely formed, they do indeed exude a sensuality that amplifies Venus's, an effect enhanced by the soft tendrils of hair caressing their backs and the haptic positioning of hands which, were it not for the golden apples, would encircle each other's bodies. With two of the Graces portrayed frontally and one from behind, they luxuriate in the female form, bringing dynamism to Venus's appeal with their intimations of dance. Waves of movement ripple across the V shapes of their upturned arms and across

the pronounced Vs of their pelvises, a motion counterbalanced by the lines and poise of their long and shapely legs. The horizontal and vertical axes create a sense both of balance and of movement, suggesting that without the dynamism of the Graces, the static essentials of beauty (proportion, harmony, symmetry, and so on) would have no power over the beholder. Further enhancing the symbolism of the goddess of love are the interlinked bodies of the Graces and the synchronicity of their gestures. This synchronicity emphasizes the complementarity of attraction, yet the women's gazes are also averted both from each other and from viewers, because true love should not seek reciprocity. It should thrive, first and foremost, for the sake of the beloved while harbouring, in second place, the hope that it will be returned unbidden. Repeated circular shapes, from navels and nipples to breasts and apples, highlight the unbroken circularity of the Graces' dance, suggesting the eternal cycle of nature and the fertility of love, at its most abundant here in the height of spring.

It is true, then, that the Graces echo the goddess of love's triumph over the god of war in the centre of the upper plane of the fresco. It also true, however, that they bear scrutiny in their own right and in terms of their independent relationship with the other elements of the elaborate iconographical plan as well. Take their relevance to the white swans drawing the float on which Venus claims her victory over Mars, for example. Since Aby Warburg's seminal lecture in 1912, Venus's swans have evoked for commentators medieval tales of the Swan-Knight and, in particular, Wolfram von Eschenbach's *Parzival* (from the early thirteenth century) expressing a penchant the Este family had for epic and romance literature. Yet swans have obvious classical roots, too, which carry special significance for the city of Ferrara. According to at least one locus classicus (Ovid), Apollo's hubristic son, Phaeton, begged to drive his father's chariot until his horse took fright at the sight of a scorpion and plunged Phaeton to his death in the river Po, which flows through Ferrara. At the site of the fatal fall, Phaeton's sisters wept such abundant tears that they transmogrified into trees weeping leaves into the river for eternity, while a close relative, Cygnus, resigned himself to voluntarily wandering the banks of the river, lamenting his cousin's death, till he found one day that he had metamorphosed into a swan. Bearer of the original Apollonian plaint, the Po River swan symbolised both poetry and mortality, associations that few original viewers of the Schifanoia frescoes could have missed. Swans were thenceforth companions of Apollo and came to be associated with the music, poetry, and illuminated rationality of the Greek god. In other classical texts, they were linked to Venus as well: Horace's first ode to the goddess of love

describes 'splendid swans' accompanying her, uniting love and poetry in their avian game. In Horace's ode to Antonius Iulis (4.2), he further develops the link between swans and poetry, calling Pindar the swan of Dirce and Antonius himself a swan who writes in a 'sublimer style' than Horace's own. Swans bring love, poetry, and the greatest poets into contact with each other, and the *Salone dei mesi* immortalises that classical communion. As they bear Venus and Mars along, the swans represent those who convey in words the mastery of war by love. Fundamental to all such conveyances is grace, that core quality of language theorised by ancient authorities from Cicero to Horace to Quintilian. Grace, like the three Graces themselves, governs the sweetness of poetry and populates the poetic imagination with images as fecund as the landscape of the *Salone dei mesi* springtime scene.

Enlivening the uppermost level of the April fresco with love, dynamic beauty, and poetry, the three Graces govern the middle and lower levels as well. All this in accordance with the architects' plan to depict the profound correspondence between life on earth, the movements of the celestial bodies, and the qualities and activities of the gods. That architectural plan, designed by Pellegrino Prisciani and collaborators, unfolds in April around a visual pattern based on the number three. From the three sisters on their pedestal to the tripartite division of the panel; from the three sources whence the river bearing Venus rises to the three deacons guarding the middle zodiacal plane of the fresco; and from the three scenes of Ferrarese life on the lower plane to the triple portrait of Duke Borso d'Este within it, these visual trinities chime with the threefold rhythms of the universe which ancient Greeks, Romans, and later Christians held in common and which linked the heavens and the earth in symbiotic harmony. For ancient authorities, the three Graces acted as the perfect illustration of such triadic rhythms and of how divine providence showers its gifts upon humankind. Bridging ancient and Christian thinking, St Paul and other early church writers harnessed a similar tripartite structure to explain the Christian God's disbursal of his gifts on earth. In his first letters to the Corinthians, St Paul describes how God's goodness is infused into human souls, expressing itself in the three theological virtues: faith, hope, and charity. The Greek word for this third virtue, *agape* (ἀγάπη in Greek), is translated variously into English as 'love' or 'charity', the latter maintaining an etymological link to the Greek *charis* (Χάρις, meaning 'grace'), to which *agape* closely corresponds. This third grace, which is grace itself, is the most important of spiritual gifts, as the oft-quoted lines of St Paul's letter makes clear, culminating with the statement 'and now these three

remain: faith, hope and charity/love. But the greatest of these is charity/
love' (1 Corinthians 13).

Fifteen centuries later, humanist syncretists sought to combine classi-
cal and Christian theological triads anew, a subject to which we will return
in chapter 2 and at various points throughout this book. The architects of
the *Salone dei mesi* are amongst those humanist syncretists, exploiting the
image of the three Graces to illustrate how divine and celestial gifts unfold
within the microcosms of human experience that make up the larger har-
monious cosmos and how they transmit the arts to humankind, infusing
human souls with the virtue of grace. From this perspective, the icono-
graphical link between the *Salone dei mesi* and the *Sala delle virtù* next
door takes on new meaning, with the smaller room acting as the Christian
apex to the cosmological design of the larger banquet room and featuring
(along with the cardinal virtues) the three theological virtues described by
St Paul (figs. 2–4, plate 2). In the spirit of macrocosmic unity, the lower
plane of the month of April does not simply depict springtime activities
in Renaissance Ferrara: it portrays the direct connection between those
activities, the domain of celestial planets and stars, and the pantheon of
classical gods. Then, as one enters the *Sala delle virtù* via the door to the
left of the *Allegory of April* and gazes up at the coffered ceiling and sump-
tuous frieze, daily life in Ferrara connects up, as well, with the theological
virtues depicted there in stuccoed polychrome relief. Personified, according
to convention, as three women, this ultimate trinity aligns the mundane
with the supreme realm of Christian divinity and points once more to the
heavens-down infusion of humankind with God's gifts and graces. At the
heart of this cosmological harmony is Duke Borso d'Este, whose rule of
Ferrara and its rural hinterland commands a degree of social order that
chimes with the divine, and whose embodiment of love, liberality, and jus-
tice echoes (albeit in mortal form) the highest virtues of the April gods.

April in Ferrara, it seems, is a time for falconry, and the lower left half of
the earthly panel depicts Borso and company returning home on horseback,
their quarry falling from the sky, a falconer putting a hood back on the
bird of prey. It is, according to the upper left section of the lower panel,
the month of the *palio* of St George, where noble ladies and their entou-
rage watch from the balconies of fine palaces while prostitutes, Jews, and
others considered undesirable race barefoot, noblemen race on horseback,
and town idiots career around on mules. Such festivities take place under
the auspices of the duke and are presented as his gifts to the general public,
tokens of his wealth and generosity. Key to this reading of the scene is the
narrative unfolding in its right-hand half. Occupying the foreground and

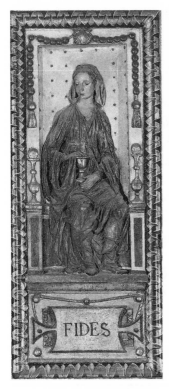 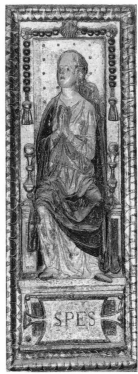 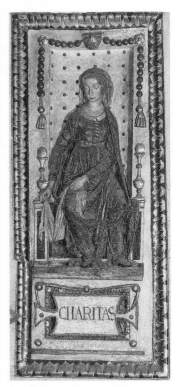

FIGURE 2 (left). Domenico di Paris, *Fides*, ca. 1467. Stucco. Musei di Arte Antica di Ferrara, Palazzo Schifanoia, Ferrara. © Photo Ghiraldini-Panini.

FIGURE 3 (center). Domenico di Paris, *Spes*, ca. 1467. Stucco. Musei di Arte Antica di Ferrara, Palazzo Schifanoia, Ferrara. © Photo Ghiraldini-Panini.

FIGURE 4 (right). Domenico di Paris, *Caritas*, ca. 1467. Stucco. Musei di Arte Antica di Ferrara, Palazzo Schifanoia, Ferrara. © Photo Ghiraldini-Panini. See also plate 2 for a more complete version of this work of art.

framed by an elaborate architectural arch with coffered ceiling, this narrative draws the eye and presents itself as particularly important. In the centre, a well-dressed figure (identifiable by his hat and profile as Borso) hands an altogether less magnificent masked figure a coin while numerous courtiers stand and observe. A conspicuous gesture of magnanimity, it sets the tone for the rest of the panel and serves as a public relations exercise testifying to the charitable generosity characterising the Este reign.

How is Borso d'Este's charitable generosity related to the three Graces? As well as being the handmaidens of Venus and a symbol for Trinitarian theology, the three Graces symbolized since classical times the just and liberal circulation of benefits on which the happiest societies depend. In

the *Nicomachean Ethics*, Aristotle (5.v, 35) suggested each city should erect a shrine to the three Graces, while Seneca in *De beneficiis* uses them to set out a detailed and influential 'discussion of benefits and the rules for a practice that constitutes the chief bond of human society' (1.iv, 2). Opening his text with the statement that 'among all our many and great vices, none is so common as ingratitude' (1.i, 2), he declares the need for 'a law of conduct' governing how 'to give willingly, to return willingly, and to set before us the high aim of striving not merely to equal, but to surpass in deed and spirit those who have placed us under obligation' (1.iv, 3). Personifying the nature and properties of the ideal of gift exchange, he says, are the three Graces and the circular dance they eternally perform. Quoting Homer, Hesiod, Chrysippus, and Hecaton, he decodes the iconography of the three Graces in the following way:

> Some would have it that there is one for bestowing a benefit, another for receiving it, and a third for returning it; others hold that there are three classes of benefactors—those who earn benefits, those who return them, those who receive and return them at the same time. . . . Why do the sisters hand in hand dance in a ring which returns upon itself? For the reason that a benefit passing in its course from hand to hand returns nevertheless to the giver; the beauty of the whole is destroyed if the course is anywhere broken, and it has most beauty if it is continuous and maintains an uninterrupted succession. . . . Their faces are cheerful, as are ordinarily the faces of those who bestow or receive benefits. They are young because the memory of benefits ought not to grow old. They are maidens because benefits are pure and undefiled and holy in the eyes of all; and it is fitting that there should be nothing to bind or restrict them, and so the maidens wear flowing robes, and these, too, are transparent because benefits desire to be seen. (1.iii, 3–5)

In truth, after surveying the authorities, Seneca then dismisses those who focus their energy on reading meanings into images rather than on setting out practical and pedagogical guidelines for citizens to follow: 'as for these absurdities', he says, 'let them be left to the poets, whose purpose it is to charm the ear and to weave a pleasing tale' (1.iv, 5–6). Nonetheless, the association between the heavenly dance of the three Graces and the terrestrial matter of giving and receiving had been established—and it remained firmly in place. Though they offered no practical guidance on how to ensure the circulation of benefits, the Graces at least served as reminders of the need to work towards that ideal of beneficence and sociability.

Such an association, between the three Graces and the principles of
beneficence, is clearly at play in the *Allegory of April*. Documentary evi-
dence surrounding the pictorial narrative inscribed therein provides con-
crete evidence of this link. Art historians have long identified the recipient
of Borso's charity in the fresco with Scoccola, his court buffoon, who was
renowned for being a converted Jew with a propensity towards card play-
ing, drinking, and borrowing from moneylenders. Letters from 1468 when
the frescoes were being executed preserve the memory of a series of kind-
nesses paid by Borso to Scoccola, whose debts to loan sharks he appears
often to have cleared. One letter is yet another request for help or, as Scoc-
cola puts it, for 'grace'. It closes with the following plea: 'Et se questa gratia
non me farai / da l'ospedale Schocola catarai' (And if this grace you'll not
bestow, it's off to the hospital Scoccola will go). Borso, apparently, did proffer
the grace his jester requested, and the fresco immortalizes such generous
acts. Clearly, the distinguished company of gentlemen and ladies visiting
the *salone* would have been urged to see this as just one magnanimous
gesture in a benevolent environment where grace and generosity reign.

The April fresco, then, aims to credit the Este court with beauty and
love as well as with the more material aspects of grace as it reigns over
a beneficent system of exchange, and a social order founded on giving,
receiving, and giving back. This combination of material and immaterial
aspects may not automatically spring to mind nowadays when we use the
word *grazia*, but they were fully operative in early modern Italian usage.
From graceful (*grazioso*) to grateful (*grato*), derivatives of grace remained
interconnected and live, even in the most common utterances of giving
thanks (*rendere gratia*) and saying 'please' (*di gratia*). In fact, the close con-
nection between the material virtues of grace and its aesthetically pleas-
ing counterparts had been newly energized by humanists, both those who
wished to restore Latin to its former glory of classical times and those who
wished to promote Tuscan as the modern language of literate culture in
Italy (a topic to which I return in chapter 2).

The iconographical plan for the *salone* frescoes draws inspiration from
a rich humanist lexicon. Alongside astronomical sources such as Marcus
Manilius's *Astronomicon*, the Este library contains copies of the more
literary authorities on whom Prisciani and his collaborators drew, from
Seneca, Servius, and Fulgentius to their medieval commentators, includ-
ing Boccaccio. All these texts were pillars of humanist education. Servius's
Commentary on the Aeneid is particularly relevant to the *Allegory of April*
since it is he (and not Seneca) who links the three Graces both to love
(as they swim with Venus in Acidalian waters) and to liberality (in their

tripartite dance). In Seneca's *De beneficiis*, the three Graces 'wear flow-
ing robes, and these . . . are transparent because benefits desire to be seen'
(1.iii, 5), and they dance hand in hand in a ring because 'a benefit passing
in its course from hand to hand returns nevertheless to the giver' (1.iii, 4).
This is how they are portrayed in Botticelli's *Primavera*. In the Schifanoia
frescoes, however, the graces are naked, with one facing away from us
while the other two face towards us, in accordance with Servius, for whom
they are naked 'because Graces must be free of deceit' and for whom 'one
is depicted from the back and two face us because for every kindness issu-
ing from us, two return' (1.720). Prisciani and his fellow architects make
good use of this text (or a subsequent adaptation of it) to project a glorified
image of an Este court where benefits are given, received, and returned;
where every good deed is rewarded and redoubled; where gifts are freely
and openly given; benefits lead one to another; and grace remains uncor-
rupted by the expectation of recompense.

Ironically, the experience of the painter of that particular fresco, Francesco
del Cossa, did not quite match the ideal. One of the richest sources of his-
torical information we have for the *Salone dei mesi* frescoes is a letter he
sent to Borso d'Este in 1470, requesting that he be paid more than his less
skilled, less diligent colleagues for his work. Del Cossa claimed to deserve
better pay than the 'piu tristo garzone de ferara' (the sorriest assistant in
Ferrara) because he was devoted to the study of his craft and had begun
to make 'un pocho de nome' (a little bit of a name) for himself. Moreover,
he claimed, his technique was better than the others: he had used gold
and good colours and painted in fresco, which was a 'lavoro avantzato e
bono' (complex and good type of work). The quality of his work would
prove his virtue as a craftsman, as indeed it has, since del Cossa's panels
survive while many others have perished, thanks in large part to the fact
that he did, indeed, paint on wet lime plaster (*in fresco*) rather than on
dry (*a secco*).

At the start of the letter, del Cossa pleads for justice. Painters have to
live 'sule [loro] braze' (by [their] hands), and when it comes to payment,
fairness should surely prevail. The set fee of ten pennies (*bolognini*) per
foot did not seem fair, and del Cossa along with other painters had already
written to Borso about the price, which would leave many of them out of
pocket. Del Cossa himself stood to lose forty to fifty ducats on the com-
mission, a fact that made him 'doglieria et tristaria' (feel pain and sor-
row). Such pain and sorrow may be what prompted the artist to impress a
portrait of himself into the lower tier of the fresco panel for March, where

Borso is depicted administering justice to two litigants, one of whom gen-
uflects before him while the other doffs his hat. Above the duke's head, a
triumphal arch displays the inscription 'Iusticia', and the whole scene is
clearly designed to bolster his image as a just and fair lord. Directly behind
his head, a figure peeps out and looks directly at the spectator. According
to the convention in which painters portrayed themselves in this way, the
figure must have been none other than del Cossa himself, staking his own
eloquent claim on the *iusticia* of his benefactor.

Should an appeal to Borso's justice work against him, however, del
Cossa had a plan B. If the fair-minded duke felt disinclined to favour his
appeal on the grounds that it sought unfair preferential treatment, he pro-
posed that there was an alternative way of looking at things: the duke
could say that the extra payment to del Cossa 'e stato extimato' (was thus
judged), as a result of those *extime*, or appraisals, that took place on the
completion of any commission. The higher fee would be a fair and just
performance-related bonus, in other words, that Borso would be perfectly
within his rights to disburse. Failing that, the duke could resort to the
conventions of grace: the artist's bonus, del Cossa suggests, could be cast
as a gift, granted in the name of grace and kindness, and well within the
bounds of justice: 'Et quando Signoria Vostra non volesse andare drieto ad
extime prego quela voglia se non el tuto che forsi me vegneria ma quella
parte li pare de grazia et benignitate Sua me la doni: Et io per gracioso
dono l'acceptarò et cossi predicarò'. (If your lordship does not want to fol-
low the appraisals, I pray you may wish to give me, if not all that I perhaps
would be entitled to, then whatever part of it that might please you in
your grace and kindness: and I will accept it as a gracious gift and will so
declare it.) An artist's grace, of course, should be unsullied by the expec-
tation of recompense; but at the end of the day, an artist had to live. If
not even single measures of grace were forthcoming as a reward for his
good deeds, then what was he to do? Surely the duke knew that generosity
shown now would be redoubled later: del Cossa's skill would reach ever
greater heights and bring prestige and renown to the court.

The appeal fell on deaf ears. Unlike the generous duke immortalized
by del Cossa's hand, the real Borso d'Este was unmoved. Del Cossa's letter
bears the decisive annotation: 'Let him be content with the set fee, for it
was set for those selected to the individual fields' (Quod velit esse con-
tentus taxa facta, nam facta est per electos perspectis singulis). Del Cossa
soon left Ferrara for Bologna.

The *Allegory of April* transforms the abstract qualities of grace into an
eloquent verbal language that we read from top to bottom by following the

line of their spiritual passage from the heavens to deserving mortals below. Close allies of beauty and faithful escorts to Love, these qualities inspire the arts of love, poetry, and music. Through the sign of Taurus, they infuse the powers of liberality into the hearts of the elect. An ideal rather than a realistic portrait of universal grace and sociability, though, the fresco also conveys the real-world dearth of its qualities. For although Francesco del Cossa paints grace with grace, he fails to receive grace in return. In stating his case to Borso d'Este, he speaks for a generation of courtiers and craftsmen seeking, but rarely finding, fair accreditation at court, and he shares in a problem that fifteenth-century poets, artists, male courtiers, and court ladies knew well: the problem of what happens when the grace personified and idealized in the figure of the three Graces meets with nothing but ingratitude. Grace's encounter with its opposite, as this book will show, is every bit as much a feature of its Renaissance history as its seemingly endless capacity to be incorrigibly plural.

CHAPTER ONE

A Renaissance Keyword

Beauty, like all other qualities presented to human experience, is relative;
and the definition of it becomes unmeaning and useless in proportion
to its abstractness. To define beauty not in the most abstract, but in
the most concrete terms possible, not to find a universal formula for it,
but the formula which expresses most adequately this or that special
manifestation of it, is the aim of the true study of aesthetics.

—WALTER PATER, *STUDIES IN THE HISTORY OF*
THE RENAISSANCE (1873)

THIS BOOK EXPLORES GRACE AS a complex keyword of the Italian Renaissance. Grace surfaces time and again in the period's discussions of the individual pursuit of the good life and in the collective quest to determine the best means to a harmonious society. It rises to prominence in theological debates about the soul's salvation and in secular debates about how best to live at court. It plays a pivotal role in the humanist campaign to develop a shared literary language, and it features prominently in the efforts of writers and artists to express the full potential of mankind. It is often treated at the level of a topic in the literate culture of the Italian Renaissance, but it is employed as an instrument of persuasion too, one whose sound was as sweet as it effects were amazing.

The title of this book is at once revealing of its ambition and potentially deceptive. Take the first definite article: is there any such thing as '*the* grace of the Italian Renaissance'? Studies have been written about the various different types of grace that abound in Renaissance Italy: grace as an aesthetic quality that characterises the period's finest art; grace as the affable and pleasing manners of its best courtiers and ladies; grace as the gift from God that was so contested during the Reformation; grace in

relation to the exchange of favours at the heart of the early modern patronage system. Which of these graces does 'the grace' in this book's title denote? The answer is all of them, and a few more besides. A central aim here is to embrace the semantic abundance of grace and to explore what happens when it crosses the boundaries between art, literature, social discourse, gender relations, theology, and politics. The definite article in the title is therefore not designed to suggest that there was just one grace in Renaissance Italy nor that the grace found in different settings was always one and the same thing. Rather, it indicates the book's focus on a single keyword that unites a range of qualities and characteristics, rather like a single family name brings together many individual members, linked by elemental genetic traits.

The second half of the title equally deserves comment: Was there any such thing as 'the Italian Renaissance'? 'Italy' itself was an aspiration rather than a reality during the fifteenth and sixteenth centuries, when the peninsula had no central seat of power, capital city, common currency, or language. It was not until 1871 that the peninsula became a united kingdom with Rome as its capital. What is now a republic was, in the early modern period, a complicated and frequently riven patchwork of nation-states of various sizes and structures. Pre-nineteenth-century 'Italy' is, therefore, a problematic concept. Yet the notion of *italianità* (Italian-ness) did exist in early modern literature, and writers from Dante to Petrarch and Ariosto called on their *italici* brothers to free their *dolci campi* from perfidious foreign invaders.[1] Political commentators and historians, too, discussed the ways and means by which 'l'Italia' could withstand attack from French, Spanish, and Germanic forces.[2] The quest for *italianità* found full expression in the early modern *questione della lingua*, that debate about language whereby intellectuals sought a common vernacular idiom to replace Latin as the language of literature. It was present, too, in Italian humanism as an intellectual movement whose revival of antiquity brought remembrance of a time when Roman emperors had made the country their principal domain and when Roman orators, rhetoricians, and poets had exemplified its virtues. Moreover, a sense of *italianità* was assured by the power of the Vatican over Italian territories, which gave the debates about religion that raged across Europe a distinctive national character. 'Italy' did exist in the early modern period, then, in the particular characteristics of the peninsula's internal concerns and quarrels, in the contrast between it and other European nation-states, and in the literary and artistic hopes and aspirations of many of its inhabitants. Grace, this book argues, was central in each of these contexts.

Grace became a mark of distinction in the *questione della lingua* and in the new language of literature. It was reenergised by the recovery of ancient texts that extolled its virtues as an instrument of persuasion in the language and visual arts. And it was the central bone of contention in Reformation and Counter-Reformation discussions about the nature of God's intervention in human salvation. Within each of these contexts, grace became a defining quality that Italians made their own. It came to represent a means of claiming distinction for artists, writers, and thinkers, and of arguing for the preeminence of their chosen fields. The adjective 'Italian' in this book's title is not used blithely, therefore, but with the dual purpose of underlining the *italianità* of the grace that it studies and of emphasising its centrality to those forces that eventually helped modern-day Italy come into being.

If the use of 'Italian' in this book's title requires clarification, its use of 'Renaissance' does, too. Can we really still speak of 'the Renaissance'? Debates about whether early modern Italy actually did witness a renaissance have animated scholarship for quite some time. Everyone accepts that something major happened to visual culture during the period 1300–1600: advances in artistic techniques and topics did occur, as did a revival of the ancient quest for beauty. Yet art historians themselves have shown that, even in artistic circles, cultural regeneration was not unique to that place and time. Italy and Europe had witnessed several 'renascences', or revivals of classical antiquity accompanied by a flourishing of literature and art and a sense amongst contemporaries that they lived in a golden age of rebirth, renovation and restoration. Previous European 'renaissances', according to Erwin Panofsky, included the Carolingian revival of classical imagery in the ninth century and a twelfth-century revitalization of classical literature in art.[3] Panofsky is one scholar amongst many to highlight how exaggerated the claims for a fourteenth- to sixteenth-century cultural miracle that put an end to centuries of intellectual and artistic darkness were. The 'Renaissance' (with a capital 'R') that Jacob Burkhardt immortalised in his *Civilisation of the Renaissance in Italy* (1861) was not a singular cultural phenomenon. Moreover, Burckhardt's 'Renaissance' was anything but uniform. In certain important arenas—such as in the lives of most women (to cite just one example)—the cultural revolution was circumscribed, limited to the highest aristocracy living in restricted geographical regions.[4] The so-called Italian Renaissance, in other words, was neither unique nor universal. So why persist with that term? Because, this book suggests, grace played a crucial role both in those movements that have characterised the period since Burkhardt's time as

one of renaissance and in the cultural processes that saw those movements yield to other ones. As such, it complicates and enriches existing accounts of sixteenth-century Italy and raises new questions about the degree to which it was a moment of rebirth and innovation.

Grace provides a unique perspective on sixteenth-century Italy, for it rose to prominence in the context of so-called High Renaissance art, yet it also played a pivotal role in its polemical progress towards Mannerism. It was not, therefore, a banner that united artists in their advance towards the full maturity of their discipline, as Giorgio Vasari would have had it, but a locus of encounter and conflict between different ways of conceiving of the visual arts. At the same time, it was a keyword in the humanist revival of classical Latin in the fourteenth and fifteenth centuries, but also in the later promotion of the vernacular as the preferred language of modern literature. It was not, in other words, the outstanding feature and sole preserve of ancient Latins, as certain humanists had argued, but a sign that living languages could carry the same authority and dignity as 'dead' ones. Moreover, grace played a significant role in the beginnings of what Norbert Elias has called the 'civilising process' in Western society, yet it also evoked the feudal manners of the 'Dark Ages' it supposedly left in its wake.[5] It evoked, in short, the social graces of great European courts as much as it did the humanist graces of Renaissance Italian ones. Finally, grace was fundamental to the explosion of debates about religion that marked the passage from Renaissance to Reformation. It was, in this respect, as much a Reformation keyword as it was a Renaissance one.

Grace marked the climax of the Renaissance, but it also stoked the embers of the past and, at the same time, heralded the dawn of a new age. It stands to reveal, therefore, not just one perspective on sixteenth-century Italy but different ways of looking at its culture and society and, as such, goes to the heart of the question: Just what *was* the Italian Renaissance? Evoking the word in this book's title is an invitation to consider both 'grace' and the concept of 'the Renaissance' afresh, and to think of the former as a sort of crucible in which the continuities and innovations, the friendships and rivalries, the rebirths and disintegrations we still sometimes think of as 'Renaissance' were formed.

Amazing Grace

Grace is not, of course, a keyword of sixteenth-century Italy alone. It acts as a crucible for culture and society, spirituality and politics across the centuries, rising time and again to prominence across a range of contexts.[6]

On June 26, 2015, to take a particularly public twenty-first-century exam-
ple, U.S. president Barack Obama delivered a funeral eulogy in which
spiritual and rhetorical grace combined with a political force that is rare in
contemporary politics. The funeral ceremony was that of the Honorable
Reverend Clementa Pinckney, pastor of the Emanuel African Methodist
Episcopal Church in Charleston, South Carolina, slain the previous week by
a white supremacist along with eight of his congregation. Obama's forty-
minute speech paid tribute to the 'graciousness' of Reverend Pinckney, 'his
smile, his reassuring baritone, his deceptive sense of humor', those quali-
ties 'that helped him wear so effortlessly a heavy burden of expectation'.[7]
He praised, too, the 'grace surrounding Reverend Pinckney and that Bible
study group . . . as they opened the church doors and invited a stranger to
join in their prayer circle', a stranger who was to shoot and kill them. He
eulogised the extraordinary grace of the grieving families for the way they
responded to that stranger during his bail hearing in court, addressing
him—'in the midst of unspeakable grief, with words of forgiveness'. Their
'amazing grace', he said, led him to reflect 'on this idea of grace' as a whole.

In an oration as powerful yet apparently simple as the eighteenth-
century hymn he evoked (and later went on to sing), Obama's reflec-
tions on the events of June 17 led steadily to the boldest statements of
his career about American society and its discontents. 'As a nation, out of
this terrible tragedy', he declared, 'God has visited grace upon us, for he
has allowed us to see where we've been blind'. Turning from the particu-
lar circumstances of the massacre to its reflection of American society as
a whole, he criticised the widespread blindness in American culture to
'systemic oppression and racial subjugation', as well as the endemic failure
to see how 'racial bias can infect us even when we don't realize it'. Tackling
the most contentious issues in U.S. politics, he condemned the degree to
which Americans had been blind to the 'unique mayhem that gun violence
inflicts upon this nation' and inveighed against the inability to discern the
circumstances that 'permit so many of our children to languish in poverty,
or attend dilapidated schools, or grow up without prospects for a job or for
a career'. The Charleston massacre, he said, was a gift from God, because
it allowed Americans to see what they had failed to see before, and offered
them a unique opportunity to create historical change. It would be a rejec-
tion of the forgiveness expressed by the Charleston families 'to go back
to business as usual' after the massacre, 'to settle for symbolic gestures
without following up with the hard work of more lasting change'. Grace,
he concluded, calls for 'an open mind—but, more importantly, an open
heart'. Through open hearts, he seemed to suggest, grace demands—and

sometimes begets—grace in return and fuels the reciprocal exchange of goodness that should form the bedrock of any civilized society.

The speech won widespread acclaim in the media.[8] The world was, once more, moved by grace: the grace of Reverend Pinckney, of the grieving family members, of the city of Charleston and the state of South Carolina whose people pulled together like never before in the wake of the tragedy. It was moved, most of all, by a world leader who called all his rhetorical graces into the service of a speech as spiritual and political as it was steeped in American history. Whatever one thought of Barack Obama's politics, there was no denying the evocative power of his words.

Behind the rhetorical force of the Charleston eulogy was the power of the word 'grace'. Charged with its array of meanings and American-specific connotations, grace permitted Obama to unleash on an unsuspecting audience his deep criticism of his country and to drive home otherwise unutterable political arguments both rousingly and respectfully. Grace allowed him to frame positively uncompromising ideologies and to gather cross-community support. This was not the first time that grace and politics had come together with such rhetorical force, but, adapted for new circumstances, it came across as original and compelling. Nor was it the first time that grace was positioned right at the heart of the most urgent debates of its day. In sixteenth-century Italy, too, grace occupied this position time and again. In tracing the movement of grace to the heart of sixteenth-century Italian ethics, aesthetics, culture, and society, this book aims to reflect on 'this idea of grace' as a whole, and to make sense of its lasting ability to move, to persuade, and to effect real change.

Meanings and Methods

So what does the word 'grace' actually mean, and how is one to approach it? Definitions of grace abound in all European languages. The *Oxford English Dictionary* alone lists eighteen entries under the heading 'grace'.[9] These range from 'divine favour, benevolence, or providence bringing about worldly benefit or advantage' (entry no. 2) and 'an instance or manifestation of favour; a favour conferred on or offered to another' (no. 3) to the archaic meanings of 'mercy, clemency; pardon, forgiveness' (no. 5) and 'a person's lot, destiny, or fate; luck, fortune' (no. 6). Other entries include 'the giving or an expression of thanks; gratitude' (no. 11); 'an attractive or pleasing quality or feature' (no. 13); 'the quality of being pleasing; attractiveness, charm' (no. 14); and 'appropriateness of behaviour' (no. 15). The *OED* lists, as well, more specific (and sometimes bizarre) meanings for

grace such as the three Graces, grace notes in music, a game otherwise known as 'grace hoops' or 'the graces', and an exemption from the statutory requirements for a degree granted to Oxford and Cambridge students.

Challenged by the abundance of meanings associated with grace, poets, writers, artists, and philosophers—from Quintilian and Pliny through Schiller and Kleist to Bergson, Beckett, and Coetzee—have set out to capture it in writings that span the fields of aesthetics, theology, social ethics, and literary criticism.[10] One of the most memorable accounts of grace is by Alexander Pope, who in 1711 described it as a beauty beyond precepts, a 'nameless allure' found in the best literature and art.[11] Pope's grace is made up of 'happiness as well as care', luck as well as learning, and its source is as mysterious as its effects are sudden and surprising. Methods cannot teach grace, human reason cannot grasp it, and only the master-hand can reach it by transcending the limits of learning, availing itself of a certain 'lucky license', and snatching it from somewhere 'beyond the reach of art'.

Pope had, of course, snatched this idea from various sources. In his article 'A Grace Beyond the Reach of Art' (1944), Samuel Holt Monk took Pope's immortal phrase as his starting point and traced grace back to its classical origins via eighteenth-century criticism, seventeenth-century aesthetics, and Italian Renaissance literary and art theory. Amongst Pope's many influences, Monk lists Pope's French near contemporaries Roger de Piles and René Rapin, who also inherit from the ancients the following understanding of the idea of grace: '(1) that grace is a distinct aesthetic quality; (2) that it is a gift of nature; (3) that it is to be distinguished from those beauties that rules make possible; (4) that its effect is sudden and surprising; (5) that it defies analysis; (6) that it appeals rather to the heart than to the head; (7) that it is especially the mark of genius'.[12] Monk's pioneering essay provides a highly influential account of grace and proves that the term carried as much nameless allure in mid-twentieth-century aesthetics as the qualities it described. What the essay also suggests, though, is that the grace discussed by Pliny, Cesare Ripa, and Dominique Bouhours is one and the same 'thing'; that writers as diverse as Quintilian, Baldassare Castiglione, and Nicolas Boileau are united by their interest in a common subject. Yet the *venustas* of Pliny, the *gratia* of Ripa, and the *Anmut* of Schiller are not, in fact, the same. The eighteenth-century grace of Alexander Pope—indebted to his self-trained neoclassicism and English Catholic upbringing—does not map onto other conceptualizations. It is a far cry, for example, from the grace expressed by twenty-first-century president Barack Obama—suffused with African American Evangelism, a deep acquaintance with the American civil rights movement, and present-day

U.S. democratic politics. How useful is it, then, in terms of understanding the complex reality of a word, to construct grand narratives that privilege continuity over specificity and sameness over difference?

Grand narratives, like Monk's, fail to capture the semantic richness of any keyword. Grace proves especially inaccessible by this method since it acts as a sort of chameleon intangible that refuses to settle down in language. Rather than remain stable across time, it is deployed by individual language users in historically and culturally specific ways. Grace, in other words, is as hard to narrativize as it is ever-present across the ages. Even within the same historical moment, individuals use it differently, revealing thereby fundamental differences in worldview. The Schifanoia *Allegory of April*, for example, illustrated its classical pedigree, its association with love and poetry, as well as its dynamism in the cycle of benevolence that passes from the graceful to the grateful. We shall see that the sixteenth-century courtier and writer Baldassare Castiglione, by contrast, described grace as that 'certain air' which distinguishes excellent courtiers and court ladies from their mediocre counterparts, an affability that could be learned in order to win the favour of princes. His artist friend Raffaello Sanzio (Raphael) saw it as that quality produced when one conceals the hard work and effort of art behind a veil of nonchalance and ease. But this classically inspired grace drew criticism from those who saw it as self-interested and superficial. Shunning the idea that grace could be cultivated merely by dissimulating effort, opponents like Michelangelo Buonarroti and Vittoria Colonna promoted instead an image of it as the God-given reward for hard work and religious devotion. Their repeated meditations on the grace of Christ made it clear that it is something that can be neither learned nor earned. Whether artistic or spiritual, grace is taken out of our hands and placed firmly in the hands of the divine.

Master narratives like Monk's, then, fail to encapsulate the semantic scope and variety of grace, while dictionary definitions like the *OED*'s fail to express the peculiarities of individual usage (nor, of course, do they purport to do so). Neither master narratives nor definitions can account for how different interpretations of grace reveal different ideological, philosophical, theological, and aesthetic perspectives. No catchall account of grace will shed light on the historical and ideological specificity of Pope's or Obama's grace, for example, just as no totalizing description will capture the distinctive interpretations of del Cossa, Castiglione, and Colonna.

Eduardo Saccone was the first to point out the trouble that bedevils universalising approaches to grace. In his 1983 essay on the grace of

Baldassare Castiglione, Saccone called into question the critical tendency within Renaissance studies to focus not on the meaning of the word within particular contexts but on its role within larger frames of reference.[13] Individual interpretations of grace, he pointed out, are all too often misrepresented by critics who wish to assimilate the term into broader conceptual debates, to co-opt it into more general studies of, for example, Neoplatonic philosophy, the history of ideas, or theories of art.[14] He called for a departure from these wider theoretical discussions and 'disembodied ideas' and a return to 'the materials of which literary texts are made, that is, the words themselves'.[15] Saccone went a long way towards retrieving grace from catchall definitions and grand narratives, in sum, by promoting a return to a philology of the word itself.

Philology has not always been fashionable in the Anglophone humanities. On the contrary, as Edward Said put it, 'philology is just about the least with-it, least sexy and most unmodern of any of the branches of learning associated with humanism.'[16] Since the 1960s and 1970s it has come to be caricatured as a dusty old practise carried out by scholars who used their knowledge of ancient and modern languages to establish the authenticity, identify the origins, and determine the meanings of particular words and texts. Unlike critical theorists, new historicists, cognitively inflected cultural critics, or other more fashionable types, philologists were thought not to concern themselves with contemporary preoccupations, nor to consider texts as uniquely revelatory of the specific cultural contexts that produced them. Allegedly hostile or indifferent to literary theory, they were seen as overly concerned, instead, with book histories and word puzzles to the exclusion of all else.

Resistance to such caricatures has come from various quarters in recent years, while calls for a return to philology or, indeed, for a 'new philology' have come in abundance.[17] In medieval studies, for example, new philologists declare a dual desire 'to return to the medieval origins of philology, to its roots in a manuscript culture' and 'to minimise the isolation between medieval studies and other contemporary movements in cognitive methodologies, such as linguistics, anthropology, modern history, [and] cultural studies'.[18] Nadia Altschul insists that new philologists in medieval studies should henceforth concern themselves not with textual criticism alone but with the study of 'culture as well as text', while Martin Eisner suggests they should combine close study of 'the textual contents' of books with 'their material and paratextual forms', that is, with 'the material record of a work's transmission not only in manuscripts and editions, but also translations and adaptations'.[19] There are

also medievalists who think new philology is the (good) old philology by another name—old wine in new bottles.[20] Clearly, there are differences of opinion about what, precisely, the philology of medieval studies should look like and about whether its orientation should be more towards book history, textual criticism, or cultural history. But it is not only medievalists who urge philological renewal.[21] In fact, as Sean Gurd has suggested, perpetual renewal is a defining feature of the best philological enquiry across the ages, which is rooted in its past even as it is responsive to the changing historical and cultural environments in which it is practised.[22] Eduardo Saccone, who wished to save grace from universal narratives by encouraging philological rigour, for example, was deeply conscious of the work of Renaissance humanists like Angelo Poliziano, for whom philology involved reading widely and closely not just literary but also medical, legal, and philosophical texts and for whom philologists were the true philosophers. Like Poliziano, Saccone was actively conversant with the prevailing theorists of his own day, too, in particular with deconstructionist reflections on the epistemological difficulties and ethical imperatives inherent in the interpretation of any text as developed by Jacques Derrida and Paul de Man (whose essays Saccone translated into Italian).[23] Coming from Italy, where philology had long been the cornerstone of literary study, however, Saccone never felt the need to define his own practise as 'new'.

The same is not necessarily true for Anglophone scholars. In 2013 Richard Scholar described for early modern studies a 'new philology' that would combine traditional philology (broad-ranging reading and careful attentiveness to the words of which literary texts are made) with practises endorsed by Raymond Williams and, in particular, Edward Said, who prefaced his (previously quoted) description of philology as unsexy and unmodern with a robust defence of it.[24] Scholar sympathised with the suggestion, in Williams's study of the keywords that defined and shaped postwar British culture, that words do not simply reflect but actually effect ideological and cultural change. In his 'historical semantics', Williams was committed to showing 'that some important social and historical processes occur *within* language, in ways which indicate how integral the problems of meanings and of relationships really are'.[25] The task of historical semantics should be to assess the relationship between the changes in language usage (the invention of new words and adaptation, alteration, transfer, extension, or reduction of old ones) and changes in the cultures and societies in which those changes took place.

Williams's recommendation left its mark on Edward Said, who praised his scrutiny of the words we live by. Said complimented, as well, the past

masters of philology—including Giambattista Vico, E. R. Curtius, and Eric Auerbach—for their erudition, comparative literary sensibility, and broad-ranging attentiveness to texts from different periods and cultures. Inspired by their work, he proposed the renewal of two of the attitudes at the core of philological enquiry: receptiveness and resistance. By receptiveness, Said meant close reading: 'a detailed, patient scrutiny of and life-long attentiveness to the words and rhetoric by which language is used by human beings who exist in history.'[26] By resistance, he meant 'a *paradoxal mode of thought*': thinking against the grain (or against the '*doxa*: common sense, received ideals'); questioning preconceived wisdom; and taking no inherited meanings for granted. A philology that emphasised reception and resistance was urgently needed, he felt, in a twenty-first century 'changed considerably since the terrible events of September 11, 2001' and 'now brimming over with belligerency, actual wars and all kinds of terrorism'.[27]

The new philology of the kind Said promoted is crucial, too, in early modern studies. In the campaign 'to protect and forestall the disappearance of the past' (which Said calls one of the most important roles of intellectual intervention), it is vital to defend the traditional philological activities (authenticating, translating, tracing, dating, producing editions, and so on) that preserve the material objects in which that past is recorded (books, manuscripts, incunabula, and so on).[28] It is necessary too, to read carefully the languages of those books—and to study the words that constituted them—so that we may gain better access to the ideas, beliefs, and uncertainties expressed therein. Such careful reading must involve receptiveness to the contexts in which words were used, and to the 'web of complexity' in which their uses and meanings are entangled. Coupled with this reception should be sustained resistance to the idea that early modern words are politically neutral signifiers unchanging across contexts and over time. New philologists working on early modern Europe must remain constantly alert 'to historical actors of the period . . . when they sought to impose their meanings on a word'; 'to the existing historiography of the period when it has attempted to clear away the web of complexity surrounding a word and, in so doing, has damaged the object it claimed to be finding'; and also 'to our modern world when it takes the modernity of its words and meanings as read'.[29]

The Grace of the Italian Renaissance combines philological receptiveness, then, with a large dose of resistance to the idea that grace was a monolithic term whose meaning was the same for all sixteenth-century users (as Monk, Blunt, and others have suggested). It analyses seminal

occurrences of grace at close quarters, comparing and contrasting them with a range of canonical and noncanonical texts that also deal with grace. In so doing, it restores to view 'the web of complexity' surrounding the term that existing accounts of it tend to obscure. The different ways in which sixteenth-century protagonists used grace belies C. S. Lewis's suggestion that words are stable repositories of meaning.[30] On the contrary, grace reveals itself to be a locus of encounter—sometimes conflictual, sometimes amicable—between individual interlocutors and disciplines. It is not just an index of tastes and aspirations, moreover, but an active agent in the processes of change that characterise the period. Always at the heart of the questions and quarrels that troubled sixteenth-century citizens, it was a sort of linguistic currency whose purchasing power changed the course of Italian culture.

Many of the instances of grace studied in this book are verbal, but many others are not. When applied to the nonverbal media of painting and sculpture, 'close readings' of grace become 'formal analyses' of how it is expressed in visual form. In the spirit of Horace's famous simile *ut pictura poesis* (as is painting so is poetry), the book's formal analyses of key paintings and sculptures (like its close readings of key texts) are accompanied by careful attention to the commentaries, letters, treatises, and poems that treat grace at the level of a topic and that precede, accompany, or follow them in time. In this respect, the principles of receptiveness and resistance still pertain. By remaining receptive to both visual and verbal sources, the book traces the interdisciplinary encounters that grace makes possible and restores the dialogue between word and image that was so active in sixteenth-century Italy. It also sheds new light on the network of friendships and rivalries in which grace played a pivotal role. In so doing, it presents a further line of resistance to sixteenth-century actors and subsequent historiographers who describe the Renaissance as an incontrovertibly golden age of creativity and culture and highlights, instead, the altogether less-than-golden transactions that helped produce some of the period's finest art and letters.

In an ideal world, each philologist would own up to the particular characteristics of his or her own resistance. The present study is shaped by an abiding fascination with theories of grace that harks back to undergraduate classes on Castiglione's foundational take on the theme.[31] It is indebted to conversations with literary critics, philosophers, and art historians about the ways in which certain 'keywords' may be said to unlock the secrets of a given place and time.[32] It is inflected by the efforts of left-wing intellectuals like Raymond Williams and Edward Said who set out to

interrogate the words we continue to live by. Last but by no means least, it is indebted to the work of feminists whose unrelenting resistance to male-dominated discourse has changed the way in which a whole generation of scholars approach early modern culture.[33]

Through a feminist lens, grace might be seen as a tool of oppression that characterises women as aesthetically pleasing adornments bedecking the top Renaissance courts. An entire book could be dedicated to the role of grace in women's affairs—its pervasiveness in treatises about beauty, manners, and gender roles; the knock-on consequences for women of the humanist popularisations of images of the three Graces, and of Reformation reevaluations of the Madonna's divine grace. The present book limits its focus on a feminist account of grace to specific case studies, exploring some of the ways in which men ascribe grace to women, probing the reticence with which such ascriptions are often met by the women, and—in a further turn—revelling in those moments when women speak back, claiming grace for themselves and wielding it as a tool not of oppression but of liberation from the yoke of excessive idealisation and sanctification.

A short answer to the question 'What does the word "grace" mean?', then, is that it means different things at different times to different people. Whittled down to its semantic essence, it means 'a certain something which pleases', but this is not a definition so much as a core principle since pleasure is, of course, subjective, encompassing a vast array of human experiences.[34] From musical grace notes to balletic graces, from the grace of artistic inspiration to God's gift of divine grace to humankind, and from the social graces of a courtier to the sexual graces of a courtesan, grace is given, received, performed, or embodied for the pleasure of a grateful recipient. It inscribes a relationship of pleasurable exchange whose nature and tenor change from one pair of individuals to the next. Grace is, in this respect, a chameleon intangible, as ever-present and ever-changing as are the concepts of delectation and delight that it carries with it.

Metaphors such as the one just employed help, better than any definition could, to harness the elusive intangibility that characterises sixteenth-century grace and its workings. Throughout the book, I explore several other metaphors besides that of the chameleon intangible. In the prologue and first chapter, alone, I describe grace as a 'mobile and multifaceted force to be traced in and around the crossroads between the ideal and the real of the Italian Renaissance'; as a 'family name [that] brings together many individual members, linked by elemental genetic traits'; as a 'sort of crucible in which the continuities and innovations, the friendships and rivalries, the rebirths and disintegrations we still sometimes think

of as "Renaissance" were formed'; and as a type of (non-Freudian) plea-
sure principle shared between one who gives, performs, or embodies it,
and another who receives it with pleasure and—ideally—with gratitude.
Metaphorical thinking of this kind serves a capacious and elusive term
like grace well, communicating those principles common to all its itera-
tions, yet without reducing its plurality unnecessarily or staying its con-
stant movement.

Perhaps no metaphor serves better to capture the movement of grace
through sixteenth-century Italian society and culture than rainfall. That
metaphor communicates how grace saturates large tracts of Renaissance
discourse, fertilizing diverse terrains whose ability to bear fruit is unpre-
dictable. It has illustrious (and highly relevant) precursors in Christian the-
ology. In *De Trinitate* (4.i, 2), St Augustine interprets the 'spontaneous rain'
sent by God in Psalms 68:9 as a metaphor for grace, which is 'not rendered
to merit, but freely given, whence also it is called grace; for He gave it,
not because we were worthy but because He [so] willed'. In seventeenth-
century France, the occasionalist philosopher Nicolas Malebranche puts
this Augustinian metaphor into the service of his controversial sugges-
tion that God's will acts in accordance with laws of nature combined with
laws of grace, as opposed to acting directly on individual human lives.[35]
In Christian thought, God's grace is ever-available to believers and yields
fruit when it irrigates fertile souls primed to receive its nourishing effects.
It does not always have the desired effect, sometimes falling on barren
ground, but it elicits in ready hearts and minds a reciprocal flourishing of
virtue and devotion that serve as thanksgiving for its nourishment. The
same analogy may be put to a secularized aesthetic use. Artistic grace can
be visualised as a natural force that inspires and influences those who are
ready for it, fertilizing cultivated minds that produce great works of art and
literature. Artists and writers, thus 'graced', please others who reciprocate
with appreciation of various material and immaterial kinds in a dynamic
cycle of reciprocity. The grace of courtiers, beautiful women, and harmo-
nious music is bestowed on those who prepare the ground for its flour-
ishing. Graceful manners and sounds flourish and bear fruit either where
nature has been particularly bountiful or where rules have been sufficiently
mastered and skill sufficiently honed. For such individuals, grace is a gen-
erative process that unfolds almost without agency, as if it acts through
them rather than being produced by them. Its effects are as profound as its
sources are elusive. For many of the protagonists of this book, this source
is God: artistic, social, and spiritual graces are indistinguishable in this
respect. For others, however, the sources are human culture and the hard

work, training, or—alternatively—*je-ne-sais-quoi* that comes who knows whence. Each may have one's own idea of what causes the rain to fall.

The aim of this book is to compare ideas of grace amongst Renaissance individuals. Thinking through metaphor provides one of the means by which it combines methods and crosses disciplines. Metaphors allows discrete manifestations of grace to speak for themselves. As they speak, *The Grace of the Italian Renaissance* eavesdrops, tracing a series of conversations—some friendly, some not—about the means of generating, cultivating, and propagating one of the most beguiling and deceptively powerful of early modern keywords.

Narratives

This book examines what grace meant to Renaissance artists and writers from Francesco del Cossa (ca. 1430–ca. 1477) to Torquato Tasso (1544–1595). It involves close analyses of pivotal texts and images from del Cossa, Baldassare Castiglione (1478–1529), Raphael Sanzio (1483–1520), Ludovico Ariosto (1474–1533), Lodovico Dolce (1508–1568), Vittoria Colonna (1492–1547), Tullia d'Aragona (1510–1556), Michelangelo Buonarroti (1475–1564), Moderata Fonte (1555–1592), Tasso, and others and attends to peculiarities and particularities of usage, exploring the correspondence— direct or indirect—between individual occurrences of the term. The end result is a narrative, but not a *grand* narrative of the kind criticized by Saccone and, more generally, by Jean-François Lyotard.[36] Rather than oppress the messy specificity of individual moments in the pursuit of a sweeping account, as Lyotard's 'grand narratives' were said to do, this book's primary focus is, precisely, those messy moments, those instances that make the life of sixteenth-century grace so interesting. These instances are then aligned with other individual interpretations as the relationship between them is explored. It is not, in other words, that the grace of this book plays a supporting role in a grand narrative about something else. Rather, it plays the starring role in its very own story of rebirth, decline, disintegration, and regeneration.

Chapter 2 situates the emergence of grace within three contexts. The humanist revival of antiquity, the quarrels about religion, and the debate about language each sought intellectual rupture with the immediate past and a radical rethinking of the secular and the sacred. With these new ways of thinking came new ways of talking: intellectual change wrought changes in language use, and vice versa. Changes in how grace was used at this time were inextricably bound up with the broader problems its early

modern users were trying to resolve. To do justice to the semantic abundance of Renaissance grace, therefore, we must view it first within those contexts that privileged it as a focal point for their conversations about culture and society. In this way, we can begin to see just how key grace was, and to chart the semantic quarry from which later sixteenth-century understandings were mined.

The life of Renaissance grace begins in earnest with Castiglione's *Libro del cortegiano (Book of the Courtier)* (1516) and Raphael's portrait of Castiglione (1514–1516). It does so, I suggest in chapter 3, because preoccupations with grace and its multiple senses are central to both the book of manners and the painting, so much so that Castiglione came to be known as the great theorist of grace while Raphael was identified as its painter. Both have been referred to in countless studies from the sixteenth century to today as the embodiments of Renaissance grace. In addition, the network of interconnections between them makes Castiglione and Raphael a promising point of departure, an ideal testing ground for observing how grace behaves in different media and examining the extent to which it can be said to contribute to those interdisciplinary rivalries and friendships that allowed Renaissance learning, literature, and arts to flourish.

Chapter 4 takes its cue from the discussion in book 3 of Castiglione's *Cortegiano* about whether court ladies required the same qualities as male courtiers. Grace, it turns out, is as vital for women of the court as it is for men, but womanly grace is more closely linked to beauty and to what Italians today refer to as *bella presenza* than its manly counterpart. Embellishing the environment of the court in ways most pleasing to men, it consists of good looks, decorous manners, and modestly entertaining conversation. Yet grace and beauty, under the pen of women writers, are by no means mutually inclusive. The chapter explores how two women authors, Vittoria Colonna and Tullia d'Aragona, sever the links that unite grace and beauty in male discourse. In Colonna's love poetry (ca. 1525–1535), grace resists semantic absorption into refined womanly appearances and rhetoric and turns, instead, towards spirituality that admits of no physical or corporeal manifestation. Tullia d'Aragona, by contrast, rejects the language of grace outright, identifying it as an impossible feminine standard, on the one hand, and perilously close to the language of sexual graces and favours, on the other. In her *Rime (Poems)* and *Dialogo dell'infinità d'amore (Dialogue on the Infinity of Love)* (both published in 1547), she identifies it as a word requiring sensitive handling, an instrument of control to flee from and a semantic trap set by men inclined in their treatment of women to the extremes of praise and blame.

While Tullia d'Aragona thus sought to avoid grace, the poet Ludovico Ariosto could not help but be caught in its web, being quickly identified as the master practitioner of grace in literature and the language arts. Chapter 5 examines Ariosto's *Orlando furioso* (1532) as an outstanding example of literary grace, following the judgement of sixteenth-century literary commentator and polygraph Lodovico Dolce. The first part of the chapter mines Dolce's many commentaries, paratextual notes, appreciations, and treatises on poetics and aesthetics for a sense of just what he meant when he declared Ariosto the Renaissance poet of grace. The second part, meanwhile, looks to Ariosto himself and focuses both on the poet's writing and on the emblems and images he used to embellish successive editions of his poem. In this encounter between grace in word and image, it offers an understanding of how Ariosto anticipated Dolce's reading while varying the terms of that reception.

The classically inspired secular grace that Castiglione theorized, Raphael painted, and Dolce saw writ large in the poetry of Ariosto was not universally welcomed. On the contrary, it provoked a quarrel at the heart of the Italian Renaissance, which pitted the Castigliones *et al.* against those who saw their grace as nothing if not vain and frivolous. Chief amongst such critics was one described as the antithesis of grace, Michelangelo Buonarroti, and his close friend, Vittoria Colonna. On her second appearance in the book, Colonna has become a more mature author of spiritual works. In her later *Rime spirituali* (*Spiritual Poems*), a much developed grace bears the hallmark of religious debate about reform and counterreform and chimes in striking ways with the alternative interpretation of grace expressed in Michelangelo's art. Chapter 6 shows that, in their work and in their poetic correspondence (1538–1547), Michelangelo and Colonna eschew the kind of grace espoused by Castiglione and Bembo and perfected by Raphael and Ariosto, cultivating instead an image of the artist as hardworking and intense. Their desire to reveal— rather than conceal—the labour behind their art can be compared in the *Pietàs* through which the artist and the poet articulate an alternative aesthetics of grace: one that resists humanist connotations, criticises courtly abuses of the term, and promotes a more Christian vision of the artist as the receiver rather than the giver of what is essentially God's gift. Restored here to the domain of religious experience, grace acts as a reminder that art and literature should praise God, not the artist, and in so doing reflects an age of Reformation and Counter-Reformation in Italy.

The conclusion explores some of the further transplantations that grace experiences towards the end of the sixteenth century. Emblematic of

these transplantations, so removed in time and tenor from those emerging at the start of the century, are the work of the Ferrarese poet and philosopher Torquato Tasso and the Venetian writer Moderata Fonte. The conclusion first examines Tasso's philosophical dialogue, *Il malpiglio* (1585), as a direct response to Castiglione in whom Tasso identifies some timeless principles while also recognising that Italy and life at court have changed. In this context, Tasso's *Malpiglio* replaces the 'grace' of *Il cortegiano* with the notion of 'prudence', a substitution that marks the passage from the graceful manners that flourished at court in the earlier age to the prudent observance of the 'strictness of the times' that is now the order of the day. There is a distinct ambivalence in the movement of Tasso's work from grace to prudence: a nostalgia for the earlier term, and the survival of its structures of feeling under the altogether more repressive notion with which he replaces it. Forming a contrastive diptych with this nostalgic portrait, Moderata Fonte's *Merito delle donne* (*The Worth of Women*) (1592) presents grace not as a privilege of the past but as a keyword of her era—as a mode of surviving and thriving in the world. After pointing out the fickleness of men who align grace with beauty for their own ends, she asserts that women should cultivate internal graces—eloquence and intellect—that will provide pleasure for themselves, that will never fade or grow old, and that will endure as long as life, and beyond. The book closes, then, with Tasso's retrospective nostalgia for a long-lost grace and Fonte's plans for its regeneration. Through them, it contemplates the unwavering ability of grace to remain uncompromisingly plural, at a time when it meant so much.

Grace Abounding

FOUR CONTEXTS

The word grace *is very frequently used in the arts. Yet, it seems that it has always been attributed the meaning of implying something indefinite and mysterious, and that by a general consensus we are content to have an approximate sense of what it means without explaining it. Could it be true that* grace, *which has so much power over us, was born from an inexplicable principle? And is it possible to think that in order to imitate grace in works of art it is sufficient to have a blind feeling and a certain disposition that cannot be understood? Certainly not.*

—CLAUDE-HENRI WATELET, 'GRACE',
*ENCYCLOPÉDIE OU DICTIONNAIRE RAISONÉ DES SCIENCES,
DES ARTS E DES MÉTIERS* (1751)

GRACE DENOTES A CERTAIN something that pleases. Like pleasure itself, it alters across time and space and from one individual or set of individuals to the next. Sixteenth-century Italian grace was particularly plural and promiscuous in its disciplinary associations. What renders it a keyword of that era is a confluence of cultural developments that made it newly pleasurable and therefore freshly debatable across a range of discursive contexts, charging it with a semantic energy and force that propelled it to the heart of epoch-defining debates and quarrels. Of these cultural developments, four play a particularly important role: the humanist revival of antiquity; the sixteenth-century debates about religion and religious reform; the combination of those two in Christian classicism; and the so-called *questione della lingua*, whose aim was to

establish once and for all the ideal idiom of literate culture. To set the renaissance of grace against the backdrop of these developments is the purpose of this chapter.

Humanist Revivals

The first cultural development to have a profound impact on the spectacular rise to prominence of sixteenth-century grace was the humanist revival of classical antiquity. Though there had been interest in classical antiquity for centuries, concern for the legacy of ancient Greece and Rome peaked in the fourteenth to sixteenth centuries as humanists achieved a systematic expansion of the corpus of classical texts in circulation and enshrined the *studia humanitatis* in the university curriculum.[1] Focused mainly on the pursuit of eloquence, humanist discourse at its height came to influence all spheres of thought, featuring prominently in the vast literature investigating how best to cultivate the cultural and civic virtues that could be derived from studying the language arts of grammar, dialectic, rhetoric, and poetics and their cognate disciplines, literature, history, and philosophy. A most desirable virtue, both cultural and civic, according to the ancients, was grace. So grace became a natural point of interest for humanist emulators of ancient tradition.

Though Renaissance humanists focused mainly on Roman culture and Latin literature, the Greek origins of grace were, nonetheless, of great interest. Known as *charis* in ancient Greek, it had featured prominently across an array of literary contexts and was picked up intact by the writers of Rome. Designating that which brings joy (a *factum laetificans*) and a pleasure-bearing power (a *uis laetificatrix*), it flourished in the female beauty, military valour, true nobility, eloquent speech, acts of charity, and pleasant manners described in writing from Homer to Euripides.[2] Rather than a static, self-contained virtue, *charis* was distinctive for the way it moved its beholder, provoking a response or exchange of some kind. In Sophocles's *Ajax*, for example, Tecmessa reminds her husband that 'it is *charis* that is ever the one begetting *charis*' (*Ajax*, 522); and in Homer's *Odyssey*, Athena uses a *charis*-unction to render Odysseus so '*charis*-filled' that he wins the grace and favour of Nausicaa, who provides him with food, drink, and an audience with her father, Alcinous (*Odyssey*, 6.224–46). Alcinous, king of the Phaeacians, in turn, reciprocates Odysseus's unction-fuelled grace, guaranteeing him safe passage home (*Odyssey*, 8.21–22). Grace begot grace in that instance, while refusing to

reciprocate *charis* had serious consequences in others. The Greek hero Achilles, for example, withdrew from fighting in the Trojan War on the grounds that he had not received the *charis* he deserved for his prowess, thereby nearly costing his countrymen their victory (*Iliad*, 9.316). Profoundly social in nature, grace represented a powerful currency in a society founded on reciprocal gift exchange.[3] As Bonnie MacLachlan puts it, '*charis* was a cardinal item in the moral system of the Greeks of the archaic and early classical age: It was the moral glue of their society'.[4]

This social importance of grace, as we saw in the prologue, was enshrined in the fourth-century BC *Nicomachean Ethics* where Aristotle encouraged the erection of a temple to the three Graces that would honour the reciprocity and mutualism required to ensure the continued stability of civilised society (5.5, 1133a 2–4). Much later (ca. AD 60), Seneca also invoked the three Graces in his treatise *De Beneficiis*, where they expressed in allegorical form a 'rule for life' relating to how we should 'be willing to give, willing to receive, willing to return; and to place before [our]selves the high aim, not merely of equalling, but even of surpassing those to whom [we] are indebted, both in good offices and in good feeling' (1.4, 2–3). The trio reappeared in subsequent iterations from Maurus Servius Honoratus's *Commentary on the Aeneid of Virgil* (late fourth to early fifth century) to Fulgentius's *Mythologies* (late fifth to early sixth century), where they were stripped of the light clothing covering their bodies in Seneca. Appearing, now, in Acidalian waters where Venus takes her bath, they are naked 'because Graces must be free of deceit', with two depicted frontally and the other from behind because 'for every kindness issuing from us, two return' (Servius, *Commentary on the Aeneid*, 1.720).

In the Roman context, *charis* is expressed either as *venustas* or as *gratia*. In his morphological and semantic analysis of *gratia et sa famille*, Claude Moussy maintains a clear distinction between the two, the former being closer to the aesthetic sense expressed in the French *grâce* or *charme*, the latter expressing both gratuity (graces given freely) and remuneration (graces given in exchange for good offices of material or immaterial kinds). Though capable of broad variations, all classical expressions of grace examined by Moussy—from the Old Latin period of Plautus (ca. 254–184 BC) to the early Christian period of Tertullien (ca. AD 155–240)—shared a notion of reciprocity that was very much in keeping with a society based on gift giving and exchange. For him, the accommodation of aesthetically pleasing *venustas* within the term *gratia* was a late, Christian-era development wrought under the influence of early Church fathers.

One of the Roman authorities on *venustas* most frequently cited during the Renaissance was Pliny, whose comparison of Apelles and Protogenes in the *Historia Naturalis* became a sixteenth-century commonplace. According to Pliny, Apelles of Cos surpassed all the painters that preceded and followed him for art that exuded the most 'graceful charm' (praecipua eius in arte venustas fuit). Linking *venustas* to the Greek word *charis* ('quam Graeci Charita vocant'), Pliny explains that Apelles's grace consisted of knowing 'when to take his hand from a picture' and understanding the 'evil effects of excessive diligence'.[5] Grace was the golden mean, the wisdom to know when enough was enough. Treading a line between excessive care and excessive negligence, it balanced Apelles's technical brilliance against his aesthetic sensibility with the one moderating the other to awe-inspiring effect.

As in the Greek tradition, Roman grace had a social dimension too. As well as being a great artist, Apelles possessed 'great courtesy of manners' (35.36, 85). For this all-round *venustas*, he won the favour of Alexander the Great, who granted him the highest honour of declaring that no other artist but Apelles should ever paint his portrait. More conspicuously, he bestowed on him the gift of his favourite mistress, Pancaspe, upon realising that Apelles had fallen in love with her while painting her naked form. Apelles's grace begot the grace of Alexander, who, in reciprocating, gave ample demonstration of the dynamic exchange initiated by the term. Conquering himself, as Pliny puts it, he honoured his portrait artist's claims with reciprocal displays of 'greatness' as effective as 'any other victory' (35.36, 87).

In his account of ancient art, Quintilian referred to Apelles's *venustas* as 'genius and grace' (ingenium et gratia, *Institutio oratoria*, 12.10, 6)—establishing thereby the triad Χάρις, *venustas*, *gratia* that was to have such resonance in humanist discourse.[6] The discovery of a complete manuscript of Quintilian's *Institutio oratoria* in 1416, in fact, proved foundational in the history of Renaissance grace as the Roman rhetorician tended to elide *gratia* and *venustas*, offering a definition of the latter that laid the groundwork for fifteenth- and sixteenth-century theorisations of grace. 'The meaning of *venustas*', he says, 'is clear; it means that which is said with grace and charm' (Venustum esse quod cum gratia quadam et venere dicatur apparet, 6.3, 18].[7] A synonym for wit in this context, it joined *urbanitas* and *salsum* as 'a simple seasoning of language, a condiment which is silently appreciated by our judgement, as food is appreciated by the palate, with the result that it stimulates our taste and saves a speech from becoming tedious' (6.3, 19). More than mere flavour enhancement,

the salt of grace and wit also 'arouses in us a thirst to hear' and plays a crucial part in the art of persuasion. 'Surpassing grace' (gratiam quae in eo maxima est, 9.4, 17), says Quintilian, is found in the 'simple and unaffected tone' of Lysias, the 'sprightliness' of Horace's language ('plenus est iucunditatis et gratiae et varius figuris et verbis felicissime audax', 10.1, 96), and the elegant humour of Terence's comedies (10.1, 99).

The *Institutio oratoria* was Quintilian's positive response to Cicero's call to widen and ennoble the standard Roman curriculum in his *De oratore*, also rediscovered in the early fifteenth century (1421) and equally crucial to the Renaissance history of grace. For Cicero, as for Quintilian, 'refinement, grace, and urbanity' (subtili venustate atque urbanitate) were essential prerequisites for excellent rhetoricians (*De oratore*, 1.17), whom he urged to abandon the excessively pedantic rules of traditional rhetoric.[8] Too great a dependence on rules did not guarantee good speech; on the contrary, it led to stiffness and a lack of grace. Excellent orators, instead, should combine a mastery of words with universal knowledge and the flexibility to adapt every speech to a particular audience to argue a particular case. To impart distinction on a speech, special attention should be paid to the grace and charm (venustatis) of its 'complexion'. Essential, not superficial, such grace was 'not as the result of rouge that has been laid on, but of blood that flows through' the complexion—or delivery—of a speech (3.199). Grace, in other words, was no mere affectation but a virtue inherent in the excellent orator's every thought, word, and gesture. Just as gladiators should take account of how to strike and dodge, but also of how to move with grace (cum venustatem moveatur, 3.200), so too orators should use words and thoughts not only for proof and refutation but also to charm.

Thanks, in large part, to the rediscovery and circulation of Cicero's and Quintilian's texts, *charis, gratia*, and *venustas* found a new meeting ground in fifteenth- and sixteenth-century Latin and, by extension, in the emerging Italian vernacular. Humanists seeking to restore classical Latin and thereby to regenerate what they saw as the corrupted, degenerate forms of it being used in the schools and universities modelled their usage on the great authors of antiquity and, in particular, on Cicero and Quintilian, leading to a shift in idiom that has come to be known as 'the Latin language turn'.[9] At the same time, many of the same humanists were arguing for a return to the original texts of the early church fathers whose wisdom and theological insights had, in their view, also been distorted in translation and transmission over the course of the centuries. Revived interest in biblical exegesis and new close readings of early Christian writers were key

both to the programme of reinstating classical Latin and to the second cultural development that contributed directly to the rise and pre-eminence of Renaissance grace: the campaign to reform the Roman Catholic Church.

Religious Debates

Alongside the programme of literary and cultural reform based on classical scholarship and on the study of ancient eloquence ran the parallel—and not unrelated—campaign for reform within the Western church. For many, the Reformation of Roman Catholicism was a plea for administrative, bureaucratic, and legal renovation. For others, the more pressing need was for the spiritual revitalisation of the Christian faith. Others still sought to reform doctrine and religious ideas. It was in these last two contexts that grace came centre-stage, as reformers sought better to understand and define its role in human salvation through close examination of foundational texts. If grace was a point of interest for humanist emulators of ancient eloquence, it was the lifeblood of those seeking religious reform.[10]

Before the Reformation, grace tended to be seen as 'a supernatural substance, infused by God into the human soul in order to facilitate redemption'.[11] Its function was to bridge the otherwise unassailable gap between human consciousness and the divine. Being endowed with grace was the only means of entering into a meaningful relationship with God. Reformation theologians contested the notion of grace as a substance: it was, rather, a divine attitude, God's dispensation to elect or condemn human souls. While they did not argue that grace was key to human salvation, they were perplexed by medieval doctrine on how this salvation was to be achieved. A gift from God, to be sure, but was grace granted freely to mortals who could never really deserve it, trapped as they were in human sin? Or was it destined for those who worked hard to satisfy certain preconditions set by God? Could it be earned, in other words, through good works and holy deeds; or did it rain down freely from Heaven, taking root where human souls were ripe to receive it?

Critical of the doctrinal confusion of medieval theology surrounding such questions, reformers were also scornful of the Vulgate, the 'official' Latin translation of the Bible, which gave rise to significant misunderstandings about the nature of grace. The misconception that grace was a sort of liquid, for example, and Mary, the mother of Christ, a reservoir to be tapped at will derived from the Vulgate's mistranslation of the Greek. As Lorenzo Valla and Erasmus pointed out, the Angel Gabriel's words in Luke 1:28 did not imply that Mary was 'full of grace' (gratiae plena) like

a vessel brimming over with liquid but that she was accepted into God's grace, one who has found favour.[12] Criticizing theologians who made too much of the words *gratiae plena*, they advocated renewed philological rigour and more accurate translations such as *gratificata* or *gratiosa*.[13] The new philologists encouraged a return *ad fontes* to the literary sources of Christian theology—to the New Testament, in other words, and to the classical texts of the fathers from the first centuries of the church.[14]

St Paul's first-century epistles became amongst the most influential source texts and major founts of Reformation grace. In his letter to the Romans, Paul expounds the real revelation of the New Testament: the advent of grace. By sending his only son to live amongst men, to die on the cross, and to rise again three days later, God bestowed the gift of grace on humankind. That is to say, by sending his son to spread a message of love and to teach by example, God demonstrated—once and for all—his love of and charity towards humankind, despite its moral corruptibility and the weakness it bore since Adam's original sin. By sacrificing his son to a painful death, he provided the most unequivocal illustration of the need to mortify and transcend the flesh, so 'that the body of sin might be destroyed' and 'that henceforth we should not serve sin' (6:6).[15] Finally, by resurrecting Jesus on the third day, God gave living proof that the righteous will be rewarded after death, raised up to a future of eternal happiness with God. Christ's life, death, and resurrection, in other words, promised the death of sin for believers who, 'in the likeness of his resurrection' (6:5), will 'walk in the newness of life' (6:4). It promised the gift of God's grace, in other words, his forgiveness of sin and redemption of the soul after death.

For Paul, God's grace is the ultimate sign of divine mercy towards the undeserving. Thanks to grace, Christians can consider themselves 'to be dead indeed unto sin, but alive unto God through Jesus Christ our Lord' (6:11). Yet achieving grace is not easy: it is only through 'righteousness of faith' (4:13) that it can be obtained. By 'righteousness of faith', Paul does not mean idle professions of faith and adherence to the external symbols and rites of the church. He means an inward transformation, profound belief in God, and deep identification with the teachings, sufferings, and triumph of Jesus Christ (4:4–5). God's ancestral promise to save the Jews, symbolized by the ritual of circumcision, does not bring automatic salvation. Inner moral renewal is what matters, 'that of the heart, in the spirit, and not in the letter' (2:29). The free gift of God's grace, in other words, rewards not outward shows of piety but inner conviction and sanctity: 'Therefore we may conclude', says Paul, 'that a man is justified by faith without the deeds of the law' (3:28).

Paul's doctrine of justification by faith raised as many questions as it provided answers for sixteenth-century theology: To what extent do individuals contribute to their own salvation? Is it that Christians determine the fate of their mortal souls by choosing whether to live lives of virtue or of vice? Or does God retain absolute freedom in dispensing grace? Paul was clear on the question of predestination: a select minority had been chosen for salvation (8:29–30, 11:4–5); but did that mean the rest were damned, irrespective of merit and faith? In the fifth century St Augustine pondered these questions to such an extent that he became known as the 'doctor of grace' (doctor gratiae). His theology, derived in large part from Paul, was crucial to sixteenth-century discussions of grace. In his writings against Pelagius, Augustine followed Paul in insisting on the radical corruption of human nature since the Fall. Because of Adam, humankind was no longer equipped to obey God's commandments and to live a life of righteousness without the help of God's grace. God's grace was an inner steer directing Christians towards virtue, an 'influence of God that modifies the human will'.[16] Grace was experienced as delight, recalling the *factum laetificans* of classical tradition. It was a sense of pleasure designed to overcome the tendency towards sin and the longing for objects for their own sake. 'Efficacious' because its effects were felt whether or not one decided to respond to them, the delight of grace would outweigh the pleasure of concupiscence. Yet it was more than just a competing pleasure; there was a cognitive aspect as well. As Michael Moriarty puts it, 'we feel a greater satisfaction in obedience: not just a greater pleasure, but a sense that obedience is where our happiness and fulfilment truly lie' (148). As well as a source of joy, in other words, efficacious grace offered a deeper understanding of the value and rewards of obedience.

As in Paul, Augustine's grace was the unmerited gift of God, salvation one could never achieve on one's own. God volunteered the grace required to break the hold of sin and, in so doing, provided the only means of redemption. Augustine's doctrine of grace emphasised God's absolute agency, in other words, and mankind's dependence on divine intervention. Pelagius, by contrast, denied the need for divine intervention and emphasised human freedom in the process of redemption. For him, the resources of salvation were located within: one could choose to save oneself through good works and holy deeds. From the so-called Pelagian controversy, sixteenth-century theologians inherited a deep concern with the question of human effort versus divine intervention. Reformers sought to minimize the contribution of human effort, with Martin Luther offering the theological breakthrough that the question of human salvation revolved around

one keyword: *iustitia*. Having pondered St Paul's teaching that 'the righteousness of God is revealed' in the gospel and that 'the righteous shall live by faith' (Romans, 1:17), Luther came to realise that God's *iustitia* did not mean his severe judgement, but rather a free gift bestowed on the faithful. It was not a case of sinners needing to meet the preconditions for salvation set by a judgmental God, but of God himself meeting those preconditions on sinners' behalf. Grace, in other words, was God's gift freely given to undeserving individuals barely capable of participating in their own salvation.[17] The Roman Catholic Church, by contrast, placed greater emphasis on human agency. The sixth session of the Council of Trent, convened in 1545 in the wake of the doctrinal controversy sparked by Luther, pondered a formulation that would guarantee God's unconditional freedom in dispensing grace while allowing some room for human agency and free will. The resulting line was that salvation depended to some extent on free choice: God distributed to all a 'sufficient' grace, enabling them to obey his commandments, but whether one availed of this grace was a matter of personal choice.[18]

Christian Classicism

Classical humanism had a profound impact on sixteenth-century grace and its expression in literature and the visual arts. A newly energised keyword featured widely in learned treatises on subjects as wide-ranging as beauty, spirituality, love, art, literature, nobility, women, and manners while poets and artists sought to model themselves on the ancients, cultivating and performing grace in verbal and visual media. At the same time, theological debates infused the term afresh with religious significance and transcendental qualities. Under the joint influence of humanism and reformation, grace evolved into a newly irresistible mix of the secular and the divine, a crucible conjoining the major intellectual, religious, and aesthetic trends of its age. In his account of literary culture during the Reformation, Brian Cummings observes the marked influence on the new theology of philological debates about literary interpretation and biblical meaning and notes the inverse as well.[19] While influencing the new theology, he asserts, linguistic practises and literary meanings were, in turn, altered by it. Grace offers a prime example of this two-way disciplinary cross-influence as the newly recovered classical variations both enrich and are enriched by theological interpretations and contestations.

Nowhere is the mutual influence of pre- and post-Christian grace more visible than in the Neoplatonism of Marsilio Ficino, his peers, and his followers. Ficino's reputation as the greatest populariser of Platonic

and Neoplatonic wisdom is uncontested and well deserved, thanks to his publication in 1484 of the first complete Latin version of Plato's dialogues and, in 1496, of commentaries and annotations on the major dialogues.[20] Such publications rendered Plato's works evermore accessible while providing crucial aids for their advanced study. Meanwhile, he also scrutinised the early church fathers, producing religious commentaries such as *De religione Christiana* (1475–1476), *De raptu Pauli ad tertium coelum* (1476), and *In Epistolas Pauli commentaria* (1497), to name just three of the most relevant to grace. Such a combination of scholarly endeavours epitomised what has been called Christian Platonism: an identification in the Greek philosopher and his followers of Christian pre-echoes and insights and an accommodation between Plato's philosophy (or, rather, Platonist and Neoplatonist philosophy) and Christian doctrine. Of particular interest to Ficino were the suggestive similarities between Christian Trinitarian theology—the belief that the Christian God is one divine entity made up of three divine, consubstantial persons, namely, the Father, the Son, and the Holy Spirit—and the Platonic hypostatic trinity—the view that three higher spiritual principles (hypostases) underpin the surface phenomena we perceive with our senses, namely, the Good/the One, the Intellect/Mind, and the Soul/World-Soul.[21] Despite the countless ways in which Plato's and his interpreters' philosophy could be—and, indeed, was—seen to be heretical, Ficino was able to recognise commonalities of thought between them and early church theology while remaining sensitive to their various differences.[22]

The question of the degree to which Ficino believed the Platonic hypostatic trinity to have anticipated the Christian Trinity in all its complexity is not one for this book.[23] Of relevance here is the fact that the originary Platonic trinity provided a fruitful and productive formula enabling Ficino to explore the myriad patterns of human experience from the ontological triad (the One, the Intellect, and the World-Soul) to the tripartite division of the One (into the exemplary, efficient, and final cause of all things); and from the triad of beauty (action/*actus*, animation/*vivacitas*, and grace/*gratiae*) to the tripartite preparation of the body for such beauty (arrangement/*ordo*, proportion/*modus*, and aspect/*species*) and the three organs of eye, ear, and mind with which we perceive it.[24] No allegorical image could encapsulate these basic trinities as well as the three Graces, which Ficino employed with relish as an expository tool. As well as the various triads listed above, the three Graces also allegorised for him the celestial union of the 'good' planets Jupiter, Apollo, and Venus, whose influence was positively to be cultivated (by surrounding oneself with objects relating to the celestial trinity such as gold and green plants and with their associated

colours, green, gold, and blue) to ward off the melancholic effects of the planet Saturn.[25] The dance of the three Graces, moreover, epitomised for Ficino the circular emanative process of God's gifts to humankind. For the elect who reach their full potential, divine goodness flows from the divine source then back to its origins, where it is perfected, in a three-part movement as indivisible as Plato's primary hypostases and the Christian Trinity. This movement involves an outpouring from God (*emanatio*), followed by a consequential state of rapture (*raptio*) in the individual, and the return or flow back to the source (*remeatio*).[26] The same dynamic governs the distribution of qualities and gifts from the heavens to mortals, processes of thought and of spiritual enlightenment, the force of love, and so on.

In his hugely influential study, *Pagan Mysteries*, Edgar Wind criticises what he calls the 'extravagancies of Neoplatonism' and an overdeveloped penchant for the three Graces who Neoplatonist philosophers exploit wholesale, sometimes for dubious and 'nefarious' purposes.[27] He singles out Ficino for criticism, pointing out that no matter which triad he was discussing, 'he did not hesitate to compare all of them to the three Graces, calling them "quasi Gratiae tres se invicem complectentes", or "quasi Gratiae tres inter se concordes atque conjunctae", or "tamquam Venus tribus stipata Gratiis", etc'.[28] Nefariously or salutiferously, there can be no doubt that the three Graces did capture the neoplatonic imagination, encapsulating for many the foundational rhythms of the universe that classical philosophy and Christian theology held (more or less) in common and that expressed more than just one rule for life.

Giovanni Pico della Mirandola was as devoted to the trio as Ficino, inscribing their image on his portrait medal in a gesture that Frances Yates interprets as talismanic—a warding off of the melancholic influence of Saturn.[29] Inscribed with the words 'Pulchritudo, Amor, Voluptas', the medal also reflects his devotion to the Ficinian philosophies of love outlined in *De amore* (2.ii) and discussed in his own work on numerous occasions.[30] In his *Conclusiones*, Pico holds up as paradigmatic the relationship between Venus and the three Graces, using their image to explain that the unfolding of unity into three indivisible parts was fundamental to understanding Orphic (that is, Platonic Trinitarian) theology: 'Whoever understands profoundly and intellectually how the unity of Venus unfolds in the trinity of the Graces, and the unity of fate in the trinity of the Fates, and the unity of Saturn in the trinity of Jupiter, Neptune and Pluto will have understood the way to proceed in Orphic theology' (Orphic Conclusion, no. 8). In his commentary on Girolamo Benivieni's *Canzona d'amore*, meanwhile, he identifies them as the handmaidens of Venus representing the three properties of ideal beauty—viridity (greenness), happiness,

and brilliance (*viridità, letitia,* and *splendore*).[31] The first is a property perceived by the senses and not reflective. Since its durability and permanence are only apparent and not real, the Grace that represents it is depicted in iconographical visualisations frontally, like someone proceeding forward who will never return. The other two properties belong to our intellect and our will and are, by contrast, reflective and contemplative. This is why they are represented as facing away from us, like those returning whence they came since all things are said to come to us from the gods and to the gods they shall return.[32]

If Pico's three Graces tend towards natural magic, Orphic theology, and Neoplatonic notions of love and beauty, Cristoforo Landino's *Commentary on the Divine Comedy* (1481) turns them toward orthodox theology and classical poetry. In his annotations to Dante's *Inferno* (2.43–57), he reads the three Graces as allegorical expressions of the Christian graces, citing St Augustine, St Paul, and St Jerome alongside Aristotle and Hesiod to explain the roles played by Mary, Lucia, and Beatrice in the salvation of the pilgrim Dante's soul.[33] The first of the three Graces he classifies as *preveniente* (prevenient or preparatory) because it illuminates our reason, preparing us for virtue, and directing our desire towards that which is good. This grace is embodied by Mary, though her name is withheld from the pilgrim Dante on his journey through Hell to symbolise the fact that our free will is concealed from the soul and unknown to us until it has been activated by God's grace. The second grace, symbolised by Lucia, illuminates our will, showing us how to direct it towards knowledge of all that is good. In a gloss on Augustine's statement that 'God Himself works so that we may will at the beginning what, once we are willing, He cooperates in perfecting', Landino clarifies that if the first grace directs our free will towards the good, the second ensures our will is not in vain, preparing us to act on it, while the third *perficiente* (leading towards perfection) or *consumante* (consuming) grace overwhelms our entire will, enabling us to contemplate and come truly to know the supreme good.[34] This third Grace is called 'Beatrice' because it renders us blessed and emboldens us to know God. In knowing God we love Him, and in loving Him we reap our full reward (*fruiamo*).

Having invoked the authority of church fathers to explain the action of God's grace on human reason and free will, Landino then turns to the poets whose meditations he claims so often express true theology, as those with any wit should know. In Hesiod's *Theogony*, he observes, the Graces are three, and so far so much in accordance with the theologians. They are the children of Jupiter—meaning that the Graces come from God alone, a point he backs up quoting St Paul and St James—and Eurymone, whose name in Greek means large pasture because there is no more abundant

pasture for the soul than divine grace. Aglaia's name denotes splendour (*splendido*) because divine grace renders brilliant our souls; Euphrosyne means happiness (*letitia*) because only grace can content us; while Thalia signifies verdant and flourishing (*fiorente e verdeggiante*) because grace makes us blossom and weed out all vice. Hesiod adds that two of the Graces turn towards the first, drawn (Landino interprets) to her brilliance for their continued happiness and flourishing. The poetic allegory alone should suffice to vanquish any doubt that the true course of life's action should be to pursue the path of contemplation, having obeyed one's reason and taken as one's guide an intellect informed by doctrine and ennobled by the three divine Graces.

Ficino, Pico, and Landino embraced grace and its classical embodiment in the three Graces as iconographical instruments capable of communicating complicated truths. Observing them through a syncretist Christian-classical lenses at crucial moments, they were equally capable of applying a secular interpretative key and of delighting in the semantic capaciousness of the word grace in more earthly settings as well. Ficino, for example, used the language of grace variously as an explanatory tool, as an instrument of political persuasion, and as a means of flattering friends and admirers throughout his vast opus. Relying on its suppleness, he pressed grace into the service of diplomacy, keeping its various meanings in play and turning its pleasing effects towards urgent calls for action—be that the reciprocation of friendship (as in the letter to his friend, Bernardo Bembo, in which he hails him worthy of love and reverence for 'his breast is like the temple of the Graces'); or the rallying of troops against a common enemy, as in a letter dated October 1480 to King Matthias of Hungary.[35] The letter in question is the dedication of books 3 and 4 of his *Letters* to King Matthias, whom he regarded as the ideal philosopher king described in Plato's *Republic*. Ficino had direct access to Matthias's court through his friend Francesco Bandini, who had settled there by at least 1477.[36] Employed as a diplomat and agent of Lorenzo de' Medici's, Bandini was an intellectual who gathered a coterie of Neoplatonists around him and brought Ficino's translations of and commentaries on Plato to the attention of the powerful king, who was impressed enough to invite him to transfer to Buda in 1479. Emboldened by the king's attention, Ficino used a rhetoric of grace to plea for military intervention to defend Italy against foreign attack.

The letter opens with an abundance of references to grace and the Graces that serve as a sweetener for the heartfelt exhortation to war against the Ottoman Empire that follows. Ficino reminds King Matthias that 'our Plato' used to tell his disciples Xenocrates and Dion 'to sacrifice

attentively to the Graces so that they should become more gracious and agreeable', paving the way for his assertion that the 'twin books' of his *Letters*—as a result of being duly offered in sacrifice to the Graces—had been 'seized and carried off' by some benevolent spirit towards the lofty palace in Buda, 'as if it were the very temple of the Graces'. The flight, says Ficino, is motivated by the hope that in Matthias's presence the books will become 'suffused with the most gracious splendor of three Graces: that is of even-handed Jove, nourishing Phoebus, and beautiful Venus'. Suffused with Neoplatonic light and flight, the florid opening soon yields to the real business of the letter: an account of the 'darkness under the ferocious Turks' and an impassioned plea to Matthias to 'rise, act again' to liberate the many nations in Asia and Europe that have long suffered 'pitiable servitude' under the Ottoman Empire and that 'call out loudly and constantly [to him], as to a second Moses'. Matthias, Ficino hopes, will 'liberate God's chosen sons from extreme slavery and affliction' and 'in turn, beautiful Italy and Holy Religion herself, the mother of everything good, will call with continuous loud cries to Matthias that they will, by his hand alone, happily go free from the monstrous hands of the barbarians'. He likens Matthias to Hercules, who 'many times wonderfully vanquished monsters of this kind by heroic virtue alone' and 'tamed them'. On Matthias alone, God will confer unlimited command.[37] Throughout the letter, multiple meanings of grace are kept in play at once: grace as creative inspiration, as rhetorical force, as the classical goddesses, as Jove (Jupiter), Phoebus (Apollo), and Venus, as an agreeable demeanour, as light, as Platonic, as divine, as earthly, and—most important—as a gift bestowed by God on Matthias and one that he, in turn, can bestow on others. The aim is to flatter Matthias and to delight other readers by the nimble flight from one grace to another while surreptitiously rallying his rhetorical forces, only to unleash his entreaty with fluency and urgency in equal measure.

Grace and the three Graces were embraced and put to allegorical and rhetorical work in the most inventive and persuasive of ways in late fifteenth-century Italy. This brief excursus into their uses in Ficino, Pico, and Landino is not designed to be exhaustive but simply to give a flavour of the enthusiasm of their uptake and of the philosophical vogue they enjoyed in those decades. In *The Interpretation of Cultures*, Clifford Geertz describes the anthropological phenomenon triggered when certain *grandes idées* 'burst upon the intellectual landscape with a tremendous force', resolving so many fundamental problems at once that they seem also to promise that they will resolve all fundamental problems, clarify all obscure issues'.[38] 'Everyone snaps them up', observes Geertz, 'as the open

sesame of some new positive science, the conceptual center-point around which a comprehensive system of analysis can be built'.[39] Towards the end of the fifteenth century, grace and the image of the three Graces seemed to hold such conceptual force, not perhaps as a *grand idée* in itself, but as a particularly versatile and relevant symbol for many of the structures of thought, feeling, and action that contemporary thinkers, writers, and artists sought to comprehend. These are, of course, the same decades in which the architects of the Palazzo Schifanoia placed the three Graces at the pinnacle of their cosmographical vision, overseeing and connecting the divine, celestial, and earthly spheres in which we move.[40] Intellectuals and practitioners from across the peninsula were engaged in similar philosophical and iconographical reflections. The influence of their activities on sixteenth-century literature and the visual arts has been stated—if not overstated—across the centuries. It is no overstatement, however, to say that the grace they relished in its various manifestations flourished widely in word and in image in the decades that followed and to claim that the symbolic potency of the three Graces continued to bear fruit for generations to come.

The Language Question

Ficino, Pico, and Landino wrote in both humanist Latin and the Tuscan vernacular, rendering ancient works together with their own commentaries widely accessible while endeavouring to set new standards of grace and eloquence for both tongues. Indeed, many humanists, grammarians, and writers of their age straddled Greek, Latin, and the *volgare*, mediating between the classical languages of the ancients and the spoken languages of the courts and cultural elites. It was those who introduced the *gratia*, *venustas*, and *charis* of antiquity into the vernacular idiom who really made grace their own, theorising it, adapting it for a variety of purposes, promoting it as the ultimate mark of distinction, and making it a key feature of the language they strove to advance. As such, the *questione della lingua* (debate about language) provided a crucial cultural foundry in which sixteenth-century *grazia* was forged.

The *questione della lingua* divided Italian humanists into two camps: those who viewed Latin as the most expressive and eloquent language of literature, and those who saw the need for a vernacular language that would equal in expressivity and eloquence its classical predecessors. In determining which language to use and how to use it, the vernacular camp was divided—as, indeed, was the Latin—in two. On one side of the divide an 'archaic' standard held sway, while on the other a 'modern' idiom

dominated. 'Archaic' Italian derived from the fourteenth-century Tuscan used by the *tre corone* (three crowns) Dante, Petrarch, and Boccaccio, while 'modern' Italian, often referred to as *cortegiano*, drew eclectically from the dialects spoken in contemporary Renaissance courts.[41] The most famous exponent of the archaic Tuscan usage was Pietro Bembo, whose *Prose della volgar lingua* (written between 1506 and 1512 but published in 1525) represents the most authoritative contribution to the *Cinquecento* debate. In his *Prose*, Bembo promoted *grazia* not just as a good word to use, but as a good way to use words. In book 2 of his *Prose*, grace plays a crucial role in the campaign to perfect the elocutionary standards of the vernacular. Taking Petrarch and Boccaccio as his models, Bembo makes a virtue of simple themes and of privileging the form of a poem over its content.[42] If one is to excel as a poet, he says, one must strike the right balance between *gravità* and *piacevolezza* in the choice and deployment of words.[43] Accomplished poets will know how to alternate harsh sounds and soft, broad vowels and narrow, long sentences and short. They will vary rhythm, tonality, register, and sound with the triple aim of avoiding *sazietà*, matching subject matter and sound, and achieving the perfect balance of what he called *gravitas* and grace.

Another important contribution to the *questione della lingua*, Baldassare Castiglione's *Libro del cortegiano* (written between 1508 and 1516 but published in 1528) also made a virtue of elocutionary grace—and, indeed, of grace itself as the 'seasoning of all things' (il condimento d'ogni cosa).[44] Unlike Bembo in that he promoted not fourteenth-century Tuscan but a blend of modern Tuscan and the language of the best Italian courts, he was like Bembo in his desire to assert the dignity and authority of the vernacular. Key to this assertion was grace, which, for the speakers in his dialogue, was a type of harmony, an excellent quality, 'a certain air [un sangue] or adornment [un ornamento] that would make any courtier worthy of the highest praise' (1.14). More specifically, grace was the art of concealing effort and sprang from *sprezzatura*, a purpose-coined word used by Castiglione's speakers to help define grace. As we will see in chapter 3, *sprezzatura* was the ability to make one's achievements seem uncontrived and effortless, as if inspired by nature and not by artifice and labour. Only those who spoke and wrote using modern words 'which sound graceful and elegant and which are widely considered to be good and comprehensible' (che hanno in sé grazia ed eleganzia nella pronunzia e son tenuti communemente per boni e significativi) (preface) could achieve grace. Archaisms, be they Tuscan or Latin, conferred neither grace nor authority on language. Instead, they obscured meaning and gave the impression that one

was trying too hard. 'I would praise', says Count Ludovico da Canossa, 'any man who, as well as avoiding archaic Tuscan terms, ensures he employs—in speech as in writing—those words that are current in Tuscany and other parts of Italy and that bear a certain grace in enunciation' (qualche grazia nella pronuncia, 1.29). All others risk the ultimate crime of *affettazione*, that is, of an excess of artifice and preciousness, an overabundance of care that expresses in its perpetrator an extreme lack of grace (1.28).

Although on opposite sides of the Tuscan / anti-Tuscan divide, Bembo and Castiglione agreed that grace should be the ultimate seasoning of language. This depiction of grace as a *condimento* presented a happy co-occurrence of classical and theological precedents. Cited above is Quintilian's account of grace as that 'simple seasoning of language' which stimulates our taste while arousing in us a thirst to hear more. Quintilian's account certainly made an impression on Castiglione and Bembo, but they knew equally well the contribution of St Paul. The original theorist of Christian grace also advocates seasoning speech with the salt of grace as he applies the principles of classical rhetoric to the art of religious oratory: 'Let your speech be always with grace [*charis*], seasoned with salt, that ye may know how ye ought to answer every man', he says to the Colossians (Col. 4:5–6). Like many of the Renaissance writers who succeeded him, Paul played on the double sense of *charis*, discouraging the use of insipid talk while urging Christians to spread the news of God's grace. 'Salt' suggested at once the idea of preserving Christian thought from corruption and of using wit to save listeners from tedium. The ability of the saving salt of grace to arouse a thirst to hear more was fundamental to the campaign of spreading the Good News. Centuries later it was crucial to the campaign of spreading the vernacular in Italy as well.

As Castiglione and Bembo demonstrate, therefore, sixteenth-century vernacular writers drew grace from a variety of sources, blending—more or less consciously—humanist, religious, and literary models. Like the proverbial bee extracting pollen from a variety of flowers to produce honey (another classical metaphor adopted by both Castiglione and Bembo), they drew grace from a range of predecessors and adapted it for their own ends.[45] Despite its wide diffusion following Castiglione and Bembo, this composite, 'modern' grace was slow to appear in the word lists and vocabularies that proliferated once the vernacular began to gain ground. Though there is plenty evidence of its prominence across a range of discursive contexts, it failed to make any impact on lexicography until 1548. This was due, no doubt, to the fact that the first word lists of the Italian vernacular were little more than glossaries or appendices to the works of the *tre corone*. Alberto Accarisio's *Vocabolario, Grammatica et Orthographia de la lingua*

volgare, con ispositioni di molti luoghi di Dante, del Petrarca et del Boccac-cio (1543) and Francesco Alunno's *Le ricchezze della lingua volgare* (1543) were the first attempts at a systematic organisation of words in a form that resembled the dictionaries we use today, but here again the object was to list words used by Dante, Petrarch, and Boccaccio rather than to offer defi-nitions, etymologies, or commentaries on contemporary usage.[46] It was only in 1548 that Francesco Alunno's *La fabrica del mondo* bucked the trend, offering the first dictionary that was no mere glossary of 'archaic' writers but, as its author claimed, a verbal replica of the universe itself. Alunno combined the words of the 'tre fecondissimi autori' with those of other great vernacular authors and arranged them into chapters that cor-responded to the various cosmographical spheres starting with God and the Heavens, then descending to Earth, the Elements, the Soul, the Body, Man, Qualities, Quantities, and, finally, Hell. Modelled on Latin vocabu-laries of the fifteenth century, Alunno's dictionary suggested that by 1548 the *volgare* had established itself firmly enough to merit the same dignity and ambition as its classical predecessors.

Gratia appears twice in Alunno's *Fabrica*, in the chapter entitled 'Cielo' (Sky). One appearance comes under the subheading 'Fortuna' (Fortune/Fate), while the other is listed under the subheading 'Venere' (Venus).[47] In the 'Cielo-Fortuna' entry, grace appears—as it did in earlier word lists and glossaries—through the words of Petrarch and Boccaccio, as something to be given, received, done, or desired, as a divine gift from God, the Vir-gin Mary, and Heaven, and as the defining characteristic of the Madonna ('Vergine santa d'ogni gratia piena' [Holy Virgin, full of every grace], 169). Under 'Cielo-Venere', a similar list of *Trecento* occurrences of the word is preceded by an account and explanation of the three Graces of classical tradition. Here, for the first time in a lexicographical index of the Italian language, the stamp of classical authority inflects the readers' reception of grace towards its classical heritage. The description of the three Graces as resplendent ('splendido'), joyful (denoting 'letitia'), blossoming, and ver-dant ('fiorente, e verdeggiante') infuses the citations that follow with the beauty and happiness of classical grace. The three crowns appear under the sign—as it were—of the three Graces:

> Gratia. Lat. *e decentia, indoles.* Tre sono le gratie, cioè Aglaia, che in Greco significa splendido. Euphrosina, che dinota letitia, et Thalia fio-rente, e verdeggiante. PET[RARCH]. e BOC[CACCIO]. Gratia Spetiale, Somma, Tanta, Gran Gratia, Grandissima. Per quanto egli ha cara la nostra Gratia. Il Re gli rendè la sua gratia. Gliocchi per Gratia gira.

Vergine sacra d'ogni Gratia piena. Che tarde non fur mai Gratie divine. Gratie ch'a poch'il ciel largo destina. DAN[TE]. Non è l'affettion tanto profonda; Che basti a render voi Gratia per Gratia.[48]

(Grace. Lat. *decentia* and *indoles*. There are three Graces: Aglaia, which in Greek means resplendent, Euphrosina, which denotes joy, and Thalia, blossoming and verdant. PET[RARCH] and BOC[CACCIO]: Special Grace, Supreme, Such, Good Grace, Great Grace.) [Followed by citations of the word from Boccaccio, *Decameron* 1, 107; Petrarch: *Canzone*, 5; *Rerum vulgarium fragmenta*, 366; *Trionfo della divinità*; Dante: *Purgatorio*, 4.120.]

As well as to advertise Alunno's humanist credentials, the effect of this broader-ranging dictionary entry is to bring out the aesthetically pleasing classical connotations of Petrarch and Boccaccio's 'gratia spetiale, somma, tanta, gran gratia', and to anchor their use of the vernacular not just in the everyday language of the *Trecento* but in its Latin roots. The approach is not original. It is, rather, a combination of the citations listed in Accarisio's *Vocabolario* and the etymological entries provided in Latin vocabularies. Indeed, Alunno in his preface identifies as his lexigraphical models Latin compendia such as the *Cornucopia di cose*, by which he most likely meant the humanist *Cornu copiae seu Linguae latinae commentarii* by Niccolò Perotti, published in Venice in 1489. It is from the latter that Alunno gets the very idea of creating a 'universe' of words (as opposed to an alphabetical list) which would assimilate his readers within the semantic system of the vernacular both linguistically and culturally. He also borrows from Perotti the idea of embellishing his entry on grace with the three Graces.

Before Perotti's compendium, *gratia* was defined primarily as a gift and relates to the saving grace of God.[49] Perotti's is the first to introduce an account of the three Graces and, therefore, to frame a primarily secular definition with an assertively classical flavour. Both etymological and interpretative, Perotti's account of the three Graces explains the origins and meanings of their names:

Alii primam Aglaian, hoc est laetitiam; secundam Taliam, hoc est uiriditatem, quaia beneficium semper uiret; tertam Euphrosynen, hoc est delectationem, nominant. Hae à Graecis charites uocantur . . . , quod laetitiam significat.[50]

(Of them, the first is called Aglaia, which is happiness; the second Thalia, meaning viridity [greenness], because benefits are always verdant; the third Euphrosyne, which is delight. The Greeks called them *charites*, which means joy [pleasure, delight].)

It offers, too, an account of how the Graces were said to be depicted in ancient times and why. The reasons provided translate, as Ann Moss observes, 'into a coherent system: a morality of the interchange of benefits and gratitude, a harmonious cycle of favours given, received and returned'.[51] Tracing the long tradition of mythography from Seneca to Boccaccio's *Genealogie deorum*, Perotti reactivates latent meanings for the new generation of classicists whose pursuit of ancient wisdom and arts profoundly affected the words they lived by and thought through.

In Perotti, the introduction of the three Graces is symptomatic of the shift from the Latin of late medieval intellectuals to the revitalised classical Latin of the humanists. In Alunno, it is a mark of the widespread ambition for a vernacular Italian that could now be seen as comparable to its classical predecessors in terms of semantic range and verbal eloquence. His alignment of classical, vernacular, and divine sources suggests that the Christian 'Vergine sacra d'ogni Gratia piena' (sacred Virgin, full of every Grace) could now resonate with a grace older than Christ, while the splendour, happiness, and verdant flourishing of the three Graces were immeasurably enhanced through the immaculate power of the Virgin's intercession as the first mortal recipient of God's grace.

Alunno's vocabulary proceeds from *gratia* through its derivates, including *gratitudine, grato, gratioso, ringratiare*, and so on. Greek and Latin etymologies abound. *Gratioso*, says Alunno (for example), comes from the Latin, but also the Greek *eucharis* and *lepidis*. Amongst the list of derivatives, *venustà* appears, acknowledging a conjunction in the vernacular of the terms *venustas* and *gratia*, which Claude Moussy identified as markedly distinct in classical Latin (see first section above). *Venustà*, Alunno confirms, is synonymous with both *venustas* and *gratia*. Quoting Cicero's dictum 'Venustatem foeminis; dignitatem viris convenire' (grace befits women as dignity befits men), he goes on to clarify that it signifies both 'beauty of body and grace in action and words' (bellezza di corpo, e gratia ne gli atti, e nel parlare).[52] The irresistible mix of secular and divine, of classical and contemporary usage has finally come to be codified in official language. Like Castiglione, Bembo, and a host of contemporaries, lexicographers too have come to recognise that grace springs from a variety of sources; that it blends humanist, religious, and literary influences to produce a rich and nuanced word adaptable to a multiplicity of ends. The major writers and artists of the sixteenth century, as we shall see in the coming chapters, had already inherited, embodied, and polished this composite grace into a veritable art form.

Grace and Favour

BALDASSARE CASTIGLIONE AND RAPHAEL

Should you like to go to the Farnesina, Dorothea? It contains celebrated
frescoes designed or painted by Raphael, which most persons think it
worthwhile to visit. . . . He is the painter who has been held to combine the
most complete grace of form with sublimity of expression. Such at least I
have gathered from the cognoscenti.

—GEORGE ELIOT, *MIDDLEMARCH* (CA. 1871)

WITH CHARACTERISTIC GRAVITY, George Eliot's Casaubon describes
Raphael as the painter who exemplifies 'the most complete grace of form'.
Casaubon does not expand on what, precisely, this means. He defers,
instead, to the nineteenth-century cognoscenti from whom he gleaned
the insight. These discerning experts, in turn, drew on an aesthetic tradi-
tion that began during Raphael's own lifetime, for even as he was design-
ing frescoes for the Roman Villa Farnesina—which Casaubon encourages
Dorothea to visit—fellow artists, critics, and writers held him to embody,
more than any other artist, the quality of grace.[1] But what, exactly, did
those sixteenth-century commentators mean when they attributed grace
to Raphael? How does the term in *Middlemarch* relate to the *charis*,
venustas, and *gratia* appropriated and redeployed in sixteenth-century
Italy?

In this chapter, I return to Baldassare Castiglione's *Libro del corteg-
iano* (1514–1516) for an answer and as a privileged source of sixteenth-
century grace. Not only did Castiglione promote in his book of manners
the cultivation of grace as the desired seasoning of the Italian vernacular,
as we saw in the previous chapter; he also elaborated the theory of grace

most influential on the Italian Renaissance. Moreover, he knew and championed Raphael, writing the bulk of his book during the years of their acquaintance in Rome.[2] A supreme virtue distinguishing the good from the great, the grace of Castiglione's text is as relevant to courtiers, soldiers, writers, and musicians as it is to painters.[3] As such, it represents a rich and complex interlacement of sociopolitical, religious, literary, and aesthetic qualities. Casaubon's borrowed reference to Raphael's grace conceals a fine semantic weave that Dorothea's visit to the Farnesina could have only begun to unravel. Unless, of course, she had thought to take *Il Cortegiano* with her as a guide. Reading the dialogue while viewing Raphael's work sheds light on the 'grace of form' and 'sublimity of expression' of which her husband speaks. At the same time, it restores to word and image their history of profound interconnection while yielding insights into one of the most famous of those interdisciplinary friendships that was so animated by the idea of grace.

A Courtier's Grace

The *Libro del cortegiano* comprises four books, each reporting conversations that took place in the ducal palace of Urbino over the course of four evenings in the spring of 1506. The first book opens with a discussion of how the assembled company should best entertain themselves, and the conclusion is that one of their number should be given the task of 'depicting in words' the perfect courtier, while the others should be allowed to contradict him and to put forward arguments of their own. On the first evening, Count Ludovico da Canossa is given the task of depicting this ideal male courtier, and his first proclamation is that the perfect courtier should be a nobleman. In addition to noble birth, he would have the courtier 'receive from Nature not only talent and beauty of countenance and person but also that certain air and grace [una certa grazia e, come si dice, un sangue] that make him immediately pleasing and attractive to all who meet him'.[4] This grace, says da Canossa, 'should be an adornment informing and accompanying all [the perfect courtier's] actions, so that he appears clearly worthy of the companionship and favour of the great' (1.14). True to the spirit of the game, Gaspare Pallavicino contradicts da Canossa and says that nobility of birth is no guarantee of virtue, reminding the company that many noblemen have been wicked in the extreme, and that many of humble birth have won glory for their descendants through their virtue. He agrees with da Canossa that talent, good looks, and—above all—grace should distinguish the perfect courtier from others, but asserts that the

finest gifts of nature are often found in those of humble birth, since nature has no regard for the distinctions of social hierarchy.

The question of whether perfect courtiers should be noble is left open and becomes one of those topics to which Castiglione's interlocutors return throughout the course of the *Cortegiano*. There is no disagreement, though, about the fact that grace should be the ultimate and crowning glory of the perfect courtier. For the first chapters of the first book it is not clear what, precisely, this all-important grace is. Da Canossa calls it a type of harmony, an excellent quality, 'a certain air or adornment that would make any courtier worthy of the highest praise' (1.14), but it is many more things besides. It is also 'a certain fine judgment' (un certo bon giudicio, 1.21), a type of 'agility' (leggerezza, 1.22). For Bernardo Bibiena, it has to do with good looks, while Cesare Gonzaga describes it, as we saw in chapter 2, as the type of seasoning that should accompany every action, thought and deed ('il condimento d'ogni cosa', 1.24). Throughout the text, it appears in a series of quasi-synonymic pairings that give a good sense of its general meaning but make the task of precisely defining it ever more difficult. Characters speak of 'grace and authority' (1.29), 'grace and splendour' (1.35), 'grace and dignity' (1.36), 'perfect grace and true virtue' (2.59), 'grace and elegance' (3.2) 'beauties and graces' (3.58), and 'grace and happiness of the soul' (3.69).[5] In the midst of this profusion of meanings, da Canossa exerts some control, producing a 'universal rule' for acquiring grace. In what is probably the most quoted passage of the *Courtier*, he says that in order to have grace, the perfect courtier must avoid affectation at all costs and demonstrate, instead, a certain *sprezzatura*:

> I have discovered a universal rule which seems to apply more than any other in all human actions or words: namely, to steer away from affectation at all costs, as if it were a rough and dangerous reef, and (to use perhaps a novel word for it) to practise in all things a certain nonchalance (*sprezzatura*) which conceals all artistry and makes whatever one says or does seem uncontrived and effortless. (1.26)[6]

Castiglione presents *sprezzatura* as a purpose-coined word. It has been translated into English as 'recklessness' by Thomas Hoby and 'nonchalance' by Singleton and Bull. It derives from the verb *sprezzare*, meaning 'to refrain from esteeming or considering' (non fare stima, non tener conto) and 'to spurn, to disdain' (spernere, despicari).[7] In modern Italian, *sprezzare* might lie somewhere between *prezzare* or *apprezzare* ('to prize' or 'to appreciate') and *disprezzare* ('to depreciate' or 'to disdain'). Neither

'appreciation' nor 'depreciation', its noun form *sprezzatura* is a refusal to evaluate or to value, a resistance to placing store by things. The word, Peter Burke suggests, was not new at all, 'but rather a new sense given to an old word'.[8] The new meaning here marks a shift in emphasis from the act of setting no price on things to the pretence of it. Having *sprezzatura*, in Castiglione, is not so much refusing to value things as creating the impression that one refuses to place store by them. As da Canossa puts it, it is art which does not appear to be art where 'art' is intended in the Greek sense of *areté*, or the ability to do things.[9] *Sprezzatura* or *sprezzata disinvoltura* is the ability to make all actions appear easy, challenging though they may be, and to conceal the hard work and study that go into excellence. It is 'the true source from which grace springs' (il vero fonte donde deriva la grazia, 1.28), while its opposite, *affettazione*, is an excess of artifice (soverchio artificio e squisitezza), an overabundance of care (troppo diligenzia) that expresses in its perpetrator an extreme lack of grace.[10]

Just in case its meaning was not yet clear, da Canossa offers a series of examples of *sprezzatura* and, by extension, of grace at work. He cites classical orators who achieve it by dissembling their learning and making their speeches appear spontaneous and easy, as if they had been inspired by nature and truth rather than by artifice and effort. He compliments men and women in the present company for their 'nonchalant spontaneity', for creating the (false) impression that they pay little heed, if any, to how they speak, laugh, and carry themselves. By contrast, he mentions a friend, Pierpaolo, who tries too hard while dancing, prancing about with rigid legs and tiptoe feet, and his head held so still that it appears to be made of wood. In so doing, Pierpaolo achieves not grace but the disgrace of affectation. For the other speakers too, the term *sprezzatura* provides a linguistic handle on grace as they interrupt da Canossa with their own examples of grace at work. Thanks to the new word, Giuliano de' Medici can now pinpoint just what it is that produces grace in music. Excessive diligence, he says, leads to 'harsh and unbearable discord' (dissonanzia aspra e intollerabile, 1.28) while a sort of wilful imperfection, or nonchalance, keeps the listener in a state of anticipation, waiting for and enjoying the perfect harmonies when they come. In art, adds da Canossa, *affettazione* has a similarly harmful effect, as, indeed, it does in all other things (1.27).

After discussing grace and *sprezzatura* in the arts of oration, music, and painting, the conversation turns to the *paragone*, that comparison or competition between the sister arts of painting and sculpture. During

the course of the debate, grace reappears as that quality which ultimately places painting above sculpture in the hierarchical scale. Sculpture, Cristoforo Romano contends, is better than painting because it is more difficult and because it represents reality more truly, thanks to its three-dimensionality. Painting, by contrast, relies on deceptive strategies such as tone, colour, and shading to give a sense of shape, perspective, and depth. Da Canossa retorts that sculpture does indeed appear more difficult in many ways, but he refutes the notion that it *is* what it purports to be while painting only *appears* to be so. Both skills imitate nature, and sculpture lacks many of the things that painting has at its disposal, such as the ability to portray love-light in a person's eyes, the colour of blond hair, or a tempest at sea. As such, it is painting that requires greater artistry, but at the same time, da Canossa implies, it is painting that must wear its artistry most lightly. Although not explicit, the discussion here is still about grace as *facilità*, or the appearance of ease, which is said to surpass *difficultà* and obvious effort. It is through the language of art criticism that the Count chooses to conclude his formulation of grace, and it is by drawing on current debates about the techniques and qualities of art that he hopes to persuade his listeners that grace is the supreme quality that sets excellent and mediocre courtiers apart.

The closing passages of book 1 draw on the language of the visual arts to describe the nature and effects of grace. But did the language of grace elaborated in the fictional dialogue influence sixteenth-century descriptions of art in turn? The answer to this question is an emphatic 'yes'. Castiglione's words had a profound effect on how sixteenth-century writers appreciated and wrote about art. They exerted influence too, as we shall see, on Raphael's reputation as 'the painter who has been held to combine the most complete grace of form'.

Before Castiglione, grace appeared in art criticism in a peripheral sense, as something vaguely pleasing and roughly interchangeable with beauty.[11] After Castiglione, the precise nature of its difference from beauty became a source of much debate, and it was treated with more careful consideration than before.[12] The account of grace in Vasari's *Le vite de' più eccellenti artisti* (first published in 1550), for example, is close enough to Castiglione's in the *Cortegiano* for Anthony Blunt to conclude that Vasari must have derived his ideas 'directly from this source'.[13] Lodovico Dolce's dialogue on painting, the 'Dialogo della pittura intitolato L'Aretino' (1557), is even more obviously indebted to the book of manners in terms of the language used to describe grace and the examples used to illustrate it. In

Dolce, as in the *Cortegiano*, true art is art that does not appear to be art, and Dolce, like Castiglione's Ludovico da Canossa, chooses Raphael as its embodiment since his work excels not only for its *invenzione, disegno*, and *colorito* (the three main concerns of art) but also, more important, for its *sprezzatura* and *facilità*.[14] Also inspired by the *Cortegiano* is Dolce's use of the classical comparison of Apelles and Protogenes to exemplify the opposition between *sprezzatura* and *affettazione*. In both texts, Protogenes surpasses Apelles in every way, except in his understanding of when to draw back from his work and of how to conceal his diligence and hard work behind a veil of nonchalance and ease.[15] Dolce's text takes the comparison one step further than Castiglione's, as the classical artists are reincarnated in the figures of Raphael and Michelangelo. Raphael, like Apelles, is a master of grace, of that *non so che* which comes from he knows not where, but which fills the soul with infinite pleasure. Where Michelangelo seeks *la difficultà* in his art, Raphael strives to effect *la facilità*, creating the illusion that his work unfolded almost without effort, and certainly without showing any signs of his learning and hard work.[16] Such clear links between writers like Dolce and Castiglione highlight the two-way traffic between literature and art in the Italian Renaissance. They also suggest that the grace for which Raphael's work is famous is closely related to and influenced by the grace theorised by Castiglione. But how, precisely, does grace express itself in the nonverbal medium of painting?

The first place to look for an answer to the question might be none other than the portrait of Castiglione that Raphael painted in 1514–1515 and that hangs in the Louvre today (fig. 5 and plate 3).[17] Raphael painted Castiglione out of friendship in those years when they were both living in Rome and Castiglione was putting the finishing touches to his first version of the *Cortegiano*. According to the principles of portraiture of the time, Raphael's objective would have been to capture both a physical likeness and a sense of the *spirito* or *animo* of his sitter; to reproduce both the appearance and the character of a man who was actively thinking about perfect courtiers and promoting grace as their supreme virtue. As his friend, Raphael would have wanted to compliment Castiglione, to endow him with the qualities with which he would most like to be associated. It is fair to say that his task would have been to imbue Castiglione's portrait with the distinction of grace, to create a pictorial equivalent of the virtue he most promotes.

It is doubtless to this end that the portrait conforms to the precepts of its subject's text. It is, in many ways, a quite literal interpretation of the

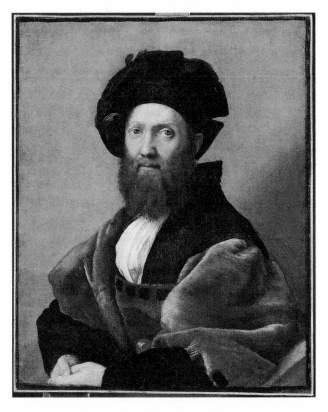

FIGURE 5. Raffaello Sanzio, called Raphael, *Portrait of Baldassare Castiglione*, ca. 1514–1515. Oil on canvas. Musée du Louvre, Paris. © Courtesy of Jean-Gilles Berizzi / RMN—Réunion des Musées Nationaux / distr. Alinari Archives, Florence.

book of manners. Castiglione's dress, for example, is elegant but not ostentatious, much as Federico Fregoso advises:

> I am also always pleased when clothes tend to be sober and restrained rather than foppish; so it seems to me that the most agreeable colour is black, and if not black, then at least something fairly dark. . . . But, to let you know what I think is important when it comes to the way one should dress, let me add that I would like our courtier always to appear neat and refined and to observe a certain modest elegance, though he should avoid being effeminate or foppish in his attire and not exaggerate one feature more than another, as do some who attend so much to their hair that they forget the rest. (2.27)

In Raphael's portrait, Castiglione wears dark but warm colours and is fitted out in a manner appropriate to his station. The sober colouring

of his attire signals the gravitas of the perfect courtier, while the sumptuous fabrics—raven-black velvet, ruffled silk, and silver-grey beaver fur—indicate his good taste, elegance, and nobility.[18] The hilt of his sword appearing just above the crook of his arm and the personal portrait medal on his beret (probably designed by Raphael himself) discreetly advertise his profession and status. Castiglione's face is serious but not severe, warm but not overly friendly. This sober amiability is emphasised both formally and stylistically. Harmonious undertones in Raphael's palette create a sense of warmth and an atmosphere of cordiality, while the grey-gold backdrop makes the blacks of his clothes gain in richness, setting off the vivacity of his ice-blue eyes. A single ray of light shines from the left and catches Castiglione almost fully on the face. There are no dark shadows or ominous secrets here. He is open and sincere. His forehead, most of all, is illuminated by that alabaster glow, suggesting the light of his intellect and highlighting the cranial seat of his fine judgement ('bon giudicio', 1.21). The portrait also adopts the artistic practises prescribed by the text. A close look at the canvas shows it to be composed of those single and seemingly effortless lines, those uninterrupted brush-strokes advised by da Canossa: 'Then again, in painting, a single line which is not laboured, a single brush stroke made with ease, in such a way that is seems that the hand is completing the line by itself without any effort or guidance, clearly reveals the excellence of the artist, about whose competence everyone will then make his own judgement' (1.28).[19] The uncomplicated subject, simple lines and harmonious range of colours combine to give a sense of easy execution and to conceal the learned attention paid to contemporary techniques of visual knowledge. In both subject matter and style, Raphael's portrait of Castiglione is a perfect example of his ability to create 'art that conceals its artistry' and to effect 'that ease which generates great wonderment' (1.26).

Viewed in this way, Raphael's portrait comes to constitute an artist's impression of Castiglione's perfect courtier. Raphael obeys *Il cortegiano's* guidelines for the external appearance of the courtier, and he adorns his sitter with grace both by emphasising the physical characteristics associated with the virtue and by being graceful in his technical execution of the painting. Examining the image and the text from the viewpoint of grace, in fact, constitutes a mutually illuminating exercise where one work completes and complements the other. The portrait of Castiglione illustrates some of the central tenets of the *Cortegiano*, while the literary dialogue, in turn, provides an aesthetic and theoretical context for Raphael's art. So

far, in other words, a comparison of the two goes some way towards shedding light on the Renaissance transactions that grace makes possible. One could even say that it gives a good sense of some of the meanings implied by the term. The problem, though, is that there is more to grace in Castiglione's dialogue than good looks, appropriate dress, and artistic practice. There is far more at stake than a set of static, aesthetic qualities to be added to the other conditions that the perfect courtier needs to acquire—and so we come to that other grace.

Two-Way Grace

In 1.24, Cesare Gonzaga sums up Ludovico da Canossa's theory of grace and provides the book's only attempt at a neat formulation of it. To explain the force of the word, he says, you could say that 'he who has grace finds grace' or, to put it literally, 'he who has grace is cherished' (chi ha grazia, quello è grato). True grace, in Gonzaga's synopsis, requires two participants: one who accompanies every action, gesture, habit, and movement with that 'seasoning' without which all other good qualities are worth little; and another who registers the virtue and repays it with gratitude, compliments, and graces in return. Grace, in other words, resides within a system of reciprocity. One cannot be graceful without having someone to recognise one as such. This reciprocity is reinforced by the syntactical structure of Gonzaga's phrase which, like perfect grace, is made up of two interchangeable but dependent parts of similar weighting. Not only is his maxim a description of grace, it is also a performance of grace, a figure for the relationship it describes. As such, it is one of the many examples in the text that hides its author's own rhetorical skill and subtlety behind a veil of *facilità* and *sprezzatura*.

This transitive dimension of grace tends to be overlooked in art historical readings of Castiglione, which search instead for a more static definition.[20] But it is crucial to understand that as well as an abstract quality derived from *sprezzatura*, it is a behavioural process, an operation that relies on its reception for success. Grace involves two people: one who emits and one who receives; a courtier, in this case, and his public. This communicative dimension reminds us that grace is not just central to the courtier's outward appearance. It also underpins his concern about his social status and is embedded in the contest for distinction that characterises the meritocratic structure of the Italian Renaissance court. Grace, in other words, is central to the courtier's struggle to survive in an emerging social order where he, and his profession as a whole, can be promoted or demoted on a whim.

Grace carries with it the requirement of recognition and reciprocity, but from whom does the courtier hope to receive acknowledgment and recompense? Later on in book 2, Federico Fregoso suggests that the perfect courtier should apply grace to win the 'universal grace' of 'lords, knights, and ladies' (grazia universale dei signori, cavalieri e donne, 2.17). The two-way traffic, he suggests, should travel along vertical lines between courtiers and their superiors (lords) and along horizontal lines between courtiers and their social equals (knights and ladies).[21] Book 2.29–30 develops the importance of winning the favour of equals. First and foremost, the courtier should strive for perfect friendship with one other whose love is constant, honest, and bound to endure until death. Without such friendships, says Fregoso, men would be the unhappiest of creatures. Beyond this exclusive bond, which Bembo dismisses as impossible to achieve, the courtier should strive to cultivate excellent relations within his broader circle of peers. He should love, honour, and respect all others so that he, in turn, will be loved and honoured by his fellow courtiers. For Fregoso, a man's need to ingratiate himself with his peers has less to do with the intrinsic value of friendship than with the reciprocal exchange of favours and graces inherent in the court structure.

In the case of winning the good grace of ladies, the main objective is also to improve one's reputation, rather than to enjoy the obvious pleasures of the relationships themselves. Fregoso tells the story of a gentleman he once knew, who, although mediocre enough in appearance and abilities, was loved by a charming and beautiful noblewoman who was so carried away by her passion that she felt compelled to tell her secret to a friend. Swayed by the first lady's positive account of this gentleman, the second lady fell in love with him, even though she had never set eyes on him, and set about winning him for herself. A third lady came across a letter written by the infatuated second and she, in turn, fell for the man. In a short time, word had spread and the man had become a general object of desire, squabbled over by ladies as cherries are by young boys. In his unflattering picture of the intelligence and judgement of women, Fregoso makes the point that winning the favour of one lady should serve as a means of acquiring the universal grace of all.[22] Grace, as before, works within a triangular paradigm and is not just an end in itself but a means to the end of winning widespread popularity.[23]

The endgame of this campaign to impress fellow courtiers is to win the favour of the courtier's superiors. Pleasing *cavalieri e donne* is all very well, but for the courtier, the ultimate goal and 'real fruit' (vero frutto, 4.5) of his actions should be to look good in the eyes of his prince. As Fregoso reminded the gathering in book 2, the courtier's noble birth, skill, virtue,

good looks ('disposizion del corpo e grazia dell'aspetto'), and other qualities should all combine to make him 'praiseworthy and highly thought of by everyone, and to secure the goodwill and grace [*grazia*] of the rulers whom he serves' (2.7). As he elaborates a theory of the courtier's function as intimate ally and counsellor to the prince, he is accused of describing a 'nobile adulatore', a first-class flatterer (Pietro da Napoli, 2.18). But he deflects the accusation by pointing out that flatterers love neither friends nor prince whereas this, above all else, is what he wants his courtier to do. Ottaviano Fregoso takes up the theme in book 4, declaring that, from his point of view, 'the end of the perfect courtier is to win for himself the good will and soul [la benivolenzia e l'animo] of the prince he serves by means of the accomplishments attributed to him by other gentlemen, and (in so doing) to be willing and able always to tell his prince the truth' (4.5). The ideal courtier should effect grace in order to become *grato* to the prince so that he can then tell him the truth about things. He should make use of the *grazia* that his good qualities earn him to remove all evil intentions from the mind of the prince and to persuade him always to follow the path of virtue. Here, grace is grace only if directed towards the good end or *buon fine* of educating and advising the prince.

The perfect courtier, in sum, must be graceful in order to receive grace from everyone from fellow courtiers to princes. But his ultimate aim must be to win the favour of his lord. This is hardly surprising, given the importance of a good reputation in a social structure where he is likely to be sent on errands to foreign parts, or even dismissed, if he is not needed to adorn the court. Earlier statements about grace requiring two participants—one who emits and one who receives—requires modification now: it actually requires three—one performs grace, a second appreciates it, while a third looks on, recognising and rewarding the originator with graces in return. To achieve 'universal grace', the courtier must activate a form of triangular desire. The first appeal is to a general public of courtiers that take his actions at face value, admire them for what they appear to be, and marvel at the apparent *sprezzatura* with which he conducts himself. Ultimately, however, such interactions target a supreme arbiter—either the prince who promotes or remunerates on the basis of grace observed and judged deserving; or true connoisseurs who see through the veil of *sprezzata disinvoltura* to the true skill beneath. In this respect, Castiglione's grace is closer in meaning to the *eironeia* of Aristotle's *Nicomachean Ethics* than to the *charis* of Dionysius of Halicarnassus or the *venustas* of Pliny the Elder with which it is usually associated. As Eduardo Saccone puts it, *eironeia*, like grace, 'is a pervasive mode of behaviour, a constant pretence of self-depression, of which understatement is only one manifestation'.[24] The

courtier's inner circle will recognise an instance of simulated *sprezzatura* when they see it, appreciate it for what it really communicates, and admire the *studio* and *fatica* that hides behind the façade of *facilità*. While the more general public plays the important role of disseminating the courtier's good name and impressing it on the prince, it is these insiders, including the text's most careful readers, who can really sanction the courtier's success.

Da Canossa, too, points to the presence of this dual public when he urges his courtier to cultivate the craft of writing. The perfect courtier, he says, should be more than an average scholar and should aim to be skilled at writing verse and prose so that he can entertain the ladies ('who are usually fond of such things'), but also so that he can learn to judge the work of others (1.44). In a rare moment of authorial self-promotion, Castiglione has da Canossa point out that not many people understand the demanding work done by writers or appreciate their stylistic talent. Learning to write will be profitable to the courtier even if he does not turn out to be good at it, because it will place him amongst an elite of peers who truly appreciate the 'stylistic accomplishments', 'triumphs', and 'subtle details' of good writing (1.44). Da Canossa's comment draws attention to the public's split into a common readership who can and should be seduced quite easily by the writers' craft, and an elite company of connoisseurs who can really appreciate the skill and effort that writing demands. He reinforces it by pointing out that the unsuccessful courtier risks letting himself down in front of his readers on two counts. If he fails as a writer, he will be scorned by the general public. What is worse, he will suffer a deplorable fall from grace from those in the know if he does not take pains to suppress his unsatisfactory efforts. These elite spectators will see that he has failed as a writer, but also that he lacks the grace to mask his failure. They will understand the true extent of his disgrace in that they will recognise the arrogance of his ambition and disdain him for the blind foolishness and *affettazione* that led him to masquerade as a writer in the first place.

As the *Courtier* unfolds, then, it becomes clear that grace consists of three intrinsically linked dimensions: it is an aesthetic quality derived from *sprezzatura*, a certain air of ease and confidence; it is a type of 'conjuring trick' intended to coax a general public into believing appearances while allowing a select few into its secrets; and it is a dynamic process, a three-way exchange of favours, aimed towards a virtuous end. The tendency of contemporary scholarship to cast grace as a fixed substance or quality obscures these performative and communicative elements. When it is moulded into convenient and determinate formulae, grace is deprived of its dynamic and transitive attributes. The question now is whether this

relational requirement of grace exists in Renaissance painting; and, if it does feature in art as well as in codes of manners, how does it express itself?

Raphael's painting of Castiglione does indeed seem to be as sensitive as the *Courtier* to the mutualism and reciprocity at the heart of Renaissance grace. Art of that period, in fact, was increasingly mindful of the need to be *grato* to the spectator, given the powerful influence of patronage and the competition and rivalry that it produced. Of all the artistic genres, portraiture gave the greatest sense of the artists' heightened awareness of the spectator's presence, and Raphael, like many of his contemporaries, devised technical strategies to develop within it what John Shearman called the 'communicative idea'.[25] Thanks to these strategies, portraiture became a register of commercial relations between patrons and artists whose aim was often to flatter so as to improve their financial and professional standing. But portraiture also began to record interpersonal relations of other kinds. This representation of Castiglione, for example, does not seem concerned with material or professional objectives. It seems motivated, instead, by a wish to engage the spectator on a more personal level. Here, the 'communicative idea' works along affective and rational lines, looking to win recognition and favour rather than recompense of any material kind.

The composition of the portrait and the viewpoint of the spectator are the most conspicuous markers of this intention. Raphael's characteristic pyramidal arrangement concentrates attention on Castiglione's head drawing the spectator into direct eye contact with him. Further attention is drawn to his face by the ample skullcap and beret and by the fact that Castiglione's bust is unusually truncated, cut off at his hands. Foreshortening his image in this way increases the sense of physical and psychological proximity between the spectator and subject so that, as Pierluigi de Vecchi puts it, the beholders are seduced into imagining themselves sitting beside Castiglione and catching his eye as if during a pause in their intimate conversation.[26] This pictorial fiction draws spectators in, engaging them in a transitive relationship with it. As the apparent objects of Castiglione's gaze, they are cast into the portrait's *istoria*, so that as well as finding it visually pleasing, they are compelled to play a part, to be moved in one way or another and to complete its plot by their presence.[27] The transitive, relational dimension of the portrait is as crucial to its charm and grace as the more objective properties of colour, texture, and light. As with courtly manners, the artist's grace requires an audience, a public that will register its success or failure, and Raphael is patently aware of that. So what public is Raphael trying to please?

Destined for Castiglione's residence in Mantova, the portrait would have had a general spectatorship that consisted of courtiers, diplomats, poets, artists, and other visitors to Castiglione's home; peers, in other words, those *cavalieri e donne* that Federico Fregoso advises his courtier to love and honour so that they will love and honour him in return. But there is also a more restricted public: the person or people towards whom the figure of Castiglione is deliberately looking. A number of scholars have taken very seriously the question of who the invisible companion sitting beyond the frame of the portrait might have been.[28] For some, the Count is locked in a visual embrace with his wife Ippolita Torrello, and the painting functions as a keepsake portrait intended to compensate for his long and frequent absences from home. This narrative, though, relies largely on the Latin elegy written by Castiglione in which Ippolita claims that only the painted image can relieve her constant anguish and that it participates in the life of her family as a surrogate for the absent husband and father.[29] Since the poem was composed years after the portrait (1519), which was, in turn, painted before Castiglione married Ippolita in 1516, the use of the elegy as proof that Ippolita is the other half of the fictional encounter staged in the portrait is unconvincing.[30] It seems more likely that Raphael wanted to invoke an instance of that 'supreme degree of friendship' that Fregoso set apart from more generic acquaintances in 2.29. His facial expression, in effect, intimates the presence of a like-minded friend, rather than a wife or child. It would seem that the figure in the portrait aspires to being *grato* to an equal, to a fellow courtier, and to convince him of his true grace. If this is the case, the implied interlocutor could be any of a number of Castiglione's friends, perhaps one of a company of humanists that spent time together in Rome during that period, including Andrea Navagero, Agostino Beazzano, Pietro Bembo, Antonio Tebaldeo, and—the irresistible candidate—Raphael himself.[31]

It is impossible to say for sure which of Castiglione's close friends Raphael would have wanted to evoke, but what can be said with certainty is that the painting has two kinds of public in mind: a general and a restricted one. Moreover, while the portrait can be said to encode two sets of 'receiver' for its communicative idea, it has two 'emitters' as well. On the face of it, it is Castiglione who 'speaks' to the general public and to the individual sitting opposite him. Behind this surface illusion, though, it is Raphael who reaches out to his viewers. The encounter he stages between Castiglione and onlookers is a figure for his own relationship with the observers of his work. Like Castiglione's audience, his is divided into two parts. One of these parts is the passive, general onlooker who will read his

portrait at surface level, admire its subject matter, and enjoy its overall effect. The other part consists of those thinking, discerning spectators who will penetrate the seemly veil of its *sprezzata disinvoltura* to recognise and appreciate the *arte* it conceals. Without the arbitration of this elect few, Raphael's portrait will not have acquired true grace, just a mere semblance of it.

First and foremost in this elite club must have been Castiglione himself. More than anyone else, Raphael would have wanted to please and impress his friend. As such, Castiglione is in the curious position of being both the sitter and the implied spectator of his own portrait, the subject and the object of his own gaze. The pictorial fiction inscribed in the portrait, then, might well have been an encounter between Castiglione and Raphael himself. Considered from this angle, the portrait comes to mean more than an artist's impression of the literary account of the perfect courtier. It is more, too, than a public relations act for Castiglione. It can also be said to set in motion a series of graces exchanged between the two. In the economy of courtly favours, Castiglione's portrait is a material compliment paid by Raphael in the hope of finding the grace and recompense of its beneficiary.

In a letter to Castiglione in 1514, Raphael testifies both to the 'courtly', reciprocal nature of their friendship and to his sense that his public may be split into common and elite parts. 'I've made various sketches', he says, 'of the *invenzione* Your Lordship suggests; and I satisfy everyone, if they are not idle flatterers, but I do not satisfy my own judgement, because I fear that I do not satisfy yours.'[32] The letter makes it clear that Raphael's intended public consists of the masses, those 'flatterers' he finds easy to please, and of people like Castiglione who understand the challenges of his craft and appreciate the true merit of his achievement. Pleasing the general public means nothing if he cannot 'satisfy' his learned friend whose *invenzione* or stories become the object of his work.[33] The letter lays bare the anxiety underpinning the courtly exchange of grace and favours. At stake here is not just the obvious risk of losing the support of his patron Pope Leo X, who is mentioned in the letter with a certain level of angst, but also the threat to his own professional and personal satisfaction. Recognition and remuneration from his lord are, naturally, central to Raphael's ambition, but the esteem and graces of learned peers and connoisseurs count for at least as much. As in the *Courtier*, moreover, winning esteem and favour is distinguished from flattery and purports to be directed towards a 'good end' (*buon fine*). In this case, the virtuous end, or 'loftier thought', is finding the way to emulate—and eventually to surpass—the grace and majesty in the architecture of the ancients.[34] Raphael hopes

that by pleasing Castiglione and winning his favour, he will earn his help and guidance in achieving the 'Icarus-flight' of preserving and reproducing classical architecture in the city of Rome. The main point, though, is that grace here (as in the *Cortegiano*) requires a *sprezzatura* that will lull hoi polloi into a state of adulation, as well as the skill and talent to impress the elect few whose appreciation goes deeper than sensory pleasure.

Raphael seems to accommodate this dual public in the portrait as well. He does this by exaggerating the discrepancy between Castiglione's right and left eyes. It is common in portraiture to see a sitter whose eyes focus on slightly different points beyond the frame. Here, though, the divergence is great enough to give the sense that Castiglione is both looking at his spectators and beyond them at the same time. This generates a certain level of dynamism and mimetic realism in Castiglione's face; but it also catches viewers in a sort of dialectic that includes them and excludes them all at once. As the public alternates between feeling like the privileged subject of Castiglione's gaze and feeling 'ghosted' by him, snubbed in favour of someone else, it becomes conscious of the two types of spectator that Raphael appeals to and of the triangulated conjuring trick at the heart of Renaissance grace. At the same time, it detects a sense of the ambiguity, and indeed hypocrisy, with which the trick was played. On the one hand, the perfect Renaissance citizen aimed to catch his public's eye and seek out its approval. On the other, he was obliged to hide his intentions, as the *Cortegiano* suggests he should, disdaining base quests for popularity and posturing as the custodian of far loftier thoughts should.[35]

Raphael's Three Graces

If Raphael in his portrait of Castiglione thematises the art of concealing art, thanks to which the courtier curries the favour of princes and peers while appearing to do nothing of the sort, the artist in his successive treatments of the three Graces shows that courtly art at its most seductive. Underpinning his painting *The Three Graces* of 1504–1505 (now in the musée Condée at Chantilly) and his drawing of the same subject of ca. 1517–1518 (now in the National Trust Collection of HM Queen Elizabeth II) are artful considerations of composition, line, and narrative designed to please the eye, along with strategies of artlessness that make his work appear natural and effortlessly wrought. Executed more than a decade apart, painting and drawing offer different studies of those classical deities that have long been known to symbolise grace. As they vary in content and style, they chart the development of Raphael's unique *maniera* and

an evolving sense of how best to engage and beguile one's public while appearing to curry no favour at all.

Few classical figures could represent quite as eloquently as the three Graces the artist's need to please while pretending not to care. Representing Venusian beauty and charisma, as we saw in the prologue, they also symbolise the circuit of grace and favour on which the Italian courts depend. At the same time, they appear not to pay that circuit any heed. As such, they hold up a mirror to the classical concepts of beauty that Raphael was said to have mastered; to the self-regulating market of benefits within which he operated; and to his particular mode of diligently negligent operation therein. Over the course of the years that separate them, in fact, Raphael returns repeatedly to a particular Venusian gesture of modesty that seems particularly concerned precisely with these features of his art. Deleted from the painting, that gesture finally finds eloquent and original expression in the drawing, attesting to an ongoing fascination with the art of concealing to reveal.

Modelled on the classical statue of the three Graces in the Piccolomini library of Siena, the Chantilly *Three Graces* features the familiar trinity of naked and finely formed deities dancing in a circle (fig. 6 and plate 4). Like those of del Cossa and Botticelli, Raphael's Graces exult in the sensuality of the female form, offering views of the naked body from front and behind. Though fully exposed to view, the nubile maidens avert their gaze, tempering with humility the unashamed sensuality of their nakedness. Treading that fine line between decorum and eroticism, they thereby offer both an invitation and an obstacle to love.

The three Graces, in Raphael's painting, not only represent both the pleasures and frustrations of love but also embody the selfless altruism at its core. Giving of itself while seeking no recompense in return, true love (as we have seen) exacts no payment, just as the Chantilly three seek neither recognition nor reward from their averted gaze. Raphael's Graces conform to traditional iconography in this and other respects, echoing classical accounts from Aristotle's *Ethics* and Seneca's *De beneficiis* to Servius's *Commentary on the Aeneid* and Fulgentius's *Mythologies*, texts read, if not by Raphael himself, then by contemporaries like Castiglione with whom he exchanged ideas. Like their ancient and modern predecessors, his trinity carries Venusian connotations of beauty and love while building on them too, exemplifying the all-important theory that beauty is worthless if static and cold. Only beauty in motion can move the beholder. Such movement is physical, symbolised here by the dance of the Graces. It is interpersonal, as well, symbolised by the contact between their bodies, the synchronicity

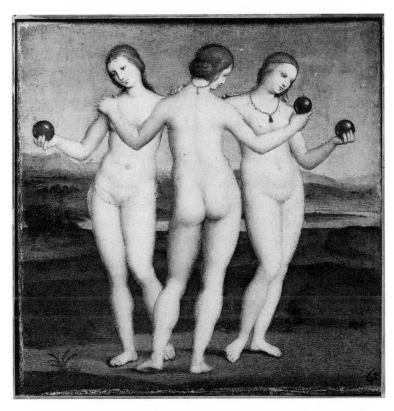

FIGURE 6. Raphael, *The Three Graces*, ca. 1504–1505. Oil on canvas. Musée
Condée, Chantilly. Courtesy of RMN—Réunion des Musées Nationaux / distr.
Alinari Archives, Florence.

of their choreography and the reciprocity of their actions. As well as
celebrating the static essentials of beauty, in other words, the Chantilly
Graces embody those vital forces that animate beautiful faces and features,
thereby activating the flow of sentiment between individuals. They impart
this vitality with tilted pelvises, upraised feet, and active, forward-tending
knees. Synchronicity of sentiment, meanwhile, is expressed in the motion
suggested by the composition as a whole. Two frontally portrayed Graces
are set slightly further back from the middle, backward-facing one. Thus
arranged, they suggest the concerted motion that represents the unbid-
den circularity of ideal, unthwarted love. This cyclical dynamic is further
emphasised both by the oval-shaped shadow depicted on the ground and
the round or elliptic shapes of which their bodies consist.

Even as they invite allegorical interpretation of a traditional kind,
Raphael's Graces appeal to the aesthetic sensibilities of the painter's age.
As iconographical signs, they require decoding and point to Venusian

beauty and desire; as figures made beautiful through the artist's skill, they exude that *non-so-che* they are said to signify, ravishing the eye of the beholder and capturing his or her heart. Classical iconography dictates that each Grace should hide as much as she shows, but by enhancing certain of her gestures, Raphael invites imaginings beyond the moment of the captured scene. The middle Grace, for instance, sways her right hip to its full extension so that the opposite motion through centre and toward the left is powerfully implied. As her hips swing, one imagines, her head sways and the body circles: she who is furthest forward will soon be furthest back; that which is concealed will ultimately be exposed to view. Mental space becomes the stage on which the dance unfolds. By attending to more than just the bare coordinates required to symbolise movement, Raphael exploits what cognitive scientists call the kinesic intelligence of his viewers, compelling them to travel, not just along the contours before them, but along a temporal trajectory into the future.[36] As he invites and we accept, artist and viewer become secret sharers, bearing silent witness to a scene that unfolds in the fertile landscape of our minds. Raphael thus shows acute awareness of how embodied cognition works: of how line and contour together with *storia* engage mind and body as well as eye, inciting thoughts, sensations, and mental images that move across time as well as space. He engages, in other words, in a seductive flirtation of his own.

Suggesting a sway of hips and swing of heads, Raphael invites us to anticipate future postures and positions for his Chantilly Graces. By implying movement, he conjures up images of what soon will be revealed and concealed. X-radiography testifies to further experiments in such kinesic manoeuvring and, in particular, in the means by which gestures of hiding to show can amplify what we see, think, and feel.[37] One such experiment visible only in the underdrawing concerns the right-hand Grace who seeks to cover her pubis with left hand. This gesture of modesty, borrowed from classical depictions of the *Venere pudica* and reincarnated in Botticelli's *Nascita di Venere*, is one that famously encourages long, lingering looks more effectively than it could ever deter them.[38] Seductive though it may be, however, the individual action threatens to compromise the balance and integrity of the scene. Leading away from the dynamic continuity of the dance, it draws the eye towards the asymmetrical idiosyncrasy of just one Grace. In the end, the artist alters the position of that arm so that, apple in hand, she comes to mirror more closely the appearance and actions of the other two. Raphael, by this alteration, privileges the overall effect of their simulated dance and deliberately facilitates that process which permits us to anticipate what comes next and what happened

before. He concentrates the eye not on the finite action of one figure but on the dynamic interplay between all three so as to encourage the impression of that free flow of action, not only in the painting, but on the screen of the imagination as well.

There is more to the Chantilly Graces than the hide-and-seek of love and artistic pleasure. As we have seen, classical Graces also stand for the circulation of benefits that should underpin all civilised societies, and Raphael's rendition is no different. As the sixteenth-century artist and art critic Giovan Paolo Lomazzo summed up in his late sixteenth-century treatises on art, the Graces were widely recognised as laughing young virgins with hands interlaced to show that whence favour comes, so it should return.[39] Performing the communal duty at the heart of harmonious communities, 'one of them renders a good service, the second receives it, while the third renders another service in return', for which they were sculpted into the portico at Athens.[40] From this perspective, the Chantilly Graces align well with their sister painting, the *Allegory* in the National Gallery of London, as the diptych aligns classical and Christian triads (three Graces here and three Virtues in the *Allegory*) to represent a combination of forces, both natural and divine, that govern the actions of individuals and determine the fate of the collective. Raphael would not be the first to conceive of such an alignment. In the *Salone dei mesi* and the contiguous *Sala delle virtù* of Ferrara's Palazzo Schifanoia, as I argued in the prologue, a similar synchrony of classical and theological goddesses is staged. Here, as in Raphael's ancient and modern predecessors, the Graces represent not just the dynamics of love and beauty but also collective care for the common good.

Drawn over a decade after the painting, Raphael's later *Study for the Three Graces* (ca. 1517–1518) (fig. 7 and plate 5) builds on the earlier work while departing radically from it as well. Most obviously, the artist liberates the sisters from their centuries-old dance, having them pour libations at the wedding banquet of Psyche and Cupid instead. This is not, of course, Raphael's invention but a scene from Apuleius's *The Golden Ass* (4.24), which describes the lavish feast during which Cupid reclines in place of honour, his wife in his arms, while the Seasons colour everything with roses and flowers, the Muses play tuneful music, and the Graces sprinkle the scene with rich perfumes. The narrative is not new, therefore, but its visual conceptualisation is. Never before in art had the three Graces been seen quite like this.

As was the Chantilly painting, the drawing is a eulogy to female beauty. Designed not just to represent beauty but to be beautiful in themselves, these three Graces demonstrate Raphael's mastery of figures engaged in

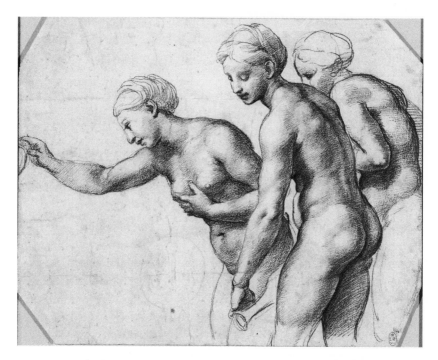

FIGURE 7. Raphael, *Study for the Three Graces*, ca. 1517–1518. Red chalk over blind stylus. Royal Collection Trust, London. / © Her Majesty Queen Elizabeth II, 2019.

the labours of love. Curvaceous bodies, modelled on a single sitter, are formed of free-flowing, red-chalk contours and unlaboured lines of the kind so highly praised by Castiglione and countless art connoisseurs in his wake. Tactility, depth, and warmth are expressed through delicate, parallel lines hatched or softly rubbed along the surface of fleshy limbs. Light shines from the left so that shadows caress buttocks, backs, and thighs and invoke the sunlight that streams from an invisible sky. Exposed thus by the sun, the Graces are nonetheless unaware of being seen. Rather than acknowledging us, they are absorbed by their work. Raphael seems, by now, to have fully mastered female form, attending to character as well as to shape. In fact, he masters the rules of female anatomy enough to be able to transgress them. Looking back on the accomplishments of his century, Lomazzo identified precisely this bending of natural laws as the outstanding discovery of High Renaissance art. Grace, according to his *Trattato*, was achieved by artists who learned the rules that govern their art— proportion, perspective, anatomy, and so on—only to transgress them.[41] Underpinning such transgressions was the profound intuition that aesthetic pleasure depends on the submission of precise anatomical and

mathematical calculations to the more impressionistic judgement of the eye. In the exaggerated torsion of his Graces' necks, especially, Raphael— for graceful effect—pushes accuracy to an extreme. Visual pleasure eclipses anatomical accuracy as the artist anticipates Lomazzo's praise for those who privilege the impressions of the eye over nature's precise proportions. Thus, as Lomazzo was to observe, he achieves the utmost grace.

Time and again, the line on which Raphael's transgressions turn is serpentine. In the shoulders, necks, and heads of his Graces, Raphael makes excellent use of the expressive qualities afforded by that delicate coil which subtly pushes natural postures beyond the limits of verisimilitude. The central Grace, for example, might well have angled her body towards the object of her libation for ease. Yet she offers her back, shoulders, and buttocks to the happy scene, counterbalancing that pose with a slightly exaggerated over-the-shoulder twist of neck and head that is as graceful as it would be difficult to hold. In so doing, she communicates a sense of active force up and down the length of her spine and down along her left arm. She expresses torsion as well, contrasting flexibility along the horizontal axis of her shoulders with the firmer immobility of her hips. The leftmost Grace, in similar fashion, angles her body in one direction and inclines her neck, head, and arm ever so slightly too much in the opposite. Turning with her body towards the wedding, she pivots the crown of her head away, as if on a gentle internal spring. Once more, this serpentine core creates the impression of a vital energy travelling upwards along her neck and head and outwards along her outstretched arm. An opposite force animates the lower half, which folds in on itself and lets gravity exercise its effects. In the juxtaposition of stretch and recoil, she exudes a gentle vitality, potential force, and exquisite grace of which the Chantilly Graces could only dream.

Painting and drawing thus show different approaches to depicting the gentle dynamism on which Venusian attraction depends. Earlier, in the Chantilly painting, Raphael achieved the contrast between naked bodies and angelic countenance by a more static form of juxtaposition, placing two opposing units of modular composition (body versus face) and of semantic meaning (unashamed sensuality versus modest decorum) side by side. Meaning and motion were expressed by counterpoise. In the drawing, by contrast, even the points of contact between one unit of composition and another have dynamic force. Angelic faces connect to naked bodies along active, serpentine spines that communicate and complicate the energy that animates them. The potential for further movement travels up and down the spine like breath. The artist's contours lead the eye up and down their length in pursuit of meaning but also, quite simply, for

the pleasure of how they appear. Drawn lines twist and turn as if caressing human flesh. As they curl and curve, they invoke the gentle, rapid movements of Raphael's hand. In so doing, they create a sensation of movement within the eye and hand of the beholder. As it moves across the surface of line, our attention feels as if it caresses, strokes, and twirls. The lasting impression is of a grace that does not rest on the graphic traces on the page but dances within the dynamic loop connecting the bodies of each Grace—and, indeed, of the artist himself—to ours.[42]

Raphael's drawing, it must be said, was not conceived with latter-day viewers foremost in mind. A preliminary sketch for the frescoes of the ceiling of Agostino Chigi's riverside villa in Rome, it was intended for his pupils to guide their execution of his design. Designed not for general consumption, the study was highly functional; but it is no less worthy of attention for that. On the contrary, it transmits a communicative force (Lomazzo calls it the force of the drawing: *la forza del disegno*) that seems all the more urgent—even to belated viewers like us—since it has to encode a visual message, as florid as it is precise, about the artist's idea, style, and form.[43] It has to whittle down Raphael's novel conceptualisation to a graphic shorthand that is both allegorically rich and aesthetically eloquent of a vision destined to be reproduced by other hands. As it issues a license for pupils to complete what the master has begun, it also exerts tight control over that vision which does not wish to be betrayed.

This mixture of freedom and control is particularly a feature of drawings that exude, as Lomazzo points out, a *forza* and *furia* derived from their communicative drive.[44] It is particularly evident in the contrast between those areas worked up to a high level of execution and those parts that are left unpolished and incomplete. Where the artist polishes, the drawing requires neither a line nor a dot more but articulates in full the image in his mind. Having overcome compositional and conceptual challenges, he builds up from a blind stylus underlay of principal and derivative lines to a monochromatic sketch as haptically appealing as it appears colourful. In the chest of the leftmost Grace, for example, Raphael models the gesture of a *Venere pudica* who conceals her right breast only to highlight the delicate perfection of the left. We observed Raphael try out such gestures before, only to change his mind. Now, he works out a way in which to lend the action integrity in its own right, while also embedding it within the choreography of the three. On the one hand, he uses the gesture to accentuate the roundness of flesh growing out of the leftmost Grace's chest bone, where it is met with soft sunlight that caresses and illuminates its precise and perfect nipple crown. On the other, he offers a bend of arm

that rhymes perfectly with the bend of the rightmost Grace's arm. He positions that arm so that it meets the central Grace's extended arm at the elbow. These overlapping elbows intimate the hinge-like movement each limb has the potential to make. The artist thus signifies motion in a literal sense while anticipating that motion in the mind's eye as well. At the same time, he introduces a seductive potential for touch as the overlaid limbs imply an interchangeability of action, so that one hand might just as well conceal another's breast as pour libations on the wedding feast. Erotic without being overt, potential narratives like this are inferred but never openly stated.

A play on limbs implies the hand that pours has the potential to be a hand that conceals. Meanwhile, it is in fact a hand that (as it pours) obscures from view its neighbour's pubis. As such, it recalls the lower half of the *Venere pudica* gesture, that abandoned expression of modesty revealed by the X-radiography of the Chantilly Graces. Raphael may well have been inspired in his use of this gesture by ancient sarcophagi depicting the Judgement of Paris and portraying Venus thus composed. Two such sarcophagi (now in the Villa Medici and the Villa Doria Pamphili) were frequently copied in Raphael's workshop and, indeed, make their way into Raphael's own *Judgement of Paris* drawing, probably hailing from those very years (ca. 1517–1518).[45]

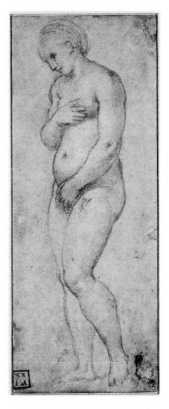

A few years previously, a silverpoint drawing of Venus (ca. 1511–1514) preserved in Budapest (possibly an early draft for an unrealised lunette for the Psyche and Cupid Loggia) features the goddess covering both pubis and breast (fig. 8). Raphael perfects this double gesture most seductively in *La Fornarina* (also dated ca. 1518–1519) (fig. 9 and plate 6).[46] Here, however, he plays with it, distributing its different actions across two bodies whose visibly compatible actions create an effect of rhythmic, sensual movement that elevates the dance of the Graces to a fine poetic art.

All this is lost in the frescoes of the Chigi Palace. Despite implicit instructions, Raphael's pupils separated the Graces,

FIGURE 8. Raphael, *Venus*, ca. 1511–1514. Silverpoint. © Szépművészeti Múzeum / Museum of Fine Arts, Budapest.

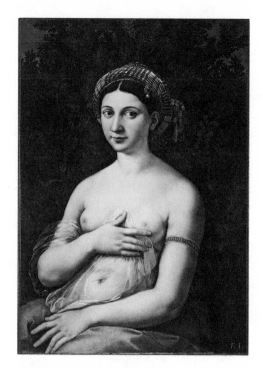

FIGURE 9. Raphael, *La Fornarina*, 1518–1519.
Oil on wood. Reproduced by kind permission
of Gallerie Nazionali di Arte Antica, Palazzo
Barberini, Rome. Photograph by Mauro Coen.

distinguishing one from the other with an application of colour that does
what Lomazzo warns against: it weakens the power of the drawing (*la forza
del disegno*). The one softly pink-skinned, the other alabaster white, and the
third somewhere in between, no Grace merges with the others in that same
synchrony of sensual action (fig. 10 and plate 7). That serpentine curve, which
lends such vital grace, too, disappears. Obscured behind the wings of an
angel, moreover, the distribution across two Graces of that iconic Venusian
pose is entirely lost in translation. The artist has been betrayed, as countless
commentators from Vasari onwards have lamented. The final images lack
'that grace and sweetness so characteristic of Raphael' (mancano di quella
grazia e dolcezza che fu propria di Raffaello).[47] Only the drawing preserves
the original grace of the artist's experiment in iconography and style.

Comparing Raphael and Castiglione from the perspective of grace, as this
chapter has done, is like eavesdropping on a discussion about the meaning
and importance of a particular word and about the risks and rewards of
court life that the word conveys. In the case of Raphael and Castiglione, at

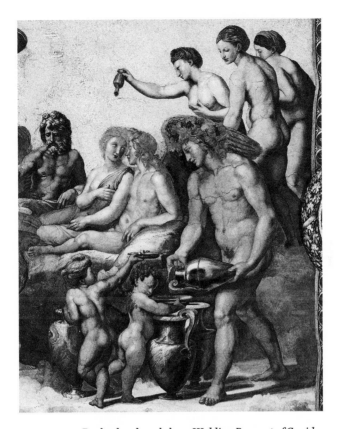

FIGURE 10. Raphael and workshop, *Wedding Banquet of Cupid and Psyche* (detail), 1518–1519. Fresco. Courtesy of Accademia Nazionale dei Lincei, Villa Farnesina, Rome.

least, the dialogue between two practitioners of the sister arts is amicable and produces a shared understanding of grace. *Il libro del cortegiano* presents it as aesthetically pleasing and as derived from a nonchalant game of simulation and dissimulation meant to conceal from the common masses the hard graft and skill behind true art. For him, it is bound up in the self-regulating market of favours at the heart of the Italian Renaissance court. Raphael's portrait and his studies of the three Graces read as artistic expressions of the same thing. Yet although relations between Castiglione and Raphael seem friendly, their exchange does not conceal the anxiety underpinning Renaissance performances of grace. There is a sense that each relies on the good taste, learning, and 'good judgement' of the other for success, and that, as with any other relationship of this kind, there are no guarantees that things will always work in their favour. At stake is not just the acquisition of beauty but that quintessentially Renaissance contest for excellence, with its clear and present threat of failure.

Grace and Beauty

VITTORIA COLONNA AND TULLIA D'ARAGONA

*Thus, grace would be the expression of feminine virtue, and this
expression would often be wanting in manly virtue.*

—FRIEDRICH SCHILLER, 'ON GRACE AND DIGNITY' (1793)

*Fallax gratia, et vana est pulchritudo (Grace deceives and beauty
is fleeting).*

—*PROVERBS*, 31:30

THE CONVERSATION IN Castiglione's *Libro del cortegiano* turns in book
3 to the subject of women and to the question of whether court ladies
required the same qualities as male courtiers. Giuliano de' Medici con-
cludes that they, too, should display nobility, avoid affectation, and dem-
onstrate a natural grace in all their actions. Women, he declares, need as
much prudence, magnanimity, and self-constraint as men, though he qual-
ifies his equitable division of attributes by saying that certain virtues befit
women better than men. Beauty, in particular, is more important in the
fairer sex, and women who lack beauty lack an awful lot indeed. Women's
honour, too, is more fragile than men's since they have fewer means to
defend themselves against slander. Moreover, though they may be equal in
virtue, men and women should never resemble each other in appearance
but conduct themselves in gender-appropriate fashion lest they be con-
fused for members of the opposite sex. The ideal court lady should never
be manly, and she should restrict herself to feminine activities and spheres
of influence unless extreme circumstances require her to act in a man's
stead. First and foremost amongst a lady's responsibilities, of course, is

governing the home and tending both to her husbands' affairs and to their children like a 'good family mother' (bona madre di famiglia). While on rare occasions she could be known to ride horses, play ball, wield arms, and go hunting (3.7), her main public concerns involve, in the highest-ranking households at least, finely honed skills in entertaining. In attire, make-up, hairstyle, and movements, says De' Medici, perfect court hostesses must cultivate grace and avoid, at all costs, the perils of affectation, a refrain repeated frequently by other speakers as well. Much attention should be given to speaking, as well, and to expressing oneself with judgement, gravity and modesty, while avoiding 'chatter, insolence and scurrilous habits' (loquacità, insolenzia e . . . costumi scurrili, 3.5). Careless conversation, excessive pride, gossip, ignorance, or lack of judgement are all serious pitfalls, primary means by which courtly women could embarrass themselves—and others. Mastering the tightrope of courtly conversation, by contrast, is a sure means to 'win and keep the grace of one's lady and of all the others' (guadagnar e conservar la grazia della sua signora e di tutti gli altri, 3.4). Prudent and graceful conversationalists will not just be loved but revered by all and worthy of being compared to this 'fine courtier' (questo gran cortegiano) in both body and soul (3.6). Giuliano's dominance over the conversation in book 3 leaves no doubt that his position is the one that prevails in its *querelle des femmes*: court ladies should be as virtuous as male courtiers, yet different from them too. They should be capable of performing male roles in virile fashion when absolutely necessary but are at their best when confined to feminine roles and within domestic spaces. Their ultimate goals in life? To win the grace and favour of their lady, just as male courtiers seek the grace and favour of their prince; and to adorn the court while complementing their men with refined habits, prudent and pleasing conversation, and that indispensable quality of 'supreme grace' (suprema grazia, 3.6).

Supreme grace is as vital for the ladies of *Il cortegiano* as it is for the men, but it is more closely linked to beauty than theirs and serves a quite different function. A man's grace provides the surest means to excel at court and to guide princes along the path of virtue. It is a crucial element in the array of aristocratic virtues needed to bolster the nobility against threat from rivals and enemies, and it is the necessary diplomatic counterpart to the military prowess needed to defend Italy during the wars that ravage it. A woman's grace, by contrast, bedecks the environment where bonds of grace and favour between men are made. The splendour of its reflected glory embellishes the men associated with it by marriage or bloodlines, seasoning their more effeminate qualities and counterbalancing their

manliness. Masculine grace counterbalances and thereby enhances the gravitas of courtiers and improves their chances of advancing at court. Feminine grace, by contrast, complements the beauty of court ladies and enables them to facilitate and promote the careers of their men. Graceful and beautiful women, in other words, help virile men inch closer to the Aristotelian golden mean: that ideal of *mediocritas* without which Italy would descend entirely into violent disorder.

As well as accentuating beauty, female grace acts as an outward sign of inner virtue in *Il cortegiano*. Accordingly, being able to identify true grace becomes a crucial skill for Castiglione's male speakers, who stand to benefit most splendidly from the light of its reflected glory or face ruin if it is mismanaged or lost. For when a woman is perceived to fall from grace, it is not just her honour but the *disgrazia* of those to whom she is answerable that is at stake, be they her patrons, birth family, or husband. Anxiety about this abounds in the dialogue and thrives, too, in the conduct manuals and philosophical dialogues theorising women and love in sixteenth-century Italy. Yet if female grace and beauty cause great anxiety, on the one hand, they offer the highest hope, on the other, and, in the final book of *Il cortegiano*, become the means by which the most enlightened courtiers can transcend the base concerns of this mortal coil and enjoy the loftiest state of spiritual awakening imaginable. Contemplating the grace of beautiful women, the figure of Pietro Bembo in Castiglione's dialogue makes clear, offers perfect courtiers the means of glimpsing the grace and beauty of the divine and of coming as close to understanding God as possible before death. Grace and beauty, in other words, render women not just ideal consorts and companions but spiritual guides as well: conduits for the presence of the divine on earth.

In the course of this chapter, I explore further the qualities required in women by men such as Castiglione, examining male-authored texts that hold grace and beauty up as intrinsically linked and quintessentially feminine ideals. My main focus, though, will not be male authors but women themselves. Concentrating on two of the most famous women writers of the sixteenth century, Vittoria Colonna and Tullia d'Aragona, I explore what the females of whom Castiglione speaks understood by grace and how they adopted it in their own writing. Did they fashion themselves according to the male ideal proposed in *Il libro del cortegiano*? Or did they reject the pairing of grace and beauty as applied to them? According to Colonna and d'Aragona, as we shall see, grace and beauty were not always the happy couple Castiglione's speakers make it out to be. In their different ways, they uncouple the terms and align themselves with one while shirking the other. For the aristocratic noblewoman Colonna, grace is of a

saintly kind that disdains mere corporeal beauty; while for poet-courtesan d'Aragona, by contrast, grace is surplus to requirements in a world where earthly beauty and intellectual virtue serve women's interests much better. As they guide grace now towards spirituality, intellectualism, and piety, and now towards physical attraction and embodied experience, d'Aragona and Colonna emblematise the range of possible responses to the high ideals that court ladies were said to embody. Occupying extreme ends of the spectrum of *dame di corte*, they reveal diametrically opposed interpretations of grace. The keyword, in turn, offers a novel means of better understanding the women who speak it.

Grace without Beauty

Vittoria Colonna (1492–1527) moved in the circles Castiglione described, being the daughter of Fabrizio Colonna (of highest Roman aristocracy and grand constable of the kingdom of Naples) and Agnese da Montefeltro (the sister of Guidobaldo da Montefeltro, whose wife hosts the conversations of *Il cortegiano*).[1] Yet, as we shall see, she roundly criticized courtly grace as vain and frivolous. Casting her eyes heavenward, she strove instead for God's grace and disdained the futile pursuit of earthly rewards. Colonna, it seems, wanted no truck with the kind of grace that Castiglione theorised, and the word 'beauty' makes only the rarest of appearances in her work. She meditates, instead, on the incorporeal mysteries of the Christian faith and on the immaterial grace of God. It is true that in her first surviving sonnets, she—like Castiglione—sought inspiration in classical sources and featured a grace that denoted not the salvific gift of God but the more terrestrial matter of the greatest qualities of her husband, Ferrante Francesco d'Avalos. The grace of the *rime amorose* she wrote after his death in 1525 bears few signs of the reform theology that characterises her later work, revealing predominantly Petrarchan and Neoplatonic influences instead.[2] Even here, though, grace is divorced from beauty and raised above our mortal existence to indicate the invisible, ethereal qualities of the soul. Because the *rime amorose* offer profound insights into Colonna's intellectual and spiritual formation and—crucially—into her most concerted response to the Neoplatonic grace and beauty of which Castiglione speaks, the first part of this chapter is dedicated exclusively to these. Against the grain of traditional Colonna scholarship, I read the poems not merely as preparatory for the increasingly spiritualised poetics of her later work, but as full-fledged meditations on topics of enduring significance for the poet and for women in general.

What has come to be known as the spiritual turn in Colonna's poetry did not begin in earnest till the 1530s when she came into contact with intellectuals who gathered in Rome and, from 1541, in Viterbo to discuss the inner reform of the Catholic Church.[3] In the mid-1520s she was surrounded instead by the Petrarchan sonnet writing that was so fashionable within the literary circles she frequented and the Neoplatonic poetry and love theories that circulated widely in the decades following Ficino's landmark translations of and commentary on Plato's *Symposium*. Combined, these models provided the perfect language and form with which to 'vent the internal grief' (sfogar l'interna doglia) of her early widowhood and, as we shall see below, to offer her own take on Neoplatonic grace.[4] Of interest in this chapter is not so much the unsurprising fact of Colonna's early tendencies, but rather the way in which she altered the grace of Petrarch and the Neoplatonists to accommodate her own circumstances within it. She does this in conversation with the so-called *scuola religiosa*: poets and intellectuals who frequented the Neapolitan Accademia Pontaniana and whose work was characterised by Christian classicism infused with Neoplatonism of the kind described in chapter 2.[5] Such acquaintances included Scipione Capece, Teofilo and Giambattista Folegno, Jacopo Sannazaro, and Giles of Viterbo, but she was also in correspondence with Northern humanists like Pietro Bembo and Baldassare Castiglione, both of whom produced their own literary theories of love (and grace).[6] Reading her work against the backdrop of theirs reveals a unique and decidedly gendered perspective on grace.

'Fiammeggiavano i vivi lumi chiari' (Those living lights were ablaze, A1:16) is the first sonnet listed in Bullock's edition of Colonna's *Rime amorose* to deal explicitly with grace. Replete with the language and imagery both of Petrarch and of the broad Neoplatonic conversation, it draws on familiar themes and tropes but departs in significant ways from the texts it deliberately emulates. The purpose of its octave is to describe the configuration of the heavens and of the loftiest celestial bodies when her beloved d'Avalos was born: those living lights that infuse the highest intellects with virtue were all aflame. Glorious souls and elect spirits displayed the rarest of gifts. The Graces were not frugal, the heavens were not mean, and the benevolent planets that infuse predisposed hearts with virtue, each in their rightful orbs, revealed their most pleasing and benign aspects. On Earth, meanwhile, the sextet declares, the sun had never dawned on a clearer day, celestial choirs of angels rang through the air, the ground teemed with lilies and violets, while the seas and the winds grew serene and her 'bel lume' (beautiful light) came into the world.

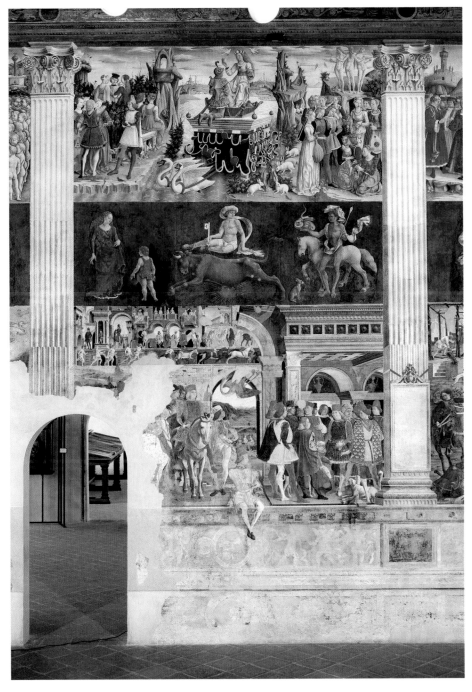

PLATE 1. Francesco del Cossa, *Allegory of April*, c. 1469. Fresco. Musei di Arte Antica di Ferrara, Palazzo Schifanoia, Ferrara. © Photo Ghiraldini-Panini.

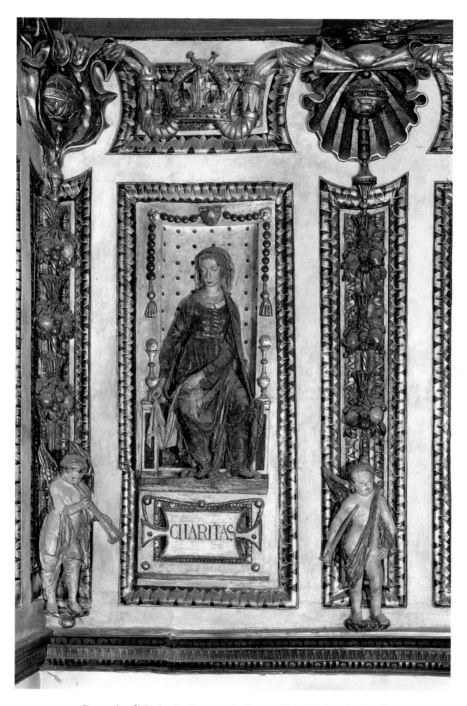

PLATE 2. Domenico di Paris, *Caritas*, c. 1467. Stucco. Musei di Arte Antica di Ferrara, Palazzo Schifanoia, Ferrara. © Photo Ghiraldini-Panini.

PLATE 3. Raffaello Sanzio, called Raphael, *Portrait of Baldassare Castiglione*, c. 1514–15. Oil on canvas. Musée du Louvre, Paris. Courtesy of Jean-Gilles Berizzi / RMN—Réunion des Musées Nationaux / distr. Alinari Archives, Florence.

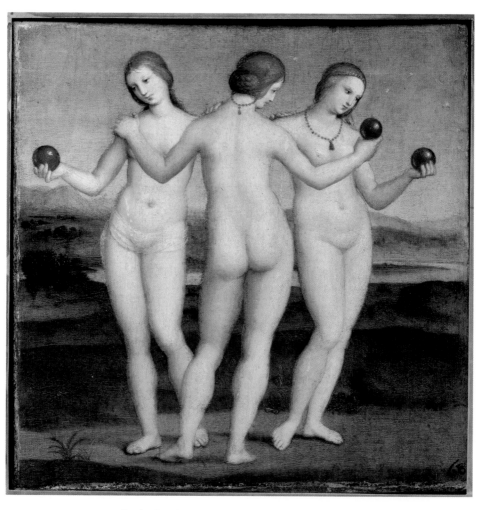

PLATE 4. Raphael, *The Three Graces*, c. 1504–05. Oil on canvas. Musée Condée, Chantilly. Courtesy of RMN—Réunion des Musées Nationaux / distr. Alinari Archives, Florence.

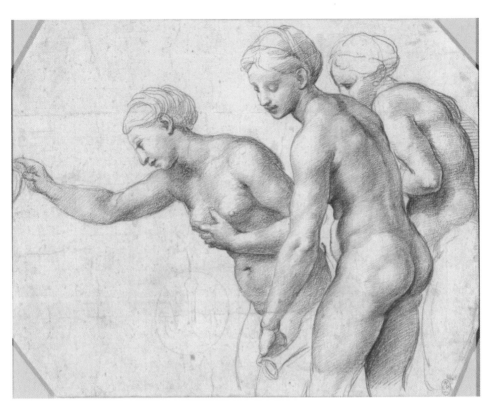

PLATE 5. Raphael, *Study for the three Graces*, c. 1517–1518. Red chalk over blind stylus. Royal Collection Trust, London. / © Her Majesty Queen Elizabeth II 2019.

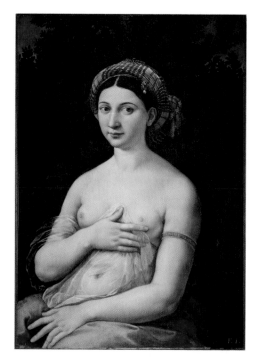

PLATE 6. Raphael, *La Fornarina*, 1518–19. Oil on wood. Reproduced by kind permission of Gallerie Nazionali di Arte Antica, Palazzo Barberini, Rome. Photograph by Mauro Coen.

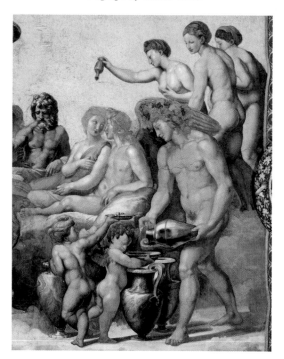

PLATE 7. Raphael and workshop, *Wedding Banquet of Cupid and Psyche* (detail), 1518–19. Fresco. Courtesy of Accademia Nazionale dei Lincei, Villa Farnesina, Rome.

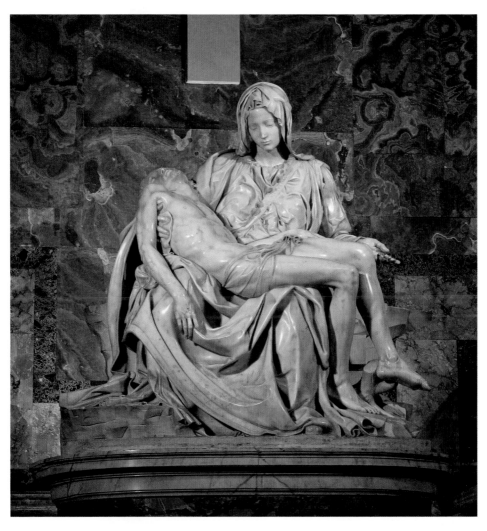

PLATE 8. Michelangelo Buonarroti, *Pietà*, 1499. Marble. St Peter's Basilica, Rome.
Courtesy of Fina Art Images / Alinari Archives, Firenze.

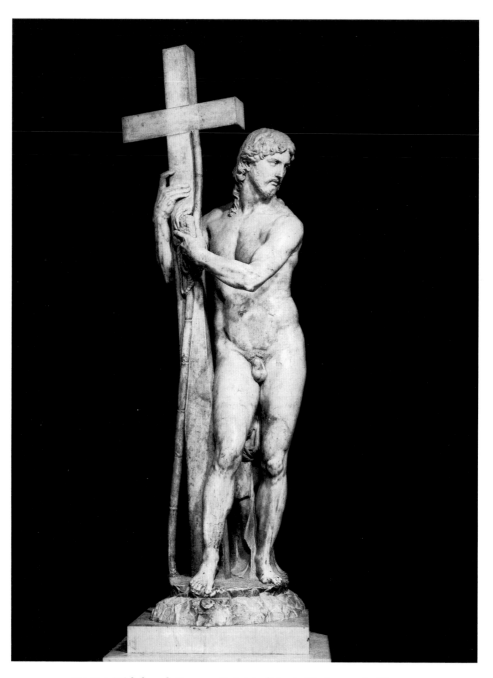

PLATE 9. Michelangelo Buonarroti, *Cristo di Santa Maria sopra la Minerva*, 1519–20. Marble. Santa Maria sopra la Minerva, Rome. Courtesy of Fine Art Images / Alinari Archives, Firenze.

In reporting the circumstances of d'Avalos's birth, 'Fiammeggia-vano' responds directly to Petrarch's 'Tacer non posso, et temo non ado-pre' (I cannot be silent, yet I fear to use my tongue), where 'a swift and self-assured lady' (una donna assai pronta et secura—the lady Fortune) describes for the poet the moment when his beloved Laura was born.[7] Maintaining Petrarch's overall conceit, Colonna departs from her model in a number of significant details, one conspicuous departure being the classical deities presiding over Laura's and d'Avalos's respective births. Verse 47 of Petrarch's poem identifies Jupiter and Venus as presiding dei-ties over Laura's entry into the world, in keeping with the *Canzoniere* as a whole, where the Roman god of gods often oversees remarkable events and the goddess of love watches over Petrarch's beloved.[8] 'Fiammeggia-vano', meanwhile, names not Jupiter and Venus but the latter's attendant Graces as the patrons of d'Avalos's beginnings. It may be that the poet felt the three Graces were more appropriate patrons for d'Avalos than Venus since, as well as unfolding the goddess's effeminate qualities of love, beauty, mirth, and eloquence, they also embody the more mascu-line virtues of liberality and magnanimity, offering a gender balance more befitting the military commander. Whatever the reason, Colonna's choice of the three Graces engages with the new wave of Neoplatonism and the vogue we have already seen in Ficino, Pico, Landino, and others for the Graces in all their allegorical glory.[9] The presence of the goddesses here, though relatively inconspicuous, brings echoes of the tripartite division of love as *pulchritudo, amor* and *voluptas* (beauty, love, and passion) theo-rised in Ficino's *De amore* and inscribed in Pico's portrait medal. They chime, too, with post-Ficinian interpretations of their circular dance as representing the three-part process of *emanatio, raptio*, and *remeatio* that enables God's love to reach humankind before circling back on itself and returning to Heaven. According to this process, as Pico makes clear in his *Commento sopra una canzona d'amore, pulchritudo* (beauty) issues from God and shines like a beacon through the figure of one's beloved by means of *emanatio. Amor* ensues in the form of a rapture (*raptio*) that floods the senses and reason of the lover. *Raptio*, in turn, yields to *voluptas* or that spiritual ecstasy which turns the souls of those equipped with intellectual and spiritual force towards the heavens and enables them to redirect their joy (*remeatio*) back towards its divine maker. We have already seen that this tripartite design inspires an impressive outpouring of literature, phi-losophy, and art in the decades that follow Ficino's *De amore* and Pico's *Commento.* By replacing Petrarch's Venus with the three Graces in 'Fiam-meggiavano', Colonna signals her entry into the fray of writers, thinkers,

and artists eager to express similar love theories in their own images and words.

Indeed, those flaming 'vivi lumi chiari' that, in the first lines of Colonna's sonnet, infuse the loftiest intellects with virtue give full voice to the Neoplatonic spirit of her poem. Those bright lights recall the luminous emanation that transports God's grace earthward, echoing Ficino's 'splendore della bontà divina', Pico's 'certa qualità . . . , la quale appare e risplende nelle cose belle', Bembo's 'immenso splendore', and Castiglione's 'influsso della bontà divina'.[10] Associated now with her deceased husband, they have returned to the heavens whence they came and act as her soul's inspiration to spiritual flight. Constantly present throughout the *rime*, they are variously described as 'the ardent ray / loosed from the world' (il raggio ardente / sciolto dal mondo, A1: 2), 'my lovely light' (mia vaga luce, A1:11), 'my beautiful light' (il mio bel lume, A1:12), 'my divine light' [la mia divina luce, A1:76), and so on. In a number of instances, the leitmotif of light gives way to that of grace and d'Avalos's rays become 'his graces' (le grazie sue) distributed across the heavens (A1:76) or 'those graces of my light' (quelle / grazie del lume mio, A2:19). Resembling the luminescence described by Colonna's male counterparts, the rays of d'Avalos's graces in 'Fiammeggiavano' also differ from it significantly by refusing to take on human form. In most Neoplatonic love theories, the human shape of God's divine light, its beauty, and the crisis it causes in the beholder—caught between the physical body and the spiritual soul—are of prime importance. Colonna, by contrast, ends her poem at the moment of d'Avalos's arrival in the world ('when the beautiful light of mine entered the world' [quando il bel lume mio nel mondo venne]) and before he properly embodies God's graces. His physical presence never gets to act on her corporeal self in a modification of the Ficinian pattern: no 'rays of love' emanate from his beautiful face and figure like arrows assailing her eyes, piercing her heart, and sparking a carnal desire in need of conversion into an uplifting intellectual and spiritual experience. No overwhelming 'desire for beauty' engulfs her causing her to shiver and perspire all at once. Throughout the *Rime amorose*, in fact, Colonna skips the lowest corporeal rungs of the ladder, moving beyond the 'vulgar' love that, in her male counterparts, precedes the conversion to 'celestial' love. She avoids, in other words, the physiological error that Castiglione's Bembo describes in book 4 of the *Cortegiano*:

> Beauty is an influx of the divine goodness which . . . adorns and illumines with wonderful splendour and grace [d'una grazia e splendor mirabile] the object in which it shines, like a sunbeam striking a lovely

vase of polished gold set with precious gems. And thus it attracts to itself the gaze of others, and entering through their eyes it impresses itself upon the human soul, which it stirs and delights with its charm, inflaming it with passion and desire. Thus the mind is seized by desire for the beauty which it recognizes as good, and, if it allows itself to be guided by what its senses tell it, it falls into the gravest errors and judges that the body is the chief cause of the beauty which it enshrines, and so to enjoy that beauty it must necessarily achieve with it as intimate a union as possible. But this is untrue; and anyone who thinks to enjoy that beauty by possessing the body is deceiving himself and is moved not by true knowledge, arrived at by rational choice, but by a false opinion derived from the desire of the senses. So the pleasure that follows is also necessarily false and deceptive.[11]

Colonna avoids the grave mistake of taking beauty for something that can be enjoyed by the body. In so doing, she aspires to saving her soul (as a lover) and to keeping her sonnets free (as a poet) from impassioned verses about the physical effects of desire. In this respect, she differs from countless Neoplatonists who, while decrying the pleasures of the flesh, nonetheless indulge in lengthy descriptions of beautiful women and ardent passion before moralising against it. Castiglione's Bembo himself permits in young men the 'gravest errors' he warns against in their elders, while Poliziano's *Stanze* offers one of the most evocative examples of poetic lingering on the oscillating sensations of heat and cold, the quickening of pulse, and the momentary loss of reason that place young men (like the protagonist, Giuliano de' Medici) on the lowest rung of the transcendental ladder:

> Ahi qual divenne! ah come al giovinetto
> corse il gran foco in tutte le midolle!
> che tremito gli scosse il cor nel petto!
> d'un ghiacciato sudor tutto era molle;
> e fatto ghiotto del suo dolce aspetto,
> giammai li occhi da li occhi levar puolle;
> ma tutto preso dal vago splendore,
> non s'accorge el meschin che quivi è Amore. (1.41)

(Oh what has he become! Ah, what fierce fire rages through the young man's marrow! What quaking jolts the heart in his breast! An icy sweat soaks him through; and avid for her sweet face he cannot detach his eyes from hers; all consumed by her charming splendour, he realises not—poor wretch—that Love has come.)

In 'Fiammeggiavano', by contrast, the 'vivi lumi chiari' illuminate not human eyes and figures but 'lofty minds', 'glorious souls', and 'chosen spirits' (alti intelletti, anime gloriose, and spiriti eletti). The narrator of the poem never sets eyes on her beloved. The poet halts the passing of time before the beloved's spirit materialises in this world. This is in marked contrast to its Petrarchan model, 'I cannot be silent' (Tacer non posso), where Laura's birth is merely the beginning of growth and blossoming towards 'her third, flowering age' (la terza sua fiorita etate) when 'the sun had never, I believe, seen such grace nor such beauty' (leggiadria né beltate / tanto non vide 'l sol, credo, già mai). Though Petrarch, like Colonna, travels back in time to the universal conditions before Laura was born, he looks forward, too, to her full maturity, to when those eyes were 'full of happiness and honesty' (pien' di Letitia et d'onestate) and that voice resounded with 'sweetness' (dolcezza) and 'well-being' (salute). Where Laura fulfils her destiny, d'Avalos remains by contrast a promise to the world, an ethereal array of abstract graces yet to be breathed into human form.

Resistance to sensory perception and an uncompromising spiritualisation of human graces, as seen in 'Fiammeggiavano', characterise the *rime amorose* as a whole. Colonna refuses to remember the physical graces and beauty of her deceased husband and suggests that even if she were able to evoke them, the lower senses perceiving them would be untrustworthy and inferior to the inner vision of heart and mind. In 'Per cagion d'un profondo alto pensero' (A profound and lofty thought allows me, A1:2), the image of her ever-present and lovely object (vago obietto) is so deeply etched in her heart and so alive in her mind that her actual eyes would not even be able truly to see it ('scorgo il mio vago obietto ognor presente / sculto il porto nel cor, vivo in la mente / tal che l'occhio il vedea men vero'). Sense perception and, indeed, verbal description fail when it comes to a love that has transcended the body and climbed the ladder towards what Castiglione's Bembo calls 'the sublime mansion where dwells the celestial, adorable and true beauty which lies hidden in the secret recesses of the Almighty where profane eyes may not see it'.[12] It is not that Colonna wishes to rewrite the Neoplatonic paradigm: rather, she accelerates her progress towards love's sublime mansion and focuses only on its heavenly aspects at the cost of its sublunar counterparts. Neoplatonic passion features in her words, but it is entirely spiritual as d'Avalos's ardent ray, released from the world (raggio ardente / sciolto dal mondo) acts as the escort (scorta gentil) accompanying the flight of her flaming spirit (spirto acceso) to the heavens. Grace throughout the *rime amorose*, in fact, acts as a figure for all he has come to

mean to her: a gift from beyond the grave and a promise of a happier life after death. Interchangeable with light and the sun, this grace is inscribed on her soul and revealed to her 'hour by hour' by a vivid memory that preserves and magnifies her husband's virtues.[13] It acts as her spiritual guide and escort, offering hope of spiritual elevation and ultimate, immaterial reunion with him.

The physical absence of d'Avalos in her sonnets and the chastity of her love for him tend to be read, in biographical terms, as appropriate for a recently widowed noblewoman wishing to extract herself from the marriage economy to which she was newly exposed. As Abigail Brundin has pointed out, her immediate retreat into a nunnery after her husband's death accentuated the image of piety already cultivated in her earlier poetry. Brundin also alleges that she refused to accept remarriage plans proposed by her brother Ascanio and Pope Clement VII thereby confirming her status as a *univira*, dedicated to one man alone for eternity.[14] Suppressing the corporeality of her husband in her sonnets, together with her own physical presence, says Shannon McHugh was a parallel means of consciously presenting herself as 'safely feminine . . . in male-dominated literary circles'.[15] Yet there is something less calculating and more poignant, too, in the poetic process of decorporealization witnessed in the *rime amorose*: it expresses more than the need to adapt her literary ambition to her new widowed status. Beneath the insistent piety of her verse and the persistent absence of the body lies a grief for that which has gone and which will never return. The body is absent in the *rime amorose* because it is also absent in life. Yet despite d'Avalos's death, sentiment and embodied passions linger on, and Colonna's assertive act of writing is designed to process those feelings (to 'sfogar l'interna doglia'). Viewed therapeutically, then, her poetic turn away from earthly grace and towards its heavenly counterpart is an act of displacement whereby her embodied responses to d'Avalos's demise are sublimated into spiritual reflections on the state of her soul.

Brundin remarks on the 'rehearsal' throughout Colonna's love sonnets of keywords like *virtù, gloria, valor, chiaro*, and *nobile* (virtue, glory, valour, illustrious, and noble), which she sees as paving the way for the spiritual sonnets later on and for their transformation of d'Avalos into Christ as the poet's main focus of attention.[16] As well as adding *grazia* to Brundin's list, however, I would like to take the teleological thrust of her argument and reflect on what those words enabled Colonna to express before the full spiritual turn. In sonnets like 'Fiammeggiavano', abstract intangibles such as 'i vivi lumi chiari' and 'le virtù ne cor preclari' (the virtues of illustrious hearts) express both hope in spiritual comfort after her

husband's death and sadness at the loss of his physical presence. Petrarch affords himself the luxury of recalling to mind Laura's actual presence. By contrast, Colonna limits herself to describing her husband's bodiless 'lume', thereby invoking the physical lack she strives to accept. 'Ne la dolce stagion non s'incolora' (A2:19) thematises this absence as well. Ostensibly celebrating the 'graces of that light of mine' (grazie del lume mio), it also laments a remoteness that not even words can embrace. The sonnet opens with springtime flowers bedecking the world and the light of dawn competing with countless stars in a limpid sky. Neither the new fronds nor the sun's rays, however, are as abundant as the lofty thoughts fired up in the narrator's soul by the graces of her beloved:

Ne la dolce stagion non s'incolora
dei nati fior o ver frondi novella
la terra, né sparir fra tante stelle
nel più sereno ciel la vaga aurora
con quanti alti pensier s'erge ed onora
l'anima accesa, ricca ancor di quelle
grazie del lume mio ch'altere e belle
mostra ardente memoria d'ora in ora.

(Springtime earth is never so tinged by budding flowers and new fronds; the lovely dawn and many stars are never so eclipsed by the serenest of daytime skies as my soul is elevated and dignified by lofty thoughts and enriched by the graces of my light, which ardent memory reveals—lofty and beautiful—hour by hour to me.)

Moving from the earthly plenty of spring through the inner bounty of her mind to the beautiful and lofty graces on high of her beloved ('quelle / grazie del lume mio'), the poem follows a joyful Neoplatonic progression from the earthly vestiges of God's goodness to their spread across the heavens towards their divine source. It ends, however, on a mournful note and a declaration of the ultimate incommunicability of those graces. The sonnet recalls the language of Neoplatonism only to reveal its deficiencies, since surely no language can relate the sacred mysteries of grace:

Tal potess' io ritrarle in queste carte
qual l'ho impresse nel cor, ché mille amanti
infiammerei di casti fochi ardenti;
ma chi potria narrar l'alme consparte
luci del mortal velo, e quelli intenti
raggi de la virtù sì vivi e santi?

(If only I could portray on paper what is so well impressed upon my heart, I would ignite a thousand lovers with chaste and ardent flames. But who could ever narrate the souls turned light released from mortal veil and those intense rays of virtue so vibrant and sacred?)

If only, she says, I could portray the graces of my true light on paper as well as they are inscribed on my heart—I would enflame many chaste hearts with ardent love. But such graces, sadly, are beyond the power of words.

Love's ineffability is, of course, a common trope from Dante to Petrarch and beyond. Castiglione's Bembo, for example, declares himself 'unworthy to speak of Love's sacred mysteries', while Petrarch, in the afore-mentioned 'Tacer non posso', confesses the certain knowledge that his tongue will fail to match mortal words to things divine ('Come poss'io, se non m'insegni, Amore, / con parole mortali aguagliar l'opre / divine?' [How can I, with mortal words, equal divine works unless you teach me, Love?, ll. 5–7]). Both writers' subsequent eloquence, however, belie their claims of verbal inadequacy. Colonna, by contrast, makes good on her claim and ends her sonnet with the following rhetorical question: Who could ever narrate the soul's light released from mortal veil and its intense rays of sacred, living virtue? The longing expressed in 'if I could only portray' and the ringing silence following her rhetorical question counterbalance the exuberance of the opening lines. Springtime flowers, the stars in heaven, lofty thoughts, and the invisible graces of one's beloved are all well and good, but what joy do they bring if they cannot be shared? The sonnet closes sorrowfully, with private memories impressed on the poet's heart only serving to compound her isolation both from her beloved and the 'thousand lovers' (mille amanti) she longs to reach. Rather than merely the cold calculations of a 'safely feminine' widow, Colonna's disembodied grace expresses an inner struggle to convert physical absence into spiritual presence and to clothe complex sentiments in inadequate words.

McHugh identifies a poetics of absence in Colonna's work, though in her case the absence/presence is decidedly erotic. Offering a close and compelling reading of the madrigal 'Occhi, piangiamo tanto' (A2:52), in which Colonna adapts the Diana and Acteon myth in a poetic 'experimentation in ideas on desire and poetry', McHugh argues that 'the entire poem pivots around what does *not* happen, what is *not* said'.[17] Citing Margaret Brose's suggestion that 'Petrarch employs verbal plenitude to mask his fear of absence', she argues that 'Colonna's tool instead is a verbal deficiency'. McHugh's comments ring especially true when applied to 'Ne la dolce stagion', where verbal deficiency is not just a tool but a theme, inviting

reflection both on her statements and on the gulf between what she says, what she lacks, and what she fails to express.

Less conceals more, as far as Colonna is concerned, and she thus invites readers to look beyond the words on the page for unarticulated meanings. Several contemporary commentators take up her invitation, reading into the hints and undertones of her sonnets full-blown Neoplatonic theories of love. Both Rinaldo Corsi's commentary (1558) and Bernardo Canigiani's public lecture for the Florentine Academy (1542), for example, extrapolate from the purely spiritual grace of her 'D'ogni sua grazia fu largo al mio Sole' (A2:20) a complete Neoplatonic schema in which grace is reunited with the beauty so frequently by its side in male-authored paradigms. In their eyes, 'D'ogni sua grazia fu largo al mio Sole' builds on Neoplatonic wisdom, developing an image of love that adheres to that wisdom. In certain respects, the sonnet does offer a concerted response to the *scala amoris* of Bembo's *Gli Asolani*, Castiglione's *Cortegiano*, and other such texts, as well as a rare concession to the involvement of the lower senses in love, but it features significant departures as well. In accordance with the standard laws of love, it was the 'color vaghi' of d'Avalos's face and the 'alto concento' (or 'alto intelletto' in Corsi) of his words that triggered her desire for him, the poet says. Gazing on him and listening to him excited her soul and sparked a flame never since quenched. Preserving its original blaze, however, the flame of her chaste desire never set fire to those other 'semplici' senses where discord reigns and beauty is born. Her 'vero / divino amor' was never cause for pleasure or sighs since the bright light of her true love bears her heart above the nadir where base sentiments and physical desire might hope to offend it. D'Avalos's grace and virtue occupy a vastly superior realm to the discord and beauty of earth.

If grace serves to unite physical and spiritual beauty in Bembo, Castiglione, and many other male authors, then, it does the opposite in Colonna. 'D'ogni sua grazia' mentions the fact that the poet-narrator did once feast her eyes on the fine colouring of her husband and her ears on his voice, but she does not hesitate at the crossroads between the higher and simple senses, instead advancing straight up the sublime path to celestial love. D'Avalos's material presence (that pleasing complexion and those lofty words) serves only to highlight his absence now and the immateriality of her own desire as his heavenly graces act as a beacon drawing her skywards, lifting her out of the choppy seas of the earthly passions. Castiglione's Bembo, like many of his male counterparts, may linger on 'the radiance, the grace, the loving ardour, the smiles, the mannerisms and all the other agreeable adornments' of the women he loves (quel splendore,

quella grazia, quelle faville amorose, i risi, i modi e tutti gli piacevoli orna-
menti della bellezza, 4.62) before eventually activating the highest sense
of all—the intellect—to abstract beauty entirely from its material form and
so to enjoy its pure and unadorned essence. Colonna's austere avoidance
of such flourish, meanwhile, reads as the proper behaviour of a recently
widowed woman, as the active sublimation of her grief, and also as a
covert reprimand to the licentiousness of those for whom Neoplatonist
love is 'nothing if not' a veiled excuse to rhapsodize over women and to
talk about sex.

'D'ogni sua *grazia*' becomes 'D'ogni sua *gloria*' in a number of manu-
scripts and printed editions of Colonna's poetry. Indeed, 'glory' is most
likely the term originally used by Colonna, since both Canigiani and Corsi
refer to it as such. There is, however, a striking conflation of the terms
grace and glory in both of their interpretations, where the very subject of
Colonna's sonnet becomes 'quella gratia che solamente si trova in . . . la
virtù dell'animo, nelle figure, e nelle voci' (that grace which is only found
in the soul's virtue, in appearances, and in voices).[18] Whether it mentions
the word *grazia* or not, according to these two, the poem aims to glorify
those forms of grace that we see in the proportions, colouring, and sym-
metries of our beloved, hear in the sweet harmony of his or her voice,
and perceive in the virtue of his or her soul. Such graces, Canigiani makes
clear, have nothing to do with the body since they are perceived by the eye
through which no material body could possibly fit and are enjoyed by the
intellect which is nourished by spiritual things alone. It is not bodies made
of flesh and blood that transmit the grace which excites love, but the 'apti-
tudine' or similitude of such bodies, which the lover perceives in a spiritual
way through the privileged organ of sight.[19] When impressed on the heart
and soul of the lover, it is the incorporeal likeness of the beloved's graceful
body that causes pleasure and fills the soul with infinite delight.

Accepting and expounding on the immateriality of Colonna's grace at
first, Canigiani then seeks to integrate her vision into more conventional
accounts of Neoplatonic love where grace and beauty conjoin. Warming
to his theme, he defines grace as that which pleases and is 'grato', mean-
ing 'cherished' or 'gratifying' in the sense of 'giving pleasure' or of 'grate-
fully received'. That which pleases, he says, is cherished, and that which
is cherished is beautiful (quello che piace è grato, et quello che è grato è
bello), so that, for him, beauty amounts to the Latin word for grace (quella
gratia . . . da i latini è detta bellezza).[20] Yet Colonna never describes grace
as beauty, and she avoids the familiar formulas of love being 'nothing if
not' the desire to possess beauty, and beauty being 'nothing if not' a kind

of grace derived from the proportions of the body and the concordant harmony of the soul. In this respect, she deliberately sets herself apart from Castiglione's Bembo and, indeed, from Bembo himself in whose *Gli Asolani* beauty 'non è altro che una *grazia* che di proporzione e di convenenza nasce e d'armonia nelle cose' (is nothing if not a grace which springs from the proportion, concordance and harmony of things, 3.6). Grace, for Bembo, is an attribute of body and of mind and the more beauty we find in one, the more grace we find in the other. For Colonna, however, grace leaves the body behind to wallow in its discordant materiality. Though Canigiani seeks to align her with her Platonic predecessors by reconnecting the grace she describes with an immaterial beauty that emanates not from the body itself but from a likeness to the body, he inadvertently highlights her difference. For she rarely identifies the shadow of God in human form or eulogises its radiant beauty. Instead, she emphatically rejects the ambiguous conjunction of spiritual and physical sentiments embedded in the body.

Grace, in this sense, is an index of Colonna's position on the broader Neoplatonic spectrum that extends from Plato to Poliziano and from Aristotle to Petrarch, taking in Christian poets and philosophers such as St Paul, St Thomas Aquinas, Dante, and Girolamo Benivieni as well as female mystics like Heloise and St Catherine of Siena. Tending more towards the Christian than the Platonic end of that spectrum and privileging mystical over physical experience, she infuses her love sonnets not just with social propriety and a sense of her bereavement but also with the piety and self-abnegation of the truly devout.[21] From high moral ground, she censors the sensuality of her male counterparts and models, even that of the self-accusing Petrarch, who is at pains to denounce the errors of his own flesh in his 'Ascent of Mt Ventoux'.[22] Indeed, as her eulogy of d'Avalos lays the foundations for pious Christian reverence in her later spiritual sonnets, her self-presentation as the grieving wife yields to later identification with Christ's bereft mother. The grace of her love sonnets, meanwhile, paves the way for the deep meditation on divine grace and on its incarnation in the figure of Mary that characterised both her *rime spirituali* and prose reflections, including the *Pianto*.[23] The ethereal, almost ascetic grace of her love sonnets, in other words, acts both as a means of reconfiguring her poetic persona in the light of her passing youth and recent widowhood and as a prototype for the grace that was to become a major focus of attention in her maturity. Her ownership of this gendered kind of grace that draws on a range of male-authored sources yet resists the aesthetic idealisation therein marks her out as embodying a new, sixteenth-century

form of female religious model. Neither the uneducated, unquestioning vessel of the Lord's grace nor a silent poetic ideal like Laura and Beatrice, whose grace, as we saw in Landino's commentary on Dante, represented the divine light acting as a beacon through them, she inaugurates a class of holy and educated women seeking to guide through words that spring from God's inspiration (of course), but also from experience and learning.[24] Such women, to quote Constance Furey, 'were infused with a kind of religious exemplarity in part because of their sex, but in many ways the gender lines dissolved as they were both catalysts for and receptacles of a model that was simultaneously based on and imputed to men as well'.[25] Indeed, Colonna's profound identification with Madonna-like grace made her an exemplary model not just for other women but for men like Michelangelo Buonarroti, an exemplarity to which we shall return in chapter 6.

Canigiani, to his credit, recognises the exemplary singularity of Colonna's endeavour, praising her as a 'mirror of chastity' (specchio di castità) and a 'harbour for every virtue' (albergo d'ogni virtù). As a poet, she authored at least one Petrarchan sonnet 'perhaps not inferior' to those penned by other members of the Florentine Academy (forse manco inferior a quei del Petrarca che io non sono à tutti gl'altri Accademici), a slightly awkward compliment he (almost) makes up for by calling her divine.[26] Yet his commentary fails to register both her active resistance to the union between grace and beauty so inviolable in the Neoplatonism of men and her insistence on grace as a spiritual quality without physical coordinates. Despite what Canigiani says, Colonna's *grazia* is interchangeable not with beauty but with *gloria*—as the editorial history of her sonnet 'Di ogni sua grazia / gloria' suggests. It expresses neither the proportions and symmetry of the human body nor the refined habits and pleasant conversation of a court lady, but that dazzling, light-filled bounty that transcends mere courts and bodies and that one receives only from God. As such, it takes issue with *Il cortegiano*'s recipe for ideal courtly consorts and for those court ladies seeking to serve at the highest-ranking courts. For Castiglione, as we have seen, grace and beauty when applied to women coexist as mutually reliant commodities in the economy of courtly favour and the equally commercial marriage market. Socially, intellectually, and spiritually exempt from both systems of exchange, however, Colonna simply decouples the terms so that grace floats free from the competition for favour amongst the *dame di corte* and from the pursuit of good husbands amongst women of fewer independent means. Simone de Beauvoir once noted that grace is one of those abstract qualities which, when applied to women, enhances their mystery and otherness, thereby becoming one of

those linguistic instruments of exclusion from a male-centred discourse that posits the masculine in a controlling and positively charged role and the feminine in a more passive, intermediary position.[27] If that is the case, Colonna turns the exclusion to her advantage, occupying that place apart and reveling in her exemption from the control of male discourse. Rather than a mode of survival at court, grace offers her the means of processing the sorrow of bereavement, of embracing the prospect of a publically celibate life, and of transforming the virtues of her deceased husband into the mystical grace of Christ. It provides, too, an assertive way of carving out an intellectual space of her own, on a par with—if not a spiritual ladder rung or two above—the male writers of her age.

Beauty without Grace

The salvific grace of Colonna's love sonnets and her disregard for earthly beauty are particularly visible by contrast with the more ambivalent grace at once classical and Christian, courtly and celestial theorised by Castiglione and other Ficino-inspired writers. It comes into relief, too, when compared with the work of female contemporary Tullia d'Aragona (ca. 1510–1556), for whom such grace seems unthinkable. Like Colonna, Tullia d'Aragona frequented courts and courtiers similar to those described in Castiglione's *Cortegiano*, but in an altogether different capacity. One of the most celebrated courtesans of the century, she exchanged graces and favours with men of letters and arms for her very livelihood. Love and amorous practises, therefore, were more than mere topics for poetic and philosophical reflection, and grace, accordingly, took on a different hue both in the sonnets she composed for patrons, friends, and admirers and in her explicit response to Neoplatonic love, the *Dialogo della infinità d'amore* (*Dialogue on the Infinity of Love*) (1547).

D'Aragona's *Dialogo* is, as its title suggests, a philosophical dialogue on whether love should be considered infinite. In it, grace is rendered conspicuous by its almost complete absence. The author writes herself into the work as a leading character in conversation first with Benedetto Varchi and later with both Benedetto and Lattanzio Benucci.[28] The dialogue is a direct response to Sperone Speroni's *Dialogo di amore* (1542), in which d'Aragona appears as a character, this time in conversation with Bernardo Tasso and Niccolò Grazia, but it also builds on the large store of philosophical tracts since Ficino's commentary on Plato's *Symposium*, including Leone Ebreo's *Dialoghi d'amore* (*Dialogues on Love*) (ca. 1501). It is surprising, at first glance, that a dialogue that mentions Ebreo's *Dialoghi*

amongst its principal models should make no mention of grace, since Ebreo treats the topic frequently and attentively.[29] The sense of surprise is increased by the fact that the real-life Benedetto Varchi, whose fictional counterpart is the source of much wisdom in d'Aragona's *Dialogo*, dedicated an entire (if short) treatise to the subject of grace and beauty, entitled 'Il discorso della bellezza e della grazia', in the very years of their acquaintance. Viewed against the backdrop of social and intellectual change that characterised the 1540s, however, and read in the light of Varchi's very treatise, d'Aragona's avoidance of grace starts to make philosophical and ideological sense.

The single passing reference to grace in the *Dialogo* is delivered by Benedetto (the character) and resounds with the rhetoric of Varchi (the author) in his treatise on beauty and grace.[30] Benedetto paraphrases Varchi's declaration as follows:

> La bellezza non è altro che una certa grazia, la quale diletta l'animo di chiunque la vede e conosce, e dilettando lo muove a disiderare di goderla con unione, ciò è, a dirlo in una parola, lo muove ad amarla.
>
> (Beauty is nothing if not a certain grace which delights the soul of whomsoever should behold and know it. In delighting the beholder, it stirs a desire to enjoy it through congress, in a word, to love.)

Benedetto goes on to declare that grace is a form of beauty or, rather, that beauty is 'una grazia che alletta, tira e rapisce chi la conosce' (a grace that allures, entices, and captivates those who encounter it).[31] In so doing, Benedetto points outwards from d'Aragona's dialogue towards Varchi, as if to suggest that enough has been said about the subject in his treatise to justify its exclusion here. Indeed, Varchi's 'Discorso della bellezza e della grazia', which sets out to determine whether grace can exist without beauty and which of the two it is more important to cultivate, offers a significant midcentury synopsis of grace. A concerted effort to combine Aristotelian principles with Platonic themes, it seeks to disentangle some of the crossed wires of Neoplatonic discourse and to distinguish, once and for all, the closely cognate key terms of its title.

At the heart of the confusion about grace and beauty, Varchi suggests in the 'Discorso', is the unhelpful intermingling of Aristotelian and Platonic notions of beauty. After setting out these notions, he declares Aristotelian beauty, or corporeal beauty, to be determined by the proportion, harmony, and colouring of its various parts. As such, it is the only species of beauty to be loved by 'il volgo con gli uomini plebei' (the masses including commoners), and since it can be perceived by only five of the six senses, it is

enjoyed by those five senses alone, failing to excite the higher-order sixth sense of reason. Therefore anyone who loves only this sort of beauty is little more than a brute animal. There exists, however, a higher form of beauty, 'la vera bellezza' (true beauty), which 'is nothing, according to Plato, if not a ray and splendour of the originary one and supreme good, which penetrates and radiates throughout the world and in all its parts'.[32] Such Platonic grace consists not in matter but in form, and since the form of man is his soul, it resides in the virtues and habits of his soul. Existing independently of the fine proportions, symmetry, and colouring that are commonly classed as beautiful, it is the only species of beauty to be loved by good and contemplative men and is of a kind that, as 'the great Platonist Plotinus' said, can never be bad. Invoking ancient and modern Tuscan authorities, as well as 'the most learned and reverend monsignor Pietro Bembo', Varchi explains that because this grace is perceived only by the higher sense organs of the mind, eyes, and ears, it can only ever be enjoyed in thoughts, images, and sounds.[33] To remove all doubt, he declares that 'la grazia è vera bellezza dell'anima' (grace is true beauty of spirit), a refrain he goes on to repeat a number of times throughout the 'Discorso'. It is often to be found in those who conform to the Aristotelian conventions of beauty, but Aristotelian beauty is no guarantee of grace since certain well-proportioned, perfectly symmetrical, and delicately coloured women can sometimes lack it. Others, meanwhile, may not be that well-proportioned or 'beautiful' by common standards and yet they abound in grace. True grace, of course, is never to be found in those who are deformed or filthy.

Varchi explains why he says 'una certa grazia' (a certain grace) as opposed to mere 'grazia' when he speaks of this 'bellezza dell'anima' (beauty of spirit/soul). It is because there are some graces that please and move the beholder to love and others that simply please. So that when he says someone reads or writes with 'grazia', he means that that person delights and pleases but has not necessarily moved one to love with their words. It is only 'that certain grace' which reaches the heart and solicits a response of any profundity. That certain grace can exist without beauty and is the most important to cultivate, although the closer one looks at it, Varchi asserts, the harder it is to define and pin down. All that can be said of it is that it somehow reaches the heart, while escaping the mind— thus its linguistic indeterminacy. Though it is the kind of grace one should aspire to cultivate, it is almost impossible to produce since it is so hard to say with any certainty where, precisely, it lies.

Though drawing on the ancients and moderns, the emphasis in Varchi is very much on the sublunary body and soul. A vestige of the 'supreme

good', to be sure, it is not presented here as a *scala amoris* back to God, and it makes no serious offers of spiritual transcendence to its beholders. Though Varchi quotes Plato's 'raggio e splendore del primo bene' (ray and splendour of the originary good), his 'certain grace' does not draw attention to God in the heavens but rather to the living, breathing mortals who possess it. Consisting of certain virtues and habits of their souls, it remains firmly anchored in the terrestrial sphere where it causes pleasure and inspires love, so although it may act as a conduit to God (and Varchi does not deny this), grace is ultimately and most importantly a vehicle for love and inspiration between earthbound human beings.

The grace once treated so reverentially by Ficino, Pico, and Ebreo is, therefore, significantly desacralized in 'Della bellezza e della grazia'. It becomes even more mundane (in the 'worldly' sense) in the near contemporary 'Dialogo della bellezza delle donne' (1541), penned by one of d'Aragona's erstwhile lovers and later critics, Agnolo Firenzuola. In this dialogue, Firenzuola opposes those who describe the grace of women as 'un raggio di amore' (a ray of love) or a 'quintessence' of any kind. Although, he says, this sounds learned and ingenious, it does not express the truth. For the real truth is that grace is 'un non so che' (a *je-ne-sais-quoi*), an occult splendour we cannot put our finger on.[34] Resplendent but not divine, grace is an aura that derives from a fortunate but elusive concordance between the individual parts of a beautiful woman's appearance. It cannot be explained in books dealing with measurements and proportions, because although its occult ways satisfy the heart and bring ease to the mind, these elude human reason: 'grace is nothing other than the splendour generated via occult means by a certain particular ensemble of parts, so that we cannot pinpoint (with any certainty): "it is this or it is that" [that cause it]'. ('La grazia non è altro che uno splendore', he says, 'il quale si ecciti per occulta via da una certa particolare unione di alcuni membri che noi non sappiamo dir: "E' son questi, e' son quelli"').[35] To say that female grace is an inexplicable and ineffable splendour is not to suggest that it is a celestial illumination or one of those enigmatic *quinte essenzie* of Aristotelian tradition.[36] It is, simply, to observe a happy coincidence of nature that exceeds the limits of language and thought.

In denying the quintessence and divinity of grace, Firenzuola demythologises the charm and beauty of women while, at the same time, revelling in those earthly splendours so beguiling and bewitching. Grace may be 'nothing other than' a certain splendour, but it hits the eye so keenly and satisfies the heart so completely that desire is compelled to follow its rays. Called 'grazia' because it renders the woman who emits it 'grata', that

is to say, 'cara' (dear), it solicits the same reciprocity as benefactors who distribute graces and benefits and are similarly held dear. It is for this reason, he explains, that the Graces act as handmaidens to Venus because 'in the actions and negotiations of love, many benefits are mutually exchanged between lovers, rewarding each one greatly all day long' (nelle veneree azioni e negocii amorosi assai beneficio accaggiono mutuamente tra gli amanti e se ne guiderdonano molti tutto il dì). Though he invokes the three Graces, Firenzuola resists any overlap between the trinity of goddesses so dear to the Neoplatonists and the Christian Trinity. His aim is not to engage in any Ficino-inspired Trinitarian thinking nor to turn his soul towards the heavens, but simply to state that grace begets grace in a mutual exchange of amorous favours which (his mercantile language of negotiation, benefits, and rewards seems to imply) may be freely swapped, sold, or purchased. Though it may captivate with its 'chiara luce' (bright light) the peregrine wits of those in thrall to beauty, this grace is entirely human and involves neither the presence nor the intervention of God.[37]

Firenzuola abandons both Plato and God in his account of grace, subjecting the term to a more radical form of aestheticization than Varchi. With characteristic ambiguity, however, the latter seeks both to express the desacralized grace that Firenzuola epitomises and to keep its philosophical inheritance alive. His interpretation, in other words, bears signs of the social and intellectual changes that influenced his writing more generally throughout the 1540s. Chief amongst these processes were the vulgarization of Aristotelian texts and the resurgent popularization of Aristotle's philosophy that was gaining a new currency during that decade; the establishment of the Accademia Fiorentina (originally called the Accademia degli Umidi), which celebrated afresh the legacy of Ficino and his circle; and the Counter-Reformation, which began in earnest with the inauguration in 1542 of the Roman Inquisition (following the model of the Spanish Inquisition) and the subsequent convocation in 1545 of the Council of Trent. As a member of the Florentine Academy from 1543 and the author of numerous (sometimes contentious) Platonic sonnets, Varchi brought his recurrent interrogations and revisions of Plato's theory of love to bear on his treatment of grace.[38] As a neo-Aristotelian whose *Lezioni* delivered to the Florentine Academy between 1543 and 1564 sought to popularize Aristotle as much as Plato, he aimed for a syncretic interpretation of the word that would accommodate the theories of both.[39] And as a poet of *rime spirituali* writing at the crossroads between Reformation and Counter-Reformation, he treated with caution questions of divine and theological grace, disassociating himself from the intense scrutiny of the

word on both sides of the religious divide.[40] Charting a course through choppy waters, in other words, Varchi's grace reflects the spirit of intellectual and cultural crisis of his age. As Annalisa Andreoni puts it, 'if the sixteenth century witnessed a crisis, Varchi was at its crossroads'.[41] Also at this crossroads was grace.

Produced against the same backdrop of crisis, d'Aragona's *Dialogo* adopts a different approach to grace, pointing readers in the direction of Varchi's work rather than embarking on those stormy waters. At the same time, however, it reflects more broadly on the nature of words and on their central importance to human knowledge and mutual understanding. Recurrent themes include the relativity of different philosophical perspectives on love; the mutual incomprehensibility between poets and philosophers; the incompatibility of philosophical and theological discourse;[42] and—at the heart of it all—the unreliability of words as they pass from one discursive context to the next. Aphorisms about the mutability of language include Benedetto's, according to which 'each word gives rise to infinite doubts, each of which doubt would require infinite time and doctrine to resolve' (203).[43] Focusing, in this instance, on the words *termine, fine, amore,* and *amare* (end, ending, love, and to love)—all requiring definition in a dialogue on the infinity of love—the rule could just as easily apply to 'grace', which certainly did give rise to 'doubts', many of which required decades of time and endless doctrine to resolve. The Council of Trent, at the time of d'Aragona's writing, had assembled the highest ecclesiastical minds precisely to resolve theological doubt about grace once and for all, as well as to re-establish the parameters within which divine grace could be earned.[44] In a declaredly different context, meanwhile, Varchi too had invested time and thought into his own resolution of philosophical doubt. What better way for d'Aragona to deal with the 'infinite doubts' surrounding the term than to redirect interest towards studies such as his?

As well as conducting readers towards Varchi, and besides reflecting on the indeterminacy of language, however, d'Aragona adopts a third strategy to deal with the complexities of grace. When identifying that which seduces and enthrals the hearts of lovers, she eclipses the grace that is distinguished from beauty in the love theories she draws on and focuses on beauty instead. Like Colonna, in other words, she uncouples the erstwhile interlaced pair of terms, but where the former alights on grace to express her experience of love, the latter insists on beauty alone as its initial impulse and ultimate goal. Love, therefore, 'is nothing if not a desire to enjoy through congress someone who is either really beautiful or who appears to be beautiful'.[45] Beauty is the mother of all loves (la bellezza [è]

la madre di tutti gli amori, 202), and knowledge of such beauty (il conoscimento di essa bellezza) is the father. Love springs, in other words, from desire and knowledge, from body and soul, but it requires neither quintessence nor divine illumination for full effect. Love is presented as an end in itself, rather than as a means to the end of knowing God. Human souls reach perfection not through the sublimation of carnal desire, the contemplation of universal beauty, and ultimate absorption into the graceful rays of divine love, but through better knowledge of and more ardent desire for love: 'Do you know that the more perfect one is, the better one knows beauty, and the more one knows beauty, the more ardently one desires it. Indeed, in all matters of this universe, whatever they may be, where there is more nobility and perfection to be found, there—necessarily—will be more perfect and greater love'.[46] Perfect human love is not linked directly to divine love in this paradigm, though God does equate to love's highest form: 'just as God is supreme good and supreme Knowledge, so, too, is he supreme love and supreme everything else' (come Dio è somma bontà e somma Sapienza, cosí è ancora medesimamente sommo amore e somma ogni cosa, 232). Unlike Colonna's disembodied passion that prepares the soul for ascent towards God, in other words, d'Aragona's human love operates along parallel lines to God's and in a separate sphere. Sublunary love is always self-interested and aims to please itself (237–39). Above the moon, by contrast, God loves selflessly and gives freely of himself without question. Neither grace nor light nor metaphorical ladders connect the two realms since above the moon, God is supreme love, while beneath it, 'Love is god and a great god is Love' (Amore è dio, e grande dio è Amore, 216). Those who either know love or are better able to love than others will be those who are the most faithful and obedient to the world's laws.

D'Aragona's strictly sublunary love is often read as a philosophical perspective born of her practical experience as a courtesan. It is true that experience—like subjectivity—is a crucial part of the dialogue's epistemology, as both Tullia and Benedetto aver:

> BENEDETTO: So, you want me to trust the authorities?
> TULLIA: No sir, but experience, in which I trust far more than all the reasoning of all the philosophers.[47]

Yet the benefits and virtues of a love as physical as it is spiritual had already been extolled by male philosophers whose professional and personal circumstances are rarely brought to bear on their views. Mario Equicola's *Libro de natura de amore* (1525), for example, describes those seeking to persuade others that they care nothing for the body's beauty but burn for

the soul's beauty alone, and that they nurture their passions solely on the sight and sound of their beloved's as suffering a new kind of madness. To love with one's eyes and ears alone is impossible, says Equicola, calling on 'that prince of all philosophers, Aristotle', since love is of both mind and body and the operations of one depend on the other.[48] Sperone Speroni's *Dialogo di amore* (in which, let us not forget, Tullia appears as a character) continues Equicola's line of reasoning, arguing that human love may be imperfect because it relies on the unreliable force of our senses, but it is, nonetheless, the only kind of love we can truly experience. It must therefore be indulged with moderation and appreciated, rather than devalued with zealous asceticism.[49] Tullia builds on these arguments, mistrusting those 'filosofi' who have loved but then abandoned their lovers in order to compose 'ragioni' in abstract and disembodied terms. Far more convincing, in the view of both Benedetto and Tullia, would be thinkers who combine doctrine with experience and logic. As Benedetto says on a number of occasions: 'One should trust in reason and not in the authorities. I declare that any single thing can be of greater or lesser value when considered from various angles or compared to other things. Thus, it can be said to be different from itself'.[50] It is all well and good to have read the philosophical treatises of Bembo and Ebreo, as Tullia and Benedetto clearly have done, but doctrine must combine with logic and experience if it is to offer any meaningful knowledge of the ever-changing world.

The impact of d'Aragona's personal circumstances on her philosophical outlook, therefore, should not be overstated, although there is a self-reflexive consciousness in her writing that should not be neglected either. A clear aim of hers is to offer a gendered perspective on the standard view of love, and Tullia makes it very clear that she speaks as a woman on behalf of all those silent female figures around whom love theories proliferated and flourished across the centuries. Think how differently things would have transpired, she says, if 'Madonna Laura had written of [Petrarch] as much as he wrote of her' (bisognava che madonna Laura avesse avuto a scrivere ella altrettanto di lui quanto egli scrisse di lei, ed avereste veduto come fosse ita la bisogna, 201). So that none should wonder the same of herself, she answers back to the men who immortalise her in words by setting out her vision of how different life and literature are from a woman's point of view.

D'Aragona speaks for silent women, then, but there is more to her emphasis on earthly love—and her consequent avoidance of grace—than a bold step towards gendered empiricism. Like Colonna, she speaks with a distinctly female voice while reflecting the broader cultural context

affecting both men and women. Her resistance to grace also responds to the more generalised reining in of the erstwhile freedom permitting grace to range from sensual to spiritual domains. In the very year in which the doctrine of *sola fides* was condemned as heretical at Trent (1547), and in the climate of suspicion and uncertainty surrounding the Counter-Reformation, extra caution when discussing a contested theological term such as grace was prudent. Distinguishing between the sublunary world with all its self-interested desires and the celestial realm where God reigns supreme was a sensible move. Rather than incur the anger of ecclesiastical authorities, d'Aragona's dialogue confines her reflections to the world beneath the moon, venturing only generalised statements about how God loves for no personal gain, with no limits, and forever. Benedetto, in fact, refers to the danger of venturing into theological territory. To engage in discussion about grace, faith, and predestination would not just be challenging and difficult but dangerous as well (le quali cose non meno lunghe e difficili che pericolose). Much better to declare oneself unwilling and unable to discuss divine love, which works in ways that are 'unimaginable' and 'unintelligible':

> God loves not for his own gain, since he already possesses all things perfectly and in ways that are unimaginable and unintelligible to us. He loves and revolves the heavens out of his infinite goodness and perfection, which he wishes to bestow upon all according, however, to their individual natures. So that some receive more and others less [of his bounty]. Not dissimilarly, the sun shines on all things equally, though its light is not received equally by all (240).[51]

Further pronouncements would be presumptuous, if not sacrilegious: some receive more of God's goodness, others less, and His ways and workings are best left unquestioned. 'Io vi confesso la verità', says Benedetto, 'Io non lo intendo bene' (I confess the truth, I don't understand these things very well, 241). Grace, at the crossroads between Reformation and Counter-Reformation, in other words, is no longer a topic for dialogues about love.

A Grace of Her Own

If d'Aragona excludes Neoplatonic grace from her *Dialogo della infinità d'amore*, she plays a different and subtler game in the choral anthology of poems penned either by or to her, entitled *Rime di signora Tullia di Aragona: et di diversi a lei* (1547). Limiting her use of the word in her own

sonnets, she selects for publication numerous other works dedicated to her in which it abounds. As her *Rime* turn away from grace in one respect, in other words, they invoke it in another, adopting an editorial selection process reminiscent of the courtly flirtation the anthology is designed to memorialise. According to this selection process, male poets lavish praise and graces on her while she averts her gaze and focuses instead upon literary goals and ambitions and on the saving grace of a reputation for erudition. While ostensibly rebutting the terms of her admirers' eulogy, she effectively beguiles them all the more, then immortalises their ardour between the covers of her book.

Unlike Vittoria Colonna's, Tullia d'Aragona's sonnets avow a desire for earthly rewards and recognition and an ambition to develop a literary voice as clear and illustrious as those of her male peers. She focuses neither on her soul's transcendence through the contemplation of celestial grace nor on presenting herself as a highly idealised mediator for her lovers' spiritual ascent. Keeping both feet firmly on the ground, she seeks to bridge the gap between the sacred and the profane not by sacralising earthly graces but by grounding the metaphysical in lively and highly personalised poetic forms. As she declines the invitation both to climb the soul's steep ladder of love and to direct male traffic upwards along it, she develops a poetic language almost entirely devoid of Neoplatonic grace.

D'Aragona's rejection of such grace and its celestial implications is evident throughout the *Rime*, which consists of five parts, two of which are dedicated to pairings of sonnets exchanged between her and male admirers in the manner of *proposte* followed by *risposte*.[52] One particularly Neoplatonic *proposta* by her most prolific admirer, Girolamo Muzio, entitled 'Donna, il cui gratioso, e altero aspetto' (sonnet 51) is replete with praise for her graceful and lofty appearance, her angelically harmonious words and the 'ben' of her intellect.[53] Responding to the stimulation of his higher senses, Muzio begs that love should never burden his breast with lowly desire, but rather that it should be attentive to d'Aragona's inner beauty (interna beltade) so that his soul will fly to her to make itself beautiful (a farsi bella). In her *risposta*, 'Spirito gentil, che vero, e raro oggetto' (sonnet 52), d'Aragona praises his gentle spirit (spirito gentil) full of that beauty which the soul most desires. So far, so Neoplatonic. Rather than seeking her soul's flight, however, the pragmatic poet then proclaims her heart's desire always to be the subject of his verse and to praise him in words as well and effectively as he does her. She does not seek the soul's escape from carnal imprisonment but rather to be immortalised in the verse of others and to be able to write immortal words herself. Moreover,

in response to Muzio's confession that his soul has left his heart to follow her in beauty, she says that the impetus came not from her but from himself: his soul abandoned his body to follow its own star. To write inspirational love poetry was always going to be his destiny, and not the result of a metaphysical transformation wrought by her grace and beauty. Her aim, in turn, is also to follow that same star and to learn from Muzio how to change her life (cangiar vita). Precisely what sort of life-change d'Aragona desires here is not stated, but the focus on writing in the central quatrain suggests the ambition is to raise her literary skills to the highest level possible, following the example of her patron/mentor. A sonnet to Bembo ('Bembo, io che fino a qui da grave sonno', no. 15) announces a similar conversion, as his lofty, infinite light wakes her drowsy soul from slumber and she discerns once more the lost path of virtue. Here, too, the epiphany relates not to the soul's redemption but to mortal and immortal fame garnered through writing. By the light of Bembo's illustrious fire, she hopes to kindle her poetic graces and leave for eternity a record of her name.

Such earthly ambition could not be in starker contrast to Vittoria Colonna's professed self-abnegation in her poetry, and this is a contrast expressed very well in their diametrically opposed treatments of grace. In one of her earliest *rime spirituali*, entitled 'L'alto Signor, del cui valor congionte' (S1:2), Colonna expresses an ardent desire that 'true faith' will awaken her heart to God's 'eternal graces' and that He will henceforth take the place of her deceased husband as her Apollo, offering a celestial font for her poetic baptism. In pursuit of divine grace, she flees fame and the needs of her body, wishing to live on 'sacred aura' and high concepts instead. She does not wish to adorn her temples with laurels, nor does she seek to elevate herself with Icarus to impossible heights. Her goals, rather, are to seek eternal life with God and to escape during her mortal existence the trials and tribulations 'of the false world' (dal falso mondo). D'Aragona, by contrast, courts temporal success and does not flee her living, breathing existence. She writes, in a defiant sonnet to Piero Manelli (no. 28), that nature—or perhaps 'the great Maker'—has given her a form and matter equal to Manelli's and that she is going to make the very best of it while she lives. Along with form and matter, she has been granted a 'desio d'honore' (desire for honour) to match his and the ambition to 'labour incessantly' both 'to draw nearer the heavens' and 'to leave the fame of [her] name on earth'. Before her soul frees itself 'dal corporeo velo' (from the corporeal veil), in other words, she fully intends to make the most of her bodily existence and to inscribe her name as a poet within the annals of history.

On the rare occasions when d'Aragona does mention grace in her sonnets, it relates neither to feminine charm and beauty nor to divine love, but to literary talent and to the commerce of grace and favour passing between writers and their patrons or peers. In her dedicatory letter to Eleonora di Toledo, for example, she justifies her dedication of the *Rime* to her on the grounds that 'compositions of all writers in all languages—and especially those of Poets—have always had such grace and pre-eminence that no one, no matter how great, has ever refused them, but always held them as very dear'. Grace is not coupled here with beauty but with the pre-eminence that licences excellent writers to dedicate lofty poetry to deserving patrons. The same sentiment is expressed in 'Dive, che dal bel monte d'Helicon' (sonnet 6), where she begs the Muses to render her mortal tongue capable of offering immortal honours and 'gratia' to her lord and dedicatee, Cosimo de' Medici. Such grace travels in two directions and her sonnet 'Donna reale, a cui i santi disi' (no. 10) testifies to the 'gratia' bestowed by the supreme goodness of Eleonora di Toledo on d'Aragona. This is a likely reference to the noblewoman's intervention on d'Aragona's behalf when the latter sought exemption from the sumptuary laws that would have required her—along with other courtesans—to wear something yellow as a marker of her profession.[54] Poetic grace, in that instance, both inspires and rewards the grace and protection of a benevolent benefactor. Following Eleonora di Toledo's intercession, Cosimo de' Medici decreed that the authorities should 'grant her grace as a poetess' (fasseli gratia per poetessa). Despite being a courtesan, Tullia d'Aragona obtained the right through her 'rare knowledge of poetry and philosophy' (la rara scientia di poesia e filosofia che si ritrova con piacere di pregiati ingegni la detta Tullia Aragona) to be 'exempt of all obligations as far as her dress and behaviour are concerned' (fatta esente da tutto quello a che ell'è obbligata quanto al suo abito, vestire e portamento).[55] The grace of her epistle to Eleonora testifies to a heightened sensitivity towards the network of favour and privileges on which she relied and speaks eloquently of her desire to be identified—within that network—as a poet and philosopher rather than as a courtesan. By carefully circumscribing the word so that it refers exclusively to writing and patronage in her verse, she proclaims a wish to be judged for her literary grace alone. Moreover, her wariness of grace is eloquent of the challenges facing those enmeshed in the intricate web of favours that Vittoria Colonna managed, to a great extent, to escape. Both *cortegiane oneste* and court-dependent poets faced such challenges, a double bind for d'Aragona, who represented both.[56] To be honoured as a poet, she depended on the admiration of erudite men and the benevolence

of wealthy and powerful patrons. To be an honest courtesan, meanwhile, she had to balance the demands of a paying clientele against the need to cultivate honour and integrity: to live as a high-ranking prostitute within the bounds of public decency and the law. Pleasing intellectual peers, prospective patrons, customers, authorities, and the general public at once was a delicate balancing act, especially when these various coteries sought graces and favours of different kinds. It required a fine sensitivity to one's different audiences and a facility for acting and speaking in ways that would please all and alienate none. In such a context, grace was a word to be handled with caution. Ranging across various semantic fields and holding different connotations for different users, it required careful handling to avoid invidious misinterpretations. D'Aragona seems instinctively and no doubt deliberately aware of that need, limiting her use of the word so as to curtail its semantic promiscuity and prevent its slippage from the field of literary endeavour and patronage to the mercantile domain of sexual favours. Only once in the *Rime*, for example, does she permit grace to enter a sonnet about love.[57] The sonnet in question is her reworking of Petrarch's 'S'i' 'l dissi mai, ch'i' venga in odio a quella' entitled 'S'io 'l feci unqua, che mai non giunga a riva' (sonnet 32), in which she defends herself against an unspecified accusation made by an unspecified lover.[58] Ambiguous in its meaning in the context of this poem, grace demonstrates the potential risks for a poet like d'Aragona of using the word too freely. Should the accusation against me turn out to be true, she writes, then let me be deprived of 'the grace wherein my every good is born' (la gratia onde nasce ogni mio bene). 'La gratia', here, is underspecified, in keeping with the ambiguity of the 'beni' it produces and the unspecified crimes she vows not to have committed. We may assume, of course, that the charge is infidelity since the poet professes hope in the final tercet that her male addressee's 'hard pride' will turn to love for her once he realises her innocence, and that the fruits of her 'bel disire' for him will long be sweet. The precise nature of the grace she would have relinquished if guilty, however, remains uncertain. Is it the general bounty bestowed by God and nature on humankind? Surrendered alongside charitable abstractions such as her lover's pity, her own hope, and the prospect of inner peace, it may well be: with a clean conscience, she feels able to offer up all the God-given virtues and benefits that she has ever enjoyed. Or does 'gratia' refer, here, to more specific, erotic graces and favours exchanged between the sparring lovers? Confident of her own innocence, she is free to forsake her lover's pity, her own hope, and the graces that they reciprocate, be they compliments, remuneration, or favours in return. In a poem by a courtesan, grace

faces a high risk of being construed as purely remunerative, a commercial commodity rather than a noble sentiment exchanged between kindred hearts. Whatever the intended meaning in the context of this sonnet, the semantic breadth of the term lays its author open to various misinterpretations. Seemingly sensitive to this risk throughout the rest of her *Rime*, she either steers clear of it altogether or constrains the word within a safe and unambiguous corral.

D'Aragona employs the word sparingly in her sonnets, but of course grace springs most abundantly when it is not overtly courted, as Castiglione's *Cortegiano* made clear. The dearth of grace in d'Aragona's own verse is compensated by a bounty in the male-authored verse she selects for her anthology. In 'Spirito felice' (sonnet 73), by Girolamo Muzio, for example, the heavens bestow so many rare and plentiful graces on d'Aragona that the poet knows of no equal to her soul; while in his eclogue, *Tirhennia*, her graces are so beautiful and rarefied (così belle, e rare) that it is hard to say whether she is simply rare amongst women or entirely unique. In a particularly Neoplatonic sequence of sonnets, Muzio begs the ardent rays of d'Aragona's beautiful eyes to act as a ladder for him to climb towards the heavens ('Mentre le fiamme più che 'l Sol lucenti', sonnet 65); asks that Love, always beating its wings, will lead him up the steep path to spiritual enlightenment ('Amor ad hor ad hor battendo l'ale', sonnet 66); and requests that his beloved's beauties accompany him on 'il bel camin' to God ('Dal mio mortal col mio immortal m'involo', sonnet 85). Pleading with love for the 'gratia' of inner peace and certain glory ('Dal mio mortal col mio immortal m'involo', sonnet 85), he identifies d'Aragona as the bridle capable of redirecting his base passions along the high path to spiritual elevation ('La sembianza di Dio, ch'in noi risplende', sonnet 84). Immortalised in print, such graces are trophies for d'Aragona to display, proof of her being revered by illustrious men.

Though she takes pains to publish the Neoplatonic fervour of admirers such as Muzio, d'Aragona neither openly courts his praise of her grace nor condescends publicly to repay it in kind. Careful to capture his words for posterity in print, she nevertheless refuses in her own verse to run with the baton he proffers, remaining cold to the suggestion that she might be uniquely endowed with much-desired feminine grace. In each of the three sonnets she addresses to him, she ignores the Neoplatonic undercarriage of his encomium and portrays herself as a poet whose inner graces outstrip her surface beauty and whose greatest investment is in intellectual rather than sensual or spiritual pursuits. 'Spirto gentil' (sonnet 52), as we have seen, is a prime example of how she tends not to reciprocate his arch

idealisation of her feminine graces. In it, she shifts the emphasis from the
soul's flight that he describes to their shared poetic legacy, responding to
his eulogy of her transcendental qualities with an appreciation of their
collected literary accomplishments. In sonnets 41 and 42, it is she who
initiates the exchange, but similar conditions prevail. 'Fiamma gentil, che
da gli interni lumi' (no. 41) praises his role as her poetic guide; while 'Quai
d'eloquenza fien sì chiari fiumi' (no. 42) responds by eulogizing her guid-
ance of his very soul. She hails him as a mentor whose words kindle in her
'untutored intellect' (rozzo intelletto) a need to rise and sing his virtues
in a thousand places; while he presents her as a veritable Laura whose
graceful rays chase vile thoughts from his mind and elevate his life on
earth to celestial status. He ends his sonnet declaring his manifest inabil-
ity to adequately commemorate just how deeply he loves, celebrates, and
honours her. She closes, meanwhile, with a wish that even in old age she
herself will continue to enjoy the (literary) glory that loving him brings.
Once again, homage to her celestial graces is rewarded with encomium
of his (and her own) artistic bravura. As they sculpt such images for each
other, Muzio and d'Aragona hold up mirrors to themselves. In placing her
amongst the host of Laura-like muses, Muzio aligns himself with their
poet champions. Unlike Petrarch and his followers, though, his praise is
for a living, breathing woman whose intellect he generously fosters, and
in this way he fashions for himself the much-coveted profile of a learned
humanist with an erudition so lofty it ennobles not just himself but the
minds of women too.[59] D'Aragona endorses this profile in her laudatory
verse and, while praising him in precisely these terms, portrays herself as
a keen disciple, eager to labour in the shadow of her mentor. Maintaining
a determined silence about her status as his lover so as to perfect the self-
portrait of humble disciple, she overtly shuns the grace he showers on her
and rebuffs the desire he openly declares, thereby promoting herself as a
poet truly worthy of being attributed *onestà*.[60]

Though relatively absent in the language d'Aragona adopts, then, grace
is well represented throughout the *Rime* in the admiration of her lovers,
the pose of unaffected detachment she strikes, and the refined exchange
of compliments that she conducts. It is enacted where it is not named and
named only when it needs to be. Such regulation of grace—at once sum-
moned and denied—acts as a figure for her self-fashioning as a whole.
Her poems portray her as confident and ambitious, her avoidance of grace
permitting her both to reveal an innate understanding of the power and
perils of language and to express reservations about excessively idealised
models of women and of love. The poetry of others, meanwhile, depicts

her as learned yet beautiful: she exhibits their uses of grace as so many trophies awarded to her by men. Yet if grace liberates Vittoria Colonna from the demands of this mortal coil, offering her a figurative stairway toward heaven, it does the opposite for Tullia d'Aragona. Notoriously duplicitous—especially where women are concerned—it imprisons her within the hall of mirrors on which her reputation depends.

Despite her careful management of it, grace contributes both to the making and the unmaking of d'Aragona's reputation across time. Decades after her death, for example, Alessandro Zilioli attests both to the successes and to the failures of her campaign to harness the word in his *Storia dei poeti italiani* (1631). Paying homage to the grace and eloquence of her rhetoric, Zilioli also praises the 'superior graces' of her eyes: 'She spoke with rare grace and eloquence, so that whether joking or speaking truth, she allured and ravished—like another Cleopatra—the souls of her listeners. And that countenance of hers, so fair and joyful, never lacked those supreme graces so desirable in beautiful faces as they seduce the eyes of men'.[61] The biographer seems only half to admire this new Cleopatra: grace renders her pleasing but deceptive as well (as the verb 'lusingare', meaning 'to lure with false words for one's own gain', suggests); at once enthralling to and potentially enslaving of her admirers (as 'allettare' / 'to lure' and 'rapire' / 'to ravish or beguile' imply).[62] Cleopatra, before her, triggered similar responses of fascination and suspicion, and Zilioli knowingly draws on a long literary tradition depicting the Carthaginian queen as 'brilliant to look upon and to listen to' but wielding irresistible 'power to subjugate every one' at the same time (Cassius Dio, *Roman History*, 42, 34.4–6). Building on classical accounts such as this, Zilioli emphasizes the winning combination in Cleopatra of rhetorical charm and beauty, echoing his predecessors' awe at its force. Plutarch, to name another predecessor, expresses open fascination for Cleopatra in his *Lives* as he describes how she led Antony astray, rousing and driving 'to frenzy many of the passions that were still hidden and quiescent in him'. With her beauty and the 'subtlety and cleverness' of her conversation, says Plutarch, she destroyed and dissipated 'whatever good and saving qualities' he had. He goes on to interrogate the exact source of such power:

> For her beauty, as we are told, was in itself not altogether incomparable, nor such as to strike those who beheld her; but converse with her had an irresistible charm and her presence, combined with the persuasiveness of her discourse and the character which was somehow diffused about her behaviour towards others, had something stimulating about

it. There was a sweetness also in the tones of her voice; and her tongue, like an instrument of many strings, she could readily turn to whatever language she pleased. (Plutarch, *Lives*, 4, 27.2–3)

Plutarch's Cleopatra conquered Antony (having already seduced Caius Caesar and Gnaeus of Pompey), just as Zilioli's d'Aragona enthralled 'molti valorosi poeti' (many valorous poets) in her prime. At the age when 'women have the most brilliant beauty and are at the acme of intellectual power', both these women bent hearts and minds to their will with their looks and words (*Lives*, 4, 25.3). Like hungry bloodhounds ('veltri affamati'), says Zilioli, besotted poets pursued d'Aragona with their sonnets, felling her with their songs, and making her prey to their greedy desires. She, vixen-like, enjoyed the game—as (Zilioli opines) is the common wont of women ('secondo l'inclinazione commune delle femmine'). Using her beauty and grace ('compiacendosi . . . della sua bellezza, e d'essere vagheggiata'), she nurtured by various arts the affections of her devotees, often repaying them for their poems, love, and compliments with poetic favours ('favori della poesia') of her own. Amongst her most prominent Antonies (as it were), Zilioli names Girolamo Muzio, the most bewitched of them all.

Mixing metaphors drawn from hunting with those of repayment and exchange ('contraccambio'), Zilioli wilfully exploits the language d'Aragona herself seeks to contain. Where she separates out poetic and sexual favours, he gives them free rein to intermingle, blurring the boundaries between her merits as a poet and as a courtesan. Though Zilioli's comments in his brief biographical note are, for the most part, complimentary, veiled suspicion undermines the hyperbolic praise. Praising her appearance so resplendent with 'tanta leggiadria . . . e tanta venustà ed affabilità', he also remarks on her craven lovers. Honouring her precocious aptitude for both Latin and Italian, he comments disparagingly on the liberal commerce of poems and favours between her and them. Though he celebrates her 'great reputation for virtue and beauty', in other words, he also commemorates her promiscuity and the many lovers whose affections she exploited to her advantage. His biography closes with an image of the aging courtesan ('già fatta mezza vecchia d'anni e d'aspetto'), publishing her *Rime* not to memorialise her own poetic achievements but out of nostalgia for the literati admirers of her (misspent) youth. We are left with an impression of fading beauty and ineffectual grace as d'Aragona, Cleopatra-like, pays tribute to her own past as a literary femme fatale.

Such double-edged judgements justify the caution the poet herself exhibits in her use of language. Risking capture between the celestial

graces heaped on her by her Neoplatonic lovers and the all-too earthly graces insinuated by misogynist critics, she prudently seeks in her own rhetoric a neutral middle ground in which the word is virtually absent.

D'Aragona did not live to read Zilioli's biography, but she would have recognized it as belonging to the body of anticourtly, antiwomen literature of her own time in which 'grace' became code for female cunning and spite and in which no opprobrium was spared. Michelangelo Biondo's *Angoscia, Doglia e Pena* (1546), for example, turns the conventions of love dialogues on their head, attacking the 'occult' grace by which women, like vixen, conceal the slyness that comes so naturally to them.[63] Pietro Aretino, too, subverts the language of Castiglione's *Cortegiano* so that, for women as for men, the art that conceals art is nothing more than vain deceit. Indeed, Aretino rebukes d'Aragona directly, criticising her for her *impudicizia* (shamelessness) in a letter to Sperone Speroni about Speroni's *Dialogo d'amore*.[64] The aforementioned Agnolo Firenzuola supplies perhaps the best example of double-edged grace and the duplicity of male authors who adopt the same rhetoric both to praise and to blame women for their effects on men. Firenzuola's 'Dialogo delle bellezze delle donne', as shown above, eulogises a female grace that may not be sacred but is, nonetheless, gloriously pleasing on earth. Infused with the language of Seneca and Servius, this female grace is to be cherished and held dear and is likened to the benefits that render benefactors *grati* and *cari* to their recipients. As well as being the source of great delight, it is exchangeable, almost commodifiable, and the author offers top tips and tricks for perfecting it to increase its market value. Wearing precisely the right type and number of flowers on one's temple, for example, accentuates a woman's grace, as does closing and opening one's mouth with measured delicacy. Biting one's lower lip with nonchalance, too, will open the gates to a paradise of delights and fill beholders' hearts with inexpressible joy. Firenzuola's stated aim in his dialogue is to express his undying admiration for women's grace. Underpinning his homage, however, lies a bedrock of suspicion about the power of their subtle arts. Morally empty and seeking nothing more than to conquer its beholder, this grace can be affected and feigned solely to captivate men. Indeed, in other works by Firenzuola, praise of grace turns to criticism of the strongest kind.

In book 9 of his *L'Asino d'oro*, for example, Firenzuola describes the 'viva bellezza' (lively beauty) and 'piacevolezza, che volentieri con beltà s'accompagna' (pleasantness that often accompanies beauty) of the young female protagonist of a stand-alone 'novella da ridere'.[65] A synonym for grace, this 'piacevolezza' is nothing more than an ingredient of inconstancy

and deceit as the young woman betrays her husband by taking in a lover while he is out at work. Though the husband 'ringraziò Iddio dell'onestà della moglie' (thanks God for the honesty of his wife), it turns out that he is nothing more than a blind cuckold, deceived by the guile and cunning of an only apparently graceful wife. One day, the cuckold returns home early from work, nearly catching his wife and her lover *in flagrante delicto*. Thinking on her feet, the natural liar distracts him with a barrage of abuse while the lover hides in a barrel. She berates him for his laziness: How could he clock off early when he should be working hard to support them both? What does he expect her to do? Earn the household money in his stead, as certain other women do by indecent means? Having gained thinking time during her tirade, she goes on to introduce the lover to her husband as a salesman cleaning the barrel from the inside in preparation for selling it to them at a good price. By her ruse, she convinces him both of her innocence and of her canny home-making skills and her betrayal goes undetected.

The *Asino d'oro* vignette turns the grace that constituted earthly splendour in Firenzuola's 'Dialogo' into a seemly veil for dishonest, sexual depravity. Its author targets none other than Tullia d'Aragona in his abuse. The unfaithful wife names her amongst those women who make money by indecent means, calling her a strumpet who 'grazes on adultery while her husband dies of hunger' and identifying her as just the type of woman a lazy 'sciagurato' like her husband deserves. In her tirade, the 'actions and negotiations of Venus' described so positively in 'Dialogo delle bellezze delle donne' along with the 'many benefits . . . mutually exchanged between lovers' take on an exclusively commercial value, plunging women into the depths of depravity. And it is not just in bawdy *novelle* that Firenzuola criticises women: his lambasting of d'Aragona develops more fully into a Petrarchan sonnet 'Mentre che dentro a le nefande mura', where she is said to have enslaved the heart of an innocent 'giovinetto' (young man). Not by God-given charm but by 'maga arte' (witchcraft), she procures the young man's love in a sonnet that features the language and conventions of Petrarchan love only to subvert them. Like many Petrarchan lovers, this young man's 'heart melts and burns in his breast' (si strugga ed arda in mezzo al petto / Il cor del Motta, 941), but this time it is a magic spell involving the burning of salts and the chanting of a curse that consigns him to love's flames. The grace of venerable tradition is replaced, here, by dark arts, and while he burns with love, she procures gifts and riches for herself, all the while enjoying the spectacle of his enslavement. This cautionary tale, Firenzuola says, should act as a fable for the general public

('una favola al vulgo') to learn from: what appears to be grace may actually be 'nothing more than' trickery; and there are lessons here for d'Aragona too. Rather than stake a claim to grace and draw more scathing criticism, better to shy away from the word.

As a sign of her caution, d'Aragona casts herself in the *Rime* as a woman of letters rather than of love; as a Muse rather than as a Grace. The three Graces do sometimes feature in the eulogies she selects for publication, but it is the Muses who preside over the anthology as a whole. Even Muzio, whose recourse to classical imagery and *topoi* we have already witnessed, dwells more frequently on her Muse-like qualities than on her affinity with the handmaidens of Venus. In 'Donna, a cui 'l santo choro ognihor s'aggira' (sonnet 83), for example, he confesses the longing in many gentle souls to proclaim her graces to the world, but these are graces bestowed by the saintly choir of inspiring Muses that forever surround her; literary graces, in other words, rather than mere beauty and charm. In similar fashion, Ugolino Martelli declares in 'Ben sono in me d'ogni virtute accese' (sonnet 60) that she is made lovely by the Graces but also rendered eloquent by the Muses: her combined virtues of eloquence (piena voce), thorough judgement (giudicio intero), and grace (leggiadria) qualifying her for the highest honours. The Muse herself encourages such alignment, asking Muzio to change her name from Tirhennia to Thalia in the eclogues he dedicated to her.[66] Eighth born of the nine muses, Thalia presides over comedy as well as bucolic poetry, the genre of Muzio's eclogues and the genre in which d'Aragona herself composes as well. As such, Thalia is the perfect guiding spirit of the *Rime*, permitting the poet to posture in her own sonnets as the shepherdess whose humble bagpipes fail sufficiently to laud her lovers while appearing in the work of others as a source of poetic creativity. In the guise of Thalia, d'Aragona confines the self-image she projects to the realm of poetry and defines the terms of her poetic correspondence as literary rather than amorous.

Yet while Thalia is the eighth of the nine Muses, she is also, of course, one of the three Graces. Naming the Muse inevitably invokes the sister of Euphrosyne and Aglaia. Adopting the one Thalia to emphasize her poetic credentials, she necessarily invokes the other whose favours—so often in the service of Venus—are clearly relevant as well. It is hard to determine how knowingly she did so. Certainly, in his letter to Antonio Mazzabarba describing d'Aragona's request to be called Thalia, Muzio makes no reference to the Graces, although he does say the idea for her renaming sprang from a conversation they had been having about her studies 'which so delight her' (de' quali ella si è cotanto dilettata) and about the Muses, their

names, and their virtues. Following their conversation, Muzio declares, d'Aragona withdrew into herself, as if lost in thought, before resuming it with 'I've had a thought in my mind these last few days which, now that it has come up, I would like to put to you. You have long sung my praises under the name of Tirhennia: I'd like you to change my name and call me Thalia. But I'd like you to do it in such a way that it is clear that Tirhennia and Thalia are the same person'.[67] Her private 'concetto nell'animo', as reported by Muzio, remains a mystery, but the context of her request—a discussion of her classical and etymological studies—suggests the name 'Thalia' was chosen as much for its dual connotations as for its suitability to the eclogue genre to which *Tirhennia* belonged. Overtly enlisting the Muse, she covertly summons the Grace, marshalling her associated qualities along silent, implicit lines. It is a subtle move she opts not to advertise in her *Rime*, where the only part of the *Tirhennia* eclogues to be published is the seventh in which Thalia does not appear. Subtle yet deliberate, it expresses the contradictions that underpin her work as a whole: the desire declared in her own words to be Muse and intellectual peer to her male interlocutors; and the wish concealed beneath her publication of their words to commemorate the sentimental, Venus-like bonds on which that interlocution often depends. It explains, too, why scholars (since Zilioli) often struggle to manage her dual identity as courtesan and poet, insisting on one at the cost of the other. To all such scholars, she offers a clue: Tullia/Thalia d'Aragona writes as both Muse and Grace, prudently anchoring her literary grace within a system of mentorship and courtly patronage, while quietly permitting her feminine graces to act on the minds and hearts of those men on whom her reputation will also depend.

What might have transpired had Laura written of love will never be known. What happens when Vittoria Colonna and Tullia write of grace, however, is a different story. Together they resist the close conjunction of grace and beauty—so common when male authors speak of women—and instead use these words as if mutually independent of and better understood in contradistinction to one another. Despite this commonality, however, they offer very different gendered responses to the key term applied so liberally to women by men.

In her love sonnets, Colonna uses grace within strict parameters, either to depict her husband's qualities or to describe the metaphorical ladder that leads her soul to the highest heavens. Nowhere in these sonnets is grace related to refined womanly habits, attractive female appearances, or the pleasing but prudent conversation that bedecks the environment

where bonds of grace and favour between men are made. In the fervour of her spiritual sonnets, grace becomes a beacon from God sent to infuse her soul with faith, to convert her work into prayer, and to reassure her of a better life after death.

Published in the year of Colonna's death and under the shadow of the Council of Trent, Tullia d'Aragona's *Dialogo della infinità d'amore* presents grace as a newly dangerous word, capable of causing infinite interpretative doubts and of incurring the condemnation of ecclesiastical authorities. In her *Rime*, meanwhile, grace is an impossible feminine standard she both rejects and courts, conscious both of the word's laudatory force under the pen of male eulogisers and of its blameworthiness in the eyes of the disgruntled or jilted. D'Aragona sees that grace as 'nothing if not' an instrument of control employed by men either to praise or to blame her and her sex.

CHAPTER FIVE

Grace and Ingratitude

LODOVICO DOLCE AND LUDOVICO ARIOSTO

On peut estre à la fois et pompeux et plaisant,
Et je hais un sublime ennuyeux et pesant.
J'aime mieux Arioste, et ses fables comiques,
Que ces Auteurs toûjours froids et mélancoliques,
Qui dans leur sombre humeur se croiroient faire affront,
Si les Graces jamais leur déridoient le front.
(It is possible to be both serious and pleasing and I hate the sublime when
it is dull and leaden. I prefer Ariosto and his cheerful tales to those chilly
and doleful authors who, in their dark moods, would take it amiss if the
Graces were ever to unknit their furrowed brows.)

—NICOLAS BOILEAU, *ART POÉTIQUE* (1674)

WOMEN WERE NOT THE ONLY ones to suffer the impossible standard
of grace. Francesco del Cossa memorializes through his *Salone dei mesi*
portrait the oft-blocked channels of grace and favour, while Castiglione
and Raphael were keenly aware of the risk of failure underpinning courtly
and artistic acquisitions of it. In literature, too, the stakes were high and
the challenges great, with anticipated recognition not always forthcoming.
If Raphael came to be considered the painter of grace in his own lifetime,
Ludovico Ariosto (1474–1533) was its poet, crowning his literary achieve-
ments with the epic romance *Orlando furioso*, first published in 1516,
then revised and republished in two further editions dated 1521 and 1532.[1]
Yet although Ariosto is afforded the accolade by a number of sixteenth-
century commentators and critics, he seems much more forthright in his

own work about its opposite: the ingratitude with which a poet's grace is so frequently met. Grace and ingratitude are, as we saw in the prologue to this book, inviolably linked polar opposites in the courts of sixteenth-century Italy. Where grace implies the circulation of gifts both material and immaterial, ingratitude halts all flow of benefits. For some, however, the former flows all the more abundantly in the presence of the latter, where it is neither recognised nor rewarded. In such circumstances, bounteous grace acts as a ballast against or an antidote to sterile ingratitude. This, I argue in the present chapter, is the principle underpinning Ariosto's written condemnation of ingratitude and the law of inverse proportions inscribed in the emblem page of his first *Orlando furioso* (1516).

Before giving voice to Ariosto's privileged perspective on the relationship between literary grace and ingratitude, we turn to those connoisseurs who did appreciate his efforts, repaying him by crowning him the poet of grace. Of particular interest is Lodovico Dolce, whose art criticism we have already had cause to examine in an earlier chapter of this book. Dolce hailed Ariosto as the exceedingly graceful author of a poem that seemed to him neither laboured nor hard-won, as if it had been produced almost without thinking.[2] Dolce praised Ariosto's grace time and again, and since the Venetian humanist played a vital role in the publication history and reception of the *Furioso*, we can be sure that what he said reflected, and indeed influenced, the wider view. Dolce holds up a mirror to learned and nonlearned readers alike, the resounding success of his editions of the *Furioso* attesting to his ability to anticipate and respond to the tastes and opinions of readers from aristocrats and courtiers to the merchant class.[3] In crowning Ariosto the master of poetic grace, he expressed a widely held view and, moreover, set himself the task of defining just what grace might mean.

Though Dolce's appreciation of Ariosto as the master of poetic grace was widely shared, the degree to which the poet himself actively courted that particular accolade is harder to determine. Prolific in the penning of comedies, plays, and satires, as well as poems, he produced little by way of literary criticism and offered rare glimpses of his own aesthetic outlook. A poet, satirist, and playwright rather than a literary commentator, he played no part in the kind of connoisseurship practised by Dolce and others invested in the increasingly profitable book trade. Yet some clues as to the reception he envisaged for *Orlando furioso* are available in certain of his *Satires* and other writings and, as I argue in the second part of this chapter, are also to be found in the emblems and mottoes he includes in the successive editions of his poem. These emblems and their evolution

between 1516 and 1532 offer a privileged insight into how Ariosto wished to be remembered for posterity. With these visual-verbal aids, I argue, he anticipates for his poem an illustrious—though at times contested— afterlife as the embodiment of literary grace.

The View from Dolce

Lodovico Dolce held up a mirror to Ariosto's admiring public by penning a series of appreciations of the *Orlando furioso*. In successive editions, he offered paratexts that included sonnets in praise of Ariosto, *allegorie* drawing moral lessons from each canto, brief treatises defending his work against detractors, indexes explaining the most difficult words, and *dimostrationi* attesting to Ariosto's links with his classical predecessors. Meanwhile, Dolce's independent treatises on literature, language, and the visual arts repeatedly featured Ariosto as the outstanding literary figure of his day and an example not just to writers but to visual artists as well.[4] Clearly, Dolce's thoughtful and extensive work on the *Furioso* represents a calculated response to the demands of the book trade. He worked for Gabriel Giolito's press from 1542 to 1568, editing more than 263 texts, including classical, medieval, and contemporary works, and his work paid dividends: his 1542 edition of the *Furioso* was republished at least sixty-two times in *Cinquecento* Venice alone.[5] Yet there was more to his work on *Orlando furioso* than marketing popular texts: driven by an enthusiastic love of the poem, Dolce's attention to Ariosto constitutes a concerted—at times missionary—effort to distil from it the qualities that appealed to him most and that he thought would best please and instruct its readers.

Grace features as a keyword throughout Dolce's appreciation of the *Furioso*. He uses it to articulate the poem's virtues, to link it to its counterparts in the art world, and to unite its learned and nonspecialist readers by highlighting both its classical credentials and its ongoing resonance in modern contexts. As such, he provides a particular perspective on literary grace and acts, too, as a crucial point of access into the contemporary reception and extraordinarily broad appeal of Ariosto's poem. In what follows, I examine grace in the three rhetorically determined phases of composition that Dolce outlined in his treatises: *inventio* (choice of subject matter), *dispositio* (arrangement of subject matter), and *elocutio* (final rendering into language). Structuring his appreciation of Ariosto in this way, Dolce follows the lead of those who, since the rediscovery of complete manuscripts of Quintilian's *Institutio oratoria* in 1416 and Cicero's *De oratore* in 1421, had adapted the five divisions of rhetoric to suit the needs of poetry.[6]

Dolce's reading has implications for the poem as a whole, but its critical purchase on the text is best appreciated at close quarters. For this reason, I explore his assessment in the context of a particularly self-reflexive passage of the poem, which appears in the last part of Astolfo's journey to the moon.[7] This passage offers a rare glimpse of the poet's own thoughts on the power and the value of poetry. It takes place in the moment after Astolfo has collected the precious phial of Orlando's lost wits and before he returns to Earth with them. As he and his escort, St John the Evangelist, make their way from the allegorical junk heap of lost things towards the point where his descent back to Earth will begin, they come across a riverside palace whose rooms are filled with spun flax, silk, cotton, and wool, all dyed in various colours. In the central courtyard, an old woman spins the threads on reels, while a second old woman separates attractive threads from ugly ones, giving them little plaques stamped with names in iron, silver, or gold. These old women, St John explains, represent the Fates spinning out human lives on their looms. As they spin, they distinguish illustrious lives from insignificant ones, rewarding them with name plaques of iron, silver, and gold, depending on their worth. These name plaques are then deposited on piles from which a tireless old man, representing Time, draws lap-loads to the river's edge. He tips the plaques bearing the names of mortal men into the river of oblivion, known as Lethe, where some sink to the bottom and stick in the sand while others are retrieved by a discordant flock of birds. Crows of every species, greedy vultures, and various other birds dive into the river, grasping the name plaques in their beaks or with their talons. But when they try to take wing, their strength fails and they drop the plaques back into the murky waters. As such, says St John, they stand for the courtiers, flatterers, and poetasters who fill Renaissance courts with idle chat and whose attempts to save their patrons from oblivion invariably fail owing to their lack of literary talent.

Out of the flock of vultures comes a pair of white swans that retrieve a select number of the falling plaques in their beaks. Now swimming, now winging their way through the air, the sacred birds carry these names to a shrine on a nearby hilltop. There, a beautiful nymph retrieves them, before affixing them to a statue and conserving them for all time. The swans, of course, represent those great and rare poets who, with serene assurance, carry the names of worthy men and women from oblivion to the shrine of immortality. The sight of their worthy undertaking elicits St John's lament at those dim-witted princes who surround themselves with poetasters, sycophants, buffoons, pretty-boys, tale-bearers, and other such

infestations who will never do them any good. It excites, too, his praise of true poets who can render men immortal.

What is it about this episode that epitomises the grace that Dolce ascribes to Ariosto? It is in part the pair of white swans, easily recognisable as the companions of Apollo, the chariot-bearers of Aphrodite, symbols of love, poetic creativity, and immortality. Here, as on the walls of the *Salone dei mesi* where Ariosto is thought to have given *Orlando furioso* its first public airing, the swans stand in for poets who, as well as singing of love and arms, praise the generative power of poetry itself. With their serene assurance, sweet song, and power over death, they certainly figure as embodiments of Ariosto's grace. The particular way in which they do that, however, will not be clear until they are read against the backdrop of Ariosto's broader repertoire of poetic gifts, starting with what Dolce would have called his *invenzione*.

INVENTIO

The term *invenzione*, a Renaissance Italian adaptation of the classical *inventio*, does not equate to our modern understanding of the word (or, indeed, of 'invention' in English). When applied to the arts, it refers not to the summoning of original thoughts but to the finding (from the Latin *invenire*) or discovering of the necessary arguments and materials for poetic composition. To persuade, according to Dolce, the best writers, composers, and artists should have an infinite quarry of materials to mine; and if they are to achieve grace, they should be guided in their discoveries by the principles of *varietà* (variety) and *onestà* (accuracy and accessibility). The 'most graceful' (graziosissimo) Raphael, for example, filled Rome with his 'almost infinite' range of sacred and secular subjects, a sign of the 'fertility of that wit' (fertilità di quel ingegno).[8] In poetry, Ariosto does the same thing, drawing ideas, words, and sentences from a range of classical predecessors and adapting them for his own purposes so that they end up looking different and as if they belonged to him all along—just as bees extract pollen from a variety of flowers to produce honey ('Apologia', 8).[9] Here on the moon, for example, 'mountains, forests, rivers, fountains, lakes, seas, many cities, castles and various human customs are marvellously described' ('Apologia', 9) with a 'pleasing variety' (piacevole varietà) that meets with universal approval.[10] In the episode in question, moreover, the classical Fates, the old man Time, and the crows and swans of Horatian odes come together in an entirely original configuration that bears witness to the fertility and inventiveness of his mind.

For his *onestà*, Ariosto, once again, earns from Dolce the highest praise. More often than not, Ariosto avoids obscure language and anagogical meaning. But if, on occasion, he resorts to allegory, he provides a glossator—in this case, St John—to explain what is going on. In so doing, says Dolce, he avoids confounding children, women and young damsels ('fanciulli . . . matrone e donzelle') with impenetrable *istorie* and produces instead a poem in which 'not only the learned' can understand the deeper allegorical meanings ('L'Aretino', 192). Dolce does not go so far as to say that this is what Ariosto is doing with Astolfo's flight to the moon, but it is clear that the episode parodies the kind of writing that is purposely dense, and that aims to impress the learned reader alone. It parodies, to be more precise, Dante and his overly erudite *Divina Commedia*. Like Dante's pilgrim, Astolfo has journeyed down into Hell and climbed back up to the earthly Paradise. But unlike Dante, this poet has no desire to travel to the highest heavens, that is, beyond the experience and understanding of his readership. The destination here is the far humbler moon. And rather than the eschatological fate of the human soul, Ariosto's allegory is concerned with the terrestrial fate of human hopes, aspirations, and desires. By satirising the *Commedia* in this way, Ariosto refutes the notion of poetry as a code that points to a 'higher' set of anterior signs, and the image of the poet as a semigodlike figure with privileged access to the mind of God. In his universe, the poet is distinguishable from others not by the light of divine intellect but by a passion for carefully discovering and writing that which he finds and by a talent for weaving words and meanings into creative compositions. The result, as Dolce would say, is a succession of stories whose deeper meanings—unlike those of the arcane Dante—confound neither the scholars nor women and children.[11]

Ariosto's grace, then, is to be glimpsed in the fortuitous combination of the diversity and communicability of his subject matter. The product of an inventive mind, it rests, in part, on his ability to entertain and engage a wide range of readers, at once learned and otherwise. But it was not enough for sixteenth-century writers merely to entertain their public. Their *invenzioni* were also required to improve readers by encoding a moral lesson. In the Counter-Reformation Italy in which Dolce was writing, poetry had to have Christian credentials as well as classical ones, to be ethically useful as well as a pleasure to read.[12] Here again, according to Dolce in at least one place, Ariosto's poem fits the bill: the *Orlando furioso* conveys a crucial overarching moral, encoded in its title, which says that we should resist love's snares and avoid extreme behaviour. Those who allow themselves to get carried away by their passions will need divine

'grace from on high' (la gratia disopra) to free them, just as Orlando
needed Astolfo and John the Evangelist to restore his sanity ('Apologia', 3).
This message is reinforced in the *allegoria* explaining the lunar episode in
the 1542 edition of the poem: 'Through the figure of St John, who has to
lead Astolfo to find Orlando's wits, we are shown that those who lose their
reason can never retrieve it without the intervention of the special grace of
God' (spetial gratia di Dio).[13] If Dolce's allegory comes across as pious and
characteristically selective, it nonetheless highlights the need for praise-
worthy texts to have didactic, Christian value. In a less conspicuous text,
Dolce endorses the secular lessons of the episode, agreeing with Ariosto
that most modern courtiers are good-for-nothing idle flatterers and that
princes would do well to make great poets their friends.[14] This reading
rings truer than the more overtly Christian one, but whichever sort of les-
son one chooses to emphasise, the point stands: Ariosto's poem must be
didactically useful as well as a pleasure to read. That is not to say that the
fundamental aim of grace is to sugar the pill, as it were, of moral instruc-
tion. For Dolce, the primary aim of poetry is to delight; yet if a poem can
provoke thought, too, and conceal lessons of moral philosophy under the
seemly veil of delectation, then it will be all the better for that.[15] Ariosto is
exemplary in this respect, combining the variety and honesty of his inven-
tions with judicious lessons for life.

DISPOSITIO

But it is not, of course, just the choice of materials that makes a graceful
poem. Equally important in the acquisition of grace are the poet's arrange-
ment of ideas, the overall structure of the text, and the relation of the parts
to the whole. In this second phase of composition, the main sources of
grace are harmony, or an aesthetically pleasing concordance between the
various parts, and surprise, the ability to move the reader into an emo-
tional or intellectual response. As we have just seen, the allegory of the
poets is a curious mixture of more or less familiar *topoi* that are reconfig-
ured here in a harmonious, but entirely unfamiliar way. Nowhere else have
the *moerae* of Homer and Hesiod, the old man Chronos of classical myth,
and the crows and swans of Horace's *Odes* come together in one vignette.

Ariosto's structuring techniques are eloquently expressed in the meta-
phor of the weaver used so many times by the narrator himself. The
Furioso, he says on a number of occasions, is composed of a vast num-
ber of threads, which he takes care to spin out, a few at a time. His craft,
in other words, is like that of the Fates on the moon. As they spin out
the threads of men's lives, so too he spins out their stories, weaving them

together into the vast tapestry of the poem. Like old women on a loom, he follows an underlying cartoon, breaking off threads here to pick them up there, taking care never to weave so far ahead that the other parts cannot be added or incorporated later on. The result is an array of independent but interrelated episodes whose undefined borders allow them to blend in to the visually pleasing background of the broader frame.

There is more at stake here than simple visual pleasure. Ariosto's tapestry also challenges interpretation as it adapts its models to their new environment, showing them in a different light. In presenting readers with familiar themes and motifs, he lulls us first into a false sense of security, reassuring and entertaining us with his intertextual dialogue across contexts and time. But as soon as we think we know what is going to happen next, Ariosto changes idiom and switches one model for another. We momentarily lose our bearings as our horizons of expectation are stretched. Familiarity and gratification give way to an intriguing mixture of surprise and curiosity. On this occasion, for example, the shift from Homer to Hesiod and Horace keeps readers on their toes, alert to the historically specific allegory that is being fabricated. As he interweaves his sources in a new way, the poet pays tribute to past masters while adapting them to suit present circumstances.[16] Such adaptation, says Dolce, is to be praised, since those who do not address 'present times' and 'the customs of the century' may just as well be talking to the dead (L'Amadigi, 2). Ariosto is clearly not talking to the dead but making clear to the living the fundamental message that poetry stands to benefit those wise and sensible patrons who recognise in it the potential to make them immortal. Time erodes the deeds of great men, reducing the sum of their achievements to nothing. Only great poets can counter its effects by capturing reality on immortal pages.

Despite what Dolce says about its ostensible clarity, however, the fundamental meaning of Ariosto's poem is never as straightforward as it seems. The poet is famously able to communicate along multiple lines at once, and the poem's structure, replete with digressions, deferrals, and interruptions, leaves many questions and scenarios open for readers to resolve. Underpinning St John's defence of poetry, for example, is the suggestion that poets lie. Reputations, St John suggests, are constructed on paper; and whether poets decide to immortalise their patrons or condemn them to oblivion is entirely dependent on the nature of their relationship. No one escapes the accusation: Homer, Virgil, and even the Gospel-writer himself are tarred with the same brush. The latter, like the rest, is a writer bound to the taste and ambition of his patron.

Does Ariosto really wish to suggest that the Evangelist is a fiction writer and the Gospel a literary fiction? And is he, by extension, reducing

his encomium of the Estensi to the status of a lie? Centuries of literary criticism hinge on this provocative assertion and on the extent to which Ariosto's 'joke' can be taken seriously. But before the text provides a definitive answer, Ariosto leaves Astolfo with the Gospel-maker and leaps the distance between heaven and earth, for, as he admits, 'my wings won't carry me much longer' (non posso più star su l'ali in alto) (35.31). Readers are therefore drawn into a discussion about what lies beneath the fabric of the narrative; but before the discussion reaches any conclusions, Ariosto changes the subject. He abandons the thread and robs us of the satisfaction of closure. This narrative technique of 'cantus interruptus', as Daniel Javitch once called it, is typical of the master weaver.[17] Nimble fingers dash here and there, up and down, in a movement that characterises the epic romance mode. As the weaver moves from this motif to that, and from that episode to this, we hope to catch a glimpse of the master plan behind his craft. As this episode shows, however, those who search for such things in the *Furioso* have embarked on a fool's quest.[18] No matter how close we feel we have come to grasping overarching patterns and underlying truths, the trace will always peter out, leaving us hanging in what Dolce would have called 'a sweet and welcome state of suspense' (una dolce e grata aspettatione) (*L'Amadigi*, 4).[19]

Ariosto's *dispositio*, in other words, involves orchestrating harmonious and unexpected arrangements of the materials he mines from a variety of sources. But the real art is in the movement between the various parts, the *andiriviene*, as Eduardo Saccone has called it, 'from this to that and from that to this' (da questo a quella, da quella a questo).[20] Grace, in other words, lies in the poet's ability to reveal and conceal himself in a kind of flirtation, a constant seduction that teases his readers with his skill and leaves us with a taste for more.

ELOCUTIO

There were those in the Renaissance who said that poetic grace was not so much about subject matter. It could only really be acquired in the third and most important phase of writing, the *elocutio*, or final expression in language. As Dolce says, a poetic subject may be as lovely as you like, but it will lose all effect if not presented in an idiom that pleases the ear (*L'Amadigi*, 3). Words and lines are the paintbrush and colours with which a poet places the wonders of nature before the awestruck mind of the reader. If one is to have the right effect, one must invest all one's study and diligence in language, in choosing the loveliest words and arranging

them in a manner appropriate to the topic being treated. Without such skill, 'every effort of his is spent in vain'.[21]

Dolce goes on, in his *Osservationi*, to defer to Bembo's *Prose* on the question of how aspiring poets should perfect their elocutionary skills. In the *Prose*, Bembo makes a virtue of simple themes and of privileging the form of a poem over its content.[22] If one is to excel as a poet, he says, one must strike the right balance between *gravità* (seriousness) and *piacevolezza* (pleasantness) in the choice and deployment of words. Accomplished poets will know how to alternate harsh sounds and soft, broad vowels and narrow, long sentences and short. They will vary rhythm, tonality, register, and sound with the triple aim of avoiding *sazietà*; matching subject matter and sound; and achieving the perfect balance of gravitas and grace, 'grazia' being the first cognate term used to qualify what he means by 'piacevolezza' (2.9). As mentioned above and testified in his letters and satires, Ariosto was a diligent follower of Bembo, and there is plenty of evidence in the final edition of his poem to demonstrate that he, too, was guided in his choice of language by those three complementary aims. As far as Dolce is concerned, Ariosto achieves what he sets out to do. The language of the *Furioso* is sweet and elegant, its sentences grave, its verses pure and terse ('Apologia', 9). Ariosto's additions and corrections to the third edition of the poem, moreover, add 'grace and splendour' (gratia e splendore) and render it so perfect that 'in it, it is impossible to desire another thing' ('Apologia', 8).

One of the finest examples of this linguistic accomplishment is St John's criticism of those poetasters who flood the Renaissance courts and his subsequent eulogy of those rare and fine poets who should reside there instead. Here *piacevolezza* follows *gravità* in a fine juxtaposition of Ariostean praise and blame. His explanation of the allegory of the crows takes the form of one long sentence, containing digressions and asides that encourage one to read it all in one breath. He truncates the sentence at the end of the first octave so that it spills over into the next, making it feel like a runaway speech of which St John has lost control:[23]

> E come qua su i corvi e gli avoltori
> e le mulacchie e gli altri varii augelli
> s'affaticano tutti per trar fuori
> de l'acqua i nomi che veggion più belli:
> così là giù ruffiani, adulatori,
> buffon, cinedi, accusatori, e quelli
> che viveno alle corti e che vi sono
> più grati assai che 'l virtuoso e 'l buono,

e son chiamati cortigian gentili,
perché sanno imitar l'asino e 'l ciacco;
de' lor signor, tratto che n'abbia i fili
la giusta Parca, anzi Venere e Bacco,
questi di ch'io ti dico, inerti e vili,
nati solo ad empir di cibo il sacco,
portano in bocca qualche giorno il nome;
poi ne l'oblio lascian cader le some. (35.20–21)

(And just as up here the crows of various sorts, the vultures and other kinds of birds all strive to pick out of the water the names which catch their eye, so down on earth the same is done by the panders, sycophants, buffoons, pretty-boys, tale-bearers, those who infest the courts and are better welcomed there than men of integrity and worth, / those who are reputed gentlemen at court because they can emulate the donkey, the scavenging hog. Now when just Fate (or rather Venus and Bacchus) have wound up their master's life-thread, all these folk I mention, supine cravens that they are, born only to feed their bellies, carry his name on their lips for a day or two, only to let the burden fall into oblivion.)[24]

The octave break comes between the truly 'virtuosi' and 'buoni' (good), and those fraudsters who are 'called gentle courtiers' (chiamati cortigian gentili), as if to emphasise the gulf that separates them. Broad and narrow vowels, harsh and soft consonants alternate in quick succession to echo the discordant cries of the crows and the chatter of their earthly counterparts. The short list of rapacious birds is followed by a longer list of those ruffians that fill the Renaissance courts. As the taxonomies lengthen, the pace of the diatribe quickens to communicate St John's rising temper. Reinforcing our sense of his anger is the imbalance between the two halves of the epic simile. Because of their unequal lengths, we lose the sense of poetic control that such similes usually transmit. Moreover, the uneven length of sentences has the effect of knocking the *ottava rima* off course and submerging its usual musicality and poise.

The following verse, however, witnesses a dramatic change in sound and tone. As the narrator turns his attention to the sacred white swans, the pace suddenly slows, the vowels broaden, alliteration and a rhythmic undulation return, conjuring up the grace and power of those birds gliding now on the water, now through the air:

Ma come i cigni che cantando lieti
rendeno salve le medaglie al tempio,

così gli uomini degni da' poeti
son tolti da l'oblio, più che morte empio.
Oh bene accorti principi e discreti,
che seguite di Cesare l'esempio,
e gli scrittor vi fate amici, donde
non avete a temer di Lete l'onde! (35.22)

(But just as the swans with their glad song convey the plaques safely to
the shrine, so it is that men of worth are rescued from oblivion—crueler
than death—by poets. O shrewd and sagacious princes, if you follow
Caesar's example and make writers your friends you have no fear of
Lethe's waters!)

The Petrarchan undertones of 'come cantando lieti i cigni' (just as the swans
with their glad song) and the pleasing symmetry of the two distinct quatrains
combine to restore a sense of balance and temperate control. This is further
enhanced by the epic simile, which, in this case, is made up of two parts of
equal length that resonate with a series of internal rhyming schemes. Note,
for example, the echo of 'cigni' in 'degni', and the reverberation of 'salve' in
'medaglie', which is counterpoised two lines later with 'tempio' and 'oblio'
and 'empio'. Here the hendecasyllabic lines are of more or less equal length
and give cause for breath with regular, more evenly spaced punctuation. The
force of the *ottava rima* is restored. Open vowels are counterbalanced with
narrow, and soft consonants complement harsh to produce a pleasing sound
that contrasts with the cacophonic chaos of the crows.

As well as preventing boredom, matching subject matter and sound,
and striking the correct balance between gravitas and grace, the language
here performs that which it describes. Through onomatopoeia, it appeals
to more senses than one, stimulating sight and sound as well as reason to
trigger an audio-visual response that makes one feel, as Dolce says, as if
one is not reading but seeing before one's very eyes that of which Ariosto
sings: 'Lastly, he is most marvellous [mirabilissimo] in painting things
before your eyes, so that most of the time I feel like I'm not reading but
manifestly seeing the thing that he's portraying' ('Apologia', 9). As well as
seeing (and hearing) crows, swans, poetasters, and poets, we are offered,
without receiving any verbal description of him, a clear image of St John.
This wise but temperamental old man, who is quick to anger, equally
quick to calm, and capable of penetrating the mysteries of the universe, is
characterised by the language that he speaks.

Grace in *elocutio*, then, consists of verisimilitude and decorum or *sprez-
zata convenevolezza*, to use Castiglione's term. It is the ability to select the

appropriate words for each occasion and speaker and to deploy them in exactly the right way.

So what, in Dolce's view, is Ariosto's grace? And where in the *Furioso* is it to be found? The language of the *Furioso*, to be sure, is central to Ariosto's grace, but despite what Bembo says in his *Prose*, speech is worth little without the material of which to speak. Likewise, subject matter counts for nothing unless it is cleverly arranged and put into words. Ariosto's grace, therefore, does not reside in his *inventio*, *dispositio* or *elocutio* alone. It comes, Dolce affirms, from Ariosto's mastery of all three: 'He is ingenious when it comes to *inventio* and orderly *dispositio*, pure and terse in versification, sweet and elegant in his language use, and solemn in his sentences' (Egli e ingenioso nelle inventioni nelle dispositioni ordinate, puro e terso nel verso, dolce e elegante nella lingua, grave nelle sententie) ('Apologia', 9).[25] In similar fashion, says Dolce, Raphael masters the techniques of visual art, but here he adds a further refinement: the acquisition of true grace requires knowledge and skill but also a certain *non so che* that springs from he-knows-not-where, but that fills the soul with infinite pleasure. In this regard, Raphael reigns supreme:

> ARET: Raphael was called graceful [grazioso]; and that is
> because—besides his *inventio*, besides his design, besides his
> variety, and besides the fact that all his works are profoundly
> moving—they display the quality that Apelles' figures had (as Pliny
> writes): and that is *la venustà*, which is a *je-ne-sais-quoi*
> [la venustà, che è quel non so che] that gives so much joy—in
> painting as in poetry—that the soul, not knowing whence the plea-
> sure springs, is filled with infinite delight.
>
> FAB: That which you call *venustà*, the Greeks called *charis*, which I
> would always translate as 'grazia'. ('L'Aretino', 195)

This *je-ne-sais-quoi* (which turns out to be knowable after all) consists of the art of making difficult things look easy, 'neither laboured nor hard-won', as if they sprang from nature and not from study or hard work. Grace is the opposite of excessive care. It is the art that conceals art. This, more than anything, is the mark of 'the greatest perfection' for poets and painters alike. As Raphael is called *grazioso* for his *facilità*, so too Ariosto may be said to achieve grace in his writing.

> ARET: And just as Michelangelo has always sought in all his works
> *difficultà*, Raphael, by contrast, has sought *facilità*, which as I

have said, is hard to achieve. Yet he has achieved it, so that his figures seem to have been produced without thought, and are neither laboured nor hard-won: a sign of the greatest perfection. The same is true for writers, where the best are the easiest: such as Virgil and Cicero for you learned folk, and Petrarch and Ariosto for the rest of us. ('L'Aretino', 196)

We might illustrate Dolce's point for him by returning, once more, to the pair of white swans. In the classical tradition, white swans act as a figure for the poet. As we have seen in del Cossa's *Allegory of April*, they are the companions of Apollo, the chariot bearers of Aphrodite, the embodiments of poetic creativity and grace (fig. 11). They also encode, however, the poet's anxiety at the prospect of death. In one of Ariosto's most conspicuous *loci classici*, Horace's *Odes* (2.20), a white swan appears as the poet nears the end of his life. As he contemplates death, he imagines himself undergoing a strange and discomfiting metamorphosis. Rough skin forms on his legs, his upper part changes into a white swan, and smooth feathers sprout along his fingers and shoulders. The biformed creature that emerges bears him away from the silence and nonbeing of death and towards a glorious afterlife. Horace's swan represents the poet's desire for posthumous renown. The uneasy, even monstrous, metamorphosis from poet to bird is an expression of his anxiety at the thought of failure and his anguish in the face of death.[26] As such, the swan may be seen as a figure for the poet's investment in his own work, for the considerable care that goes into art.[27]

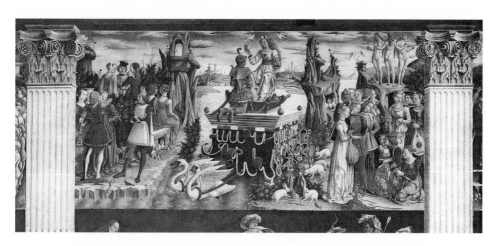

FIGURE 11. Francesco del Cossa, *Allegory of April* (detail), ca. 1469. Fresco. Musei di Arte Antica di Ferrara, Palazzo Schifanoia, Ferrara. © Photo Ghiraldini-Panini.

Yet in the *Furioso*—as in the graceful movements of a swan—there are no outward signs of discomfort at the prospect of the poet's death. The swans do not *seem* to feature here as symbols of Ariosto's immortality or lack of it but rather as reminders that he can ensure his allies' legendary status after death. Whatever anxiety Ariosto might have had about his posthumous fame is displaced onto those who should feel concerned about their own and so learn to make poets their friends. As well as reinforcing the message to patrons to take great care in singling out true grace from common flattery, this important shift leaves readers with an impression not of Ariosto's self-doubt but of his self-assurance, *facilità*, and grace. Far from drawing attention to an anxious investment in his own work, these swans highlight the apparent nonchalance and artlessness of Ariosto's art. It is this *sprezzatura* that differentiates Ariosto from those poetasters whose words are destined for oblivion. It is this grace that renders him not just a rare but a divine poet whose song will echo a long way downstream.[28]

A Portrait by Ariosto

Ariosto earned Dolce's praise by adhering closely to the principles of seriously pleasant and pleasantly serious poetry as outlined in Bembo's *Prose della volgar lingua*. Yet gravitas and grace are not subjects he thematises in any overt way. More characteristic of the poet, especially in his *Satires*, is the condemnation of the ingratitude with which his gravitas and grace are so often met. It has often been claimed that Ariosto not only suffered ingratitude at the court of Ferrara but wished to have been seen to have suffered it. No one has claimed, however, that whenever he laments unpaid debts, he also highlights the original act for which repayment should be forthcoming. Behind Ariosto's bold critique of courtly ingratitude is the self-promotion of a poet who knows his own worth. In this respect, Ariosto anticipates Dolce's reading of the poem while varying the terms of that reading. He does this most eloquently, I suggest, in the emblem page with which he decorates the first edition of his poem.

In 1516 Ariosto makes the unusual editorial choice of embellishing the first edition of *Orlando furioso* with an emblem page (fig. 12).[29] The page consists of three elements: a central image of flaming logs fumigating a hollow tree trunk whence a swarm of bees flee; a frieze depicting eight representations of a mallet and axe bound by a snake; and an inscription in the corners of the frieze, 'PRO BONO MALUM'. Combined, the words and motto tend to be read in one of two ways: as denoting human ingratitude in general and the ingratitude that Ariosto suffered at court in particular;

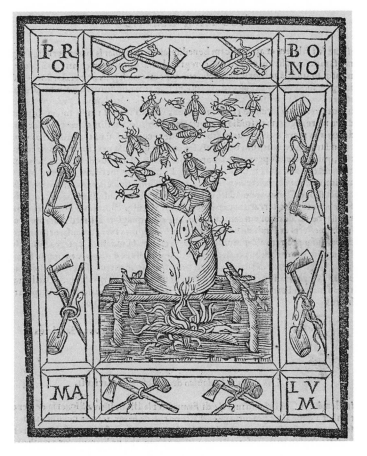

FIGURE 12. Anonymous, Emblem with bees. In Ludovico Ariosto, *Orlando furioso*, 1516. Ferrara: Giovanni Mazzocchi, 1516. Woodcut emblem. Source: Bibliothèque Nationale de France, department Réserve des livres rares.

or as a conjunction of contraries—a rule for life about the *bonum* that accompanies every *malum*. At the core of the critical debate is an argument about the interpretation of the word 'PRO' in the inscription 'PRO BONO MALUM'. For the contraries camp, the motto's *pro* means 'for' in a coincidental sense, as in 'for every good there is an ill': in this reading, *pro* is 'a conjunction and no more', implying neither subordination, generation, nor teleology between the two items.[30] For the ingratitude camp, by contrast, *pro* is better understood in a causative sense as 'in exchange for', making the motto mean 'an ill in exchange for a good'—the definition of ingratitude.[31] In my view, any reading of the emblem should combine elements from both lines of interpretation. While agreeing with the

contraries camp that the emblem points to an array of irreducible dichotomies, I propose adding ingratitude into that array alongside its contrary, grace. Ariosto's emblems and mottoes, from this perspective, represent a series of situations in which, for every ingratitude encountered, grace is offered in exchange. So, too, *Orlando furioso*, which, for every ingratitude experienced, reciprocates with boundless poetic grace.

INGRATITUDE

Ample evidence corroborates the emblem-as-ingratitude line of interpretation for the beehive motif, foremost amongst which is the interpretative key that Ariosto himself provides in his *Cinque canti*.[32] In canto 5 of these five *Canti*, the knight Rinaldo sports an emblem on his military cloak depicting bees being chased 'from their native place / by the ungrateful peasant with smoke and fire' (5.46:2–8). On the basis of the reference to 'l'ingrato villan', critics explain that the bees express Rinaldo's (mistaken) belief that his lord and king, Charlemagne, has betrayed him. Like the industrious bees who worked so hard for their thankless 'protector', Ariosto too saw himself as the undeserving victim of the highest ingratitude, a characterisation that critics identify as decisive proof that the bee motif expresses the poet's own self-identification as the recipient of the same gross injustice.[33]

As far as the PRO BONO MALUM motto is concerned, Alberto Casadei cites biblical sources that also denounce ingratitude and express bitter awareness that evil is all too frequently the reward for good.[34] He lists at least five biblical references—from *Jeremiah*, *Genesis*, and the *Book of Psalms*—in which the words are used (in more or less the same order) to decry the malicious reception by nonbelievers of public demonstrations of Christian faith.[35] I will come back to these citations shortly. Suffice, for now, to say that the argument likens Ariosto to the long-suffering Christians of Scripture. In both cases, good faith is repeatedly met with bad, while, in the specific case of Ariosto, the immortalisation of his patrons in poetry is constantly rebuffed with a severe lack of grace.

The snakes, axes, and mallets, too, add further grist to this interpretative mill when one looks to Aesop's fables, as Giorgio Masi did, singling out three separate fables in which they serve to enhance the iconography of ingratitude inherent throughout the emblem page. In one fable, a snake repays the farmer who saved his life by biting him; in another, an oak tree complains to Zeus because his timber is being used to make axes that chop down other trees; while in the third, a pine tree laments it is being felled by a wedge made of its own timber.[36]

It must also be said, in support of the emblem-as-ingratitude argument, that Ariosto himself complains bitterly of the poor recognition his literary efforts receive at the hands of his patrons, the Este family of Ferrara, throughout his works.[37] His *Satires* abound with repeated criticism of the oppressive yoke of patronage and the way in which the Este family leaders keep him constantly on the move, turning him from a poet into a horseman.[38] Nowhere is his indignation better expressed than in a Latin epigram penned early in his career entitled 'De lupo et ove'. In a few pithy lines, he offers a particularly bitter but eloquent meditation on thanklessness as a ewe, constrained by her master to suckle a wolf, is later devoured by her protégé: 'A ewe, with heavy heart but compelled by her master, / nourishes the young of a she-wolf, depriving her own lambs of her milk. / Of course, the pup in adulthood devours his benefactor: / no grace can alter nature'.[39] This adaptation of a Greek declamatory epigram testifies to the oft-times futility of *gratia* and its complicated role within the cycle of giving, receiving, and returning that should—but does not always—form the basis of civilised society.[40] Despite the third-person narrative perspective, it is not hard to imagine the epigram bemoaning the poet's own bitter experience at Ippolito d'Este's court. Written sometime before 1503, it coincides with the years in which the poet was forced to abandon his humanistic studies because of his father's death and to become one of the cardinal's functionaries and diplomats. 'De lupo et ove' may be designed to allegorize Ippolito's banishment of Ariosto from Ferrara to the remote citadel of Canossa, where he was commissioned to act as military commander and to quell the fractious, ungovernable citizens. The sheep and master could be said to symbolize himself and Ippolito d'Este, while the wolf represents the belligerent commoners of Canossa that Ariosto is forced to control.[41] Alternatively, it may be said to emblematize a more universal message, which is that no grace can soften a graceless heart.

It is not difficult, then, to read Ariosto's emblem as invoking ingratitude.[42] Though plausible, however, the ingratitude reading is reductive in a way that is not at all in keeping with a poem and poet famous for irony, innuendo, and an unrivaled ability to communicate along both implicit and explicit lines at once.[43] Moreover, emblems of this kind were designed to promote a poet's identity and authority in print: Why would a self-assured poet like Ariosto wish to memorialize himself primarily and prominently as nothing more than a disgruntled man afflicted by courtly ingratitude? Each of the symbols and, indeed, the words themselves offer multiple and sometimes contradictory meanings. Renaissance bees, for example, do indeed denote the hard work of ideal citizens as well as the

poor rewards they often receive, but they also carry more positive connotations of poetic imitation, regeneration, sweetness, loyalty, cooperation, and so on. As well as denouncing ungratefulness, they are just as likely to celebrate the poet's confident appropriation of the classical past and his unique ability to make and remake antiquity with both seriousness and grace.

CONTRARIES

Classical motifs become a hive of Renaissance activity in which Ariosto participates with full awareness. The eclectic poet would have been attracted in his choice of emblem to any number of the classical connotations that were available to him. He would have delighted in the way emblems are designed to express sophisticated conceits within complex word-image compositions (the purpose that Paolo Giovio assigns to them in the opening lines of his 1555 *Dialogo* on the subject). Yet Ariosto never plundered antiquity without a sense of purpose and order. Throughout the *Orlando furioso*, ancient booty is always put to good and eloquent use, and the same is true here. So while whittling his emblem down to a solitary meaning belies the spirit both of early modern emblems and of a poet whose allusive eloquence and playful ambivalence are rivalled by none, so too does the endless proliferation of meaning. Striking a balance between the one and the too many are those critics who read the emblem page as expressing a conjunction of contraries that is characteristic of the *Orlando furioso* itself from its very opening line.

Eduardo Saccone is one such critic. Looking not to the Bible but to the *Furioso* itself as a source for Ariosto's PRO BONO MALUM motto, he points to the preamble of canto 45 where the narrator draws on the ancients, as well as on recent history, to identify a general rule that governs all the world's affairs: 'good follows evil and evil good, each marking the end of the other'.[44] Two sides of the same coin, the one interrupts the other in the endless revolution of Fortune's wheel. Critical of those who reduce the motto down to just one of the two terms it expresses— *malum*—then narrowing that yet further down to one or two subsets of meaning—ingratitude or envy—Saccone emphasizes the 'extreme generality' and semantic capaciousness of Ariosto's 'good' and 'bad'. The words *bonum* and *malum* convey a vast array of opposites, as do the images on the emblem page. The axe and mallet, Saccone points out, are both peacetime instruments of agriculture and wartime weapons of destruction; the injurious fire is both a destructive method for extracting honey and a salutary means of ridding the hive of disease. The bees themselves are both

dangerous to humans and the benevolent producers of sweet nectar for them to eat.[45] From the charms to the sting of love, and from the ravages to the rewards of war, PRO BONO MALUM suggests not that one eclipses the other but rather that one cannot exist without the other in the bitter-sweet balance of human existence.

I agree wholeheartedly that certain scholars have been too quick to determine on which side—*bonum* or *malum*—the balance hangs. They have been hasty, too, in closing down the proliferation of associated imagery that the emblem—like all emblems—is designed to invoke. To illustrate this point, let us single out once more Ariosto's bees and their allegorical accommodation of an array of dichotomies which renders them the perfect figures for a poem that invites constant reflection on the relationship between opposites from shifting perspectives. This is, after all, the main task of the *Orlando furioso*: from the opening line it sets up a range of dualities—*le armi* versus *gli amori*; *le donne* versus *i cavallier*—and proceeds to explore them from different angles.[46] Not by chance, each of these cardinal themes finds allegorical expression in sixteenth-century literature and art as bees. While this is not the place to embark on a comprehensive survey of all such allegorical apiology, it is worth highlighting a few of the most readily available associations. Not only will this broaden Ariosto's cultural frame of reference to include visual as well as verbal sources for his emblem page, it also will serve as supporting evidence for the case I wish to make for including grace alongside ingratitude in the list of contraries acting under the aegis of 'good' versus 'bad' in the poet's motto. Bees, as we shall see, can be said to symbolise how grace takes pride of place not as the most obvious contrary but rather as the silent partner of and antidote to the ingratitude that Ariosto suffers as a poet and thematises in his poem.

Love, to begin with the last word of the *Furioso*'s first line, is an apian association that scholars tend to ignore in Ariosto's emblem. Yet love's beesting is too common a Renaissance trope and too central a theme in the poem to be overlooked.[47] Bees appear in a range of reflections on love, one of which is an influential Tito Strozzi poem that Ariosto would have known well and that draws on Theocritus's nineteenth *Idyll*. The original *Idyll* reads as follows:

> A cruel bee once stung the thievish Love-god as he was stealing honey from the hives, and pricked all his fingertips. And he was hurt, and blew upon his hand, and stamped and danced. And to Aphrodite he showed the wound, and made complaint that so small a creature as a

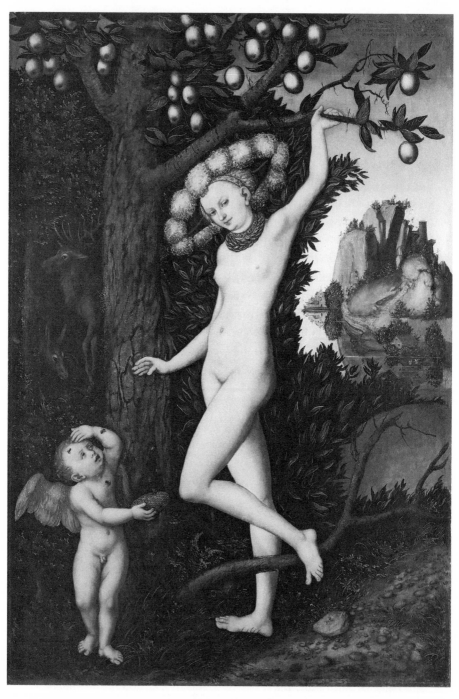

FIGURE 13. Lucas Cranach the Elder, *The Honey Thief*, ca. 1526–1527. Oil on wood.
© The National Gallery, London.

bee should deal so cruel a wound. And his Mother answered laughing, 'Art not thou like the bees, that art so small yet dealest words so cruel?'

Strozzi's 'In Amorem Furem', in imitation of Theocritus, describes the hurt and confusion of the young Cupid when stung by a bee while stealing honey, to which his mother responds: 'Don't you, my Son, inflict great wounds, small though you may be?'[48]

Strozzi's poem is thought, in turn, to have inspired Lucas Cranach the Elder's *The Honey Thief*, which he executed fifteen times from 1529 onwards (fig. 13). It is Frederik W. G. Leeman who proposes Strozzi's couplet as the main source of Cranach's inspiration in his numerous paintings of the subject. Others, however, contest the link between Strozzi and Cranach and identify as his source a rhyming couplet variously attributed to Benedict Chelidonius, Philip Melanchthon, or Melanchthon's relative Georg Sabinus.[49] Whatever the exact nature of the link, such traffic of Cupid-stinging bees across European literature and art testifies to their broad cultural appeal. Far and near, they come to symbolise the pain of love—the *malum* to love's *bonum*—in ways that clearly resonate with the interests of the *Furioso*.

Cranach may have imitated Strozzi, who most likely imitated Theocritus. Theocritus, meanwhile, imitated Anacreon, losing in translation an association the earlier poet made between snakes and bees when his Cupid exclaimed 'a little snake bit me, a winged serpent that farmers call a bee'.

The winged snake re-emerges in Ariosto's time in Andrea Alciati's emblem of the Theocritus poem in the 1531 edition of his emblem book, *Emblemata* (fig. 14). Illustrating Cupid (identifiable by his blindfold, wings and arrow) fleeing a beehive and running for the protection of Venus (recognisable by her nakedness and characteristic apple), the emblem boasts not one but two epigrams. In the first of these, beestings and snakebites are aligned with love as the 'Lydian child' of the epigram calls the bees who sting him more vicious than any 'vipera'. An iconographical alliance between bees and snakes is, of course, reproduced in Ariosto's emblem page. Meanwhile the title of Alciati's emblem, *Dulcia quandoque amara fiera* (Sweetness turns at times to bitterness), resonates profoundly with his PRO BONO MALUM motto, conjoining as it does polar opposites and expressing the codependence of the benefits and sorrows of love. Alciati's and Ariosto's emblems seem in direct correspondence with each other about the bitter sweetness of love. Indeed, the *Furioso*'s paragon of fidelity, Isabella, curses the tyrannical cruelty of fate in words that recall both emblems as well as Strozzi's verse. Love, she laments, turns her 'conforto in dolor' and

FIGURE 14. Andrea Alciati, *Dulcia quandoque amara fiera*, 1531. Woodcut emblem. In *Emblematum libellus* (1531). Venice: Aldus Manutius, 1546. Source: University of Glasgow Library, Special Collections.

her every 'bene in male' (13.20), a refrain soon to be captured in Cranach's inscription aligning the honey-thieving Cupid with those who 'seek transitory and dangerous pleasures / that are mixed with sadness and bring us pain'.[50] Given its amorous associations in so many contemporary settings, it is hard to imagine Ariosto's bees failing to invoke the paradox of love.

If the ancients and moderns employ bees to invoke 'gli amori', they use them to symbolize 'le armi' as well. Ariosto's patron Alfonso d'Este, for one, appropriated two bee-inspired mottoes for himself, both relating in one way or another to war. The first of Alfonso's mottoes, EX BELLO PAX (fig. 15), is illustrated by a swarm of bees nesting in a helmet; the second, DE FORTI DULCEDO, which appears on one of his personal coins is a biblical reference to Samson's riddle in the *Book of Judges*—'Out of the eater, something to eat, out of the strong, something sweet' (14:14)—and features a swarm of bees making their homes in the head of a lion (fig. 16). In both cases, the mottoes express the benefits of sweet peacetime following the horrors of war and declare Alfonso d'Este's ambition to move from the bellicose arts to those of peace, an ambition (as his *Satires* and numerous passages of the *Orlando furioso*

FIGURE 15. Andrea Alciati, *Ex bello pax*, 1531. Woodcut emblem. In *Emblematum libellus* (1531). Venice: Aldus Manutius, 1546. Source: University of Glasgow Library, Special Collections.

avow) Ariosto unequivocally shares.[51]

In symbolising the peace that follows war, bees also invoke 'i cavallier', identified by Ariosto as thematically important to his poem. Of available classical sources here, book 4 of Virgil's *Georgics* strikes a particular chord because of its adaptation in the form of Rucellai's *Le Api* (1524). Too late to have influenced Ariosto directly, Rucellai's text suggests revived interest in Virgil's apian wisdom and renewed circulation of the range of contrasting

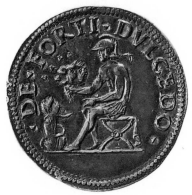

FIGURE 16. Alfonso d'Este personal coin, *De forti dulcedo*, ca. 1505. Coin.
Courtesy of the Trustees of the British Museum, London.

metaphorical associations incorporated in the tiny creature's body. The
Roman poet offers a study of the lives and habits of bees that acts as an
allegory for human society. Virgil's bees, like ideal citizens, normally work
selflessly for the common good, showing unwavering allegiance to their
king. At times, however, owing to a lack of the arts and love, they are prone
to perishing in entire colonies consumed by the furious boiling anger so
easily incited in their little bodies.[52] Rucellai's adaptation relocates Vir-
gil's Mantuan lines to sixteenth-century Florence. Here, bees are praised
for their sweetness, song, honey on lips, industry, ingenuity, architectural
skill, undying loyalty to *patria*, prudence, and foresight. At the same time,
however, they are quick to anger, prone to chaos in the absence of a good
leader, and capable of extinguishing themselves with collective anger
when threatened or provoked. Eloquent figures both for arms and love,
they emblematise both knights and ladies and the behavioural swing, so
common in human communities (and so interesting to Ariosto), between
peaceful cooperation and stinging belligerence.

'Le donne', the remaining item on Ariosto's list of four themes, occupy
pride of place in apian iconography thanks to the misconception that
worker bees were the female servants of their king bee. Ariosto him-
self aligns bee colonies with female communities when describing the
women of Alessandretta as they swarm to the city's grand arena to wit-
ness the conclusion of a battle postponed the night before between war-
riors Marfisa and Guidone. 'Eager to see the outcome of the battle', he
writes, they 'flowed into the arena, like a swarm of bees into their hive
when the time has come for a change of regent' (20.82). Aiming, perhaps,
to communicate the size and excitement of the female horde rather than to

comment in any meaningful sense on the allegorical kinship between bees and women, Ariosto's analogy nonetheless gives cause in the case of at least one early modern commentator for allegorizing along Virgilian lines. The similitude, says Orazio Toscanello in his 1574 appreciation entitled *Le bellezze del Furioso*, is 'bellissima' because women, like bees, are fecund, sweet, inclined to flee or travel in crowds, and prone to 'guereggiare', as we see, he says, in *Georgics* 4. What Toscanello recognises in Ariosto's passing comment is a distillation of Virgil's (and later Rucellai's) fantasy of bees as models for female behaviour living, as they do, like sweet and fecund virgins thinking only of *pudicitia*, duty, and honour.[53] Encoded in Ariosto's lines, too, is the opposite vision of bee-women: their belligerence and mob-like movements. This, too, is grounded in Virgil (and Rucellai), for whom the female 'popolo' breaks faith when the king bee dies or grows too old, sacking its own treasury of honey, razing the kingdom to the ground, and awaiting the domination of a successor who will calm and reorder their riotous assembly in a new realm. Toscanello's interpretation shows how readily available such cultural associations were to the *Furioso*'s readers.[54] Whether or not Ariosto deliberately invested his metaphors and emblems with specific ancient and modern meanings, the broader iconographical context within which he knowingly produced them and within which they were received plays a significant part in any subsequent interpretation of their original significance. Buzzing around the hinterland of his cultural milieu were multiple, often contradictory appropriations of classical bees, and there can be little doubt that he would have relished their rich allegorical complexity. In the manner of those minute apian figures, he would have raided numerous sources to produce his own sweet variation on the theme.

Of particular relevance to the subject of this book is one further iconographical association: the alignment of bees and poets. Since classical antiquity, bees have acted as figures both for the imitative practices on which poetic creativity depends and for poets themselves. The Senecan metaphor of honeybees drawing pollen from different flowers has appeared a number of times in this book so far, testifying to its prominence in early modern iconography as a whole.[55] Given its place on the tip of so many early modern pens, it is surprising that it does not receive any mention in studies of Ariosto's emblem page. It is true that Ariosto's bees do not gather pollen and there are no flowers for them to plunder in sight, but source gathering and creative imitation are central enough both to his poetic practise and to the very elaboration of his emblem page as to render the link irresistible. Lodovico Dolce felt compelled to praise his bee-like activities on a number of occasions: it is not hard, therefore, to imagine

other early modern readers drawing similar conclusions.[56] There is more to early modern poet-bees than the sweet industry of hunter-gathering. In Horace, the alliance between poets and bees was a topos of humility as well. In his ode to Iulus Antonius (4.2), as we saw in our analysis of Ariosto's swans, the ancient poet compares his poetic 'toiling in the groves and along the banks of the' Tiber unfavourably with the lofty songs of Pindar. 'I fashion my elaborately worked verses', he says, 'after the manner and the art of the Matinian bee'. Pindar, 'a poet of a more robust plectrum', by contrast, sings of Caesar 'honoured with his well-earned garlands' as he climbs the sacred slopes, dragging in his wake his savage enemies' (ll. 27–35).[57] The image of Horace's carefully toiling bee is designed to contrast with Pindar's soaring swan: his polished but artificial art paling by comparison with Pindar's natural, original, and lofty skill. Yet the modest bee goes on to ventriloquize the swan's song, offering a splendid example of Pindar's style in describing Augustus's return, even while denying his own ability to do so. Horace himself sings of Caesar, his eulogy boasting a style no less natural, original, or lofty than that of his hero Pindar. The *topos* of modesty and imitation, in other words, barely conceals a poetic confidence which the passage of time will prove to be utterly justified.[58]

Here, at the vestibule to *Orlando furioso*, Ariosto executes a similar manoeuvre. Offering an image of bees where a self-portrait would normally preside, he highlights the inglorious, unrewarding labour of poets. What the emblem does not reveal, though, is the later metamorphosis in the lunar episode of the poet-bee into a soaring swan. In full Horatian mode, this author toils in the service of supreme confidence, connecting the apparent modesty of his poetic persona with the great ambition of his poem. In connecting bee to swan, he meets the pungent ingratitude of an anticipated public with the boundless grace of his art.[59]

INGRATITUDE MEETS ITS CONTRARY

Ludovico Ariosto was the Renaissance poet of grace who sought due favour from his patrons in vain. In the 1516 emblem, as in the *Orlando furioso*, he allegorizes an encounter between the art that conceals art and indifference: between grace and ingratitude. The honey-mouthed bees meet the 'ingrato villan', just as the axe and mallet of the hard work that goes into making difficult things look easy meet the viperous tongues of envy, *bonum* meets *malum*. Both survive and rely on each other for definition.

We saw earlier Alberto Casadei's use of five biblical citations to prove once and for all that Ariosto's emblem page epitomised ingratitude. Of

these citations he concludes: 'So, then, the meaning of Ariosto's phrase is tightly linked to the theme of *human* ingratitude, that of the man who evicts the bees to obtain their honey in the celebrated woodcut. But it is tied, too, to the more specific evil of detractors, enemy courtiers (symbolised by the serpents) who have rendered "evil for good" to the just poet'.[60] Yet in each of those biblical references, the *bonum* of faith persists in the face of the *malum* of detractors. And Casadei's list excludes some key citations in which the persistence of good *despite* the presence of evil could not be more explicit. In Psalms 36:27, for example, we find 'recede a malo et fac bonum et habita in sempiterno' (depart from evil and do good; and dwell for evermore). More to the point, the advice in St Paul's *Epistle to the Romans* (12:21) is 'noli vinci a malo sed vince in bono malum' (Do not be overcome by evil, but overcome evil with good). Do not be defeated by ingratitude, Ariosto's emblem might say, but overcome ingratitude with grace. As he concludes in the Latin epigram mentioned above: 'no grace can alter nature' (mutare ingenium nulla gratia potest): yes, but let not *gratia* surrender to graceless *ingenium*, no matter what.

Ariosto removes the original emblem page from the final and definitive 1532 edition of his poem. In that edition, 'pro bono malum' moves from the opening pages to the very end of the text, becoming a closing refrain, rather like the 'amen' at the end of a prayer. Instead of the bees, axes, mallets, and snakes with which the 1516 edition opens, Ariosto offers a new emblem placed, this time, on the last page.[61]

The new emblem represents—lo and behold—a ewe nurturing a wolf (fig. 17). In 1989 Conor Fahy was one of the few literary critics to attend to this iconographical development in Ariosto's editorial history. He saw the new emblem as merely confirming the ingratitude encoded in the old. For him, it was a desolate renunciation not merely of Ariosto's personal experience of ingratitude, nor even of human ingratitude in general, but of 'a cosmic ingratitude inherent in all things'. Yet the 1532 image, like the much earlier epigram, could just as easily be seen as an act of defiant humility and dissimulated self-confidence. Closing the poem, it is a performative utterance with which Ariosto submits the sheep of his *Furioso* to the wolves of its reception. In the image, it is the act of giving that is recorded while the poem's reception is merely anticipated as yet. Expecting ingratitude in the future is, of course, very different from complaining about past injuries. Exchanging an image that portrays the actual destruction of a beehive for one that merely foresees the slaughter of a sheep, Ariosto welcomes the worst but leaves room for a better narrative outcome. With this image, one can still harbor hope for a better form

FIGURE 17. Anonymous, Image of Ewe Suckling Wolf-Cub, ca. 1532. Woodcut. In
Ludovico Ariosto, *Orlando furioso*. Venice: Francesco Rosso da Valenza, 1532. By
permission of the Warden and Fellows of All Souls College, Oxford.

of recompense and, even if the inevitable happens, it is nonetheless the
image of 'gratia' and of 'aspettar le gratie' that will be celebrated for pos-
terity.[62] Like Horace with his bees, the poet is ostensibly demeaning his
work only to quietly assert the level of recognition it truly deserves. As the
ewe stands over the wolf cub, the poem stands intact before its audience,
giving generously of its fruits. Emblematizing his gift to the world with
the self-assurance of a great poet, Ariosto dissimulates its virtues and, in a
gesture of characteristic *sprezzatura*, offers his grace to the wolves.

CHAPTER SIX

Grace and Labour

MICHELANGELO BUONARROTI
AND VITTORIA COLONNA

*I offer you graces and thanks, my Lord, for the good impulses you give me
and, indeed, for the very impulse to offer you these graces.*

—BLAISE PASCAL, *PRIÈRE POUR DEMANDER
LE BON USAGE DES MALADIES* (CA. 1658–1662)

IN 1516—as Ariosto was publishing his first *Orlando furioso*, Raphael
was completing his portrait of Castiglione, and Castiglione was putting
the finishing touches to his *Libro del cortegiano*—Michelangelo Buon-
arroti already had a store of masterpieces behind him. Not yet halfway
through his uncommonly long life (he died at eighty-nine in 1564), he had
produced his best-known sculptures, the *Pietà* (1499) and the Florentine
David (1504), as well as that titanic feat of painting, the frescoes on the
ceiling of the Sistine Chapel (1508–1512). In Rome, where he lived, and
in all the major centres of Renaissance Italy, Michelangelo's fame was
secured. Popes, patrons, artists, and connoisseurs marvelled at his excel-
lence. Commissions for life seemed guaranteed.

By 1516, though, the ascendant star of the younger Raphael posed a
serious threat to Michelangelo's otherwise unrivalled success.[1] Two years
earlier, the most sought-after patron of the day, Pope Leo X, had con-
spicuously favoured Raphael by granting him the distinguished position
of superintendent at St Peter's Basilica in Rome. The year after that he
sidelined Michelangelo again, commissioning Raphael to make a series
of tapestries representing the lives of Saints Peter and Paul for the Sistine
Chapel as well as electing him papal commissary of antiquities. Wanting

to make use of the artist's talent without having to deal with his difficult character, Pope Leo sent Michelangelo to Florence (1517) to work on the façade of the Medici chapel of San Lorenzo. After three years of delays, mishaps, and considerable expenditure, the pope finally terminated the contract before work on the façade had ever really begun.[2] History does not usually portray Michelangelo as a loser, but in those difficult years, a loser to Raphael he was.[3] What was it that led to this defeat? The answer, I suggest, is nothing other than grace. And Michelangelo's response? He would wrest grace back from Raphael and restore it to its rightful, divine owner.

This chapter explores Michelangelo's campaign to conquer grace. It is not, I suggest, that he aspired to the grace attributed to Raphael and strove to master that. Rather, he exemplified an interpretation of grace in his life and in his art that conflicted and competed with the one that Raphael embodied. Michelangelo's grace can be seen both in work produced during those pivotal years of competition with Raphael and in Michelangelo's later-life correspondence with Vittoria Colonna. The 'and' in this chapter title, therefore, does not indicate a dual focus throughout on the grace of both Michelangelo and Colonna. The first two parts offer a single-minded focus on Michelangelo's grace, beginning towards the end of his life and assessing the success of his campaign as evidenced by sixteenth-century biographers and theorists of art. It is in the third part that I bring his grace into dialogue with the grace of a mature Colonna, whose spiritual sonnets were only touched on in chapter 4. In the final analysis, I show the grace whose meaning they shared to be more than a keyword, an incitement to love, or a badge denoting artistic talent. It was a creed and a statement of beliefs about art, spirituality, and how one should live.

Michelangelo's 'Most Graceful Grace'

The most famous of all sixteenth-century biographers, Giorgio Vasari, proclaimed Michelangelo to be the Renaissance artist of grace. This was the burden of the section that Vasari devoted to the Florentine in his *Le Vite de' più eccellenti architetti, pittori, et scultori italiani* (*Lives of the Artists*) (1550). Crowning millennia of artistic experiment, Michelangelo had been sent by God to transcend and eclipse every other artist, living or dead, with what his biographer called 'a most graceful grace' (una grazia più interamente graziosa).[4] In Vasari's text, grace was a symbol of the 'most absolute perfection' (la più assoluta perfezione) (543), the mark of distinction separating late fifteenth- and sixteenth-century artists from their inferior fourteenth- and fifteenth-century predecessors. Grace was what

distinguished, in other words, those artists working in the full maturity of the Renaissance, from the late 1500s on, from their inferior predecessors working in the infancy of Renaissance art, around the early 1300s, and its experimental youth in the early to mid-fifteenth century. Fourteenth- and fifteenth-century artists, for Vasari, lacked the spontaneity and visual judgement that render art graceful.[5] It was only after Leonardo da Vinci that painters were able to achieve that 'divine grace' (grazia divina) and facility that give most pleasure to the eye. This grace and facility derive from a natural gift that requires careful cultivation. Much study and infinite pains must be spent in learning the techniques and practices of drawing and copying from life and from the great masters. But when it comes to the final execution of a painting, artists must work rapidly with confidence and ease so that no traces of that earlier effort appear on the canvas.

Artistic grace is never fully defined in Vasari's text, but it is frequently coupled in synonymic pairings with the qualities of ease, good judgement, and the concealment of art. Presented in this guise, it recalls and applies to the arts the grace described at great length by the interlocutors of Castiglione's *Libro del cortegiano*.[6] The *Cortegiano*'s grace, as we saw earlier, was the ideal 'condimento d'ogni cosa', a subtle mix of the diligence and hard work that go into true skill and of the dissimulation and nonchalance required to efface all signs of effort. For the perfect courtier, the characters of Castiglione's dialogue prescribed grace in every action, thought, and deed, as well as in the visual arts. So when Vasari writes that Michelangelo achieves 'a most graceful grace' (una grazia più interamente graziosa), he is speaking in Castiglione's terms. He is talking about 'art that conceals artistry' (l'arte che nasconde arte). Like Castiglione, in fact, Vasari lauds the most graceful (il graziosissimo) Raphael for his *facilità* and compares him with the ancient Greek masters Apelles and Zeuxis.[7] In the final analysis, though, the critic maintains that none surpasses Michelangelo for the effortless intensity of a graceful style that defies all comparison.

Vasari's understanding of grace was not the only available one. His attribution of grace to Michelangelo, moreover, did not achieve universal consensus. For many sixteenth-century theorists, in fact, it simply did not ring true: Michelangelo's art was not characterised by a nonchalant concealment of effort, they said, but by *terribilità*, a proud display of skill and complexity.[8] In 'L'Aretino', for example, Lodovico Dolce expressly opposed the common view (giudicio comune), articulated by Vasari, that Michelangelo had achieved the highest grace.[9] Those who peddled this hackneyed view, he said, were blinded by the provincial desire to promote a Florentine over others while refusing to think for themselves. The free-thinking

view reverses the judgement: it was Raphael's sweet and graceful style that surpassed all others.[10]

On close examination of Michelangelo's work, one might accuse Vasari not just of provincialism but of bending grace out of shape in the service of an overarching narrative of Renaissance art. If the grace that concealed artistry was the distinguishing feature of the High Renaissance; and if Vasari's fellow-Florentine Michelangelo was the culmination of High Renaissance art; then, the syllogism went, Michelangelo was the perfection of grace. Vasari's desire to reconcile his promotion of Michelangelo with his history of art led to the unconvincing attribution of grace, the highest virtue in the visual arts, to the artist whom so many saw as essentially *terribile*. As a result, neither Vasari's account of grace nor his account of Michelangelo met with comprehensive approval. On the contrary, it provoked a debate not only about the meaning of the crucial word but— through that debate—about the very nature, role, and status of art. No one denied that grace was the ultimate goal of art. What grace was, however, and how it was to be achieved, were questions that came to be the subject of widespread discussion.

One of Vasari's most conspicuous opponents in this quarrel was Michelangelo's chosen biographer, Ascanio Condivi. Three years after Vasari's *Vite*, Michelangelo sanctioned an alternative account of his life, and Condivi's *Vita di Michelagnolo* (1553) set out to correct certain factual errors in Vasari's text, altering the details of certain events. It supplied more information about Michelangelo's youth, included certain images missing from Vasari's biography and set the record straight on the 'tragedia' of Pope Julius II's tomb.[11] There were, in addition, significant differences between Condivi's and Vasari's evaluations of Michelangelo's work and the language used to describe him as an artist. The word 'grace', central to Vasari's account, is almost entirely missing from Condivi's text and it never appears in terms of effortless art.[12] No mere accident, the absence of the keyword in *La vita di Michelagnolo* offers a corrective to the earlier biography and mounts a direct criticism of the new terminology of art criticism.

Like Vasari, Condivi fashioned an image of Michelangelo as naturally endowed, self-taught, and divinely inspired. Here, too, Michelangelo is sent by God to transcend and surpass all others, living and dead. But while Vasari weaves his narrative of Michelangelo's divinity into his theory of the three ages of art, Condivi rejects all links between Michelangelo and artists of his time. For Vasari, Michelangelo reigns supreme while residing within the company of artists belonging to what he calls the High Renaissance. For Condivi, too, he reigns supreme, but he resides far beyond the

reach of all others. In the earlier biography, artistic 'grace' plays a crucial role as the invention and distinguishing feature of the High Renaissance, so that Michelangelo, Leonardo, and Raphael share credit for its perfection. In the later text, however, Michelangelo shares nothing with anyone. Condivi denies debts, affinities, and even friendships between Michelangelo and his peers. Correspondingly, the language of the text emphasizes his divinity and uniqueness, eschewing the modish terminology that characterizes Vasari's work. Using the word 'grace' more sparingly in Condivi's biography, in other words, is a means of extracting Michelangelo from Vasari's totalizing narratives of art history, of rejecting the kinship dramatized in the earlier account of his life, and of vaunting the singularity of the Florentine artist.

It is not, however, that Condivi eschews grace entirely. On the contrary, he offers readers an alternative interpretation of the word showing how Michelangelo strives to perfect a different kind of grace in his life and work. Rather than a nonchalant master of the most graceful of graces, as Vasari would have it, the artist—in Condivi's portrayal—strives diligently to prepare himself for the arrival of the divine spark of creative genius, in other words, the grace of God's divine gift. Living simply, despite his great wealth, says Condivi, Michelangelo denies himself the pleasures of the flesh and devotes himself entirely to nurturing his God-given talents. Through painstaking observation and imitation of nature, careful practice of colour and design, and long study of scripture, literature, and the necessary arts of anatomy and geometry, he turns that talent into fertile ground for God's grace to thrive. Where Vasari's artists must in the final act of painting demonstrate flair and spontaneity, however, Condivi's Michelangelo still struggles and strives. The more laboriously wrought his work, in fact, the more beautiful it is. For Condivi, grace was not so much an effect one sought to achieve by concealing effort but a prize one hoped to receive from God through manifest hard work, sacrifice, and devotion to one's art. His concluding remarks on the Sistine Chapel make a point of the damage done to Michelangelo's eyes from looking up at that ceiling so intensely and for so long. 'From this', he says, 'we can realize with what attention and assiduity he applied himself' (Per questo possiamo considerare con quanta attenzione e assiduità facesse quest'opera).[13] Vasari, too, recognized the marvellous thought and care that went into the Sistine frescoes, though in his account, the mention of thought and care is dwarfed by the extensive eulogy of his inspired genius. Grace is crucial to both biographers, but the difference in emphasis between Vasari's effortless brilliance and Condivi's devout diligence reveals profoundly divergent understandings, not just of grace but of art itself.

Condivi's account of Michelangelo's generosity towards other artists offers the most articulate condemnation of Vasari's classically inspired grace and the most visible promotion of that other, theologically inspired one. Michelangelo was never jealous of the works of others, Condivi says, and praised them universally. He was, nonetheless, capable of damning with faint praise. He subjected the grace of Raphael to just this treatment. Condivi reports that all he ever heard Michelangelo say of his rival was that he 'did not have this art from nature, but from long study' (Solamente gli ho sentito dire che Raffaello non ebbe quest'arte da natura, ma per lungo studio).[14] This most backhanded of compliments strikes at the heart of Raphael's grace as praised by Castiglione, Vasari, and Dolce. It lays bare the hard work that went into the younger artist's most dazzling executions and thus punctures a hole in the subtle veil of his *sprezzatura*. As he shows up Raphael in this way, Michelangelo reveals acute awareness of the discourse of effortless grace. Unimpressed, he shrugs it off in this one devastating line.

While he dismisses effortless grace, says Condivi, Michelangelo also shows utter disdain for the courts in which it had become common currency. He learned early on in his career the reciprocal nature of grace, the fact that it begets the grace and favour of patrons and peers. For commentators like Castiglione, winning grace and favour is a fact of life and, indeed, the raison d'être of courtiers who are advised to show grace in order to win the hearts and minds of the princes they serve.[15] For Michelangelo, however, the exchange of favours inherent in the contemporary court structure is its greatest flaw. It arouses envy between peers and places them at the mercy of their patrons' whims and fancies. The artist had suffered endless persecution for the favoritism shown him by Pope Julius II and Pope Leo X in Rome. As a result, he began to shun the company of men and to lock himself away as he worked. It comforted him, Condivi says, to know that the current pope, Julius III, was discerning enough to pardon him for his absence at court and to have his goodwill accepted instead. In refusing his patron's invitations to court, Michelangelo made perfectly clear what he thought of court culture with its interconnections, rivalries, and market economy of favours. Michelangelo was, of course, unable to extract himself entirely from the bonds of grace and favour: that his official biographer commended the current pope for his discerning attitude towards Michelangelo was in itself a form of flattery. But the distance he now kept at least excused him from the indignity of having to please peers and the courtly community as well.

Reading Condivi's biography from the perspective of grace reveals how little purchase Vasari's ideal of art without artistry had on Michelangelo.

For the latter, grace was indeed the ultimate aim of artists, but it was far more than a performance of nonchalance and ease aimed at pleasing princes and peers. Grace, for him, was a gift from God bestowed on those who laboured to develop their talents. The highest art was not that which pleased the courts, but that which brought artists and viewers alike closer to the majesty and mystery of the divine. Michelangelo put God back into grace and, in so doing, distinguished himself from rivals who opted for a more worldly understanding of the term.

The Achievement of Grace

Condivi seems to suggest that Michelangelo's sense of what makes artists excellent is modelled on Christian doctrine. Good Christians cultivate faith, taking the Bible as their guide, and devote their lives to learning and obeying the precepts of the church; thus prepared, they hope to receive the gift of God's grace. In similar fashion, excellent artists cultivate natural talent, taking Nature as their guide, and invest vast amounts of time and energy into learning the tools of their craft; in turn, they hope to receive the spark of divine genius in the execution of art. One achieves God's grace in art, as in life, by revealing—not concealing—the hard work that goes into virtue. Far from a reciprocal object of exchange, this grace is one-directional, rained down on the worthy. It cannot be earned but is offered freely to those who prepare themselves to receive it by working hard and keeping the faith. By Condivi's account, in other words, Michelangelo cultivated an aesthetic of difficulty that bore a close kinship with his religious beliefs and was thoroughly implicated in his quest for divine grace.[16] But what, exactly, is this aesthetic of difficulty, and how did he articulate it in his work?

Michelangelo learned young about the difficulty of artistic achievement.[17] He made no attempt to conceal the sweat, pain, and sacrifice that art required in his sonnets, letters, and images. His concern, however, was not with producing work that bore the physical signs of his labour (although his unfinished works spectacularly do), but with creating art that overcame technical and conceptual challenges, then drew attention to the extent of their achievement. Rather than just please viewers with sweet and graceful images, Michelangelo sought to amaze them with his artifice and to astound them with the loftiness of his inventions. His renowned *terribilità* amounted to a desire to advertise—and not conceal—the complex, almost sophistical, characteristics of his work.[18] An early glimpse of this aesthetic of difficulty is to be found in the signature carved across Mary's breast in the Vatican's 1499 *Pietà*.

FIGURE 18. Detail of Michelangelo Buonarroti, *Pietà*, 1499. Marble. St Peter's Basilica, Rome. Courtesy of the Fabbrica di San Pietro in Vaticano. See plate 8 for an image of the *Pietà* in full.

Most unusual for its prominence and wording, the inscription 'MICHAEL. AGELVS. BVONAROTVS. FLORENT. FACIEBA[T]' is a most emphatic declaration of the time, skill, and effort spent in creating the image and a clamorous assertion of the twenty-five-year-old Michelangelo's desire that that labour be attributed to him (fig. 18 and plate 8).[19] There is a sense here that the *Pietà* is not just a commissioned art piece but a deeply felt offering whose misattribution would amount to the greatest injustice. Vasari says as much in his 1550 *Vite*, when he claims that 'Michelangelo put into his work so much love and effort that (something he never did again) he left his name written across the sash over Our Lady's breast'. In his 1568 edition of the *Vite*, Vasari adds the anecdote that Michelangelo was reacting to a crowd of strangers from Lombardy who misattributed the sculpture to the Milanese Solari. 'Thinking it very odd to have all his efforts attributed to someone else', Michelangelo allegedly shut himself in with a chisel at night and carved his name in a place that would be visible to all.[20] Given the placement of the band across Mary's breast and the way her garments pucker round it, it is almost certain that this anecdote is not true. Michelangelo must have conceived of the band, which serves no function other than to carry his signature, sooner rather

than later in his execution of the piece.[21] Nevertheless, the fact remains that Michelangelo, like Vasari, wished to emphasise 'all the effort' that went into his *Pietà*, to make a display of the skill and expertise, as well as the spiritual and intellectual deliberation, it required.

Michelangelo's signature reveals his close attachment to the difficulty of sculpture. At the same time, it also encodes the opposite ideal, a contradictory desire to be associated with the nonchalant spontaneity of what Castiglione would later call *sprezzata disinvoltura*. This was one of the first times an artist of Michelangelo's era had opted for *faciebat*, the imperfect tense of *facere* (to make), as opposed to the more common simple past *fecit*. The choice of tense suggests the unfinished nature of the *Pietà* and implies a certain modesty about its execution, a desire to give the sense that the artist had been snatched in an untimely way from his work. Pliny had noted the practise in the preface to his *Natural History* and had complimented it as a praiseworthy show of humility. Poliziano had discussed it in his *Liber miscellaneorum* ten years before the *Pietà*, and since Michelangelo knew Poliziano in person, it was quite likely that he was well aware of its classical heritage.[22] Critics have almost always read Michelangelo's *faciebat* as a defence against criticism, a means of claiming that he had 'intended, if not interrupted, to correct any defect noted', as Pliny had put it. Yet it can also be seen as a gesture of nonchalant *sprezzatura*, one that draws attention to the work's imperfection even as it suggests that, with the necessary time, the artist would have brought the work to completed perfection. As such, it anticipates the willed imperfection recommended in Castiglione's *Cortegiano*. In music, says Castiglione's da Canossa, introducing the odd note of discord or imperfection into otherwise flawless playing keeps an audience keenly engaged. Roused by imperfections, they await perfect harmonies and enjoy them all the more when they come. Michelangelo's *faciebat* seeks a similar response: wonder amongst spectators at what the artist might have achieved if only he'd been allowed to finish, and eager anticipation of what perfect art forms will come next. As it happens, the aspiration backfired. Any effect of nonchalant spontaneity Michelangelo might have achieved was belied by the polish and utter completeness of his sculpture. He regretted the gesture and never repeated it. The impression remained, nonetheless, of an ambivalence in the artist's mind. On the one hand, there was a tendency towards an aesthetic of difficulty, which broadcast the intellectual and technical difficulties it had to overcome. On the other, there was a wish to be viewed as spontaneous and natural, to impress spectators with the grace and ease of classical art. This uneasy coexistence of religious and classical ideals pointed to

a further division in Michelangelo's mind between spiritual and earthly themes. As time went on, the spiritual overcame the earthly until by the end of his life he felt that all his earthly pursuits—even art—had abandoned him. 'Painting and sculpture soothe the soul no more', he says in his final years, 'its focus fixed on the love divine, outstretching / on the cross, to enfold us closer, open arms' (Né pinger né scolpir fie più che quieti / l'anima, volta a quell'amor divino / c'aperse, a prender noi, 'n croce le braccia') (sonnet 285).[23] At twenty-five, however, earthly and spiritual concerns jostled with one another. The grace that dissimulated effort, gave the impression of nonchalance and ease, and aimed at impressing worldly patrons had not yet ceded to its loftier counterpart, the one that revelled in difficulty, shunned vulgar appreciation, and fixed on the ultimate goal of 'the love divine'.

The *Pietà*, in sum, is a meditation on divine grace that uneasily combines a spiritual aesthetic of difficulty with a worldly aesthetic of effortlessness. On balance, however, it is the more difficult grace that wins out. For what is the ultimate subject of this *Pietà*? The simple answer is divine grace. According to Christian doctrine, God bestowed the gift of grace on humankind by sending his son to die on the cross. Thanks to the Crucifixion, Christians can identify with Christ's martyrdom, believe in his resurrection, and hope for their own assumption into Heaven after death. By portraying the hour of Christ's death, the *Pietà* exhibits the very moment of Christian salvation and the means by which Christians are saved. At the same time, it depicts the operation of grace through the figure of Mary, the first and most important recipient of God's gift. Because she keeps faith, even at Christ's death, Mary receives divine grace and is spared the most devastating maternal grief. It is grace that enables her to accept and transcend the appalling reality of her son's torture and death. In the absence of any perceptible evidence, it is grace that fuels her belief that this is not the end but the beginning of Christ's eternal life in Heaven. Michelangelo's depiction of Mary as this serene and exceedingly beautiful woman is a sculptural expression of the 'Ave Maria, gratiae plena'. It is a hymn to the grace that shields the elect from mortal concerns, conjoins them with the love of God, and grants them life everlasting.[24] At the same time, it is a supplication to God for the grace that inspires creativity, renders the artist divine, and earns him immortality even after his own death.[25]

Most Michelangelo scholars observe a turning point in Michelangelo's aesthetic and religious outlooks precisely in those years when he was suffering from the ascendancy in Rome of Raphael. It is in these years, I would argue, that grace comes to mean, for Michelangelo, something precise and unambiguous in its Christian terms of reference. Following

his charmed early career, the second decade of the fifteenth century saw Michelangelo struggling to wrest commissions from the popular young Raphael. If the grace of the first *Pietà* secured Michelangelo papal patronage at the turn of the century, there can be no doubt that his rival's grace lost him the contest for artistic supremacy in Rome soon after. Raphael rose to fame as effortless grace incarnate, in character as well as in his art. Michelangelo's exacting style and difficult character, by contrast, cost him the absolute papal favour he had previously enjoyed. Numerous accounts testify to the fact that both Pope Julius II and the famously sensualist Pope Leo X preferred Raphael's sweet and serene style over Michelangelo's more serious and grandiose art. Moreover, Raphael's congenial personality appealed to the humanists, poets, and musicians who surrounded the popes, while Michelangelo's obdurate character inspired fear, as Sebastiano del Piombo's letters affirm.

Michelangelo's sonnets of this period demonstrate his intolerance of the vagaries of the papal court and the fickleness of its leaders.[26] In one, he criticises the patron who spurned him in favour of some bold contender. If Karl Frey's dating of 1511 is correct, this sonnet alludes to Pope Julius II and to his dealings with Raphael, who sought, with Bramante's support, to supplant Michelangelo as lead artist in the Sistine Chapel, and to obstruct Michelangelo's progress on Julius's tomb (together they convinced the pope that it would be bad luck to have his own tomb completed during his lifetime and so had the contract suspended). Alternatively, the sonnet may have been written later, and allude to Leo X, who, as we saw earlier, cast Michelangelo aside to favour the younger artist with the best architectural and artistic commissions of the day. Whatever its date of composition, the sonnet describes the same delicate patron–protégé relations discussed in Castiglione's *Cortegiano* and criticised both in Francesco del Cossa's frescoes and on Ariosto's emblem page. Yet while the *Cortegiano* devises strategies for flourishing as a protégé and Ariosto prescribes grace as a ballast against its ills, Michelangelo rails against both strategizing and counterbalancing. Having lost his patron's good grace, he criticises those who simulate loyalty to win favour. More to the point, he condemns those gullible princes who fall for the trick. The gullible prince in question had believed idle talk and lies, sidelining Michelangelo to reward an enemy instead: 'You've believed those fables and false words and rewarded an enemy of truth' (Tu hai creduto a favole e parole / e premiato chi è del vero nimico, no. 6).[27] The same prince had failed to recognise Michelangelo's labours as signs of true virtue, so that the harder he tried, the less he appealed:

I am and was your loyal servant of old;
Given to you like rays to the sun.
My time causes you no sorrow or self-reproach,
The more I toil, the less I please.

(I' sono e fui già tuo buon servo antico,
a cte son dato com e' raggi al sole,
e del mie tempo non ti incresce o dole,
e men ti piaccio se più m'afatico.) (no. 6)

Hard work, it seems, is no virtue for these patrons, but an impediment to success. He had hoped to advance his career, but the times are such that true virtue is no longer rewarded. Instead, it is implied (albeit somewhat cryptically), the appearance of virtue is all:

Thanks to your eminence, I had hoped to rise up
and that the just scales and the powerful sword
would respond to need, not to the sound of echoes.
But Heaven is that which disdains planting
each virtue in the world, [as if] wanting all to
pluck fruit from a tree that is barren.

(Già sperai ascender per la tua alteza,
e 'l giusto peso ella potente spada
fussi al bixognio, e non la voce d'eco.
Ma 'l cielo è quel ch'ogni virtù dispreza
locarla al mondo, se vuol ch'altri vada
a prender fructo d'un arbor ch'è seco). (no. 6)

Here, as in the *Courtier*, those who flatter princes and simulate virtue thrive, while those who are seen to toil lose favour. For Michelangelo, though, the end of securing patronage and—as Castiglione would have it, of guiding the prince along the path of virtue—does not justify, as it does for Castiglione, the means of flattery, simulation, and concealed effort. On the contrary, Michelangelo rejects such tactics outright and opposes the culture of currying grace and favour. In so doing, he intimates a mode of operating diametrically opposed to Raphael's—the ethos, in fact, captured in Condivi's account so many years later.

 Though disparaging of the machinations of the papal court, Michelangelo was nonetheless bound by its rules, and he struggled to produce any work without the patronage and protection of the popes. Those first years spent 'piangendo' (crying) in Florence (as Condivi puts it) were arid and

frustrating. He spent the years 1516 to 1519 working on a wooden model for the San Lorenzo façade, sourcing marble in Carrara, and then, on Leo's orders, establishing a new marble quarry in Pietrasanta. During this time, scarcely any new pieces appeared. One of the few completed projects of those years was a Man of Sorrows, a depiction of Christ bearing the instruments of his Passion.

This life-size figure, the *Cristo di Santa Maria sopra la Minerva*, was commissioned by Michelangelo's Roman friend Metello Vari in 1514 and completed between 1519 and 1520 (fig. 19 and plate 9). Vari had requested a life-sized marble figure of Christ, standing naked with a cross in his arms, and he had granted Michelangelo artistic freedom to design the pose as he saw fit. It is precisely in the pose, critics contend, that Michelangelo most departs from his own earlier style, revealing a change in aesthetic outlook, the beginnings of what has been called 'a new ideal'.[28] Accompanying this new ideal was an intensified engagement with Christian doctrine, 'a serene evangelical conception', as Charles de Tolnay put it many years ago.[29] Behind this modification in style and enhancement in religious attentiveness lay a clearer understanding of grace and of what it signified for Michelangelo. The concession made to effortless grace in the 1499 *Pietà* now yielded to its effortful but loftier counterpart.

Traditionally, devotional images of the 'Man of Sorrows' bore not just the instruments (the *Arma Christi*) but the wounds of his martyrdom. They were inspired by *Isaiah 53* and meditated on Christ's suffering and the pain of Crucifixion:

> He is despised and rejected by men, a man of sorrows, and acquainted with grief: and we hid as it were our faces from him; he was despised, and we esteemed him not. Surely he hath borne our griefs, and carried our sorrows: yet we did esteem him stricken, smitten of God, and afflicted. But he was wounded for our transgressions, he was bruised for our iniquities: the chastisement of our peace was upon him; and with his stripes we are healed. (*Isaiah* 53:3–5)

In conventional depictions, Christ's contorted body evoked the abjection and grief of his Passion. Blood spurted more or less liberally from his side where the soldier's sword pierced him, and from his hands and feet where nails bound him to the cross. The crown of thorns tore into his scalp, and he often pointed to his own wounds further to emphasize his suffering.

In Michelangelo's Christ, however, the emphasis is on the victory over pain that God granted to his son. Though he holds the cross that killed him, it is a very light affair and does not weigh him down. No wounds

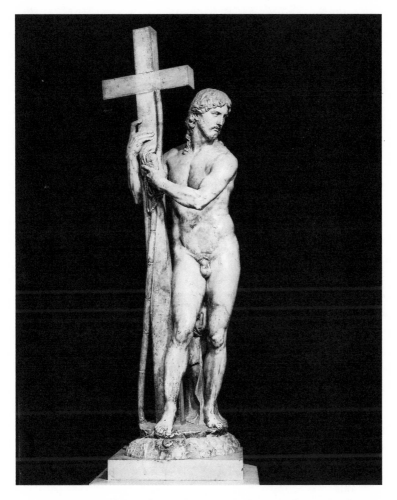

FIGURE 19. Michelangelo Buonarroti, *Cristo di Santa Maria sopra la
Minerva*, 1519–1520. Marble. Santa Maria sopra la Minerva, Rome.
Courtesy of Fine Art Images / Alinari Archives, Firenze.

appear on his perfectly formed and resplendent body, and he does not
wear the crown of thorns. He holds the cross to his right side with both
hands and turns his head and lower body away from it. The right leg, in
fact, nudges it behind him, and the curve of his torso gives the impression
that he could place it to one side and walk away at any moment. This is a
new conception of the Man of Sorrows. Unlike its predecessors, this one
downplays the *Arma Christi*. As almost everyone who has commented on
this sculpture points out, this Christ refuses to make a display of his agony;
he endures, conceals, and bears it, instead, with stoicism and serenity. In
doing so, he encourages us to look beyond the hour of the Passion towards

the spiritual resurrection beyond it and the redemptive power of God's grace. Following the mortification of his flesh, Christ rose again. The suffering was not in vain, for his death ensured the redemption of the faithful who, like him, would be assumed into Heaven after death. The invitation in the *Minerva Christ* is to ponder less Christ's physical agony than the miracle of his recovery. With his gaze directed away from viewers and towards the altar of the Santa Maria della Minerva Basilica, this Christ asks us to contemplate God's grace and its miraculous, transformative qualities.[30] Like the 1499 *Pietà*, divine grace is the ultimate subject of the *Minerva Christ*. And like the *Pietà*, it draws attention, as well, both to the sculptor's investment in the subject and to the difficulties he had to overcome to represent it. In this sense, the *Minerva Christ* is a veritable performance of his own struggle for divine favour, a new depiction of the suffering Christ and a portrait of the artist rolled into one.

From the perspective of grace, it is plausible to read in the *Minerva Christ* traces of Michelangelo's recent experience, of his firsthand exposure to social exclusion and persecution, his new appreciation of the solitary nature of human suffering, and, at the same time, his renewed belief in the redemptive power of God's grace. If, as he was to say in a later sonnet, created works bear close kinship to their creator, this redeemed Christ could be said to reflect the disposition of one who also bore his suffering with noble composure, who resolved to place persecution behind him, and who fixed his eyes more firmly than ever before on the higher rewards of artistic and spiritual endeavour.[31] Further identification between creator and created work is to be found in the rope, sponge, and bamboo rod in Christ's left hand. In Christian iconography, the rope represented the cords that bound Christ in prison the night before his crucifixion, the sponge was the means by which gall and vinegar were offered to quench his thirst, and the reed was placed in his hands as a sceptre in mockery. But rods, sponges, and ropes were tools that could just as easily be found in a sculptor's studio. Opting for these—as opposed to, say, the crown of thorns, the veil of Veronica, or the soldier's lance—was an unusual choice, one that emphasised Christ's humanity rather than his singularity, and pointed up a subtle link between the instruments of his passion and the familiar tools of Michelangelo's labour. As in the *Pietà*, Michelangelo seems to be making a veiled reference here to his own workmanship, to his quotidian labour, and to the skill and effort that goes into art. One could go so far as to suggest that the rod represented the sceptre given to Michelangelo himself in the Rome that so quickly dethroned him. Without wishing to over-biographize his work, the sculpture seems to liken—in the

subtlest of ways—his own travail to the sufferings of Christ, comparing its instruments to those of the *Arma Christi* in the attainment of God's grace.

For Michelangelo, then, the only grace worth talking about involves difficulty revealed. In response to Benedetto Varchi's invitation to compare the arts of painting and sculpture, Michelangelo wrote that sculpture had been, in his view, 'the guiding light of painting' (la lanterna della pittura), the sun to its moon because of the greater 'iudicio e difficultà, impedimento e fatica' it required.[32] Judgement and difficulty, impediment, and effort made the accomplishment of an image in stone superior to its counterpart in painting. Having read Varchi's views on the matter, however, he claims to have changed his mind and now to hold painting and sculpture in equal esteem. Clearly, the *paragone* between the arts did not really interest him 'because it occupies more time than executing the figures themselves' (perché vi va più tempo, che a far le figure).[33] Nonetheless, by pairing *iudicio* with *difficultà*, he also makes it clear that difficulty was not just about the physical effort of sculpting, the hard graft of chipping, chiselling, modelling, and polishing. It applied equally to the conceptual difficulties of sculpture. Conceptual achievements, in fact, were what raised sculpture and painting above manual crafts and other forms of physical labour. The fine arts required such powers of perception, knowledge, and know-how that they were worthy of a high standing amongst the liberal arts. The most difficult subject to sculpt or paint, technically and conceptually, was the living human figure. Describing the effects of life on flesh and bone—thought, emotion, movement, and so on—was an almost insurmountable *impedimento*. But depicting the most perfect human being, the son of God, and the most perplexing of divine mysteries, the workings of grace, required the greatest *fatica* of all. There could be no worthier subject, no greater *difficultà*, and therefore no greater accomplishment than that. The originality of the *Minerva Christ* bears witness to the degree to which Michelangelo took the *fatica* seriously. In reconceptualising Christ redeemed by grace, he was rethinking grace itself. Once he had mastered the challenge of representation, he had mastered grace too, or come as close—at least—as any living mortal could hope to do. Grace had come to mean more than an object of his attention, it was his *via dolorosa*, the cross he chose to bear, and the means of his own artistic as well as spiritual redemption.

This embodied and introspective religiosity was a far cry from the showy piety of the church in Rome. In fact, the *Minerva Christ* emerged during a time when Michelangelo was keenly aware of the worldly ecclesiasticism of church leaders and openly opposed to their materialism and belligerence. We saw this earlier in his criticism of one of his pope-patrons.

In another sonnet, most probably written in 1512, Michelangelo lashes out once more against the Vatican, challenging this time its misguided investment in activities and objects of no value.[34] It is especially wicked, he suggests, when the contemporary patrons who value the appearance of things are distinguished leaders of the church, for the riches they lavish on unworthy objects belong to the church and should be put to loftier use. God has no place in Rome if 'the blood of the Saviour is sold with both hands' (e' l sangue di Cristo si vend'a giumelle), 'helmets and swords are made from chalices' (qua si fa elmi di calici e spade), and 'cross and thorns become shields and lances' (e croce e spine son lance e rotelle).[35] In an act of resistance to such materialism, Michelangelo represents neither blood nor chalices nor thorns. He features, instead, rope, sponge, and rod— objects of no real monetary value—and depicts one who thrusts even these most humble of symbols behind him. In doing so, he suggests that spiritual redemption will not come to those who profit from the church. God's grace will not rain down on popes who sell the blood of Christ and close Rome's streets to virtue. It will be bestowed on those who, like Christ—and Michelangelo himself—are serene in the face of human suffering, unfettered by worldly goods, and dignified in their unadorned spirituality.[36]

To state that Michelangelo's devoutness had an increasing impact on his work is not to suggest that he did not continue to be profoundly influenced by the secular arts of classical antiquity. The point is not that his work became solely devotional, single-mindedly focused on the acquisition of divine grace, and wholly devoid of other interests. It is that Michelangelo resisted the fashionable trend to conceal the artistry and artifice of art and refused to cultivate the grace retrieved by his contemporaries from the ancient world. Ancient sculpture inspired and instructed him throughout his career, and he was in perpetual dialogue with his classical forebears. Increasingly, though, what he learned from the ancients was called evermore into the service of his spiritual and artistic quest for God's grace. In this sense, too, the effortless grace practised by the ancients yielded to the transcendental grace of the Christian era.

Lessons learned from the pre-Christian *Laocoön Group*, for example, became instrumental in expressing the enigma of Christian grace and the hardship required to prepare for its reward. The *Laocoön Group* was discovered in Rome in 1506.[37] The ancient sculpture of the Trojan priest punished for warning the Trojans against bringing the Greek wooden horse into their city astounded the Renaissance art world. There was its technical accomplishment, its massive scale, and its expert composition.[38] And there was the dynamism and expressivity of its serpentine form.

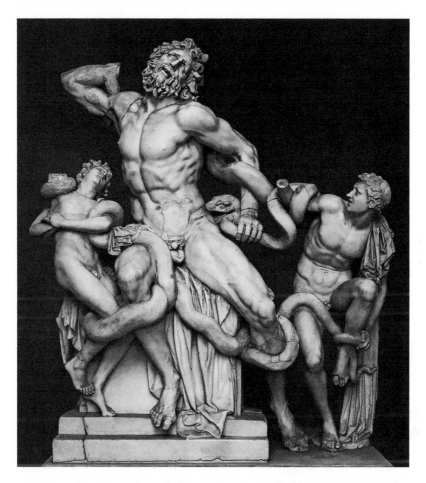

FIGURE 20. Anonymous, *Laocoön Group*, ca. 42–20 BC. Marble. By permission of the Museo Pio Clementino, Vatican Museums © Musei Vaticani, Rome.

So many human emotions—fear, paternal anguish, anger, pain—were captured not just in the eloquent face but in the torsion of Laocoön's midriff as he and his two sons are crushed to death by two enormous sea serpents (fig. 20). The vivid sense of movement and the torturous physical effort the father makes to twist himself away from his fate and beyond the limits of his anatomy left its mark on many of Michelangelo's later sculptures, most notably the rebellious slave and the dying slave of Julius II's tomb. He had been summoned by Julius II to the scene of the statue's discovery in an underground room in a vineyard outside Rome and wrote enthusiastically about its effects on him.[39]

Here, in his Man of Sorrows, those effects find their earliest nonverbal expression.[40] Christ's suffering, as mentioned before, is not visible in the

crown of thorns, the effusion of blood or the golden chalice traditionally associated with the Crucifixion, but that is not to say it is not present at all. The cross, of course, is a most eloquent symbol of his torture—how could it not be? But here, the Passion is chiselled into Christ's Laocoön-inspired body as well. His serpentine form creates a sense of movement in two directions. His chest and arms face the cross, suggesting he is about to turn towards it and embrace it. The twist of his neck and head, by contrast, and the forward step of his right leg suggest movement in the opposite direction, towards his everlasting future with God.[41] In this way, his anatomy embodies the paradox of the Crucifixion—the agony and the ecstasy.[42] Ultimately, the movement towards God triumphs: the victory is with grace; but it is the pre-Christian *figura serpentinata* that best enhances and compounds this most Christian of messages.

God-Given Grace

Michelangelo's invocation of spiritual grace through art finds mature expression some forty years later in the *Colonna Pietà* (fig. 21). This drawing was intended as a gift for Vittoria Colonna, Marchesa di Pescara (1492–1547), whom we have already encountered in this book. Michelangelo met Colonna in Rome around 1536, and the two struck up a close friendship that was to last till her death in 1547. One of several presentation drawings he gave her during their friendship,[43] this *Pietà* is framed by an epistolary exchange that yields invaluable insights into Michelangelo's meditation on grace as an artist and as a Christian. An unbidden gift intended to surprise and delight his friend, the *Colonna Pietà*, like the *Minerva Christ*, was free from any of the constraints placed on commissioned art in terms of its content and style. The choice of subject was entirely Michelangelo's, and he selected one both dear to his heart and reflecting his friendship with Colonna.

The artist had, by the time he met Colonna, returned to live in Rome. Following Raphael's death in 1520, he had no more rivals in the art world, and the most important papal commissions were once again his for the taking. Under Clement VII (who had succeeded Leo X in 1521), he had even gained the unprecedented honour of being called on to judge the works of other artists: 'Everyone was always asking for his opinions', says Antonio Forcellino, 'or for one of his sketches, and people were quite contented with works planned by him but executed by his friends'.[44] At the time of meeting Colonna, he was employed as the 'Supreme Architect, Sculptor, and Painter of the Vatican Palaces' (with the highest salary ever

FIGURE 21. Michelangelo Buonarroti, *Colonna Pietà*, ca. 1538.
Black chalk on paper.
Courtesy of the Isabella Stewart Gardner Museum, Boston.

paid to any artist), and working on his most *difficile* and accomplished work of all, the Sistine Chapel's *Last Judgement*.

Deeply religious, Colonna had renounced the aristocratic courts into which she was born upon the death of her husband, the Marquis of Pescara, Ferrante Francesco d'Avalos. She retired to a life of contemplation in various convents where she applied her humanistic education and considerable talent to writing the poetry that gave her wide acclaim. Her earliest published sonnets, as we have already seen, were dedicated to the memory of her husband, but her art turned increasingly towards spiritual matters. Since the mid-1530s she had belonged to the circle of cultivated

men and women who gathered around the figure of Cardinal Reginald Pole in Rome and, later on, at the monastery of Santa Caterina in Viterbo to discuss matters pertaining to the inner reform of the Catholic Church. Influenced, no doubt, by this distinguished company of intellectuals, the focus of her poetry shifted in those years from honouring her deceased husband to exploring her profound spirituality.[45] In the *rime amorose*, grace denoted d'Avalos's glorious qualities as well as the metaphorical ladder he extended from his post-mortem seat in the heavens to her ardent, mourning soul on earth. In the *rime spirituali*, this individual grace was subsumed into the sacred grace of God and his divine Son, raining down on the collective souls of all humankind, slaking the thirst of the faithful for justification, the remission of sins, and eternal life.

Divine grace was, of course, of the utmost importance to European reformers seeking the spiritual revitalization of the Christian faith and the reform of its doctrine and religious ideas.[46] Martin Luther's belief that grace could be gained by faith alone and that salvation was available only to those whose spirituality was direct, unmediated, and irrespective of the rites and practises of church law spread through Europe, where it was quickly perceived as a most serious threat to the fabric of the Roman Catholic Church. The institution that relied for its existence on a close adherence to ritual and strict obedience to figureheads condemned Luther as a heretic and his doctrine of justification by faith as heretical. The sixth session of the Council of Trent, convened in January 1547 (a month before Colonna's death), made its position crystal clear: God's grace was reserved for those faithful Christians who observed church law, received the sacraments, and acted according to the church's teachings. Faith alone did not suffice for the obtaining of grace, and anyone who suggested that this was the case would be excommunicated.[47]

In the years leading up to this unequivocal condemnation of reformation theology, though, there had been hope in Italy of reconciliation between the Protestantism of the North and the traditionalism of Rome. Cardinal Pole's evangelical circle at Viterbo (including Colonna) sought a 'third way' that would reunite the church and its detractors and avoid the crisis that was already costing lives. Their conviction was that God's grace could be gained through faith, but that good works had the power to accentuate the truth and the righteousness of that faith. A short work entitled *Il beneficio di Cristo*, which was published anonymously in 1543, articulated the group's beliefs.[48] The emphasis here was very much on faith as an inner journey, a personal commitment binding the individual to God. Chances of

receiving grace could be improved by good works and obedience to church law, but they did not depend on it. Faith alone was key.

Conciliatory doctrine pervades Colonna's spiritual sonnets, which resound with the metaphorical language common to both reformers and orthodox theologians. For her, as for partisans from both sides of the religious divide, God's grace springs from a celestial fount; rains down from Heaven on fertile plains to bear fruit; melts frozen hearts; sets the world afire; illuminates the earth with divine light; and cleanses it with a wave of sacred benevolence.[49] In all camps, grace is granted to those who believe Christ's advent to have radically changed the lines of communication between God and mortals, instituting a more direct and loving relationship between them. Colonna celebrates this change, acknowledging in 'Quando di sangue tinte in cima al monte' (S1:42) that Christ's crucifixion marked a transition from the anger pervading Old Testament laws ('l'ire disperse / già ne l'antica legge') to the ardent love and charity that characterised the New Testament. In 'Le braccia aprendo in croce' (S2:94), she again confirms that the 'harsh but just law of fear' (l'aspra e giusta legge del timore) that characterised the Old Testament had yielded, thanks to His ultimate sacrifice, to 'much-desired peace', 'blissful bounty', and 'grazia, lume, amore!' (grace, light, love!) (S2:94). Such celebration chimes harmoniously with *Il beneficio di Cristo*, which also credits Christ's coming with the conversion of Old Testament 'timore servile' into New Testament 'timore filiale' and with the transformation—thanks to His crucifixion—of the children of God's anger (long-suffering since Adam and Eve's original transgression) into the offspring of His love.[50] It resonates just as profoundly with Roman Catholic orthodoxy, according to which 'that state in which man is born a child of the first Adam' becomes (through 'the second Adam, Jesus Christ, Our Saviour') a 'state of grace and of the adoption of the sons of God' (*Canons and Decrees*, 31).

Yet although Colonna's interpretation of grace steers a conciliatory path between Protestantism and Catholicism in certain respects, in other respects it manifests itself in ways that were soon to be declared heretical. Indeed, her doctrinal leanings, as well as her associations with the Viterbo circle, were to draw the suspicion of the Roman Inquisition, testifying both to the dangerous uncertainty of her times and to the daring of her outspoken beliefs. Of particular concern for the Roman Inquisition were Colonna's confidence in predestination and her belief that faith—as opposed to 'fragile, mortal works' (as she calls them in S1:42)—was the true source of God's grace.[51] The *rime spirituali* time and again revel in

the unadulterated joy of the deeply personal cognitive change heralded by 'la grazia divina'. As the sonnet 'Quando io riguardo il nobil raggio ardente' (S2:15) declares, divine grace illuminates the intellect (illustra l'intelletto) and inflames the heart (infiamma il core) with superhuman virtue (virtù sovra umana). Concentrating one's mind and one's soul's every desire on honouring God's grace draws the light and fire of His favour, till one gains complete confidence in predestination and in one's own election amongst the hordes of the Saved. For Colonna, such confidence pleases God, the author of our every good, but the Council of Trent was to declare it 'rash presumption'. Reacting against reform-minded faith like Colonna's, Tridentine legislation retained a degree of Old Testament 'fear and apprehension', declaring that 'no one can know with the certainty of faith . . . that he has obtained the grace of God'.[52] The canons and decrees of the Council of Trent would insist in the very year of Colonna's death on 'the gift of perseverance' and on the frequent renewal of faith through the observance of the Ten Commandments, the ritual undertaking of the sacraments, and the execution of good works. Viterbo intellectuals, by contrast, privileged not timorous uncertainty but a perfect, saintly spiritual happiness as the preserve of those who entered 'nel regno della grazia evangelica' (into the kingdom of evangelical grace).[53] They advocated a confidence in God's saving grace that could neither be purchased nor be bargained for by good works, as the following pronouncement makes clear:

> I giustificati per la fede, conoscendosi giusti per la giustizia di Dio, eseguita in Cristo, non fanno mercatanzia con Dio delle buone opere, pretendendo con esse di comprar da lui la giustificazione; ma, infiammati dello amore di Dio e desiderosi di glorificare Cristo, il qual gli ha giustificati, donandogli tutti i suoi meriti e tutte le sue ricchezze, attendono con ogni studio a fare la volontà di Dio, e combattono virilmente contro allo amor proprio e contro al mondo e al diavolo.[54]

> (Knowing that they have been rendered just through the justice of God as enacted through Christ, those justified by faith do not bargain with God on the basis of good works, and they do not presume to acquire through such works their own justification. Rather, inflamed with the love of God and wishing only to glorify Christ who justified them and bestowed upon them their every merit and richness, they invest every effort in carrying out God's will and in fighting viciously against self-love, the world, and the devil.)

Colonna's faith was clearly of this bent as she asserts in the sonnet just quoted that neither our effort (nostra industria) nor our wit (ingegno)

spurs the steady course of our redemption but Heaven's favour in which we should place all our trust (S2:15). Elsewhere she makes it clear that grace brokers no negotiations but operates 'sol per amor' (purely out of love) (in 'Deh! manda oggi, Signor, novello e chiaro raggio', S2:18) and 'sol per viva fede' (only through living faith) (in 'Quando in se stesso il pensier nostro riede', S1:41). Rather than meditate on her 'own weakness and indisposition', as the Council of Trent was to recommend, she espoused reform-minded confidence in a grace that acts as a seal on faith, as *Il beneficio* described it: 'un sigillo, che autentica e sigilla nei nostri cuori quelle promesse divine, la certezza delle quali innanzi ci ha impresse nelle menti' (a seal which authenticates and locks into our hearts those divine promises, the certainty of which it impresses upon our minds).[55] Of crucial importance to the cultivation of this confidence was repeated and profound meditation on Christ's life and ultimate crucifixion. Prayer, the frequent taking of communion, the memory of baptism, and belief in predestination were instrumental in its growth, but each of these practises was a natural consequence of the cognitive change wrought by *sola fides*, acting as accessories to rather than the causes of justification.[56] Not long after the publication of both *Il beneficio* and Colonna's *Rime*, this view of grace was to become anathema, condemned as 'the vain confidence of heretics' by a Council of Trent which decreed:

> It must not be said that sins are forgiven or have been forgiven to anyone who boasts of his confidence and certainty of the remission of his sins, resting on [their faith in the gratuity of Christ's divine mercy] alone. . . . Moreover, it must not be maintained, that they who are truly justified must needs, without any doubt whatever, convince themselves that they are justified, and that one is absolved from sins and absolved and justified, and that absolution and justification are effected *by this faith alone*, as if he who does not believe this, doubts the promises of God and the efficacy of the death and resurrection of Christ.[57]

Yet although they were clearly influenced by Lutheran theology, Colonna and the Viterbo *spirituali* did not see themselves as 'heretics and schismatics' adhering to the 'ungodly confidence' that was 'found and preached with untiring fury against the Catholic Church'.[58] Instead, they sought to promote that church, albeit a version of it that was more spiritual than the present one.[59] Carving out the 'third way' meant entering into doctrinal grey areas and risking the wrath of the authorities, but the leading role played by one of the circle's foremost members, Gasparo Contarini, at the pre-Trent Diet of Regensburg (1541) and the prominent presence

of Reginald Pole at the Council of Trent, where he acted as Pope Paul III's papal legate, testified to the hope they held out for reconciliation. After the failure of Regensburg, though, and certainly by June 1546 when Pole retreated from the council—ostensibly for health reasons—the writing was on the wall for the *spirituali*. Given the increasing scrutiny drawn by their sympathy with Luther's doctrine of *sola fides* over the course of the 1540s, there can be little doubt that reform and the precise nature of divine grace were topics of urgent debate when Michelangelo and Colonna met.[60]

It is not known how that meeting came about (they may have been introduced by Tommaso de' Cavalieri), but by 1539 their friendship was close and famous enough to be recorded by the Portuguese painter Francisco de Holanda in his *Dialoghi di Roma*. De Holanda records conversations between the two about the status of art and the role of the artist, but they must have discussed spiritual beliefs as well and engaged with the religious quarrels of the day, especially since the *Dialoghi* locate their conversations at the church of San Silvestro di Monte Cavallo in Rome, where the noted Dominican preacher Frate Ambrosio Politi had just delivered a discourse on the Epistles of St Paul.[61] St Paul's Epistles were, of course, of paramount importance to Luther's teachings on grace and, indeed, to the deliberations of the Viterbo *spirituali*. Politi's discourse would doubtless have stimulated lively debate of which no comprehensive record exists. Nonetheless, the words and images they exchanged provide ample evidence of their strong allegiance to a deeply felt faith and to close, personal engagement both with the word of the Scriptures and the passion of Christ.

Colonna's sonnet 'Odo ch'avete speso omai gran parte' (S1:145) was one of the many literary and artistic gifts the pair exchanged in the ten or so years of their acquaintance. Included in the gift manuscript she presented to him in 1540, it registered the roles of spiritual mentor and pupil they seem to have assumed and records their shared views on the relationship between art and grace in the scheme of Christian redemption.[62] In it, the poet admonishes the artist for wasting the best part of his early years in the idolatrous pursuit of wealth and on unworthy, secular subjects. In a sonnet that plays on the language of alchemy, she criticizes his youthful attempts to pursue in vain the stone that would turn metal into gold through art ('d'aver la pietra ch' i metalli in oro / par che converta sol per forza d'arte'), and to hope that 'lively' Mercury and 'iron-armed' Mars would restore his honour when he should have fled to the sanctuary of Christ. For only Christ's *vera pietra* (true stone), through the *sol de la sua grazia* (sun of His grace), can transform the lead of our error into eternal gold.[63] An avowed admirer of Michelangelo, Colonna also acted

as his spiritual confessor and one whose unique perspective on matters of divine theology—and on grace—could serve as a model for him. With considerable doctrinal influence, she advocated an approach to art that chimed with Michelangelo's own. She did not discourage art as idolatrous *tout court* (as Calvinism and other forms of Protestantism did), but she did condemn those idols produced 'sol per forza d'arte' (only by force of art) and not under the influence of divine inspiration. In her own youth, the opening sonnet of the gift manuscript confesses, she too had 'nourished a serpent in her breast' (un angue / In sen nudriò), seeking fame through the penning of love poetry.[64] Now, enlightened by evangelical fervour, Christ's passion is the sole spur for writing, His holy nails serving as her quill, His precious blood her ink, His sacred lifeless body her page. In presenting artistic endeavour as a form of religious meditation or 'divine consideration' (to quote Valdesian theology), Colonna offers doctrinal justification of Michelangelo's natural proclivity. As well as endorsing art as an instrument of self-study and discovery, she offered a community of likeminded individuals persuaded of the virtuous role played by visual and literary culture in the reform both of doctrine and of the church in Rome. What must have been particularly exciting for Michelangelo was the way in which the evangelical view of spirituality chimed with his aesthetic of difficulty and its insistence on the need for art to astound with its achievements and to provide spiritual as well as visual stimulation. His efforts to engage with the mysteries of the Christian faith in ways that were deeply personal and aesthetically *difficili* redoubled in the company of his distinguished and highly influential friend.

Evidence of Michelangelo's evolved understanding of both divine and artistic grace can be found in the notable differences between the 1499 *Pietà* and the Colonna drawing of the same subject. The most conspicuous of these differences is in the position of Christ's body. Frontally presented in the *Colonna Pietà*, this Christ strongly evokes the 'Man of Sorrows' tradition also exploited in the *Minerva Christ*. The visual meditation on Christ's passion usually associated with the late Middle Ages had gone out of fashion by the sixteenth century. Michelangelo's choice to bring it back into use was a conscious act of preservation that revealed his deep respect for fourteenth-century artists, for a time before art fell prey to the distractions of secular patronage and obsessive naturalism.[65] Michelangelo's interest in the *imago pietatis* reveals at once his anxiety about the increased secularization of religious imagery during his lifetime and his intense engagement with the reformation campaign to restore emphasis on Christ's sacrifice. Presenting Christ to viewers as he does here, he

reveals nostalgia for a lost culture of piety characterised by mystical contemplation of Christ's passion rather than theological speculation about it. Other signs of this archaism are the Y-shaped cross, now missing, which was modelled on one used by the Bianchi flagellants as they processed into Florence during the pestilence of 1399,[66] and the inscription from Dante's *Purgatorio* 'non vi si pensa quanto sangue costa' (they do not consider how great the cost in blood, 29.91).[67] Viewed together, these particular evocations of the fourteenth-century reveal Michelangelo's identification with those seeking a more direct relationship with the word of God and a more immediate identification with the sufferings of Christ. They reveal, in other words, his sympathy with the reformation doctrine so dear to the Viterbo circle.

Yet even as he recalls fourteenth-century iconography, Michelangelo modernizes it. The *Colonna Pietà*, unlike its medieval predecessors, does not linger solely on the physicality of Christ's suffering. As art historians from de Tolnay to Nagel have pointed out, Michelangelo removes 'the blotches of blood and the wounds from Christ's body', offering instead 'a pristine and radiant Christ based on the models of ancient sculpture'.[68] Pristine and radiant, Michelangelo's Christ draws the spectator's attention away from the physical suffering of the Crucifixion and towards contemplation of his ultimate victory over death, the resurrection. Una Roman d'Elia subtly modifies this point, suggesting that rather than entirely erasing signs of Christ's suffering to emphasise the glory of his resurrection, the drawing exhibits 'a deep ambivalence toward the contemplation of Christ and Mary's suffering during the Passion. The suffering is both insisted upon to an unusual degree and denied'.[69] Suspended between the suffering of the flesh and the resurrection of the spirit, in other words, the Colonna drawing celebrates the means by which we pass from one to the other: the grace of God.

Indeed, the Colonna virgin contrasts strikingly with the virgin of the 1499 *Pietà* in precisely this way, embodying the ambivalence—the agony and the ecstasy—at the heart of Mary's experience of divine grace. Her skyward eyes, raised arms, and straddled legs all suggest the sorrow of a bereaved mother as well as deep sorrow for and identification with her son's passion. Her heaving chest, emphasised by the folds of dress, expresses profound human suffering. The decorative band crossing her breast provokes in viewers a feeling of breath constricted by grief. Forty years earlier, Michelangelo's Mary was shielded, as if anaesthetized, from a mother's grief. Here, by contrast, she seems to implore the heavens to lift her out of her bodily trauma. Enshrined in the same sorrowing face,

grieving body, and supplicating hands, however, is a deep understanding of Christ's passion as the redemption of humankind. As she implores the heavens, she simultaneously reaches up as if in praise and thanksgiving for the knowledge that in her arms she holds the source of all grace. The open gesture of her hands radiates spiritual hope. The relaxed fingers and upward-facing palms counter the downward slump of the chest, recalling a priest presiding over the mystery of transubstantiation, not a despairing, grieving mother. Michelangelo's mastery lies in his ability to carve an image poised between corporeal anguish and spiritual elevation: to capture the precise moment when God's grace is communicated to her and, through her, to all humankind.

The contact between Mary's and Christ's bodies—once again significantly different from the earlier *Pietà*—acts as a further enactment of God's grace. As Alexander Nagel convincingly argues, the composition as a whole suggests two directions, deathward and lifeward:

> Christ is nestled deep down between the Virgin's legs, and the lower half of his body is submerged below the ground. At a concrete and literal level, such an arrangement effectively displays the heaviness of the dead body and suggests its imminent interment. At a 'figural' level, however, Christ's simultaneous embeddedness in the Virgin's body and in the earth combines a metaphor of birthing with a metaphor of horticultural growth. There is, in fact, very little emphasis placed on Christ's wounds or the deadness of the body. Instead, the drawing throughout suggests an incipient stirring, a life-giving energy that contrasts the deathward tendency.[70]

In the end, says Nagel, it is the upward sense that triumphs. To my mind, however, Michelangelo keeps both directions in play at once and emphasises equally the lifeward and deathward tendencies. The 'incipient stirring' and upward movement is certainly there in Mary's posture, in the movement of the angels raising Christ's arms, and in the drawing's inanimate insignia. The inscription on the cross, for example, draws our eyes up and skywards. The unexpected ornament on Mary's chest, too, suggests heavenward motion with its cherub's head, oversized halo, and outspread wings.[71] Occupying the middle position between Mary's upturned chin and Christ's falling forehead, it almost tips the balance in favour of the upward trend and suggests in the subtlest of ways an emanation of life-force from Christ's head. Yet there is no doubting the lifelessness of his tomb-bound body. Michelangelo, so expert at portraying the living, breathing torso, displays equal mastery in his portrayal of the dead. The breath is gone

from this chest, its diaphragm drawn up where breath used to be. The inability of the angels to lift Christ's arms from Mary's lap emphasises its dead weight and imminent burial. And although Mary's pose seems hieratic, raised in prayer from one point of view, from another it expresses a grief whose effects seemed accentuated to those accustomed to seeing her in nothing other than the most decorous of postures.[72] In this drawing, Michelangelo aims to capture not eternal life vanquishing death but the moment when Christ and Mary's suffering is as real and pressing as their victory over it. He memorializes, in other words, in all its theologically complexity, the precise moment of Christ's redemption and, by extension, humanity's redemption, through the grace of God.

Similar things could be said of the Crucifixion that Michelangelo also drew for Vittoria, so unusual because of its depiction of Christ in the final moments of his life (fig. 22). Conventional crucifixions, as Condivi points out, depict the dead Christ, his body pierced and broken, the spirit fled. In this drawing, he is 'in a godlike attitude, raising his countenance to the Father, and appearing to say "Eli, Eli"'.[73] If Michelangelo did indeed intend Christ to be saying the last words ascribed to him by Matthew and Mark ('Eli, Eli, lamma sabachthani?' or 'My God, my God, why hast thou forsaken me?', Matthew 27:46), this image depicts him at the lowest point of his abjection, the nadir of his agony. It is the moment when he is at his most human, as theologians point out, and therefore the moment at which the greatness of his sacrifice is at its most pronounced. Paradoxically, this is also the moment of his salvation. The enormous gift he makes of his own life is but an echo of the extraordinary gift of grace that he—together with the rest of humankind—is about to receive from God. As in the *Pietà*, the pain and the glory at the heart of God's grace are expressed by means of opposing tendencies. Anticipating the imminent entombment of Christ's body are the *memento mori* at the foot of the cross, his downward pointing feet, and the sense imparted of his last intake of breath in the muscles across his chest. Hinting, by contrast, at the transcendence of his soul are the serpentine twist of his body, his raised countenance, and the strength and horizontality of those straining arms that suggest a body not dragged down by its own weight but capable of hoisting itself away from the cross. In the background, clouds swell. Portentous of an impending downpour, they communicate levity and elevation as well, an insubstantiality enhanced by the cherubs suspended on either side of Christ and the diaphanous veil that barely conceals his groin. Christ's darkest hour is juxtaposed with his imminent salvation to convey the extraordinary human sacrifice necessitated by that first

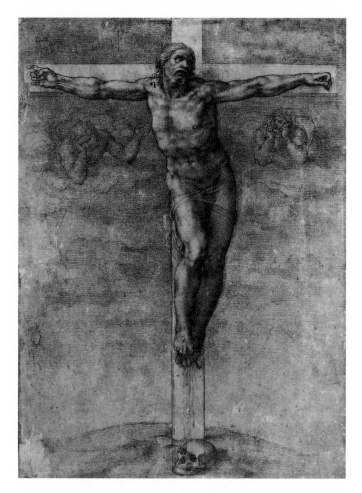

FIGURE 22. Michelangelo Buonarroti, *Colonna Crucifixion*, ca. 1538. Black
chalk on paper. Courtesy of the Trustees of the British Museum, London.

transmission of grace and the exceptional effort that grace continues to
demand of every true believer.

As well as express private reflections on spiritual and artistic grace,
the Colonna drawings indicate the tenor and orientation of Michelangelo's
reform-minded talks with their recipient. They are reflections *à deux* on
the divine nature of grace and on its transmission to those who work hard
to achieve it. At the same time, they are a profession of their belief in the
higher purpose of art and in the divine source of its inspiration. As they see
it, the objective of art is to stimulate contemplation and understanding—
however partial—of the mysteries of God's universe. Art achieves this
end, not by having recourse to mere symbols, but by the more challenging

means of creating artefacts that are accomplished, original, and beautiful in their own right. In the eye of the sensitive viewer, hard-wrought artefacts of this kind will generate wonder, stirring the soul to marvel at God's light as it radiates through all beautiful things. Inspired art, therefore, will offer a conduit leading directly to its divine source.

Colonna's response to Michelangelo's drawings confirms that they do precisely this work. Her letters describe, with remarkable lucidity, the transformative and edifying effects they have on her. On receipt of the *Crucifixion*, she describes first a visual impression that erases from her memory (or 'crucifies', as she says) all other images she has ever seen ('ho hauta la vostra et visto il Crucifixo, il qual certamente ha crucifixe nella memora mia quale altri picture viddi mai').[74] The impression excites wonder—she marvels at how well-wrought it is, how alive and finished ('Non se po vedere più ben fatta, più viva et più finita imagine'), and this triggers sensorimotor scrutiny. She touches the drawing, turns it over in her hands, and examines it with eyes, lamp, lens, and mirror ('Io l'ho ben visto al lume et col vetro et col specchio, et non viddi mai la più finita cosa').[75] The fruit of this investigation is not an understanding of how the drawing achieves its effects but a dawning realisation that anything is possible for those who believe. It is highly significant that she seeks but fails to understand Michelangelo's technique: his mysteries remain, like God's, *difficili* and unfathomable.

The drawings are indeed technically remarkable. For all their monochromatic simplicity, they achieve the same expressive and affecting ends as painting or sculpture. Their subtly achieved effects bear none of the multiple stages of preparation that went into them. No trace remains of the sketching and outlining that determined their composition. Gone, too, are the hatching and stipling that created shadow and depth. Nowhere is an artist's skill more on show (or faults more visible) than in monochrome design, and here Michelangelo has brought it to an unprecedented level of perfection. His drawings epitomise *difficultà*, that art which overcomes seemingly unsurmountable technical and conceptual challenges. Though his means and methods are unfathomable to Vittoria, the effect of his *difficultà* is not. Confounding her reason, as well as her eyes, lens, and mirror, they alert her to the unfathomability and near perfection of the artist. The effect of your work, she says to her correspondent, is to exercise to new extremes the wit of those who view it ('Li effetti vostri excitano a forza il giuditio di chi li guarda'). It provokes wonder at the artist's achievement: 'certainly I could never explain how subtly and marvellously it is done' (certo io non potrei mai exsplicar quanto sottilmente et mirabilmente

è fatta). Philosophy, as Aristotle said, begins in wonder (*Metaphysics* a.2,982b). The wonder Colonna feels upon viewing Michelangelo's drawings prompts a metaphysical contemplation of its divine source. Pondering his accomplishment, she realises afresh that all things are possible to those who believe: 'Et ho visto che *omnia possibilia sunt credenti*'.[76]

Her aesthetic response, in other words, becomes a religious experience: wonder at the drawings' marvels excites awe at God's mysteries and, in particular, the mysteries of Christian faith and grace. Using the language of faith and divine grace to describe her response to Michelangelo's drawing, Colonna implies that aesthetic pleasure, for the sensitive consumer, should be intellectual and spiritual, not just sensory. The implications of this seemingly spontaneous epiphany move her to declare the artist's work to be an expression of God's supernatural grace. 'I had the greatest faith in God', she says, 'that he would grant you a supernatural grace in making this Christ. Yet what I saw is so marvellous it has surpassed my every expectation' (Io ebbi grandissima fede in Dio, che vi dessi una gratia sopranatural a far questo Cristo; poi il viddi sì mirabile, che superò in tutti i modi ogni mia exspettazione).[77]

Particularly worthy of note in Colonna's appreciation of Michelangelo's work—and, indeed, in the recognition and transmission of grace—is the emphasis on sight ('il viddi sì mirabile' [what I saw is so marvellous]), a sense she all but excludes from her quest for grace in the *rime amorose*. In contemplating the graces of her deceased husband, she tended to deny the body and mistrust the evidence of her sensory organs, isolating, instead, the highest sense of reason as she sought to commune with the memory and posthumous reality of his virtues in an aerial, immaterial space beyond herself.[78] Here, however, she looks and touches with deliberate care, applying optical instruments of lens, glass, and mirror to aid her own eyes, as if to convey the material evidence of God's 'gratia sopranatural' inside her body and directly to the heart and mind she seeks to inflame with faith and wonder. Once potentially deceptive snares of mere mortal existence, sight and touch have become instrumental in her devotional practise and essential to any meaningful communion with God's grace. Indeed, vision and touch play decisive roles in her prose meditation on Christ's crucifixion, the *Pianto sopra la passione di Christo*. The *Pianto* is a perfect literary accompaniment to Michelangelo's *Pietà*.[79] A written reflection on the image of Mary holding the dead Christ, it ponders the mystery of Christ and places strong emphasis on the haptic and visual contact between mother and son as key to understanding the transmission of God's grace to humankind. Adopting the position of witness, Colonna

sees what the Virgin sees, declaring that *seeing* the dead Christ in His mother's arms is what prompts her lament. 'I see', she declares, 'the sweet mother, her heart full to the brim with most burning love, tied by so many chains in the love of her Son that they cannot be expressed in ordinary language'.[80] Seeing, but not understanding, how Mary makes 'of her own, almost dead body, a sepulchre' in the hour of his death, she persists in looking, gazing and contemplating until belief takes over. 'I believe' supersedes 'I see' and is repeated in the manner of a creed:

> *I believe* that the Queen of Heaven mourned Him in many ways: first as
> a human being, seeing this most beautiful body, created from her own
> flesh, entirely torn. . . . And *I believe*, limb by limb, she mourned Him,
> remembering how they had served Him and how they had acted on her
> and our behalf on earth. But then, raised to a loftier thought, *I believe*
> that she was contemplating the sacred pierced head as the rich vessel
> in which all wisdom, divine and human, was gathered.[81]

From seeing to believing how Mary mourned her son, Colonna grows progressively closer to the object of her scrutiny as her gaze intensifies. She becomes less a witness to Mary's grief and more the narrator of what she thinks and feels so that as Mary 'meditate[s] upon, even [sees] depicted upon the divine face, the vestiges of charity, obedience, humility, patience, and peace in the divine face', the poet's eyes are sharpened as well to the ordinarily invisible effects of His death made perceptible now through His mother's senses. As if present in Mary's very heart and mind, the poet declares that all the heavenly graces inscribed in Christ's body 'shone forth in Christ's face more to the Madonna than to others'. She knows what Mary is thinking ('she was still thinking over what He had felt in that hour'), understands what she was feeling ('the varying sufferings . . . made her toss and turn from pang to pang, almost took her outside herself'), and accompanies her every emotion till the climactic enfolding of Mary into the body of Christ and her epiphanic realisation that 'the sacraments of our so many graces' would now flow for the benefit of all. With characteristic 'true love', she says, Mary wants 'everyone in the entire world to be able to see what she saw, so that they might enjoy such immense grace'. Clearly, for her, seeing is believing is preparing to receive God's grace.[82]

Such looking is not, of course, mere sensory perception but the intellectual and spiritual penetration of God's mysteries that characterised medieval meditative and devotional practises. The fourteenth-century *Meditationes vitae Christi* exhorted a similar embodiment of sights and

visions leading to profound cofeeling with Christ and his mother while mystics from St Catherine of Siena to St Teresa of Avila provide ample testimonies of physical sight yielding to inner vision yielding to spiritual union with God. Exhortations in the *Meditationes* to kneel and adore Christ as if present at his nativity offer striking pre-echoes of Colonna's lingering meditations on the bruised and wounded body of the dead Christ and the loving kisses Mary lavishes on 'His most holy wounds':

> Kneel and adore our Lord God, and then His mother, and reverently greet the saintly old Joseph. Kiss the beautiful little feet of the infant Jesus who lies in the manger and beg His mother to offer to let you hold Him a while. Pick Him up and hold Him in your arms. Gaze on His face with devotion and reverently kiss Him and delight in Him. . . . Then return Him to the mother and watch her attentively as she cares for Him assiduously and widely, nursing Him and rendering all services, and remain to help her if you can. Rejoice in these events and think of them continually; familiarize yourself as much as you can with the Lady and the boy Jesus. Look often at His face, on which the angels wish to gaze, but as I said before, do this always with reverence and love, that you may not be driven away.[83]

From looking and gazing to kneeling, adoring, and kissing Christ, this spiritual guide structures devotional practise in ways that Colonna adopts in her *Plaint* and even advises in letters to her cousin, Costanza d'Avalos Piccolomini, Duchess of Amalfi.[84] Having minimised the physical evidence of her eyes in her love poetry, she now relies on it as a primary tool of devotion, all the while acknowledging the inferiority of her physical eyes to the spiritual eyes of the soul. 'There are two ways of looking at the great and dear / graces of Heaven', she avers in the sonnet 'Doi modi abbiam da veder' (S1:165): one is to gaze on Scripture with eyes that are alive to the Light manifest therein, and the other is to raise 'le luci chiare' of the heart to the 'libro de la croce' (book of the cross). In both cases, the organs of sight are but triggers to the organs of faith that combine sensory, imaginative, and cognitive powers (the *sensus communis*, *imaginativo*, and *vis cogitativa* of St Thomas Aquinas) to reveal what sensory observation alone fails to detect.[85] With 'l'occhio vivo [a] quel Lume', Colonna's *Pianto* observes on the deceased body of Christ the imprint of 'a thousand heavenly graces'. As if with two sets of eyes, she sees the mortal body together with the immortal graces newly flowing from it and achieves that faith which justifies in a dual looking reminiscent of St Catherine of Siena herself.

Particularly attuned to inner vision, St Catherine was reputedly able to perceive the beauty of souls in the state of grace, which she described as beautiful beyond words and dazzling with luminosity. To her confessor, Blessed Raymond of Capua, she compared the beauty of elect souls to the sweet light of the morning, the beautiful colours of the rainbow, the dazzling beams of noontime sun, and the pure whiteness of lily and fresh snow, all of which paled by comparison. Colonna reflects on this dual looking as she describes the closed eyes of Christ's body and the open eyes of His soul: 'although [Mary] saw His closed eyes in that most sacred body, she knew that His soul's eyes opened the fates of Limbo to the Holy Fathers. His lips were closed, but His more celestial ones were saying: "Lift up your fates, O ye princes"'. Two sets of eyes, two sets of lips, and two bodies, one mortal and deceased, the other immortal and raised to Heaven for the glory of all humankind.

Touch, too, plays a fundamental role in the *Pianto*, as it did in the *Meditationes*. Hand and mind attuned, Mary seeks 'most reverently the noblest places inhabited by that holy soul'. Touching his heart, feeling his limbs, she searches for signs of life, grieving with 'sorrowful anxiety and torment' but also giving deepest thanks 'to that which pained her greatly'. Knowing His heart to be still now, thanks to the evidence of her fingers, she comes to the full cognition of 'where His blessed soul' resides and experiences herself a miraculous division of the indivisible: her spirit leaves 'with Christ's soul' while 'her soul remained to honour God and mourn His dead body'. Such self-division is the ultimate goal of Colonna's own meditation, it would seem, but it is no longer the Neoplatonic-flavoured splitting of soul from body that she pursues. Unlike in her amorous sonnets, the empirical constraints of the body are much more readily accepted with information gained through the senses playing a vital role in cognitive and spiritual renewal.[86] The partnership of body and soul becomes a recurrent theme throughout Colonna's spiritual sonnets, with 'Duo lumi porge a l'uomo il vero Sole' (S1:13), for example, clearly delineating the two lives we lead at once or, to put it metaphorically, the two lights that guide the course of our lives to two very different ends. One Sun-given light leads towards a frail and fleeting end, while the other ascends to the Heavens 'per disuate scale': both are instrumental to our experience of the sacred.[87] In sonnets such as these, the body and its beauty are no longer to flee from, but vessels containing both the lights of life. Sight and touch are gateways to the inner senses, working together in what twenty-first-century cognitive philosophers might call a 'body loop'.

In *Descartes' Error*, neurologist and cognitive philosopher Antonio Damasio popularises the most recent thinking about mind-body

synthesis in precisely these terms, placing the body 'directly within the chain of operations that generate the highest reaches of reasoning, decision making and, by extension, social behaviour'.[88] The 'body loop' metaphor serves to describe how emotion, feeling, and biological regulation participate in human reason on the basis of neurological observations of individuals whose ability to process sensory and emotional feedback in order to make rational decisions is impaired. In later work, Damasio extends the metaphor to describe an 'as-if body loop' which expresses the chain of operations triggered in the mind and body of one who observes the actions and feelings of another or who calls on past experiences to imagine future actions. Anticipating the concept of 'embodied simulation' informed by the discovery of mirror neurons, the 'as-if body loop' encapsulates thoughts and feelings experienced 'as-if' the observer were wired into the body loop of someone else or back into the observer's own body loop at another moment in time.[89] Damasio's scientifically informed cognitivist language chimes in striking ways with the language Colonna herself uses to describe the phenomenology of 'as-if' meditation. She envisages just such a loop or, as she calls it, a 'knot' connecting mind or spirit to body and individuals to the world ('al mondo') and to themselves ('a se stesso'). The goal of suffering alongside Christ and of identifying so closely with Mary is to loosen the hold of such bonds so as to bind oneself to God instead. As her sonnet addressed to 'Padre nostro e del Ciel' (S1:95) professes, it is God's bounteous love and grace that enables us to disentangle ('snodarsi') from ourselves so as to tether ourselves with powerful knots ('con possenti nodi') to the divine other, from which process faith is born ('nasce la fede').[90] This is not, however, permanent bondage: as long as they live, Christians are destined to pass back and forth between the sensory world they inhabit and the heavens they aspire to, between the 'body loop' (to use Damasio's terms) of mortality and the 'as-if body loop' of divinity, between communication with other mortals to communion with God. The sublime 'ladder' leading to the 'Ciel superno' (highest Heavens), in other words, goes down as well as up.

Previously inspired to write poetry by her widowly grief, Colonna is now motivated by an inner love ('l'amore interno') and internal ardour ('interno ardore') ignited by God. Divinely inspired, she moves her pen (as she writes in S1:46) and, without being fully aware of herself or of what she is writing, composes God's praises. Having once vented her grief, she is now inspired by the Christian desire to join hand in hand ('di mano in man') with the blessed souls in Heaven (S1:73) and also to communicate with other mortals on earth about God's saving grace. Faith, hope, and

charity, St Paul's three Graces, act as steps on the heavenly ladder leading her thoughts skyward as she takes it on herself to do as Paul prescribes and to spread the news of God's spiritual gifts to the world.[91] St Paul's first letter to the Corinthians distinguishes between the theological virtues required for personal sanctification infused into individuals by divine grace ('faith, hope, and charity/love', 1 Corinthians 13) and the God-given *charismata* or spiritual gifts with which Christians work to further the growth of the church (including 'the word of wisdom, the word of knowledge, faith, the grace of healing, the working of miracles, prophecy, the discerning of spirits, diverse kinds of tongues, interpretation of speeches', 1 Corinthians 12:8–10). In composing her lines of divine praise, Colonna stokes the fire of personal faith while serving her Christian duty towards others. It is often in this evangelical spirit that she addresses Michelangelo, bound by a sense of charity to advise him in spiritual matters. Yet the relationship is mutual, and if Michelangelo offers Colonna the chance to exercise and distribute her charismata, she affords him an opportunity to reciprocate with spiritual gifts of another kind, as her letters to him testify.

Previous scholars have commented on the status of the Colonna drawing as a gift within the context of reformation discourse.[92] They point out that gift giving takes on a special significance for those who wish to emphasise the unmerited bounty of God's grace and to insist on humankind's inability to earn it through good works and adherence to church law. Symbolising the unbidden, unmerited nature of God's gift, nonreciprocal gifts reenact a crucial part of reformation doctrine, and Michelangelo and Colonna are perfectly aware of their symbolic power. Michelangelo, for example, teases Vittoria for foiling his plans to surprise her with one of his drawings by asking for it. By seeking something that should not be solicited, she breaks the rules of gift giving and thwarts his 'design' ('È stato guasto el mio d[i]segnio'). Like God's grace, gifts are meant to arrive unbidden and unexpected: 'la gratia di Dio non si può comperare'.[93] So, too, gifts between friends cannot be reciprocated, requested, or paid for. It is not only Vittoria, in other words, who recognises the presence of God's grace in these drawings. The artist himself sees in the circumstances of their presentation a reflection of divine grace and the dynamic it establishes between the one who gives and the one who receives.

What, precisely, is the nature of the gifts that they exchange? They give each other material objects, of course, keepsakes to be cherished. They also provide each other with opportunities to rehearse the act of receiving God's unbidden and unmerited grace, as the artist's joke implies. Of greater importance, though, Michelangelo's gift to Vittoria Colonna

consists of a metaphysical experience. This experience involves first visual, haptic, and sensory, then cognitive and spiritual awakening. In this respect, his art is inseparable from its subject matter since contemplating his methods is like meditating on Christ's passion. Both have the effect of confounding reason, provoking wonder, and leading ultimately to a deeper appreciation of God's beauty and power. Michelangelo's gift, in other words, is an epiphany, a manifestation of the divine and a close, personal encounter with grace. For the supernatural grace Michelangelo receives make him godlike or, as Colonna says, 'Angel Michael at the right hand of the Father' (Michel Angelo alla destra del Signore).[94] Artistic and spiritual grace become indistinguishable, the artist and his divine subject matter converge, and Colonna 'in the middle of all this' (in questo mezzo) comes into direct contact with the grace she knows not how to respond to 'except to pray to this sweet Christ, whom you have painted so well and so perfectly, and to beg you to command me as yours in everything and for everything' (non so come servirvi in altro che in pregarne questo dolce Christo, che sì bene e sì perfettamente havete dipinto, et pregar voi mi comandiate come cosa vostra in tutto et per tutto). Colonna's belief in the real and sacred presence of God's grace in Michelangelo's drawings explains the otherwise puzzling anxiety in her letters about their true authorship. Upon receipt of the Crucifixion, she begs the artist to confirm that it is, indeed, his own work and not the imitation of some pupil.[95] Art, it would appear, can transmit God's grace to its recipient only if created by the hand endowed with its supernatural power; no other hand will do.

Grace, for Michelangelo and Colonna, is a far cry from the courtierly attribute theorized by Castiglione and translated into visual language by Raphael. Their repeated meditations on the passion of Christ both in image and in word as well as their correspondence make it clear that their grace is a gift from God—something that can be neither learned nor earned. Colonna's almost idolatrous praise of Michelangelo's work shows that, on those rare occasions when artistic and spiritual grace combine, aesthetic experience is nothing short of divine. It is no surprise that when Michelangelo sanctioned Condivi's account of his life in the years following Vittoria's death, the effortless grace of contemporary art criticism was relegated to the margins. At the time of writing, Condivi reveals, Michelangelo was working on yet another *Pietà*. This *Pietà*, says Condivi, had not been commissioned by others but was intended by Michelangelo 'for his own pleasure' (a suo diletto). Condivi describes the sculpture (now in the Cathedral Museum of Florence) as beautiful beyond words, 'a rare thing, and one of the most laboriously wrought works that he has made till now'

(Vo' ben dire ch'è cosa rara e delle faticose opere ch'egli fin a qui abbia fatte). Here, as elsewhere, Condivi emphasizes the link between labour and beauty and between Michelangelo's hard work and divine inspiration. It is as if the physical and intellectual effort that goes into art is Michelangelo's own Calvary, his means of identifying with Christ's passion and abnegating the self so that redemption through God's grace is possible. In true Reformation style, it is as if he seeks not outward recognition through his art but inward transformation and deeper identification with the sufferings and triumph of Jesus and Mary. As a reward for his pains, he reaches 'a prescribed limit, fixed and ordained by God, which cannot be exceeded by normal talent' (un prescritto termine, posto e ordinato da Dio, il qual trapassare non si possa da virtù ordinaria).[96] He becomes in Condivi's eyes, as well as Vittoria Colonna's, the artist who surpasses every mortal expectation and makes his art a vessel of divine grace.

CONCLUSION

Beauty, like all other qualities presented to human experience, is relative; and the definition of it becomes unmeaning and useless in proportion to its abstractness. To define beauty not in the most abstract, but in the most concrete terms possible, not to find a universal formula for it, but the formula which expresses most adequately this or that special manifestation of it, is the aim of the true study of aesthetics.

—WALTER PATER, *THE RENAISSANCE* (1873)

THERE IS A POPULAR NARRATIVE in the history of art that relates how Raphael embodied and perfected painterly grace while Michelangelo and his followers vanquished it, cutting off subsequent generations of artists from knowledge of it and depriving connoisseurs and art lovers from the pleasure of it. What I have sought to show is that grace was neither created nor destroyed in sixteenth-century Italy, but that it flourished and developed from one form into another, according to the context and aspirations of the individual user. My study has been motivated by the observation that grace in that period becomes a term of preference for capturing an array of human experiences: aesthetic, social, and spiritual. Reduced to its semantic essence across each of these domains, it denotes a certain something that pleases; but since pleasure is endlessly subjective and broadranging, that seemingly narrow definition is not actually narrow at all, encompassing instead a wide and varied cultural landscape. Like all other qualities presented to human experience, grace is relative (as Walter Pater says of beauty in the epigraph above). If the experiences it communicates are to be fully appreciated and if the word is to be used with true discernment, it is best pursued not in abstract formulae but in concrete instances and special manifestations. The aims of this book have been, therefore, to appreciate grace in all its complexity, and to witness the word in action in some of its most intense and personalised sixteenth-century Italian manifestations. A third aim has been to show how moments of encounter between individual interpretations of grace inform and shape the ideological and cultural processes that mark the course of history; how grace (alongside various other forces, of course) made the Italian Renaissance.

Grace was not vanquished but flourished in large and important arenas this book has had to neglect. A selective approach privileging depth

of engagement over breadth has required the exclusion of a host of writers, thinkers, and artists who thought about, wrote about, and portrayed grace in visual form, as well as entire disciplines such as music, dance, and theatre (to name just three). A welcome response to this book, therefore, would come in the form of further studies identifying and examining the graces not included herein. Our understanding of Renaissance grace would be enhanced no end by an introduction, into the mix, of singers like Lucrezia Bendidio and Laura Peverara from Duke Alfonso d'Este II's private *concerto delle donne* (for example), alongside dancers such as Fabrizio Caroso and Cesare Negri, whose 1602 treatise entitled *Le grazie d'amore* (The graces of love) expresses balletic aspirations to grace. Grace pervaded sixteenth-century manuals on dance, voice, music, and theatre just as animatedly as it did the texts and images explored in this book. Further studies would unlock the specificities of such manifestations of grace while shedding further light on the interconnections and cultural transactions between them and those occurrences presented in this book. They would also help amplify and improve the keyword approach to culture and society, testing the limits of its applicability yet further by applying it to other nonverbal forms of expression and exploring other areas of human experience where grace was key.

It was Johann Joachim Winckelmann who observed the supposed defeat of grace as the classically inspired aesthetic of Raphael and Coreggio yielded to the intellectualism of Michelangelo. Its downfall, Winckelmann claimed, was Michelangelo's 'high intelligence and great knowledge': these spurred him to look beyond the ancients for inspiration and to apply his powerful imagination, which 'was too passionate for tender feelings and gentle grace', to create works that were extraordinary and difficult but never pleasant. Blinded by his genius, generations of artists followed suit, argues Winckelmann, sacrificing 'what is suitable in nature' for artificiality, and difficulty for grace. Since it was first published in 1775, his *Reflections on the Painting and Sculpture of the Greeks* has left a lasting impression on art historical discourse, circulating first amongst German art historical circles before becoming a classic expression of European aesthetics. By using grace to express a particular type of aesthetic experience and by associating it with the style of specific artists in a circumscribed age, Winckelmann established himself as the first modern historian of art and a founding father of aesthetic theory.

It is fair to say—as Winckelmann did—that the classical naturalism of the early sixteenth century yielded to an artificial elegance and intellectual sophistication, known since the nineteenth century as Mannerism, and

that Michelangelo was a leading exponent. It is not accurate, however, to claim that grace disappeared with Raphael. In many respects, grace persisted—both as a major source of inspiration to Mannerists and as a feature of their style. For Michelangelo, as we have seen, the pursuit of the Christian grace that set the moderns above the ancients (to his mind at least) drove his resistance to the mere imitation of those ancients. According to certain connoisseurs, moreover, nothing expressed artistic grace quite like the serpentine curve, that slight exaggeration of naturally occurring arcs which Lomazzo claimed gave 'la maggior gratia e leggiadria' to painting. This line of grace, investigated by Leonardo and Raphael with diligent care, became Michelangelo's legacy to practising artists, according to Lomazzo, and came subsequently to characterise Mannerist art, with painters and connoisseurs from Lomazzo to Du Fresnoy to Hogarth theorising its generous, easy waves and the way in which they render graceful not just the individual contours they describe but the whole of a painting. Rather than a dividing line between graceful classicism and graceless intellectualism, then, grace connected one artistic trend to the other, ensuring continuity rather than rupture over the course of time. As Winckelmann himself freely admits, 'a general feeling for what is truly graceful is . . . not natural' but acquired—like good taste—by the training of the senses, through education, and by frequently comparing works of art. The decline of grace that he observes in artworks judged by others to be graceful is also a question of taste and the result of his own ideological immersion in and devotion to the antique.

I have sought, in this book, to resist adjudicating in matters of taste and ideology and to represent instead the preferences of others. The fact that I might, like Winckelmann, find Raphael's work more pleasing than Michelangelo's is irrelevant. What is relevant is the fact that grace becomes a quality to emulate, imitate, and compete over in the courts, arts, and churches of the Italian Renaissance. Sought after, acquired, bestowed, denied, bought, sold, and sometimes fled, it is as contested as it is popular amongst men and women alike. As such, it yields insights into the tastes and aspirations not just of critics like Winckelmann but of sixteenth-century Italians themselves, offering a greater understanding of the friendships and quarrels that animated the period and of the processes at play when the 'good' are set apart from the 'great'.

Grace did not die with Raphael, then, although there were moments and places during the *Cinquecento* when it thrived less obviously than in others. We have already seen, for example, how Ariosto neither thematized nor theorized the word grace but embodied it in his writing and inscribed it in

the emblems and mottoes that served as a personal portrait to embellish his poem. In her *Dialogo dell'infinità d'amore*, meanwhile, Tullia d'Aragona's fictionalised Benedetto Varchi desists, under the shadow of Trent, from entering into any discussions of grace, despite the sense that his conversation seems inexorably to be leading that way. More conspicuously still, Torquato Tasso's dialogue *Il malpiglio* (1585), which purports to be a direct response to Castiglione's *Libro del cortegiano*, replaces the grace of his forebear with 'prudence', deliberately repressing that most Castiglionesque of terms.

In *Il malpiglio*, a wise man known only as the Neapolitan stranger (*il forestiere Napolitano*) speaks as Tasso's alter ego to the nobleman Vincenzo Malpiglio and his son, Giovanlorenzo, about life at court and about how to win the favour of princes while avoiding the envy of peers. Citing Castiglione as the ultimate authority on all such matters, the stranger humbly offers to reiterate what Castiglione has already said in the light of his own experiences at court. When it comes to naming the ultimate quality of ideal courtiers, however, prudence—not grace—is pronounced. Without prudence, says *il forestiere*, courage is blind and rash. Prudence, which guides courage, is the noblest virtue of all.

Readers are momentarily discombobulated. Was *grazia* not the key term in Castiglione's *Libro del cortegiano*? Reading on, however, we realise that Castiglione's grace and Tasso's prudence have much in common. Close neighbours on the Aristotelian line connecting various forms of *mediocritas* (the avoidance of excess) and *prospoeíesis* (dissimulation and pretence), they are virtues that do not draw attention to themselves but that dissemble their talents so as to avoid envy and reproach. Both graceful and prudent courtiers cultivate wisdom and skill while at the same time concealing them too. It is only, says the *forestiere*, via means other than great virtue, knowledge, and qualities both visible and attention seeking that courtiers can please princes and befriend peers. Prudence, the *forestiere* concludes, is—like Castiglione's grace—the virtue that overcomes all difficulties at court. *The* principal virtue, prudence is another form of 'l'arte che nasconde arte', that art which conceals the artistry that goes into notable talent. Just as da Canossa's 'regula universalissima' in *Il cortegiano* exhorts courtiers to 'dissimulate their knowledge', so too the *forestiere* in *Il malpiglio* advocates the wisdom to conceal oneself from one's prince.

Not everything changes, then, when Castiglione's grace becomes Tasso's prudence, but some things do. The move from grace to prudence constitutes a shift in emphasis from that which pleases to the concealment of all that might possibly please and, therefore, offend. Castiglione's ideal courtiers foster grace and *sprezzatura* to achieve an understated appearance of

excellence and to give princes and peers a taste for more without arousing envy. Tasso's courtiers, by contrast, insist on the veil of concealment itself rather than on the talent that lies beneath. There is a greater sense of confidence in the courtier's outstanding abilities in *Il malpiglio*, but a greater sense of the dangers involved in ostentatious displays of such abilities as well. Tasso's courtier does not just appear but *is* excellent, yet he must prudently hide his brilliance at all costs.

Castiglione's courtier is prudent too. In book 4, he is described as the prudent captain of a seafaring barque, displaying the quiet confidence of a savvy diplomat on an upward career trajectory. Throughout *Il cortegiano*, in fact, courtiers are presented as captains of a ship—the (understated, unassuming) power behind the throne—while princes are portrayed variously as rudderless, blind, and morally weak. They are, in one of Castiglione's most audacious metaphors, children in need of sweet medicine. Grace, accordingly, suggests a quiet license and aristocratic freedom to guide with (cleverly concealed) flair and superior knowledge. Tasso's courtiers are less empowered. Unlike the citizens of a republic whose prudence, the stranger claims, can effect change for the common good and lead to the making and reforming of laws, courtiers direct their prudence solely to the pleasing and serving of their tyrant princes. Where grace gains the courtier of early sixteenth-century Urbino privileged access to power, prudence permits the courtier of late sixteenth-century Ferrara to preserve the status quo and, if he is lucky, to save his own skin. Yet despite such low aspirations, prudence is a noble virtue: the man who possess it is inferior to no one. Being of the intellect, prudence is not made by nature to obey but to rule. Tasso's prudent courtiers have the potential to rule, but not the means, since princes hate any greatness of mind. The art of diminishing the praises one really deserves, therefore, is the order of the day. Hiding one's dazzling light behind a bushel and expecting no recognition at all is a necessary means of survival.

Tasso's dialogue reflects the experience of a courtier whose relationship with authority is complicated (to say the least) and whose life was plagued with self-doubt and mental illness. The dialogue was written within the walls of the Arcispedale Sant'Anna, where the author had been consigned for behaviour that displeased his very own prince, Duke Alfonso d'Este II, and during the years when his epic poem *Gerusalemme liberata* sustained its most virulent critical attacks. It is the testament, therefore, of a courtier who could not please. It expresses, too, the uncertainty of 1580s Ferrara, whose court was just emerging from the shadow of suspicion cast by the Inquisition when Renée of France, Duke Alfonso II's mother,

brought Protestantism and its intellectual sympathizers to its court. It marks the passing of time, in other words, and the changing of courtly customs that led those Graces that danced on late fifteenth-century Ferrarese walls to conceal themselves—temporarily—underground.

Grace goes to ground in Tasso's Ferrara, but it flourishes anew elsewhere. In Moderata Fonte's Venice, for example, it becomes a rallying cry for women who criticise the oppressive yoke of marriage and domestic servitude. The female interlocutors in Moderata Fonte's *Il merito delle donne* (*The Worth of Women*) identify grace as one of the foremost qualities of women and propose its cultivation as a source of great happiness and joy. Published in 1600 but probably written more or less contemporaneously with Tasso's *Il malpiglio*, the dialogue explores freedom, marriage, the merits of singlehood, and the plight of women whose lives have long been blighted and talents suppressed by envious men. Grace appears in the women's conversation as a quality of Venice ('residenza de tutte le grazie ed eccellenze sopranaturali'), as a particular feature of the utopian garden setting of their dialogue (amongst whose primary graces it boasts 'that there are no men' [che non vi sono uomini]), as the ultimate goal of men who seek to trick women into parting with their favours, and as a gift of human nature dispensed unto women by that rare thing, 'true love'. Most important, grace is one of the trinity of qualities that undergirds the worth of women.

There is no more poetical topic, says the main speaker, Corinna, than the grace, beauty, and virtue of women. Revelling in a freedom of speech normally reserved for men, Fonte's women seem at first glance to be relatively uncritical of the gender politics underpinning the words they brandish with such relish. Their praise of those 'lively' (and, presumably, male-authored) eulogies to feminine grace, beauty, and virtue that 'rob the senses and lift the soul from the body in ecstasy' seem to bear none of Colonna's condescension nor any of d'Aragona's caution. Despite what they say about the ills of marriage, their conversation about women's worth seems primarily directed at securing good marriages, their perspectives on female virtue unquestioningly inherited from men. In large tracts of the dialogue, in other words, the aim seems neither to flee from the rhetoric of men nor to adapt it for their own purposes, but to exercise it as bequeathed them by men and thereby to strike a blow for women.

As the conversation unfolds, however, a more nuanced, gendered perspective emerges, altering in subtle ways the inherited standards. Corinna's observations about 'the most poetical' topic cause Lucrezia to ask whether women should concentrate on grooming their outward appearances or

on cultivating their minds, to which the reply is that the present company would be well advised to nurture both outer and inner graces, virtues that will never fade nor grow old and will endure as long as life and beyond. The body is to be appreciated, but the soul is much more important because, like flowers, bodies are corruptible and will decline through age, illness, or work. Corinna goes on to explain that beautiful women attract men at first glance, but those with beautiful minds attract them for longer; and so far, so conventional. Attracting men is, of course, an urgent concern in early modern Venice (no matter how undesirable patrician marriages may be) since single women of independent means are few and far between. But Corinna's speech does not end there. Visible and invisible beauty helps attract good marriage offers, she says, but it is also a source of pleasure to other women. Crucially, it is a source of comfort and satisfaction to women themselves. Cultivating inner virtue, a gentle nature, and fine intellect, being wise, courteous, and well-mannered enables women to bristle with vivacity and spirit. Though they may not be conventionally beautiful, they will be 'tutta grazia', and this grace will render them rich in internal beauties that issue forth from their eyes and mouth and find expression in handsome gestures and virtuous works. Physical beauty is all well and good, concludes Corinna. It is powerful and capable of igniting the visceral spirits and conquering mountains. Beauty of mind and inner beauty, however, produce a grace that pleases oneself and one's friends both in this life and beyond. Such grace becomes a comfort in domestic strife and a lifelong companion to counterbalance the inevitable suffering of women and wives.

Grace, as Fonte makes clear, is not vanquished in sixteenth-century Italy. Rather than dying out, it dies back under certain conditions, only to flourish again under more favourable skies. It goes to ground with Tasso's sleight of hand, for example, only to blossom afresh under Moderata Fonte's pen. Little wonder, then, that the three Graces weave their perennial dance in Francesco del Cossa's spring and that, as we said from the start, April is the month of grace.

Chapter 1. A Renaissance Keyword

1. For an account of the quest for *italianità* in Italian literature, see Luzi, *Romantic Europe*, 163–94.

2. In his *Vite di Dante e del Petrarca* (1436), Leonardo Bruni recounted how the election of Henry VII of Luxemburg as Holy Roman emperor in 1312 had filled 'tutta l'Italia' with 'speranza di grandissima novità', a hope that was dashed on his premature demise in 1313. A hundred years later, Francesco Guicciardini's *Storia d'Italia* (written between 1537 and 1540) postulated cross-lateral agreement amongst the individual Italian states as the best solution to political disunity on the inside and vulnerability to attack from the outside, while Machiavelli's *De principatibus* (1513) sought a home-grown monarchy that would unite the peninsula and act as a dam against the river flooding Italian soil from abroad.

3. Panofsky, *Renaissance and Renascences*.

4. See Virginia Cox's response to Joan Kelly-Gadol's question, 'Did women have a Renaissance?', for an authoritative exploration of this topic; Cox, *Women's Writing*, xi–xxviii.

5. Elias, *Civilising Process*.

6. MacLachlan (*Age of Grace*) calls post-Hellenistic Greece 'the age of charis', for example, while Rossi Monti (*Cielo in terra*) charts other moments of particular visibility from Platonic and Plotinian iterations to Medieval and Renaissance highpoints.

7. The transcript is accessible on the White House website at https://www .whitehouse.gov/the-press-office/2015/06/26/remarks-president-eulogy-honorable -reverend-clementa-pinckney.

8. It was hailed 'a striking performance', 'the emotional pinnacle of his presidency' (*Financial Times*, June 28, 2015), 'his single most accomplished rhetorical performance' (*Atlantic*, June 27, 2015). Others called it 'a searing speech on race' (*Guardian*, June 26, 2015), 'a transcendent moment that will live on in history' (*Time*, June 29, 2015), and a moment 'in which a lot of Americans felt they were actually watching the arc of history bend in front of their eyes' (*New York Times*, July 3, 2015).

9. Relevant surveys of Latin dictionaries can be found in Ricci, 'Grazia'; Saccone, 'Grazia, Sprezzatura, Affettazione'. Moss (*Renaissance Truth*) charts an evolution in definitions of grace through fifteenth-century Latin dictionaries. Rather than attempt to cover this ground again, I limit myself here to the standard reference point for English-language users to illustrate a general point, reserving examination of Italian dictionary entries for chapter 2.

10. Classical interpretations of grace include, but are by no means limited to, Cicero (55 BC), *De Oratore*; Pliny (AD 79), *Historia Naturalis*; Quintilian (AD 95), *Institutio Oratoria*. Since the eighteenth century, quintessential accounts of grace include Winckelmann, 'On Grace' (1759); Schiller, 'On Grace and Dignity' (1793); Kleist, 'Puppet Theatre' (1801); Bergson, 'Intensity of Psychic States' (1889).

11. 'Great Wits sometimes may gloriously offend, / And rise to faults true Critics dare not mend; / From vulgar bounds with brave disorder part, / And snatch a grace beyond the reach of Art, / Which, without passing through the judgment, gains / The heart, and all its ends at once attains'; Pope, *Essay on Criticism*, 1:152–57.

12. Monk, 'A Grace Beyond', 132.

13. Saccone, *'Grazia, Sprezzatura, Affettazione'*. This essay remains a keystone text, leaving its mark on subsequent studies that also resist the reductionist tendency. Studies following in Saccone's wake, exploring particular instances of grace and focusing on the range and diversity of the term within specific contexts, include Ricci, 'Grazia'; Emison 'Grazia'. These essays have enriched my understanding of Renaissance grace. Historical surveys of the word whose careful readings have also informed my approach include Rossi Monti, *Cielo in terra*; MacLachlan, *Age of Grace*; Moussy, *Gratia et sa famille*.

14. Such studies are valuable as theories of Neoplatonism, art history, or the history of ideas, but their teleological drive often involves sacrificing the specificity of Castiglione's grace and privileging continuity of meaning over time rather than particularities of usage. Examples include Blunt, *Artistic Theory*, 93–98; Garin, *L'umanesimo*, 146–71; and Wittkower, 'Genius', 302–3. Berger (*Absence of Grace*) submits *Il cortegiano* to New Critical concepts of Renaissance self-fashioning (or self-representing, as Berger calls it, making a subtle but important distinction). Identifying an absence of selfhood in Castiglione's text, he emphasises the high-risk, compensatory performances of masculinity or femininity required of men and women at court. In a series of close readings, he produces useful insights into gender relations and self-representation within a social milieu that requires artificial construction of the self. But he also bends Castiglione's words out of shape at times, in the service of an overarching theory about early modern identity making. Though described as the source of grace in the *Cortegiano*, for example, *sprezzatura* is set apart from grace in Berger, with the latter being reduced to a function of nobility and the former to a set of angst-ridden practices designed to compensate for the absence of aristocractic entitlement to grace.

15. Saccone, *'Grazia, Sprezzatura, Affettazione'*, 47.

16. Said, *Humanism and Democratic Criticism*, 57.

17. Calls for a return to philology began in 1982 with De Man, 'Return to Philology'. They now include Patterson, 'Return to Philology'; Culler, 'Return to Philology'; Harpham, 'Roots, Races and Return'.

18. Nichols, 'Introduction'.

19. Altschul, 'What Is Philology?', 148; Eisner, 'Return to Philology', 7, 9.

20. Those who oppose the new philology's call to foreground the materiality of texts point out that there is nothing 'new' in it: this is what philologists have always done. See, e.g., Pickens, 'Future of Old French Studies'. Other medievalists propose updating the dichotomous categorization of philological approaches as traditional (old) versus new or material, replacing these with less hierarchical categories of reconstructive and descriptive philologies. See Bäckvall, 'Description and Reconstruction', 21–34.

21. 'New philology' also refers to a branch of Mexican ethnohistory that seeks to reconstruct the history of indigenous Americans by using native-language texts collected during the colonial era. The name was coined by James Lockhart in the 1970s. See Lockhart, *Nahuas and Spaniards*; Restall, 'History'.

22. Gurd, *Philology*, 4. See also Harpham, 'Roots, Races, and Return', 77.

23. Saccone translated de Man's *Blindness and Insight* (*Cecità e visione*) and *Allegories of Reading* (*Allegorie della lettura*).

24. Scholar, 'New Philologists'.

25. Williams, *Keywords*, 22. Mieke Bal offers a different approach to the transformations that occur within language. Whereas Williams concentrates on specific words that he says act as agents for social and historical change, Bal's cultural analysis focuses on specific concepts, which she tracks as they travel between disciplines, individuals, historical periods, and academic communities. She sees these concepts as sites of debate that 'travel between ordinary words and condensed theories' and thereby 'trigger and facilitate reflection and debate of all levels of methodology in the humanities'. This book draws inspiration from Bal's method of using concepts as 'intersubjective tools' that facilitate and engender interdisciplinary cultural enquiry. At the same time, it favours Williams's emphasis on words since a word-based method permits 'grazia' to host several intersubjective concepts whose interaction both reflects and brings about social, historical and cultural change. Bal, *Travelling Concepts*, 29.

26. Said, *Humanism and Democratic Criticism*, 62; discussed in Scholar, 'New Philologists', 8.

27. Said, *Humanism and Democratic Criticism*, 83; discussed in Scholar, 'New Philologists', 2.

28. Said, *Humanism and Democratic Criticism*, 141.

29. Scholar, 'New Philologists', 9.

30. Lewis, *Studies in Words*.

31. These classes were taught at University College Cork (Ireland) by Eduardo Saccone, to whom this book owes a great debt.

32. I refer here to participants in the 2008 conference that led to Mac Carthy, *Renaissance Keywords*, and to collaborators on the ongoing research project 'Early Modern Keywords', which I codirect with Richard Scholar.

33. For an exemplary model of feminist philology see Bal, 'Virginity'.

34. In his meticulous morphological and semantic analysis of the Indo-European roots of *gratia*, *grates*, and *gratus* (and of χαρις and cognates), Clande Moussy identifies the word's origins in **gher-* meaning 'pleasure' or 'desire'. In all applications of the word, 'that which pleases' or 'that which triggers desire' seem appropriate, highlighting the core principles of pleasure, reciprocity, and ineffability. Moussy, *Gratia*.

35. For a succinct account of Malebranche's use of the metaphor, see Moriarty, 'Malebranche'.

36. Lyotard (*Postmodern Condition*) criticises the 'grand narrative' or 'master narrative' for being oppressive and old-fashioned, privileging institutional and ideological forms of knowledge, and allowing sweeping accounts of social and cultural history to exclude all other versions of events.

Chapter 2. Grace Abounding: Four Contexts

1. The aim here is not to provide a detailed history of humanism but rather to sketch a (necessarily faint) outline of the cultural background against which grace emerged as a keyword. For authoritative studies of humanism, see Garin,

L'umanesimo italiano; Kristeller, *Classics and Renaissance Thought*; Kraye, *Cambridge Companion*; Nauert, *Humanism*; Kelly, *Renaissance Humanism*.

2. See the reference to a dissertation by Otto Löw entitled ΧΑΡΙΣ for the University of Marburg (1908) in MacLachlan, *Age of Grace*, 4.

3. In the wake of Mauss's seminal study of gift giving (*Essai sur le don*), archaeologists, social anthropologists, and historians continue to examine the extent to which gift exchange pervaded the Greek world before and after the c. 700 BC introduction of coinage and trading. For more on this in relation to *charis*, see MacLachlan, *Age of Grace*, 7–10. See also Vidal, 'Three Graces', for a reassessment of Mauss's theory in the light of the three Graces and their symbolic importance in ancient Greece.

4. MacLachlan, *Age of Grace*, 147.

5. This and the preceding two quotations are taken from Pliny, *Historia Naturalis*, 35.36, 79–80. Protogenes's painting, by contrast, was 'immensely laborious and infinitely meticulous' and displayed not grace, but the disgrace of affectation (35.36, 80). I quote Rackham's English translation.

6. As Monk pointed out in 'A Grace Beyond', 133, n. 4.

7. I quote Donald Russell's English translation.

8. For Cicero, I use May and Wisse's English translation.

9. For a succinct analysis of this programme of renewal, see Tavoni, *Latino, grammatica, volgare*; Pittaluga, 'Restaurazione umanistica'; Moss, *Renaissance Truth*.

10. Useful introductions to the Reformation and the role of grace therein include McGrath, *Reformation Thought*; Cummings, *Grammar and Grace*; McGrath, *Intellectual Origins*.

11. McGrath, *Reformation Thought*, 89. For more on grace in the medieval theology, see Alszeghy, *Nova creatura*.

12. Valla discusses this in *Collatio*, 95.2–28; while one place in which Erasmus develops the argument is *Opera Omnia*, 6.223D–F.

13. McGrath, *Intellectual Origins*, 131.

14. Drawing on Lorenzo Valla's notes on the Greek text of the New Testament, which Erasmus published in 1505, the hugely influential *Enchiridion militis Christiani* (*Handbook of the Christian Soldier*) advocated a collective return to the writings of the fathers and scripture.

15. When quoting St Paul, I refer throughout to the authorized King James English version of the Bible.

16. Moriarty, 'Grace and Religious Belief', 145.

17. Later on, Calvin took the position of human helplessness to an extreme, stressing the absoluteness of the decree by which God predestined some to salvation and the rest to damnation.

18. This book occasions many returns to both cultural developments outlined in brief above. Chapter 3 returns to the classical origins of grace as theorised in *The Book of the Courtier*, while chapters 4 and 6 explore in greater depth the theological backdrop to the vernacular development of grace and, in particular, the views of reform-minded Italian Catholics as well as the doctrine of grace espoused by the Catholic Council of Trent.

19. Cummings, *Grammar and Grace*.

20. The renaissance of Plato had begun in the earlier fifteenth century with translations of Plato's works by Italian humanists Leonardo Bruni, Uberto Decembrio, Cencio

de' Rustici, Pier Candido Decembrio, Antonio Cassarino, Rinuccio Aretino, Francesco Filelfo, George of Trebizond, and Lorenzo Lippi. Ficino's publications marked the culmination of a pre-existing scholarly interest and accelerated the progress of the Platonic revival at the turn of the new century. See Garin, *L'umanesimo italiano*, for a full account of fifteenth-century translations of Plato before Ficino; and Hankins, *Plato in the Renaissance*, on the central role of Ficino in his Renaissance revival.

21. Plato seems, on the surface of it, to postulate a duality of ontological principles, namely, World-Soul and the One/Good. Through the subtle readings of interpreters from Plotinus to Ficino, however, a second hypostasis mediating between the first (the One) and the third (the World-Soul) was identified. See Allen, 'Ficino on Plato', 569.

22. On Ficino's sensitivity to the irreconcilable difference between Platonic trinities and the Christian Trinity, see Allen, 'Ficino on Plato', 555–84. Hankins (*Plato in the Renaissance*, 7–13) provides an overview of Christian critiques of Plato's heresy.

23. It has, in any case, been satisfactorily resolved in Michael J. B. Allen's persuasive assertion that Ficino openly acknowledges the fundamental *in*compatibility of the pre- and post-Christian triads throughout his works. As Allen ('Ficino on Plato', 566) puts it, Marsilio felt that Plato 'had adduced formulas and images whose connotations transcended his intentions, and over whose anticipatory force he could not have exercised full conscious control. But to support that he had fully intended the three primary hypostases to be of the same substance would be an error. [. . .] Only a minority of Platonists, the Catholic Platonists inspired by the Areopagite, had been able to rise from Plato's subordinationism to the dogma of consubstantiality'.

24. In *De amore* (5.6) the beauty of a body is said to consist in the action, animation, and appeal of the idea which illuminates it, a brilliance that flows only when the body is prepared for it through the appropriate *ordo* (arrangement), *modo* (manner), and *species* (aspect) of its parts, that is, through the disposition, proportion, and appearance of a beautiful individual's various features. In the same text, the eye, ear, and mind are those three Graces of whom Orpheus sang, for they enable us to perceive the beauty of the soul: the eye perceives physical beauty, and the ear that pure, powerful, and eternal pleasure of musical melody (5.2).

25. This is Ficino's advice in *De vita libri tres* (1489).

26. See Ficino, 'In Plotinum' (1.iii), as reproduced in his *Opera* (1559).

27. Wind, *Pagan Mythologies*, 32.

28. Ibid., 39.

29. Yates, *Giordano Bruno*, 2:90.

30. Ficino translated his own *Commentarium in convivium Platonis, De amore* (1484) into Italian as *El libro dell'amore* (1491).

31. Pico della Mirandola, *Commento*, 54–55.

32. Pico della Mirandola, *Commento*, bk 2, xv. These general observations are explored in greater depth in Pico's commentary on stanzas 6, 7, and 8 of Benivieni's poem, invoking the authority of classical authorities from Catullus to Porphyry and the irresistible Platonist, Plotinus.

33. All references to Landino, *Comento sopra la Comedia*, in the following paragraphs also hail from his commentary on Dante's *Inferno* (2, 43–57).

34. For Landino's source, see St Augustine, *De gratia et libero arbitrio*, ch. 17.

35. The letter to Bernardo Bembo (no. 18) is undated, while the letter to King Matthias is the preface to vol. 3 of his *Letters* and subtitled 'Exhortatio ad bellum contra barbaros' (An exhortation to war against the barbarians).

36. Francesco Bandini, a Florentine priest, acted as an intellectual and diplomat in Matthias's palace in Buda and ensured good relations between Lorenzo de' Medici and the powerful king. See Kristeller, *Studies*, 395–410, 411–34; and Feuer-Tóth, *Art and Humanism*, 56–66. On Hungarian-Florentine relations in the fifteenth century, see Monfasini, 'Plato-Aristotle Controversy'; Neagu, 'Power of the Book'.

37. He had every good reason to place his trust in Matthias. In the late 1470s the Hungarian King had sent reinforcements to Stephen the Great, Prince of Moldovia, enabling him to repel a series of Ottoman invasions. In 1476 Matthias besieged and seized Sabac, an important Ottoman border fort. If anyone could defend Europe against the steady progress of the Ottoman Empire towards the west, it was Matthias.

38. Geertz, *Interpretation of Culture*, 3. Geertz picks up the notion of explosive grand ideas from Langer, *Philosophy*.

39. Geertz, *Interpretation of Culture*, 3.

40. Scholarship tends to neglect the three Graces within the larger iconographical scheme of the *Salone dei mesi* and the Palazzo Schifanoia as a whole. My study of them draws, nonetheless, on keystone studies of other aspects of the frescoes as well as on iconographical studies of the three Graces more generally. These include Warburg, *Pagan Renewal*, 573–74; Wind, *Pagan Mythologies*; Varese, 'Novità a Schifanoia'; Varese, *Atlante di Schifanoia*; Rosenberg, 'Sala degli Stucchi'; Lippincott, 'Dei-decani'; Lippincott, 'Iconography'; Ragn Jensen, 'Universe'; Manca, 'Call for Justice'; Bertozzi, *Tirannia degli astri*; Natale, *Cosmè Tura*; Settis and Cupperi, *Palazzo Schifanoia*; Vidal, 'Three Graces'.

41. Detailed studies include Migliorini, *Storia della lingua italiana*; Dionisotti, *Gli umanisti*; Tavoni, *Storia della lingua italiana*; Mazzocco, *Linguistic Theories*.

42. Dante gets short shrift here: if only, Bembo (*Prose*, 103) says, the poet had concentrated on treating a few simple topics, instead of trying to master all of Christian theology, the seven arts, *and* philosophy.

43. Bembo, *Prose*, 71.

44. Castiglione, *Cortegiano*, 1.24. All further references to the *Cortegiano* are given in the text. This and all subsequent translations of the text are mine. My practise has been to reduce to a minimum all references to the Italian text for ease of reading, focussing primarily on those citations where the exact original wording merits attention.

45. Chapter 5 offers a more detailed analysis of this metaphor.

46. Examples of these word lists include Niccolò Liburnio, *Le tre fontane* (1526); Lucilio Minerbi, 'Il vocabulario del Decamerone' (1535); Fabrizio Luna, *Vocabulario di cinquemila vocaboli toschi* (1536); Francesco Alunno, *Osservationi* (1539) and *Ricchezze* (1543); Lodovico Dolce, *Osservationi nella volgar lingua* (1550). For an overview of these, see Teresa Poggi Salani, 'Lessicografia italiana'.

47. Alunno, *Fabrica*, s.v. 'Fortuna'; s.v. 'Venere'.

48. Alunno, *Fabrica*, s.v. 'Cielo-Venere'.

49. In the thirteenth-century *Catholicon* compiled by Johannes Balbus, for example, grace is a gift that is freely given (*donum vel donatio*), s.v. 'gratia'.

50. Perotti, *Cornu copiae*, s.v. 'gratia'.

51. Moss, *Renaissance Truth*, 21.

52. Alunno, *Fabrica*, s.v. 'Venustà'.

Chapter 3. Grace and Favour: Baldassare Castiglione and Raphael

1. The 'gratissimus' artist, Raphael, was attributed 'gran gratia' during his lifetime by admirers such as the Ferrarese humanist and scientist Celio Calcagnini and the Venetian art collector and connoisseur Marcantonio Michiel. Paolo Giovio, too, describes his painterly and social graces in his elegy to illustrious artists, thought to have been written around 1525. Calcagnini, *Opera*, 100–101; Michiel, quoted in Golzio, *Raffaello*, 103–4; and Giovio, quoted in Barocchi, *Scritti d'arte del Cinquecento*, 64.

2. A number of studies align Castiglione and Raphael from the viewpoint of grace. In some cases, the aim is to seek in the writer and artist an overarching narrative of the grace of the Italian Renaissance at the expense of the specificities of their individual usage of the term. Others read Castiglione closely for insights into Raphael's graceful style. This approach is closer to my own, although the specifically art historical focus of many such close readings can limit the range of Castiglione's (and, indeed, Raphael's) usage. For examples of the overarching narrative approach, see Williamson, 'Concept of Grace'; Londen, 'Sprezzatura'. For approaches methodologically closer to my own, see Patricia Emison's essay on 'Grazia' and Ben Thomas's close reading of Marcantonio Raimondi's *Judgement of Paris* engraving after Raphael in light of Castiglione's *Cortegiano*. More narrowly focused than I am on questions of aesthetic style, Emison prefaces her analysis of Raphael's grace as expressed in individual paintings with a close reading of Castiglione. Thomas, meanwhile, concludes that Raphael's grace consists of a Castiglione-like paradox of *sprezzatura*, imitation, and love that is condensed in a gesture that can be seen as the index of his style. See Emison, 'Grazia'; Thomas, 'Art Consists of Hiding'; and Thomas, 'The Idea of Drawing'.

3. Distinguishing, where necessary, between male and female attendees at court, my general practise here is to use the gender-neutral English term 'courtier' to refer to both men (*cortegiani*) and women (*donne di corte*).

4. Castiglione, *Cortegiano*, 1.14. As in chapter 2, all future references to the *Cortegiano* are given in the text. Translation is mine, unless expressly attributed to that of Bull, *Courtier*.

5. In the original, respectively, 'grazia ed autorità', 'grazia e splendor', 'grazia e dignità', 'grazia perfetta e vera virtù', 'grazia ed eleganzia', 'tante bellezze e grazie', and 'grazia e felicità nell'anima'.

6. Bull, *Courtier*, 67. 'Trovo una regula universalissima, la qual mi par valer circa questo in tutte le cose umane che si facciano o dicano piú che alcuna altra, e ciò è fuggir quanto piú si po, e come un asperissimo e pericoloso scoglio, la affettazione; e, per dir forse una nova parola, usar in ogni cosa una certa sprezzatura, che nasconda l'arte e dimostri ciò che si fa e dice venir fatto senza fatica e quasi senza pensarvi'.

7. Hoby, *Book of the Courtier*; Singleton, *Book of the Courtier*. Definitions of *sprezzare* are from *Vocabolario degli Accademici della Crusca* (1611) (henceforth *Vocabolario della Crusca*).

8. Burke, *Fortunes of the Courtier*, 31.

9. 'The Greeks felt that *areté* was, above everything else, a power, an ability to do something. Strength and health are the *areté* of the body; cleverness and insight the *areté* of the mind'; Jaeger, *Paideia*, 418.

10. *Vocabolario della Crusca*, s.v. 'Sprezzatura'.

11. Quantitatively, we can chart the rise of grace in art historical texts thanks to digital technology. Word searches on digitally available art treatises confirm increased usage over time, with fifteenth-century authors Alberti and Ghiberti, for example, mentioning it 20 and 19 times, respectively (in Alberti's *Della Pittura* [1436] and Ghiberti's *Commentarii* [begun 1447], and sixteenth-century successors like Castiglione and Vasari featuring it 132 and 255 times, respectively (in *Il cortegiano* and the 1550 *Vite*).

12. Samuel Holt Monk describes the Ficino-influenced tendency that associates beauty with grace, 'ignoring the attempt of the ancients to separate them', but glosses over those later treatises that make such separation their business: Monk, 'A Grace Beyond', 137. On the later treatises, see Blunt, *Artistic Theory*, 93; Baxandall, *Painting and Experience*, especially 128–35.

13. Blunt, *Artistic Theory*, 97.

14. Dolce, 'L'Aretino', 164. *Inventione, disegno*, and *colorito* can be loosely translated as 'invention' or 'idea', 'sketch', and 'colouring' and are adopted by Dolce to reflect the first three divisions of the art of rhetoric: *inventio, dispositio, elocutio*. See Lee's 'Ut Pictura Poesis', 264. For more on Dolce, see chapter 5 of this book, which examines grace in the language arts.

15. For an example of the obvious parallels, compare the (Italian) wording of da Canossa's and Aretino's statements below. Da Canossa: 'dicesi ancor esser stato proverbio presso ad alcuni eccellentissimi pittori antichi troppo diligenzia esser nociva, ed esser stato biasmato Protogene da Apelle, che non sapea levare le mani dalla tavola' (it is also said that there was a proverb amongst some excellent painters of old stating that too much diligence was damaging; and that Apelles criticised Protogenes for not knowing when to lift his hands from the canvas, 1.28). Aretino: 'onde Apelle soleva dire che Protogee (se io non prendo in errore) in ciascuna parte del dipingere gli era eguale e forse superior; ma egli in una cosa il vinceva, e questa era ch'ei non sapeva levar la mano dalla pittura' (So that Apelles used to say of Protogenes [if I am not mistaken] that he was his equal—if not superior—in all aspects of painting bar one: which is that he never knew when to lift his hands from a painting), Dolce, 'L'Aretino', 185.

16. This, says Aretino, is how Raphael comes to embody *charis* as the Greeks would have had it, *venustà* as the Latins might have said, or *grazia* as the new generation of Renaissance theorists prefer to put it (Dolce, 'L'Aretino', 196).

17. Grace is not commonly sought in Raphael's portraits of men. Daniel Arasse examines the *grazia* and *venustà* of Raphael's Madonnas (1506–1508), arguing that *venustà* alongside *terribilità* become amongst the first terms of aesthetic appreciation in the modern sense. For David Rosand, meanwhile, 'no drawing of Raphael's more profoundly embodies the grace of figural line . . . than the study for the personification of Poetry on the vault of the Stanza della Segnatura'. Rosand describes how Poetry 'turns in quiet serpentine flow' while communicating a 'concinnity of execution and expression, of the body imitating [Raphael's] and the body imitated [Poetry's]'.

Patricia Emison seeks grace in the female figures of paintings like *The Massacre of the Innocents* and the *Fire in the Borgo* as well as in Marian images such as the *Madonna della Seggiola* and the Sistine Madonna. For her, style is the greatest innovation of High Renaissance art, and Raphael's style is distinctly feminine, combining theological, social, and sexual graces to furnish paintings whose grace is as naturally beautiful as it is artificial and divine. A notable exception to this tendency to seek Raphael's grace in images of secular and sacred women can be found in *Raffaello: Grazia e bellezza*, the exhibition and catalogue that include Castiglione's portrait amongst other portraits of men and various female figures said by the contributors to exemplify the artist's Leonardo-inspired beauty and grace. Arasse, 'Raffaello senza venustà'; Rosand, *Drawing Acts*, 128–39; Emison, 'Grazia'; Nitti, Restellini, and Strinati, *Grazia e bellezza*.

18. In this respect, I disagree with John Shearman, for whom the clothing in the portrait expresses 'a richly disingenuous calculation as much on Castiglione's part, perhaps, as on Raphael's [because] Castiglione is not, here, the reserved dresser he promoted in the *Courtier*, but more the dandy who writes bullying letters to his mother demanding the latest in Mantuan hairnets' (*Only Connect*, 135). Shearman suggests that *Il cortegiano* promotes a more conservative reserve in the perfect courtier's dress than the portrait displays. Yet Castiglione's text urges courtiers to advertise their best qualities through the quality and design of their garments. Without being foppish or outlandish, their luxurious dress should serve as external markers of wealth, nobility, and good taste. In this respect, the portrait illustrates to perfection the text's advice.

19. Bull, *Courtier*, 70. 'Spesso ancor nella pittura una linea sola non stentata, un sol colpo di pennello tirato facilmente, di modo che paia che la mano, senza esser guidata da studio o arte alcuna, vada per se stessa al suo termine secondo la intenzion del pittore, scopre chiaramente la eccellenzia dell'artefice, circa la opinion della quale ognuno poi si estende secondo il suo giudicio e 'l medesimo interviene quasi d'ogni altra cosa'.

20. See, e.g., Monk, 'A Grace Beyond', 131–32. For exceptions to this tendency, by contrast, see Emison, 'Grazia'; Ricci, 'Grazia'.

21. Saccone, '*Grazia, Sprezzatura, Affettazione*', 49.

22. There is more to be said about the treatment of women in such discussions. We will return to the topic in chapter 4.

23. Fregoso is describing triangular or mimetic desire in much the same way as it is later theorised by René Girard. See Girard, *Mensonge romantique*.

24. Saccone, '*Grazia, Sprezzatura, Affettazione*', 58.

25. Shearman, *Only Connect*, 108.

26. My translation of Pierluigi de Vecchi's 'il riguardante è indotto a immaginarsi seduto al fianco del Castiglione, come se l'incrociarsi degli sguardi segnasse una pausa di silenzio nell'inimità di un colloquio'. De Vecchi, 'Ritratto', 108.

27. See Dolce, 'L'Aretino', 186, on the need of the spectator to feel moved by painting.

28. See, e.g., Shearman, *Only Connect*, and 'Le portrait', 261–72, as well as Rosand, 'The Portrait', to name but three.

29. Shearman, 'Le portrait', 267; Rosand, 'The Portrait', 94.

30. The full elegy is in Maier, *Il cortegiano*.

31. Shearman's reading of the Andrea Beazzano and Agostino Navagero portrait as a keepsake intended to evoke their friendship with Bembo (the owner of the painting) and Raphael himself in times of separation might just as well be applied to this portrait. Shearman, *Only Connect*, 132–36.

32. 'Ho fatto disegni in più maniere sopra l'invenzione di Vostra Signoria e sodisfaccio a tutti, se tutti non mi sono adulatori, ma non sodisfaccio al mio giudicio, perché temo di non sodisfare al vostro'. Sanzio, *Scritti Letterari*. All translations of the letter are mine.

33. *Invenzione*, says Lodovico Dolce, refers to the fable or story the painter either selects for himself or receives from others as his raw material ('La invenzione è la favola o istoria, che 'l pittore si elegge da lui stesso o gli è posta inanzi da altri per materia di quello che ha da operare'), Dolce, 'L'Aretino', 164. For more on early modern *invention*, see the first part of chapter 5.

34. 'Ma io mi levo col pensiero più alto. Vorrei trovar le belle forme degli edifici antichi, né so se il volo sarà d'Icaro' (But I distract myself with loftier thoughts. I wish to imitate the shapes of classical buildings, although my flight may be like Icarus).

35. 'Voglio ben che ami i favori, ma non però gli estimi tanto, che non paia poter anco star senz'essi' (I wish him to enjoy favours, but not to value them so highly as to appear unable to exist without them, 2.19) (Bull, *Courtier*, 127).

36. Cognitivists working in the sciences and humanities today have much to say about kinesic intelligence and its effect on aesthetic appreciation. Since the 1990s, in fact, the discovery and observation of mirror neuron activity have increased our understanding of embodied cognition and led to theories of 'embodied simulation' in art lovers. Such theories have much in common with the kinds of aesthetic response anticipated by sixteenth-century artists like Raphael and outlined by contemporary commentators from Vasari to Giovan Paolo Lomazzo, whose work we encounter briefly in this section. See, for pioneering examples of cognitively inflected art history, Freedberg and Gallese, 'Motion, Emotion and Empathy'; Freedberg, *Power of Images*; and Gallese and Guerra, *Lo schermo empatico*. For excellent overviews of the field and studies of kinesic intelligence and embodied cognition in literary study, see Bolens, *Style of Gestures*; Cave, *Thinking with Literature*; and Banks and Chesters, *Movement in Renaissance Literature*.

37. De Couessin, 'Le dessin sous-jacent', 65–96.

38. Though similar in terms of composition, there is a world of difference between the irrepressibly seductive self-caresses of the *Venere pudica* and the bashful self-clasping of the modest wife in much Renaissance portraiture. The former, modelled on classical Venuses disturbed at their open-air bath, aspires primarily to a visually pleasing aesthetic while the latter, inspired by religious imagery in the manner of Masaccio's *Expulsion of Adam and Eve from Paradise* (ca. 1425), aims primarily to express the virtue of the invisible soul.

39. I refer, in particular, to Lomazzo, *Trattato* (1584) and *Idea* (1590).

40. Lomazzo, *Trattato*, 665.

41. This and remaining references to Lomazzo in this paragraph are from Lomazzo, *Trattato*, book 5.

42. Cognitively inflected art history has much to say about that 'as if' power of line that Raphael seems instinctively aware of and that Lomazzo praises in his *Trattato*

and *Idea*. Indeed, there is much scope for further study of the ways in which Raphael and Lomazzo each anticipate contemporary 'as-if body loop' theories by exploring in image and word the effects on viewing eyes and bodies of the artist's manual actions on a page. On the 'as-if body loop', see Damasio, *Feeling of What Happens*, and subsequent studies on his so-called somatic marker hypothesis.

43. Lomazzo, *Idea*, 101.

44. Lomazzo, *Idea*, 95.

45. Raphael's drawing survives only in Marcantonio Raimondi's engraving of the subject, of which numerous copies are in circulation.

46. Kárpati, *Raphael Drawings in Budapest*, 93–107. Doubt has been cast over Raphael's authorship of *La Fornarina*: it may have been painted by Giulio Romano or another of his school. Whatever the case may be, the point stands about the fascination in Raphael's work and school with the Venusian gesture of the most seductive modesty.

47. Vasari, *Vite* (1986), 4:27.

Chapter 4. Grace and Beauty: Vittoria Colonna and Tullia d'Aragona

1. See Targoff, *Life*, for a full biography.

2. No poetry from before d'Avalos died survives, apart from the verse epistle written by Colonna when the French imprisoned him in 1512 following the gruesome Battle of Ravenna. Evidence that Colonna was active as a poet in those years, however, exists in the form of citations of the first lines of seven poems in Filonico Alicarnasseo's biography of her *Vita* published in Ferrero and Müller, *Carteggio*, 497, 504–7, 510. We also know that she moved and was admired in Neapolitan literary circles, thanks to numerous examples of contemporary encomiums and dedications to her, as described by Therault, *Un cénacle humaniste*, and Mirella Scala, 'Encomi e dediche'. For an overview of Colonna's publishing history, see Ranieri, 'Vittoria Colonna, 'Descriptio', 'Il cenacolo ischitano'; and Crivelli, 'The Print Tradition'.

3. See chapter 6 for further details on this.

4. Most of Colonna's extant *rime amorose* were written in her widowhood and designed, precisely, to vent her grief, as she proclaimed in 'Scrivo per sfogar l'interna doglia' (A1:1). A1 refers to the *Rime amorose* of Bullock's edition, as opposed to A2 (Colonna's *Rime amorose disperse*); S1 (her *Rime spirituali*); S2 (the *Rime spirituali disperse*); and E (*Rime epistolari*). The second cardinal number (also 1 in this case) refers to the placement of the sonnet within its particular catalogue. See Colonna, *Rime*. All subsequent references to these works are placed in the text. All translations are mine, unless otherwise stated.

5. Ranieri, 'Premesse umanistiche', 533–34.

6. Thanks to his translations of and commentaries on ancient philosophers and early church fathers from Plato to Plotinus and St Paul, Marsilio Ficino is credited with a revival of interest in the ancient philosopher and (as we saw in chapter 2) in a newly charged syncretic form of grace, which contemporaries both within and beyond his native Florence embraced with enthusiasm. Whether Colonna was directly acquainted with Ficino's grace-rich popularisation of Plato's theories of love cannot, of course, be ascertained, but she most certainly was influenced by a number of his

friends and followers. Giles of Viterbo, for example, studied under and was deeply influenced by both Marsilio Ficino and Giovanni Pico della Mirandola (as well as being active and outspoken in the movement for church reform), while Colonna acknowledges her debt to Bembo in numerous letters and sonnets and is credited (or blamed, as Castiglione would have it) with the publication of *Il libro del cortegiano*, which she read (and allegedly circulated without the author's permission) before 1525.

7. See Petrarch, *Canzoniere*, no. 325.

8. Laura regularly appears in Petrarch's *Canzoniere* under the aegis of Venus, both because the goddess enslaves him to love of her (as in the *Triumphis cupidinis*, where Petrarch joins the procession of love's prisoners before Venus) and because she presides over April, the month when Petrarch first set eyes on her (purportedly April 6, 1327) as well as when she died (allegedly April 6, 1348). Designating Venus as her presiding deity communicates both a symbolic desire to transfer the goddess's virtues onto the woman and a poetic gloss on factual information.

9. See chapter 2. So central were the three Graces to Marsilio Ficino's philosophical outlook that he named his villa at Careggio 'Charitum ager' (the soil of the Graces), while Pico (as we saw above) inscribed their image on his portrait medal.

10. See Marsilio Ficino, *De amore* (2.3); Giovanni Pico della Mirandola, *Commento sopra una canzone d'amore* (sixth stanza, ll. 7–8); Pietro Bembo, *Gli Asolani* (3.17); and Baldassare Castiglione *Il libro del cortegiano* (4.52).

11. Bull, *Courtier*, 326; Castiglione, *Cortegiano*, 4.52.

12. Bull, *Courtier*, 341.

13. McHugh ('Rethinking Vittoria Colonna', 346) argues that we have been conditioned to think of Colonna as traditional and, therefore, dull. Her love tends to be thought of as 'a chaste and spiritual devotion to a bodiless light in the sky', yet her poetry is 'capable of conveying a powerfully erotic poetics for an absent body'. I agree entirely that Colonna's desire is no less passionate because the body is absent.

14. Brundin, *Colonna and Spiritual Poetics*, 23.

15. McHugh, 'Rethinking Vittoria Colonna', 346.

16. Brundin, *Colonna and Spiritual Poetics*, 25.

17. McHugh, 'Rethinking Vittoria Colonna', 357.

18. Canigiani, 'Esposizione', 13.

19. Canigiani, 'Esposizione', 11.

20. Canigiani, 'Esposizione', 15, 13.

21. This aspect of her sonnet writing undoubtedly draws inspiration from the writing of female mystics like St Catherine of Siena but also from the Christianised form of Neoplatonism that characterised the Neapolitan Accademia Pontaniana, whose members she often saw at the court of Ischia. See Ranieri, 'Premesse umanistiche' on this.

22. The letter (in *Epistolae familiaris*, 4.1) describes his ascent of the mountain with his brother, Gherardo, and recounts an epiphanic realisation of the vanity of men and of his own error in lingering too long over his earthly love for Laura.

23. The *Pianto della Marchesa di Pescara sopra la passione di Christo* was first published in 1557 but composed between 1539 and 1542 when she was actively conversant with the Valdesian evangelical circle, including Cardinal Reginald Pole, in Viterbo and reform-minded preacher Bernardino Ochino da Siena. For further comment on the *rime spirituali* and the *Pianto*, see chapter 6.

24. An exchange between Colonna and Marguerite de Navarre suggests a degree of self-consciousness in the institution of this new class of woman as both noblewomen cast around for appropriate female guides in times of spiritual uncertainty and social upheaval. In a letter to de Navarre, Colonna confesses she had sought but failed to find a female mentor of sufficient will and intellect to learn from and imitate in her own country, suggesting that the French queen would be just the right kind of model. De Navarre, in turn, repays the supreme compliment in kind, reflecting that she has already been influenced by Colonna's prayers and writings and seeking further spiritual guidance of that kind. The figure of the Virgin Mary as the ultimate inspiration for women looms large in the collection of sonnets Colonna gives to de Navarre as a sign of her esteem and fellow feeling in around 1540 or 1541. For the letters, see Vittoria Colonna, *Carteggio*, 186–87 and 203; and for a deft analysis of the figure of Mary in the gift manuscript, see Brundin, 'Colonna and the Virgin'. On Cristoforo Landino's allegorical reading of the figures of Mary and Beatrice (together with Lucia), see chapter 2.

25. Furey identifies in figures like Colonna a 'shift from medieval Christianity that emphasized asceticism and charismatic sanctity to an early modern religion influenced by educated lay people who put a premium on education and knowledge'. Indeed, one can see in her interpretation of grace traces of both ascetic female mysticism and humanist female learning, a combination I explore further in her correspondence with Michelangelo in chapter 6. Furey, 'Intellects Inflamed', 21.

26. Canigiani, 'Esposizione', 9.

27. Beauvoir, *Deuxième sexe*, 295–99.

28. Girolamo Muzio's dedicatory letter to D'Aragona prefacing the Venice edition of the *Dialogo* (1547) suggests the female interlocutor was originally called 'Sabina' out of a sense of authorial modesty. It was his idea, he says, to rename her 'Tullia' because a dialogue between two real characters (Benedetto and Lattanzio) and one fictional one (Sabina) did not seem to him to be quite right ('non parendo a me che bene stesse in un dialogo un nome finto tra due veri'). Muzio, 'Alla molto eccellente sign ora', 246.

29. For a close analysis of the presence of Ebreo's dialogues on love in d'Aragona's, see Giovanozzi, 'Leone Ebreo'.

30. Smarr, 'Dialogue of Dialogues'. I shall adopt Smarr's practise of using d'Aragona and Varchi to refer to the historical figures and Tullia and Benedetto for the interlocutors of the dialogue.

31. D'Aragona, *Dialogo*, 232. All translations of this text are mine.

32. 'Non è altro, secondo Platone, che un raggio e splendore del primo bene e somma bontà, la quale penetra e risplende per tutto il mondo in tutte le parti'; Varchi, *Opere*, 295. All further references to the *Discorso* are to this edition and are given in the text. This and all subsequent translations of the text are mine.

33. See also Varchi's lesson 'Sopra alcune quistioni d'amore,' in *Opere*, 198, where he lists his main Tuscan authorities (besides Dante and Petrarch) as Ficino, Pico, Bembo, and especially Leone Ebreo, his highest authority.

34. Paolo D'Angelo and Stefano Velotti identify Firenzuola's *non-so-che* as the linguistic fulcrum around which a cluster of terms (*sentimento, gusto, grazia, cuore, simpatia, sorpresa, delicatezza, charme, arte e natura*) gather in anticipation of

pre-Romantic and Romantic aesthetics. Guido Natali, too, recognizes the significance of Firenzuola's use in the history of the term. Richard Scholar illuminates its influence on the development of the French *je-ne-sais-quoi*. D'Angelo and Velotti, *Il 'non so che'*; Natali, 'Storia' and 'Ancora'; Scholar, *Je-Ne-Sais-Quoi*, 27–28.

35. Firenzuola, 'Dialogo delle bellezze delle donne'. This and all subsequent translations of the text are mine.

36. Aristotle's 'quintessence'—originally called the first element—was described in his treatise *De Caelo* alongside the other four elements, fire, water, air, and earth. While the four elements make up the corruptible substances of the sublunary world, the *quintessence* hails from the incorruptible heavens and constitutes those particles of the divine that are latent in all things. Belief that quintessences lay deep within earthly substances inspired alchemical practices and innovations during the Renaissance that sought to extract them for medicinal or other occult purposes.

37. For more on the 'peregrine wits' of the Renaissance, see Klein, 'Pensée et symbole'.

38. Few of Varchi's sonnets survive, though contemporaries attest to their impact during his lifetime. In a series of ribald poems, for example, he was famously mocked by Francesco Grazzini (il Lasca) for his predatory homosexuality and pedantry. At least one of these satires subverts the conventions of Platonic verse, declaring sarcastically that Varchi is heir to Socrates and Pythagoras in his predilection for young and beautiful students whose beauty 'comes from God' and into whose minds he (Varchi) thrusts his deep and lofty knowledge. See Grazzini, 'Rime burlesche', 40. Platonic love is also a recurrent topic in his *Lezioni*, where he returns to it time and again. See, for example, Varchi, *Due lezioni* (1560). His lectures on Michelangelo, too, are infused with Florentine Neoplatonism: Varchi, *Due lezioni* (1550).

39. Aristotelian lectures include Varchi, *Prima lezione*, published in Andreoni, *La via della dottrina*. He also produced a preface and detailed commentary on Aristotle's *Meteorology* claiming to have translated the work from Greek into Tuscan (though no copy of this translation has been found). On this, see Gilson, 'Vernacularizing Meteorology'. More syncretic lectures seeking to reconcile Aristotelian natural philosophy with Platonic and later theories include Varchi, *La prima parte*.

40. Many of Varchi's spiritual sonnets circulated in manuscript form and in interspersed publications before being published as a collection in Varchi, *Sonnetti*. Also relevant in this context is the publication of his Good Friday sermon published alongside Colonna, *Pianto*. Varchi was ordained a priest shortly before dying in 1564.

41. Andreoni, *La via della dottrina*, 14. The metaphor is not mixed in the original Italian, the Italian word *crisi* retaining the Latin connotations of 'choice' and 'decision' that make 'crossroads' a more fitting image than it is in English. Andreoni was the first contemporary scholar to place Varchi's interest in Aristotle alongside his better-known work on classical authors ranging from Seneca and Boethius to Virgil and Ovid in her preliminary studies of unedited fragments and manuscript notes in Andreoni, 'Benedetto Varchi'. Simon Gilson's aforementioned chapter goes a long way towards completing the picture of an eclectic scholar interested, too, in vernacularizing Aristotle.

42. Numerous points of divergence between theologians and philosophers serve to separate the two discursive contexts. See, for example, Tullia's distinction between

the theological affirmation that God is infinite and the Aristotelian view that he is not. Declarations of a philosophical perspective such as 'parlando filosoficamente' or 'ho favellato e favello come peripatetico' become a recurrent refrain, too, steering the interlocutors clear of the riskier terrain of religious debate. D'Aragona, *Dialogo*, 210.

43. 'Sovra ciascuna parola nascono infiniti dubbi, ciascuno de' quali averebbe bisogno di infinito tempo e dottrina' (Infinite doubts, some requiring infinite time and doctrine, arise about every word). Other aphorisms include 'chi non intende le parole mai non potrà intender le cose' (those who never understand words can never understand things) (*Dialogo*, 211) and Aristotle's rule 'che mai non si debbia rispondere ad uno che usi nomi equivoci, ancorché fosse chiaro di qual significato intendesse, se prima non lo dichiara egli stesso' (that one should never reply to those who use ambiguous words until it is clear which meaning they intend or unless they declare their meaning themselves, 212).

44. For discussion of the Council of Trent rulings on grace and on its role in the debate about predestination, see chapters 2 and 6.

45. 'Non è altro che un desiderio di goder con unione quello o che è bello veramente o che par bello allo amante' (202).

46. 'E sappiate che quanto uno è più perfetto, tanto conosce più la bellezza, e quanto la conosce più, tanto più ardentemente la desidera; anzi in tutte le cose dell'universo, siano quali si vogliano, dove si truova piú nobilità e piú perfezzione, quivi necessariamente vi si truova ancor più perfetto e maggiore amore' (232).

47. BENEDETTO: Dunque volete ch'io creda alla autorità. TULLIA: Messer no, ma alla sperienza, alla quale sola credo molto più che a tutte le ragioni di tutti i filosofi (204).

48. See Equicola, *Libro de natura d'amore*, 383–84, which affirms that 'there are those amongst whom a new type of madness is to be found. These simulators attempt to persuade the foolish that they care not for the body's beauty but burn only for the beauty of the soul; that they nurture their passions on sight and sound alone. . . . But to halt desire in sound and vision is impossible because love belongs to body and soul. The operations of the soul depend on the body and vice versa so that both minister to desire and delight cannot exist without both. All the philosophy of that prince of philosophy, Aristotle, reveals the actions of the soul to be connected to the body, and those of the body to be mixed up in and linked to those of the soul'. Decades before d'Aragona's dialogue, Equicola argued that all desire and affection stems from self-love and the pursuit of well-being, as well as from the more general need to procreate and preserve the human species. As well as offering a critique of love theories from Ficino to Bembo, Equicola's *Libro de natura d'amore* sought to revalidate the 'lower' senses and to recuperate the ontological power of touch, in particular, which he says is the condition of our being. The other senses, by comparison, are mere 'ornaments of our essence'.

49. Speroni, *Dialogo d'amore*, 17.

50. 'Alle ragioni di dee credere, non alla auttorità. Dico che una cosa medesima, considerate variamente ed agguagliata a diverse cose, può essere e più degna e men degna di se stessa, e così sarà differente da se medesima' (195).

51. There are hints of the theological debate surrounding predestination here and, in particular, of the quarrel about the role of free will and human agency in

the earning of God's bounty. Benedetto's statement, however, is uncontroversial since both the orthodoxy and most reformation theologies agree that ultimate jurisdiction over the justification of souls is God's and that grace is given to individuals 'each according to his own measure, which the Holy Ghost distributes to everyone as He wills' (*Canons and Decrees*, 33).

52. Section 1 of the anthology contains sonnets by d'Aragona dedicated to various patrons, friends, and acquaintances; sections 2 and 3 contain the conversational sonnets discussed here; section 4 is a bucolic eclogue dedicated to the poet by Girolamo Muzio; and the final section contains other poems dedicated to her by friends and admirers.

53. D'Aragona, *Rime*. Sonnet enumeration throughout this chapter is placed in the text and relies on the sequencing of this first edition, which records d'Aragona's own editorial choices as opposed to those of Enrico Celani who, in his 1891 republication, disrupts the original order so as to include a greater number of works by and to the poet. All translations are mine.

54. This sumptuary legislation dates to 1546, the year before the publication of the *Rime*, and required courtesans to advertise their professional status by wearing a yellow item of clothing. D'Aragona's plea to Eleonora di Toledo for help was edited by Benedetto Varchi and begs 'tanto di grazia' from Eleonora's most excellent and illustrious consort, Cosimo de' Medici, on the grounds that she never behaves like the other courtesans and rarely leaves her room, not to mention her house. Cosimo concedes her the favour, writing 'Grant her this grace as a poetess' (Fasseli gratia per poetessa). For more on the sumptuary laws, see Contini, *Legislazione*, 1:332. D'Aragona's letter is published in Biagi, *Tullia d'Aragona*, 139–40, while Cosimo's decree, archived in the Archivio di Stato in Firenze, is quoted by Enrico Celani's edition of d'Aragona, *Le rime*, xxxix.

55. D'Aragona, *Le rime*, xxxix.

56. *Onestà* in this context, of course, refers to dignity and privilege: 'Honesty is the maintenance of honour, which, in this life, is the reward for virtue' (Onestà è mantenimento d'onore, lo quale onore è premio, in questa vità, della virtù), *Vocabolario della Crusca*, s.v. 'Onestà'. *Cortegiane* were *oneste*, as Ann Rosalind Jones puts it, if 'honoured: prosperous, highly placed'. Jones, *Currency of Eros*, 104.

57. This cautious use of grace reflects a broader mindfulness of being caught within 'a grid of economic and cultural structures that determined what she could say, how she could say it, and to whom', as Jones puts it, in her discussion of d'Aragona's rhetoric, *Currency of Eros*, 117.

58. Petrarch, *RVF*, no. 206.

59. For a compelling analysis of the 'usefulness' of women writers in the crafting of male literary identities, see Cox, *Women's Writing*, 99–108.

60. As Téoli put it in his edition of d'Aragona's *Dialogo*, 'the power of the pen did not just transform less honest women into models of honesty, rendering them decent and acceptable, it also brought honour to courtesans' (my translation). D'Aragona, *Dialogo* (1864), iii.

61. 'Parlava con grazia ed eloquenza rarissima, sì che scherzando o trattando da vero, allettava o rapiva, come un'altra Cleopatra, gli animi degli ascoltanti e non mancavano nel volto suo sempre vago e sempre giocondo quelle grazie maggiori che in un

bel viso per lusingar gli occhi degli uomini sogliono esser desiderate'. Zilioli's biography is reproduced in various nineteenth-century editions of d'Aragona's work. I draw on Zilioli, 'Breve vita', xxiii; and on Mazzuchiello, 'Notizie', xxiii.

62. *Vocabolario della Crusca*, s.v. 'Lusingare'; 'Allettare'.

63. Biondo had already published the first two parts of his invective in 1542, adding *Pena* to the second edition in 1546.

64. Aretino, *Lettere*, book 1.295. Vittoria Colonna, meanwhile, receives Aretino's highest praise as 'having the grace' of divine inspiration.

65. *L'Asino d'oro* is a rather free translation of Apuleius's famous work, *The Golden Ass*. The same Apuleian anecdote mentioned below is also the source for one of Boccaccio's most famous *novelle*, the second story told on the seventh day of the *Decamerone*.

66. Muzio, *Lettere*, 197.

67. 'Già sono più giorni che io ho un mio concetto nell'animo, il quale poi che hora mi viene in proposito io il tu voglio pur dire, Tu mi hai lungamente cantata con nome di Tirhennia: e io vorrei che tu mi mutassi nome, e appellassimi Talia; Ma che lo facessi in guisa che si conoscesse, che Tirhennia, e Talia sono una cosa istessa'. Muzio, *Lettere*, 197.

Chapter 5. Grace and Ingratitude: Lodovico Dolce and Ludovico Ariosto

1. Praised by Leonardo Salviati as 'la più sovrana tromba del moderno nostro idioma' (the most sovereign trumpet of our modern idiom), Ariosto compared favourably to all ancient writers sounding the trumpets of their own languages ('a ciascun di quelle antiche, che risonarono in altre lingue, secondo il comune credere, meritevole di compararsi'). Salviati, *Risposta*, 2r.

2. Dolce, 'L'Aretino', 195–96.

3. For Lodovico Dolce's editorial work and literary output, see Di Filippo Bareggi, *Il mestiere*; and for his life and works more generally, see Terpening, *Lodovico Dolce*. *Orlando furioso* did not meet with universal acclaim. As well as being praised, it was also criticised for its unruly disobedience to the Aristotelian principles of poetic composition. There have been a number of excellent studies illuminating the scholarly controversy over the merits and weaknesses of Ariosto's poem that spanned the forty years after its publication. See, for example, Weinberg, 'Quarrel'; Hempfer, *Diskrepante*; Javitch, *Proclaiming a Classic*. Less work has been done on the reception of Ariosto by his nonspecialist readership. By focusing on Dolce, who writes for a wide and not always scholarly readership, this chapter addresses this gap.

4. Ariosto is held up as an exemplary poet in Dolce's prefaces to Tasso, *L'Amadigi*; Dolce, *Quattro libri*; Dolce, *Modi affigurati*. He also acts as a model for painters in two dialogues by Dolce, 'Dialogo della pittura intitolato L'Aretino' and *Dialogo . . . dei colori* (1565). All translations of Dolce in this chapter are mine.

5. Ariosto, *Orlando furioso novissamente ridotto*. This was to become the most frequently reissued of its time, and numerous other sixteenth-century editions of the poem featured paratexts penned by Lodovico Dolce, a testament to his importance as a leading cultural figure.

6. The two divisions of rhetoric that Dolce excludes are *memoria* and *pronuntiatio*. An important predecessor for Dolce in this essay was Giovanfrancesco Pico della Mirandola (nephew of Giovanni), who, in his epistolary correspondence with Pietro Bembo on the subject of *imitatio*, rebutted Bembo's suggestion that modern writers should model themselves on the best ancient orators—especially Cicero for prose and Virgil for poetry—to perfect their own style by pointing out that there was no place for *imitatio* within the classical rhetorical categories of *inventio, dispositio*, and *elocutio*. See Bembo and Pico della Mirandola, *Le epistole*. It was also not unusual to organise commentaries on Ariosto around the divisions of rhetoric: Giraldi Cinzio's 1548 (?) correspondence with Giovambattista Pigna concerning the poet, for example, is structured in this way. See Cinzio, 'Discorso'. On the dating of Cinzio's letter, see Weinberg, 'Quarrel', 958.

7. It has been argued that extracting a single theme, episode, or character as representative of the whole *Orlando furioso* is best avoided. It risks betraying the rich complexity of the poem and disrupting its compositional ingenuity, so that the unpicked threads lose their original shape and much of the meaning derived from their position within the overarching architecture of the poem. This chapter does not seek a comprehensive account of the *Furioso*'s meaning, however, but rather a small-scale demonstration of its grace in action within a highly representative single episode. A selective approach is therefore justified. For a critique of 'fragmentary' readings of the *Furioso*, see Carroll, *A Stoic Comedy*, 1–23.

8. Dolce, 'L'Aretino', 192. As is the case throughout the book, my practise here is to provide the original Italian text when the specific words used are directly relevant to the overarching argument of the chapter.

9. Dolce, 'Apologia' (1535), where Dolce defends Ariosto against those who accuse him of lacking wit (of being 'di poco ingegno') and of stealing his ideas from others (of being a 'rubatore de le atrui cose' [*sic*]) by pointing out that imitation is the mainstay of good poetry. Future references to the 'Apologia' are cited in the text. For more on literary imitation and on the commonplace of imitation as analogous to the bees collecting pollen for honey, see McLaughlin, *Literary Imitation*; and Moss, *Commonplace-Books*. For more on the fine line between imitation and theft in early modern letters see Bjørnstad, *Borrowed Feathers*, and Eden, *Friends*. Eden's investigation of early modern intellectual property takes Erasmus's adage 'between friends all is common' as a figure for his eclectic discursive practice in the *Adages*, which Eden describes as a repository of the intellectual property of classical antiquity. I will return to the subject of bees and poetic creativity anon.

10. Tasso, *L'Amadigi*, 3. Dolce speaks here of Tasso, who comes close to 'quella piacevole varietà, che nell'Ariosto è stata dall'universale giudizio degli uomini lodata, ed approvata' in his preface to *L'Amadigi*. I quote from the 1581 edition of Tasso, *L'Amadigi* (originally published in 1560). Future references to the *L'Amadigi* are given in the text.

11. For more on Ariosto's parody of Dante, see Quint, 'Astolfo's Voyage', and Mac Carthy, 'Lunar Traveller', which provides a more complete bibliography.

12. The retranslation and revived interest in Aristotle's *Poetics* put extra pressure on poetry to be as heroic and instructive as it was delightful, and the degree to which Ariosto adhered to Aristotle's aesthetic principles became the subject of fierce debate from the late 1540s on. Yet Dolce's allegorization precedes the first published (or at

least extant) defense of Ariosto's work against pro-Aristotelian attack by Fornari, *Spositione* (1549), so it is more likely to have been influenced by the climate of conformity ushered in by the reform of the Catholic Church preceding the Council of Trent (1545–1563).

13. Ariosto, *Orlando furioso ornato* (1554), 381. 'Per S. Giovanni, che conduce Astolfo per fargli havere il senno di Orlando, dimostrasi, che come l'huomo è divenuto pazzo, per se medesimo non puo racquistare il perduto intelletto, se spetial gratia di Dio non vi si interpone'.

14. Commenting on Ariosto's allegory of the crows and the swans, he says: 'You couldn't say it better than that because it reveals the nature of most courtiers today. As we have said before, all virtue and all praiseworthy, fine habits flourished in the courts of old. . . . He concludes, then, with excellent men, in the guise of swans, praising their lords and snatching their names from oblivion. By which means he shows that princes should hold them in high regard'. Dolce, *Modi Affigurati*, 438–39.

15. 'Poetry, a divine gift, is nothing less than imitation. . . . So the business of Poets is to imitate the actions of men; and the goal, beneath graceful [leggiadri] veils of ethical and useful "inventions", is to delight the soul of readers', Dolce, *Osservationi*, 189. 'To delight [Il dilettar]: the most important aim of Poets. . . . Poets are not read if not, first and foremost, because they bring pleasure. It's true that usefulness can be conjoined to delight: but not necessarily'. Dolce, *L'Amadigi*, 3.

16. On Ariosto's continued relevance, see Mac Carthy, 'Fiordispina's Afterlives'.

17. Javitch, 'Cantus Interruptus'.

18. A similar argument is developed further in Mac Carthy, 'Lunar Traveller'. See also Ugolini, 'Self-Portraits'.

19. Dolce is writing about Bernardo Tasso in this excerpt, but his closing remarks in the preface suggest that the two are so alike that what can be said of one can also be said of the other.

20. Saccone, *Il 'soggetto'*, 247.

21. Dolce, *Osservationi*, 193.

22. Here, as mentioned before, Bembo criticises Dante for over-ambitiously trying to master all of Christian theology, the seven arts, and philosophy. See Bembo, *Prose*, 103.

23. In so doing, Ariosto flouts the rule, outlined by Dolce, that sentences or clauses should run in pairs of lines. This rule may be broken on rare occasions, says the critic, to create a particular effect: Dolce, *Osservationi*, 239. The legislating critic is here surely trying to catch up with the inventive poet.

24. I invert, here, the order of English translation followed by original Italian text featured throughout the rest of my book because of the importance of phonetic, rhythmic, and other aural features of the original to my argument.

25. 'Sentence', in this context, refers to brief sayings and expressions (proverbs, aphorisms, adages, and so on) so highly praised by humanists and the classical rhetoricians they championed, including Aristotle, Quintilian, and Horace.

26. See Anna Holland's persuasive reading of Horace's poetic metamorphosis and its afterlife, 'Swansongs'.

27. The iconic image was taken up by generations of subsequent poets wishing to soothe poetic insecurity and to project themselves forward into a glorious afterlife.

See, for example, the popular sixteenth-century madrigal written by Guidiccione and set to music by Jacques Arcadelt, 'Il bianco e dolce cigno', which leaves an obvious impression on Orlando Gibbons's most famous madrigal, 'The Silver Swan', which ends: 'Farewell, all joys! O Death, come close mine eyes! / More Geese than Swans now live, more Fools than Wise.'

28. 'Già l'Ariosto è stato accettato communemente per Poeta non pur raro, ma divino', *L'Amadigi*, 6.

29. The 1516 *Furioso* was published in Ferrara by Giovanni Mazzocchi under Ariosto's personal supervision. The second edition, also published in Ferrara, was published by Giovanni Battista della Pigna (1521) and received the same personal attention. The third and definitive version of the poem was first published in Venice by Francesco Rosso da Valenza (1532).

30. Saccone, *Ritorni*, 106.

31. A sign that the balance currently swings in favour of the emblem-as-ingratitude side of the argument is Brian Richardson's unquestioning translation of the motto as 'evil in return for good' (as opposed to the more ambiguous alternative) in a recent article. Later in the same article, Richardson mentions a comparable emblem page to Ariosto's in a volume he argues may well have circulated in Ferrara sometime after 1509. The title page of Jean Lemaire's *La Légende des Vénitiens* (1509), he points out, also 'depicts bees buzzing around their nest, which is also in a log rather than a man-made hive' and a biblical motto 'Favus distillans labia mea' (My lips are a dripping honeycomb), an adaptation from the *Song of Songs* (4.11) that alludes to the sweetness of poetry. The point he wishes to make is that both emblem pages can be seen as examples of 'a growing and transnational desire by authors to promote their cultural identity in print'. He does not, however, consider the possibility that Lemaire's honey-dripping bees and Ariosto's fire-fleeing ones might be iconographically related and that this prospect should unsettle the certainty with which the motto is claimed to represent ingratitude alone. Richardson, '1516 Edition', 98. See also Tura, 'Jean Lemaire de Belges'.

32. The *Cinque canti* are a sequence of chapters originally intended to act as an annex (un poco di gionta) to the *Furioso* but never actually incorporated into the main text. Seminal studies of the emblem page include Fahy, *Profilo*; Ceserani, 'L'impresa'; Casadei, 'Il *Pro Bono Malum*'; Saccone, *Il 'soggetto'* and *Ritorni*; Richardson, '1516 Edition'.

33. Rinaldo is often viewed as the poet's alter ego within the poem, further 'proof' that the significance of the bees in the *Cinque canti* is intrinsically linked with their meaning on the emblem page. Rinaldo L. Martinez, for example, connects up Rinaldo's journey along the Po River with the narrator's homecoming in canto 46 and aligns Rinaldo's refusal to test the fidelity of his wife with the narrator's efforts at confronting his own jealousies (Martinez, 'Two Odysseys'). The *Cinque canti* were not published during Ariosto's lifetime, so the dating of their composition remains uncertain, complicating the question of how closely they can be aligned with the iconography of the emblem page. Most critics agree that they were written after the appearance of the first *Furioso*: how soon after has yet to be ascertained (Dionisotti proposes a dating of 1518–1519, while Segre suggests between 1521 and 1528). See Dionisotti, 'Per la data'; Segre, 'Studi'; and (for an isolated counterclaim that they were written before the publication of the first *Furioso*) Capra, 'Per la datazione'.

34. Casadei, 'Il *Pro Bono Malum*', 566–68.

35. Casadei lists *Genesis* 44:4; *Jeremiah* 18.19–20; Psalms 37:20–21; Psalms 51:5; and Psalms 108:4–5.

36. Masi identifies a collection of versified fables by Bobrio as a possible source for Ariosto's acquaintance with Aesop, which the poet accessed either directly or with the help of a more Greek-literate friend (Masi, 'I segni', 158–59).

37. Further reading on ingratitude in Ariosto includes Maldina, 'Ariosto, l'ingratitudine'.

38. What remuneration he gets from his 'mala servitude' (and it was not much) was never, he claims, for his poetry: Ippolito 'non vuol che laude sua da me composta / per opra degna di mercé si pona; di mercé degno è l'ir correndo in posta' (doesn't think the tributes I compose for him are worthy of reward; the only thing worthy of reward is changing [my] horse at every post, 1:97–99). Ariosto earned 240 lire per year from Ippolito and complained bitterly about how poor that made him in *Satire* 1: see Cesare Segre's notes on *Satire* 1 in Ariosto, *Opere minori*, 502–3. Other comments include 'dal giogo / del Cardinal da Este oppresso fui' (I was oppressed by the yoke of the Este Cardinal) (*Satire* 6:233–34); and 'non mi lasciò fermar molto in un luogo / e di poeta cavallar mi feo' (he never let me linger long in one place and turned me from a poet into a horseman) (*Satira* 6:237–38). Ariosto's *Satires* are published in Ariosto, *Opere minori*.

39. 'Foetum invita lupae, sed iussu nutrit herili, / Et sua lactae suo pignora fraudat ovis; / Scilicet ut meritam bene de se perdat adultus: / Mutare ingenium gratia nulla potest.' Ariosto, *Opere Minori*, 35.

40. Ariosto may have accessed the Greek either in the *Antologia Palatina*, book 9, or the *Antologia planudea*, book 1. Ariosto alters his source, originally in the first-person singular (in Greek), to universalize the fable and, perhaps, to distance himself from overidentification with its message. The original Greek translates as 'It is not by my own will that I suckle the wolf at my breast, but the shepherd's folly compels me to do it. Reared by me, he will become a beast to attack me. Gratitude cannot change nature.' The translator is William Roger Paton, who renders the Greek original Χαρις or *charis* in the last line as 'gratitude' (Paton, *Greek Anthology*, 27). Ariosto translates Χαρις more faithfully into Italian as *gratia* or 'grace'. More could be said about the process of adaptation that led from the first-person singular in the original Greek epigram and the third-person singular in Ariosto's version. Fahy saw it as an error (and the translation a language-practise exercise), but, given the frequent return to such themes, it is just as likely to be a deliberately subtle adaptation that any of Ariosto's learned peers would have been able to appreciate (Fahy, *Profilo*, 114).

41. An apocryphal story relates that when, years later, Ariosto recited the first cantos of *Orlando furioso* to Ippolito (or presented him with a copy of the text—the story varies), his response was 'Messer Ludovico, dove hai trovato queste coglionerie?' (Mr Ludovico, where did you find all this rubbish?). Indeed, another Latin epigram from around the same time, 'De diversis amoribus', articulates similar sentiments, openly criticizing the 'ungrateful prince' (male grati principis) who tired of Ariosto's company all too easily and banished him to the remote citadel of Canossa, where he was required to act as military commander from 1501 to 1503.

42. Indeed, a number of his near contemporaries did read it as such. Paolo Giovio, for example, was content to interpret the bee *impresa* as denoting 'com'egli era stato

maltrattato da qualche suo padrone, come si cava dalle sue satire' (how he had been treated badly by some patron of his, as his satires suggest), leading several contemporary critics to privilege this reading over others (Giovio, *Dialogo*, 153). Yet early modern interpreters were not necessarily right. Others, as we shall see, read Ariosto's *impresa* differently, and it was not uncommon, as Susan Gaylard points out, for early moderns to get the significance of personal emblems entirely wrong. Gaylard, 'Silenus Strategies' offers a persuasive study of early modern misreadings of personal emblems (including Tasso's Giovio-inspired misreading of Ariosto in 'Il Conte').

43. The bibliography on Ariosto's famous irony is vast. Recent studies that offer persuasive readings while summarizing previous scholarship include Jossa, 'Entertainment', and Sangirardi, 'Trame e genealogie'.

44. '[Il] ben va dietro al male, e 'l male al bene / e fin son l'un de l'altro'. Masi discredits Saccone's reading on the grounds that the exordium features only in the 1532 edition, emerging, therefore, sixteen years after the first usage of the emblem. Yet one could also read the exordium as a disambiguation in words of the all-too-ambiguous earlier image: the exordium stands in for the bees that no longer feature in 1532. There is no way to prove that this was Ariosto's intention, of course, but there can be no doubt that the core themes of the *impresa* accompanied him throughout his career. So to connect the later words to the earlier image seems entirely justified. In fact, when Masi's own reading of the bee emblem relies on the later *Cinque canti*, he makes a similar move to Saccone and thus undermines the coherence of his own objections.

45. 'Good and evil are necessarily intertwined. In fact, their evaluation—the attribution to one or the other of a positive or negative value—is a question of perspective that depends precisely on the point of view assumed.' Saccone, *Ritorni*, 106 (my translation).

46. The first line of the 1516 edition varies from the final 1532 edition, but both list (more or less) the same main subjects of interest. Compare 'I donne e cavallier, li antiqui amori, le cortesie, l'audaci imprese io canto' (I sing of ladies and knights, of ancient loves, courtesies and courageous deeds) (1516) with 'Le donne, i cavallier, l'arme, gli amori, / l'audaci imprese io canto' (I sing of ladies and knights, of arms and love, of courageous deeds) (1532).

47. Giorgio Masi makes a similar point and hints that Lazzari's eccentric interpretation of the *impresa* as symbolising ingratitude in love (1928) may have acted as a deterrent to further enquiry.

48. 'Non tu quoq[ue]; Nate / Corpore non magno vulnera magna facis?'. Strozzi, 'In amorem furem', 90.

49. On Cranach's borrowing from Strozzi, see Leeman, 'A Textual Source', and on the controversy as a whole, see Talbot, 'Central Europe', and Foister, 'Lucas Cranach'.

50. In all copies, Cranach's painting bears the Latin inscription 'DVM PVER ALVEOLO FVRATVR MELLA CVVPIDO / FVRANTI DIGITVM CVSPIDE FIXIT APIS / SIC ETIAM NOBIS BREVIS ET PERITVRA VOLVPTAS / QVAM PETIMVS TRISTI MIXTA DOLORE NOCET' (As Cupid was stealing honey from the hive, / A bee stung the thief on the finger; / And so do we seek transitory and dangerous pleasures / That are mixed with sadness and bring us pain).

51. Remo Ceserani, too, aligns Ariosto's and Alfonso d'Este's mottoes, emphasizing their shared juxtaposition of opposites. In Alfonso's case, however, he identifies a

more optimistic note and a clearer steer towards the *bonum* of peace that comes out of the *malum* of war (Ceserani, 'L'impresa', 184–85).

52. Fortunately, writes Virgil, bee colonies can be restored by 'bugonia', or spontaneous regeneration from the carcasses of sacrificed bullocks (the Old Testament fable is reborn). As well as a mystery of natural philosophy, bugonia serves Virgil as a convenient metaphor for his hopes in the political and moral renewal of Rome under Octavian. In somewhat similar circumstances, Alfonso d'Este's emblem expresses his aspirations for the regeneration of Ferrara under his leadership following years of war and political wrangling. Under his command, the emblem augurs, peace will reign and citizens, like dutiful bees, will thrive in the spirit of cooperation and loyalty on which security and survival depend. On the iconography of bees emerging from the bodies of dead animals, see also David Freedberg, for whom they stand (at the level of the individual) for the soul's ability to rise to heaven (Freedberg, 'Iconography').

53. Born without insemination and nurtured 'with celestial humours' (Rucellai, ll. 615–17), bees offer themselves up entirely for their one and only lord (the king bee) and for their homeland. Though short-lived, they belong to an immortal bloodline, sharing one mind and one single desire with their regent, a paradigm of 'fecund sweetness' (to paraphrase Toscanello) for all chaste and dutiful female citizens.

54. Toscanello's interpretation of Ariosto's women-bees in this episode is very different from Paolo Giovio's reading of the bees of the emblem page. Lodovico Dolce's interpretation in 'Dialogo dei colori' is different again, testifying to the need for caution when ascribing greater interpretative insights to early modern readers (as Gaylard, 'Silenus Strategies', argues). For Dolce, Ariosto's motifs embrace contradictory narratives, from the jealousy of rivals whose envy had stung the rare and excellent poet to a sign of his perseverance and firm belief that 'in persevering, man will obtain his desires'. Ariosto's snakes, too, denote for Dolce prudence as well as envy. Their wise habit of hibernating in winter and renewing themselves regularly by shedding their skins alludes, he says, to the 'immortalità del anima' (as opposed to the mortal, dispensable body), a classical trope 'felicemente' imitated by Ariosto.

55. Seneca, *Ad Lucilium epistulae*, 276–85, letter 84.

56. See the first part of this chapter for Dolce's description (in 'Apologia', 8) of Ariosto extracting, with bee-like skill, ideas, words, and sentences from a variety of classical predecessors to produce his own sweet verse.

57. Horace, *Complete Odes*, 156.

58. See Putnam's commentary on Horace's humble posturing in this ode as he describes the Icarus-flight of seeking to imitate Pindar while Pindar imitates no one—not even Mother Nature—since he is nature itself. Putnam, *Artifices*, 55–56. Citing Petrarch, Bembo, Pico, Castiglione, and Erasmus (amongst others), Kathy Eden links metaphors of intellectual borrowing, such as Seneca's metaphor of the bee, to early modern debates about literary style. 'The best ideas are common property', as Epicurus had argued, and imitation of truths is as inevitable as it is uncontroversial in the republic of letters. Style, however, is unique to individual authors, who should strive for originality in this respect. Eden, 'Literary Property'.

59. Martial's epigram 'On a bee enclosed in amber' also appears relevant here: 'the bee is enclosed, and shines preserved, in a tear of the sisters of Phaeton, so that it seems enshrined in its own nectar. It has obtained a worthy reward for its great toils;

we may suppose that the bee itself would have desired such a death' (4.xxxii). Martial's pithy lines are dense with insights into the humble and seemingly thankless yet actually very well rewarded work of poet-bees.

60. 'Ecco quindi che il senso della frase ariostesca si lega strettamente al tema dell'ingratitudine *umana*, quella dell'uomo che scaccia le api per ottenere il miele della celebre xilografia. Ma si lega anche a quello più specifico della malvagità dei detrattori, dei cortigiani nemici (eventualmente simboleggiati dalle serpi) che hanno reso 'male per bene' al poeta-giusto' (Casadei, 'Il *pro bono malum*', 568).

61. This emblem appears only on some of the 1532 editions. Others bear the simple motto and include no emblem at all.

62. 'Aspettare le gratie' in the *Vocabolario della Crusca* (s.v. 'Grazia') denotes awaiting something that is much desired but never realised, an early modern equivalent of 'waiting for Godot', as Samuel Beckett put it.

Chapter 6. Grace and Labour: Michelangelo Buonarroti and Vittoria Colonna

1. The year 1516 was when Leonardo da Vinci, who had also rivalled Michelangelo, left Italy for France and Raphael became his main competitor. For an authoritative account of Michelangelo's various rivalries, see Goffen, *Renaissance Rivals*.

2. For Michelangelo's account of these years, see the letter to Domenico Buoninsegni of January 1520 in which he enumerates his efforts and tribulations. Michelangelo, *Carteggio*, 2:218–21.

3. See Forcellino, *Michelangelo*, 125–44, for an account of those years.

4. Vasari, *Vite*, 543. This comment and those that follow are taken from the *proemio* to part 3. Translations of this text are mine.

5. Insisting on correct and careful measurements and ignoring the 'sweet and graceful facility' (quella facilità graziosa e dolce) that is suggested rather than revealed in living figures, these artists committed the ultimate crime of giving 'proof of diligent study' (lo stento della diligenza). Diligent study, without delicacy, refinement, and 'supreme grace' (somma grazia), produces a dry and graceless style (Vasari, *Vite*, 540–42).

6. Castiglione, *Cortegiano*, 1.24. As Blunt put it back in 1940 (*Artistic Theory*, 97), 'the account of grace in its social sense in the *Cortegiano* is so close to Vasari's view of it applied to the arts, that we may conclude that he derived the idea directly from this source'.

7. Vasari, *Vite*, 542.

8. For more on *terribilità*, see below.

9. Dolce, 'L'Aretino', 42.

10. Dolce, 'L'Aretino', 147–49.

11. For more on this, see Hirst, *Six Lectures*, 12.

12. It appears just 4 times in Condivi, compared with Vasari's 266. Condivi's text is, admittedly, much shorter, but the two texts also differ in frequency as well as in number of citations.

13. English translation by George Bull in Buonarroti, *Life*, 39; Condivi, *Vita*, 35.

14. Buonarroti, *Life*, 70; Condivi, *Vita*, 63.

15. The ultimate goal of the perfect courtier, as we have seen Ottaviano Fregoso point out in Castiglione's *Cortegiano* (4.5), is to exploit this system of exchange and to

NOTES TO CHAPTER 6 [213]

manoeuvre oneself into a position where one can always tell the truth about things so as to guide the prince along the path of virtue without displeasing him.

16. A number of studies attest to this fact as well and illuminate the inexorable link between Michelangelo's reform-minded religiosity and his aesthetic outlook and practice. See, for example, Calì, *Michelangelo*; Campi, *Michelangelo e Colonna*; Nagel, *Reform of Art*; D'Elia, 'Drawing Christ's Blood'; Forcellino, *Michelangelo*.

17. To cite two references to this by Condivi: 'From childhood Michelangelo was very hard-working'; 'Michelangelo, when he was young, gave himself not only to sculpture and painting, but also to all those branches of study which either belong or are close to them' (È stato Michelagnolo, fin da fanciulllo, uomo di molta fatica; Si dette adunque Michelagnolo, essendo giovane, non solamente alla scoltura e pittura, ma ancora a tutte quelle facultà che sono o appartenenti o aderenti con queste) (Buonarroti, *Life*, 58, 66; Condivi, *Vita*, 52, 59). Condivi goes on to emphasize his investment of time and effort into studying not just drawing, painting, and sculpting but all branches of knowledge, including philosophy, theology, anatomy, geometry, and literature.

18. David Summers aligns *terribilità* with the term from Greek rhetoric *deinotes*, which, to paraphrase his chapter, 'had three principal meanings; one had to do with loftiness or grandeur, the second with force of expression, and the third with artifice and skill'. For his chapter on *terribilità*, see Summers, *Language of Art*, 234–41.

19. Della Latta, 'Storie', reveals incidences of *faciebat* signatures dating from before Michelangelo's. See also Hegener, *Künstlersignaturen*, for further discussion.

20. Vasari, *Lives*, 336. For a comparison of the 1550 and 1568 editions, see the Barocchi and Bettarini edition of Vasari, *Vite* (the relevant section in this instance being 6:17). Bull's English translation is of the 1568 edition.

21. Objecting to the knee-jerk reaction of dismissing this anecdote, Lavin (in 'Divine Grace') calls attention to the anonymous letter, presumably addressed to Vasari and written before the 1568 of his *Vite* (but discovered only in 1930 by Karl Frey), which provides the source of this story. The letter gives, he suggests, such verisimilar details on an exchange Michelangelo supposedly had that night with one of the *murate* nuns residing next to the church that it is unlikely to be mere fabrication. The band across Mary's breast, says Lavin, was certainly part of the original design (intended, perhaps, to recall the strap of a baby sling as in Filippo Lippi's altarpiece of the Virgin in the Louvre), but the signature may well have been an afterthought added in the heat of the moment, just as Vasari said.

22. Juřen, '*Fecit-faciebat*'; Wang, 'Michelangelo's Signature'; Goffen, *Renaissance Rivals*, 113–18.

23. Buonarroti, *Complete Poems*, 150; Buonarroti, *Rime*, 323.

24. Condivi testifies to the depth of Michelangelo's theological engagement in this first *Pietà* when he recounts the artist's justification of Mary's youth compared with her son's. 'Don't you know', Michelangelo is reported to have said to his biographer, 'that chaste women remain far fresher than those who are not chaste?' He goes on to explain that Christ is depicted as his actual age to emphasize that the son of God took a truly human body. Such reflection, says Condivi, 'would be worthy of any theologian' (Buonarroti, *Life*, 22).

25. Lavin also suggests that Michelangelo's signature renders the *Pietà* a sort of spiritual self-portrait; but for him the underlying meditation is on death, 'the Savior's

and his own'. The *Pietà* signature adumbrates, he says, 'Michelangelo's preoccupation toward the end of his life with death and his own, ultimately imperfect, tomb' (Lavin, 'Divine Grace', 150). Attending more to Michelangelo's youthful exuberance than to his morose disposition is Wang's reading of it. She highlights Michelangelo's self-conception as an angel (MICHAEL. AGELVS., as the inscription asserts) and emphasises his affinity with the conviction that gifted poets and artists are divinely ordained. With this inscription, she suggests, Michelangelo himself introduced the epithet 'divino' that was to become so common throughout the rest of his career (Wang, 'Michelangelo's Signature', 467–73).

26. They chart, too, a spirituality informed by Neoplatonism that establishes patterns of thought that lend themselves to Reformation spirituality. On this development in Michelangelo's poetry, see Moroncini, 'La poesia' (2010).

27. The numbers in brackets here and following all citations of Michelangelo's poetry refer to the sonnet number in the editions I reference above. Sonnet 6 is notoriously hard to interpret and translate, particularly the final three lines. The translation I offer here is a transmodification of various English translations combined with my own understanding of those lines as suggesting that it is impossible to know where the Heavens will distribute virtue in this world, so that seeking it where one might expect to find it is futile.

28. Wilde, *Six Lectures*, 147.

29. De Tolnay, *Art and Thought*, 63. In most critical commentaries, de Tolnay's 1964 account of the Minerva Christ continues to leave its mark.

30. William Wallace, not a fan of the 'unpleasantly thickset figure with monumental buttocks', argues that the Minerva Christ was originally intended to be placed in a niche set in to a pier on the northern side of the nave, with the feet of Christ at or above shoulder level.

31. Michelangelo, *Rime*, 279: 'col fattor l'opra suo consuona'.

32. Michelangelo, *Carteggio*, 4:262.

33. Michelangelo, *Carteggio*, 4:262.

34. Again, the dating of this sonnet is contested, being put anywhere between 1496 (Michelangelo's arrival in Rome) and 1527 (a response to the sack of Rome). Most critics, however, date it as 1512 under the pontificate of Julius II. For our purposes, the dating is relatively insignificant since it expresses a sentiment that can be associated with Michelangelo throughout his career.

35. Michelangelo, *Rime*, 12.

36. In the words of De Tolnay (*Medici Chapel*, 95): 'the Christ of the Minerva is one of the less outstanding works of Michelangelo. However, it is it is historically important as . . . a document of his religiosity: this image of the true Christ, erected in the middle of the secularized Papal city, may be considered as an artistic counterpart to Pico della Mirandola's address to Leo X concerning the reform of ecclesiastical morals, presented to the Pope in the Spring of 1517'.

37. The dating of the *Laocoön Group* and the question of whether it is the original Greek statue described by Pliny the Elder or a Roman copy are still being debated. If Greek, it most likely hails from some time between 42 and 20 BC, when the sculptors named by Pliny, Agesander and Athenedorus, are believed to have been active.

38. According to Pliny, the entire composition was formed of one single block of marble, though the version unearthed in Rome (most likely an ancient copy) comprised seven interlocking pieces.

39. This is according to a letter written by Francesco da Sangallo, whose father, Giuliano da Sangallo, had also been summoned to authenticate the statue as a Greek original. For the full text of the letter, see Maffei, 'La fama'.

40. In 2005 Lynn Catterson proposed that the *Laocoön Group* was neither Greek nor Roman but a Michelangelo forgery from around the turn of the sixteenth century. Whether or not Michelangelo really was its author, the fact remains that the *figura serpentinata* began to appear in his work around that time. Only one other sculpture, his *St Matthew* (now in the Accademia in Florence), precedes the Minerva Christ and demonstrates the same writhing torment and struggle to break free as the *Laocoön*. Catterson, 'Michelangelo's Laocoön?'.

41. From this point of view, it is interesting to compare the Minerva Christ with its first draft. The first draft, abandoned because of a black vein in the white marble four or five years before the final one was realised, presents a Christ in *contrapposto* but without the bodily twist. Here, Christ's left hand rests by his side—somewhat in the manner of the Florentine *David*—and the upper part of the fully frontal torso occupies the same plane as the lower. This Christ is similarly naked and beautiful, open in his gesture, serene in his gaze. What is missing is the vital energy contracting the second Christ's middle, the two-directional sense of movement, the conflicting emotions of agony and ecstasy. It is here that the *figura serpentinata*, which came to characterise Michelangelo's later work and Mannerism more broadly, originated.

42. It was the *Laocoön*'s paradoxical capacity to express pain while retaining beauty (which left its mark on Michelangelo's sculpture) that also inspired the famous critical debate between eighteenth-century German art critics Johann Joachim Winckelmann and Gotthold Ephraim Lessing.

43. Condivi and Vasari mention a *Christ with a Samaritan Woman* and a *Crucifixion* as well as this *Pietà*.

44. Forcellino, *Michelangelo*, 156. Despite his professional success, his life had been anything but easy: family tragedies, the sack of Rome, treacherous Florentine politics, plagues, and other calamities made the seventeen years he spent in Florence gruelling and dangerous. He fled the city for Venice in September 1529 and planned to leave for France to work for his admirer Francis I. But the sojourn was short and he returned to his native city once more. In 1532 he met and was (allegedly) overwhelmed by the Roman nobleman Tommaso de' Cavalieri, for whom he abandoned Florence and returned to the Vatican City, where he was finally in a position to enjoy the accolades bestowed on him.

45. Determining the chronology of Colonna's poetry is difficult, but a letter from her close confidant, Gualteruzzi, suggests that by 1536 she had turned herself towards God and wrote of no other matter (Colonna, *Sonetti*, 25). Bernardo Tasso, publishing in 1534, also speaks of her poetic and existential change (Ferroni, *Bernardo Tasso*).

46. See chapter 2 for an introductory overview of Reformation and Counter-Reformation grace.

47. See canon 4: 'If any one saith, that the sacraments of the New Law are not necessary unto salvation, but superfluous; and that, without them, or without the desire thereof, men obtain of God, through faith alone, the grace of justification;—athough all (the sacraments) are not indeed necessary for every individual; let him be anathema'; and canon 7: 'If any one saith, that by the said sacraments of the New Law grace

is not conferred through the act performed, but that faith alone in the divine promise suffices for the obtaining of grace; let him be anathema'. See *Canons and Decrees*, 43.

48. Probably written by the Benedictine monk Benedetto Fontanini (known as Benedetto da Mantova) and revised by Marcantonio Flaminio, *Il beneficio* had been in circulation in manuscript form since at least 1541. Translations of the text are mine.

49. In 'Quando dal lume, il cui vivo splendore' (S1:9), for example, 'si dissolve per grazia il ghiaccio duro / che sovente si gela intorno 'l core' (grace melts the hard ice that often forms around human hearts); while, in 'Deh, manda oggi, Signor' (S2:18), faith in God's grace 'illustra, accende / e pasce l'alma sol di lume vero' (illuminates, ignites, and nourishes the soul), sewing and establishing in us 'l'alta radice / qual rende i frutti . . . tutti d'amore' (the lofty root / that yields fruit made all of love). In 'Quando, mercé del Ciel, per tante prove' (S2:20), grace 'nel mondo piove' (rains down upon the world), purging, sating, and cleansing it with the 'nove / acque' (new waters) emanating from 'sì abondante e largo fonte' (such a generous and abundant source) in 'sacri rivi / che son più dolci al cor ch'ha maggior sete' (sacred rivulets that are sweeter to those hearts that have the greater thirst).

50. See Flaminio and da Mantova, *Il beneficio*, 88–89, for a comparison of 'timore servile' and 'timore filiale'. On becoming children of grace, see Flaminio and da Mantova, *Il beneficio*, 46: 'Chiunque accetta questa buona nova e la crede veramente, ha la vera fede, e gode la remissione de' peccati, ed è riconciliato con Dio, e di figliuolo d'ira diventa figliuol di grazia' (Whomsoever accepts this good news and really believes it has true faith, enjoys the remission of sins and is reconciled with God. Having been a child of anger, he becomes a child of grace).

51. Evidence suggests that an investigation by the Roman Inquisition of Colonna was planned but never executed, though friends and acquaintances were interrogated about her doctrinal leanings during their own trials for heresy (for details, see De Frede, 'Vittoria Colonna'; Fragnito, 'Vittoria Colonna'). The court record for Pietro Carnesecchi's third trial (1566–1567) provides invaluable evidence of the suspicion with which she was regarded as he was pressed by interrogators for his insights into her attitudes towards *sola fides* and predestination. See Firpo, *Inquisizione*; Firpo and Marcatto, *I processi inquisitoriali* and Colonna, *Carteggio*.

52. *Canons and Decrees*, 35.

53. Flaminio and da Mantova, *Il beneficio*, 89.

54. Flaminio and da Mantova, *Il beneficio*, 63.

55. Flaminio and da Mantova, *Il beneficio*, 83.

56. Recalling chapters 103 and 104 of Valdés's 110 *considerazioni*, *Il beneficio* describes 'le orazioni, e l'uso frequente della santissima communion, e al memoria del battesimo e della predestinazione' as arms against the devil, human prudence, and all other obstacles to faith (Valdés, *Cento e dieci*, 462–72).

57. See also chapter 9, 'Against the Vain Confidence of Heretics', and chapter 12, 'Rash Presumption of Predestination Is to Be Avoided' (*Canons and Decrees*, 35, 38).

58. *Canons and Decrees*, 35.

59. Debate about Colonna's relationship with Roman Catholic doctrine has continued over the centuries with the famed historian of the Council of Trent, Hubert Jedin, feeling able to insist on her orthodoxy in 1947 ('Il cardinal Pole'). Of the opposite opinion was Carlo Ossola, who in 1985 emphasized her affinity with the Spanish

writer credited with inspiring the leading proponents of reform in Italy, Juan de Valdés (Valdés, *Lo evangelio*). The discovery and publication in 1989 of new documents relating to Colonna and Reginald Pole in the Vatican Archives offered clearer insights, enabling historians like Emidio Campi to align her views with those of Bernardino Ochino da Siena, although this was not a universal view. See Campi, *Michelangelo e Colonna*, and, for a different perspective, Firpo, 'Vittoria Colonna'). For the 'new documents', see Colonna, *Nuovi documenti*.

60. After the failure of Regensburg, Pope Paul III was convinced that doctrinal reconciliation with the reformers was impossible so that the Viterbo circle became thenceforth increasingly alienated from the church. From 1542 its members and sympathisers were forced to recant, flee Italy, or remain firm enough in their beliefs to face the Inquisition. Contarini died shortly after the Regensburg Diet, but not before warning Bernardino Ochino against facing the Inquisition, which had issued him with a citation. Instead of travelling to Rome to answer to accusations of heresy, Occhino fled to Geneva. Pole, as mentioned above, withdrew from Trent in 1546, never to return. Vittoria Colonna herself was fortunate enough to have died just after the sixth session of the Council of Trent at which the doctrine of *sola fides* was unequivocally condemned. On Colonna and Ochino, see Bardazzi, 'Le rime spirituali'.

61. De Holanda, *Dialoghi*, 42–43.

62. Of the many excellent studies that have emerged in recent years on the relationship among Colonna, Michelangelo, and Reformation circles, see, in particular, Brundin, *Colonna and Spiritual Poetics*; Calì, *Michelangelo*; Campi, *Michelangelo e Colonna*; Prosperi, 'Michelangelo'; Forcellino, *Michelangelo*; Masi, 'Le rime michelangiolesche'; Copello, 'Il dialogo poetico'; as well as the biographies by Wallace and Forcellino.

63. 'Correte a Cristo, la cui vera pietra / il piombo de l'error nostro converte / col sol de la Sua grazia in oro eterno' (Flee to Christ, whose true stone turns the lead of our sins into eternal gold through the sun of His grace') (my translation). No. 91 in the gift manuscript that Colonna gave to Michelangelo in 1540, the sonnet had already appeared in her *Rime* of 1538 and was probably, therefore, written before their acquaintance addressed to someone else. The degree to which the language of alchemy was meant to be taken literally is in Michelangelo's case not clear. Certainly Michelangelo, like many of his contemporaries, dabbled in pseudo-scientific methods in the pursuit of colours that best imitated nature (just as they studied corpses to better understand anatomy), but the reference to the philosopher's stone in this context is also, certainly, intended metaphorically, denoting the attempts of a sculptor to turn his art into profit. For a bilingual edition of this poem, see Colonna, *Sonnets*, 128.

64. See 'Poi che 'l mio casto amor gran tempo tenne' (Colonna, *Sonnets*, 57).

65. This is a central thesis of Nagel, *Art of Reform*.

66. See Buonarroti (*Life*, 68), where Michelangelo's archaism is made explicit: 'The cross is similar to the one which, at the time of the pestilence of 1348, was carried in procession by the Bianchi, and which was then put in the church of Santa Croce in Florence'. Nagel points out the historical inaccuracy of Condivi's statement (the year should have been 1399, and the Bianchi crosses were not Y-shaped), but the point remains: Michelangelo and, accordingly, Condivi consciously evoke iconography associated with the unembellished, more Christ-centred faith (as they saw it) of fourteenth-century Florence (Nagel, *Art of Reform*, 186).

67. The inscription alludes to the spread of the Gospel and condemns the distortion of the original Gospel message by preachers. See Nagel, *Art of Reform*, 183; D'Elia, 'Drawing Christ's Blood', 123–24. D'Elia points out that the line on Dante's Beatrice's lips is a criticism of those who unduly complicate the words of the Gospel. The line, she says, is 'a call for a new simple faith, focussing on Christ's suffering'.

68. Nagel, *Art of Reform*, 17.

69. D'Elia, 'Drawing Christ's Blood', 94.

70. Nagel, *Art of Reform*, 184.

71. This detail is made even more prominent in some sixteenth-century copies of the Colonna drawing. See, for example, the *Pietà* in the Graphische Sammlung Albertina, Vienna, by the engraver Nicolas Beatrizet, who worked under the direction of Michelangelo from 1540 to 1560. One wonders if it could be the nonverbal signature of MICHAEL. ANGELUS located, just like his 1499 one, between Mary's breasts, thereby recalling (as Lavin pointed out in relation to that earlier *Pietà*) the crucial passage from the *Song of Songs*: 'A bundle of myrrh is my well beloved unto me; he shall lie all night betwixt my breasts' (*Songs* 1:13). The same motif—a cherub's head framed by an angel's wings—adorns Mary Magdalene's headband in the Florentine *Pietà* at the Museo dell'Opera del Duomo.

72. D'Elia ('Drawing Christ's Blood', 115) makes a similar point: '[Mary's] gesture is unusually broad, as the Virgin is not generally shown gesticulating. Other figures, usually Mary Magdalene, express their grief with great sweeps of their arms. . . . In this sense the gesture could be an unusually melodramatic expression of the Virgin Mary's emotion at the Pietà. Her gesture, however, was also an ancient one that could signify prayer or reverence, so that she could be seen to be calmly turning away from the body of her son and praying on the significance of the Salvation, perhaps even thanking God for his mercy, rather than lamenting the human pain of the Passion.'

73. Buonarroti, *Life*, 68.

74. Michelangelo, *Carteggio*, 4:104.

75. Michelangelo, *Carteggio*, 4:104.

76. Michelangelo, *Carteggio*, 4:104, 105.

77. Michelangelo, *Carteggio*, 4:105.

78. In the sonnet 'D'ogni sua grazia / gloria', as I argue in chapter 4, she offers rare mention of having once been attracted to his physical features, handsome face, and pleasing voice. Ordinarily, however, she focuses on the luminous, ethereal graces of her metaphorical 'sun'.

79. For further studies of the *Pianto* as a direct response to Michelangelo's *Pietà*, see Niccolini, 'Sulla religiosità'; Nagel, 'Gifts' and *Art of Reform*; Brundin, 'Colonna and the Virgin'.

80. Colonna, *Plaint*, 53.

81. Colonna, *Plaint*, 55.

82. Colonna, *Plaint*, 55–57.

83. Pseudo-Bonaventure, *Meditationes*, 38–41.

84. First published in 1544 as Colonna, *Litere*. For a study of inner vision in these letters, see Doglio, 'L'occhio interiore'; for a reading of the letters in the context of Colonna's interpretation of the Madonna, see Brundin, 'Colonna and the Virgin'.

85. For a concise overview of St Thomas of Aquinas's account of inner vision, see Lisska, *Aquinas's Theory*.

86. St Thomas Aquinas, once more, offers relevant philosophical insights into the necessity for cognition of sense perception. As Robert Pasnau paraphrases: 'in this life human beings are subject to an empirical constraint: we must acquire our information through the senses (§10.2). The human mind is entirely powerless without those senses; it begins as a blank slate (§4.3sc) and would stay that way if not for the sensory information it receives'. Pasnau, *Thomas Aquinas*, 113. In Aquinas's own words: 'the intellective soul needed to have not only a power for intellectively cognizing, but also a power for sensing. But sensory action does not occur without a corporeal instrument. Therefore the intellective soul needed to be united to a body of the sort that could serve as an appropriate organ for sensation' (§76.5c). He goes on in question 76 to valorize the intelligence of touch confirming that 'those who have the best sense of touch have the best intelligence. A sign of which is that we observe "those who are refined in body are well endowed in mind," as stated in *De Anima* II, 9' (§76.5c).

87. 'Duo lumi porge a l'uomo il vero Sole: / l'un per condur a fin caduco e frale / un pensier breve, un'opra egra e mortale / col qual pensa, discerne, intende e vole; / l'altro, per cui sol Dio s'onora e cole, / ne scorge al Ciel per disusate scale, / ed indi poggian poi più su quell'ale / ch'Egli, Sua gran mercé, conceder sòle.'

88. Damasio, *Descartes' Error*, xiii.

89. On the 'as-if body loop', see Damasio's studies, *Descartes' Error* and *Feeling What Happens*. The discovery and observation of mirror neuron activity have also led to theories of 'embodied simulation' and 'kinesic intelligence', which chime with the kinds of spiritual-aesthetic experiences described by Colonna. On these, see Freedberg and Gallese, 'Motion, Emotion and Empathy'; also relevant is the concept of 'empathic meditation' developed by Freedberg in his *Power of Images*.

90. 'Padre nostro e del Ciel, con quanto amore, / con quanta grazia e in quanti vari modi / dal mondo e da se stesso l'uomo snodi / acciò libero a Te rivolga il core! / Rivolto, poi di puro interno ardore / l'accendi, e leghi con possenti nodi; / indi lo fermi con sì saldi chiodi / ch'ogni / aspra morte li par dolce onore. / Dal fermo stato poi nasce la fede' (S1:95). (Father of ours and of the Heavens, with how much love and grace and in how many ways do you untie man from himself and from the world, so that thus freed he turns his heart to You. Once turned, You set him alight with pure internal ardour, and tether him with powerful bonds; bonds fixed with such firm nails that any bitter death would seem a sweet honour to him. From this firm state, faith is born).']. See also 'Tira su l'alma al Ciel col Suo d'amore / laccio attorto' (The great Father raises souls to Heaves with cords of love) (S1:73). The imagery of knots abounds in the *Plaint*, too, and in the 'Oratione', where Mary is bound to Christ by innumerable ties both physical and emotional, bonds that Colonna envies and seeks to emulate through meditation. For Veronica Copello, S1:95 and other sonnets featuring the imagery of body-soul entanglement and disentanglement reflect on the processes of abnegation and self-effacement at the core of 'via del annichilarmi' preached by Cardinal Reginald Pole and discussed within the Viterbo circle. This is undoubtedly true, but it is worth emphasizing that this process is two-way: those bonds that dissolve through prayer and meditation are reconstituted by the fact of

one's undeniable corporeality, a humble state that cannot be entirely transcended before death. Copello, 'Per un commento'.

91. See 'Tira su l'alma' (S1:73) (He draws up the soul), where 'Steps of faith and charity and hope . . . compose the stairway to highest Heaven' (Gradi di fede e caritate e speme . . . fanno scala infino al Ciel superno).

92. Brundin, *Colonna and Spiritual Poetics*, 67–73; Nagel, *Art of Reform*, 169–79 and Copello, Il dialogo', to name just three.

93. Michelangelo, *Carteggio*, 4:102, 122.

94. Michelangelo's name offers obvious opportunities for wordplay, which Colonna exploits with humour and more than a hint of seriousness. The suggestion here is that the artist helps her to see better and therefore to believe more profoundly in the mysteries of faith, just as angels in traditional mysticism aided human enlightenment and the realisation of inner visions. St Thomas Aquinas theorizes angelic intervention, and, in his wake, St Catherine refers in earnest to the angels that strengthen her understanding and act on her intellect. Colonna exploits this tradition when she declares joy at the fact that 'l'angelo da man destra' in the gift drawing of the crucifixion 'sia assai più bello, perchè il Michele ponerà voi Michel Angelo alla destra del Signore, nel dì novissimo' (And I can tell you that it made me very happy to see that the angel to the right was significantly more beautiful, because Michael will place you, Michael Angel on the right hand of the Lord on the last day). Admiringly, she aligns Michelangelo with the angels of his own drawing, suggesting that he, like Aquinas's angels, enables one to 'see what is not really there' and to believe, therefore, that 'all things are possible to those who believe'.

95. Michelangelo, *Carteggio*, 4:104–5. 'Et però chiaritemi: se questo è d'altri, patientia; se è vosto, io in ogni modo vel torrei. Ma in caso che non sia vostro et vogliate farlo fare a quel vostro, ci parlaremo prima, perché, cognoscendo io la dificultà che ce è de imitarlo, più presto mi resolve che colui faccia un'altra cosa che questa; ma se è il vostro questo, habbiate patientia che non son per tornarlo più'.

96. Buonarroti, *Life*, 58–59; Condivi, *Vita*, 51–53.

Alciati, Andrea. *Emblematum libellus*. Venice: Aldo Manuzio, 1546.

Allen, Michael J. B. 'Marsilio Ficino on Plato, the Neoplatonists and the Christian Doctrine of the Trinity'. In *Renaissance Quarterly* 37.4 (1984): 555–84.

Altschul, Nadia. 'What Is Philology? Cultural Studies and Ecdotics'. In *Philology and Its Histories*, 148–63. Edited by Sean Gurd. Columbus: Ohio State University Press, 2010.

Alszeghy, Zoltan. *Nova creatura: la nozione della grazia nei commentari medievali di S. Paolo*. Rome: Analecta Gregoriana, 1956.

Alunno, Francesco. *La Fabrica del mondo*. Venice: Nicolo de Bascarini, 1548.

——. *Le richezze della lingua volgare*. Venice: Aldo Minuzio, 1543.

——. *Osservationi sopra il Petrarca* [1539]. Venice: Paolo Gherardo, 1556.

Andreoni, Annalisa. 'Benedetto Varchi all'Accademia degli Infiammati. Frammenti inediti e appunti sui manoscritti'. *Studi rinascimentali* (2005): 29–44.

——, ed. *La via della dottrina: Le lezioni accademiche di Benedetto Varchi*. Pisa: Edizioni ETS, 2012.

Arasse, Daniel. 'Raffaello senza venustà e l'eredità della grazia'. *Studi su Raffaello: Atti del Congresso internazionale di Studi 1984*, 703–14. Edited by Micaela Sambucca Hamoud and Maria Letizia Strocci. Urbino: Quattroventi, 1987.

Aretino, Pietro. *Lettere*. Edited by Francesco Erspamer. Parma: Guanda, 1995.

Ariosto, Ludovico. *Opere minori*. Edited by Cesare Segre. Milan: Ricciardo Ricciardi Editore, 1954.

——. *Orlando furioso*. Ferrara: Giovanni Mazzocchi, 1516.

——. *Orlando furioso*. Ferrara: Giovanni Battista della Pigna, 1521.

——. *Orlando furioso di M. Ludovico Ariosto ornato di varie figure, con alcune stanze et Cinque Canti d'un nuovo libro del medesimo nuouamente aggiunti e ricorretti*. Venice: Gabriel Giolito, 1554.

——. *Orlando furioso nuouamente da lui proprio corretto e d'altri canti nuoui ampliato*. Venice: Francesco Rosso da Valenza, 1532.

——. *Orlando furioso . . . novissamente alla sua integrità ridotto ornato di varie figure. . . . Aggiuntovi per ciascun canto alcune allégorie et nel fine una brieve espositione et tavola*. Venice: Gabriel Giolito, 1542.

Bäckvall, Maja. 'Description and Reconstruction: An Alternative Categorization of Philological Approaches'. In *Philology Matters! Essays on the Art of Reading Slowly*, 21–34. Edited by Harry Lönnroth. Leiden: Brill, 2017.

Bal, Mieke. 'Virginity: Towards a Feminist Philology'. *Dispositio* 12.30/32 (1987): 65–82.

Banks, Kathryn, and Timothy Chesters. *Movement in Renaissance Literature: Exploring Kinesic Intelligence*. London: Palgrave Macmillan, 2018.

Bardazzi, Giovanni. 'Le rime spirituali di Vittoria Colonna e Bernardino Ochino'. *Italique* 4 (2001): 61–101.

Barocchi, Paola. *Scritti d'arte del Cinquecento*. Milan: Ricciardi, 1977.

Baxandall, Michael. *Painting and Experience in Fifteenth-Century Italy*. Oxford: Oxford University Press, 1972.

Beauvoir, Simone de. *Le deuxième sexe*. Paris: Gallimard, 1979.

Bembo, Pietro. *Gli Asolani* [1505]. Edited by Giorgio Dilemmi. Florence: Presso l'Accademia della Crusca, 1991.

———. *Prose della volgar lingua [1525]*. Edited by Claudio Vela. Bologna: Cooperativa Libraria Universitaria Editrice Bologna, 2001.

Bembo, Pietro, and Gianfrancesco Pico della Mirandola. *Le epistole 'de imitatione' di Giovanni Francesco Pico della Mirandola e di Pietro Bembo*. Florence: Olschki, 1954.

Berger, Harry, Jr. *The Absence of Grace: Sprezzatura and Suspicion in Two Renaissance Courtesy Books*. Stanford, CA: Stanford University Press, 2000.

Bergson, Henri. 'The Intensity of Psychic States' [1889]. In *Time and Free Will: An Essay on the Immediate Data of Consciousness*, 1–74. Translated by F. L. Pogson. London: Allen and Unwin, 1910.

Bertozzi, Marco. *La tirannia degli astri: Gli affreschi astrologici di Palazzo Schifanoia*. Livorno: Sillabe, 1999.

Biagi, Guido. *Un'etèra romana, Tullia d'Aragona*. Florence: Roberto Paggi, 1897.

Biondo, Michelangelo. 'Angoscia, Doglia e Pena, le tre *furie* del mondo'. In *Trattati del Cinquecento sulla donna*, 71–220. Edited by Giuseppe Zonta. Bari: Laterza, 1913.

Bjørnstad, Hall. *Borrowed Feathers: Plagiarism and the Limits of Imitation in Early Modern Europe*. Oslo: Oslo Academic Press, 2008.

Blunt, Anthony. *Artistic Theory in Italy 1450–1600*. Oxford: Clarendon Press, 1940.

Boileau, Nicolas. 'L'Art Poetique'. In *Oeuvres complètes*. Edited by Escal Françoise. Paris: Gallimard, 1966.

Bolens, Guillemette. *The Style of Gestures: Embodiment and Cognition in Literary Narrative*. Baltimore: Johns Hopkins University Press, 2012.

Bolzoni, Lina. 'The Visualization of the *Orlando Furioso*: From the Original Editions to Modern Video Art'. In *Ariosto, the* Orlando Furioso *and English Culture*, 27–49. Edited by Jane Everson, Stefano Jossa, and Andrew Hiscock. London: British Academy, 2019.

Brundin, Abigail. *Vittoria Colonna and the Spiritual Poetics of the Italian Reformation*. Aldershot: Ashgate, 2008.

———. 'Vittoria Colonna and the Virgin Mary'. *Modern Language Review* 96 (2001): 61–81.

Buonarroti, Michelangelo. *Carteggio*, vols. 1–9. Edited by Paola Barocchi e Renzo Ristori. Florence: S.P.E.S., 1965–1983.

———. *The Complete Poems of Michelangelo*. Translated by John Frederick Nims. Chicago: University of Chicago Press, 1998.

———. *Life, Letters and Poetry*. Translated by George Bull. Oxford: Oxford University Press, 1987.

———. *Rime*. Edited by Ettore Barelli. Milan: Biblioteca Universale Rizzoli, 1996.

Burke, Peter. *The Fortunes of the Courtier: The European Reception of Castiglione's Cortegiano*. Cambridge: Polity Press, 1995.

Calcagnini, Celio. *Opera Aliquot*. Basil: Hier. Frobenium et Nic. Episconium, 1544.

Calì, Maria. *Da Michelangelo all'Escorial: momenti del dibattito religioso nell'arte del Cinquecento*. Turin: Einaudi Editore, 1980.

Campi, Emidio. *Michelangelo e Vittoria Colonna: un dialogo artistico-teologico*. Turin: Claudiana, 1994.

Canigiani, Bernardo. 'Esposizione inedita di un sonetto della divina poetessa'. In *Bricciche Letterarie*, 7–17. Edited by Domenico Tordi. Rome: Fratelli Pallotta, 1889.

The Canons and Decrees of the Council of Trent. Translated by Rev. H. J. Schroeder. Charlotte, NC: TAN Books, 2011.

Capra, Luciano. 'Per la datazione dei Cinque canti dell'Ariosto'. *Giornale Storico della Letteratura Italiana* 151 (1974): 278–96.

Carroll, Clare. *The Orlando furioso: A Stoic Comedy.* Tempe, AZ: Medieval and Renaissance Texts and Studies, 1997.

Casadei, Alberto. 'Il *Pro Bono Malum Ariostesco* e la bibbia'. In *Giornale Storico della Letteratura Italiana* 173 (1996): 566–68.

Cassius, Dio. *Roman History.* Translated by Earnest Cary and Herbert Baldwin Foster. Cambridge, MA: Harvard University Press, 2014.

Castiglione, Baldassare. *The Book of the Courtier.* Translated by Charles S. Singleton. New York: Anchor Books, 1959.

———. *The Book of the Courtier.* Translated by George Bull. London: Penguin Classics, 1967.

———. *The Book of the Courtier.* Translated by Thomas Hoby, edited by Virginia Cox. London: J. M. Dent, 1994.

———. *Il libro del cortegiano.* Edited by Ettore Bonora. Milan: Mursia, 1972.

Catterson, Lynn. 'Michelangelo's Laocoön?'. *Artibus et historiae* 52 (2005): 29–56.

Cave, Terence. *Thinking with Literature: Towards a Cognitive Criticism.* Oxford: Oxford University Press, 2017.

Ceserani, Remo. 'L'impresa delle api e dei serpenti'. *Modern Language Studies* 103.1 (1988): 172–86.

Cicero. *On the Ideal Orator.* Translated by James M. May and Jakob Wisse. Oxford: Oxford University Press, 2001.

Cinzio, Giovambattista Giraldi. 'Discorso sui romanzi' [1548?]. In *Discorsi sul comporre,* 11–204. Edited by Susanna Villari. Messina: Centro Interdipartimentale di Studi Umanistici, 2002.

Colonna, Vittoria. *Carteggio di Vittoria Colonna, marchesa di Pescara.* Edited by Ermanno Ferrero and Giuseppe Müller.Turin: Loescher, 1892.

———. *Litere della Divina Vettoria [sic] Colonna Marchesana di Pescara alla Duchessa de Amalfi, sopra la vita contemplative di santa Catherina, Et sopra della attiva santa Maddalena non più viste in luce.* Venice: Alessandro de Viano, Ad instantia di Antonio detto il Cremaschino, 1544.

———. *Nuovi documenti su Vittoria Colonna e Reginald Pole.* Edited by Sergio Pagano and Concetta Ranieri. Vatican City: Archivio Vaticano, 1989.

———. *Pianto della marchesa di Pescara, sopra la passione di Christo, con una Oratione della medesima, sopra l'Ave Maria. Oratione fatta il venerdì santo, sopra la passione di Christo.* Venice: Gabriel Giolito de' Ferrari, 1563.

———. *Rime di Vittoria Colonna.* Edited by Alan Bullock. Bari: Laterza, 1982.

———. *Sonetti in morte di Francesco Ferrante d'Avalos Marchese di Pescara.* Edited by Tobia R. Toscano. Milan: Mondadori, 1998.

———. *Sonnets for Michelangelo.* Edited and translated by Abigail Brundin. Chicago: University of Chicago Press, 2005.

———. *Vita di Michelagnolo Buonarroti.* Edited by Giovanni Nencioni. Florence: Lungarno Guicciardini, 1988.

———. 'Vittoria Colonna's *The Plaint of the Marchesa di Pescara on the Passion of Christ'.* In *Who Is Mary? Three Early Modern Women on the Idea of the Virgin*

Mary, 47–66. Edited and translated by Susan Haskins. Chicago: University of Chicago Press, 2008.

Condivi, Ascanio. *Vita di Michelagnolo Buonarroti* [1553]. Edited by Giovanni Nencioni. Florence: Lungarno Guicciardini, 1998.

Contini, Lorenzo. *Legislazione toscana*. Florence: Albizziana, 1800–1808.

Copello, Veronica. 'Il dialogo poetico tra Michelangelo e Vittoria Colonna', *Italian Studies* 42. 3 (2017): 271–81.

———. 'Per un commento alle rime spirituali di Vittoria Colonna: considerazioni a partire dal sonetto S1: 52'. *Schifanoia* 58–59 (forthcoming).

Cox, Virginia. *Women's Writing in Italy: 1400-1650*. Baltimore: Johns Hopkins University Press, 2008.

Crivelli, Tatiana. 'The Print Tradition of Vittoria Colonna's Rime'. In *A Companion to Vittoria Colonna*, 69–139. Edited by Abigail Brundin, Tatiana Crivelli, and Maria Serena Sapegno. Leiden: Brill, 2016.

Culler, Jonathan. 'The Return to Philology'. *Journal of Aesthetic Education* 36 (2002): 12–16.

Cummings, Brian. *The Literary Culture of the Reformation: Grammar and Grace*. Oxford: Oxford University Press, 2002.

Damasio, Antonio. *Descartes' Error*. New York: Avon Books, 1994.

———. *The Feeling of What Happens: Body and Emotion in the Making of Consciousness*. New York: Harcourt Brace, 1999.

D'Angelo, Paolo, and Stefano Velotti. *Il 'non so che': Storia di una idea estetica*. Palermo: Aesthetica Edizioni, 1997.

D'Aragona, Tullia. 'Dialogo dell'infinità d'amore'. In *Trattati d'amore del Cinquecento*, 185–244. Edited by Giuseppe Zonta. Bari: Laterza, 1912.

———. *Dialogo della infinità d'Amore*. Edited by Carlo Téoli. Milan: G. Daelli, 1864.

———. *Le rime de Tullia d'Aragona: cortegiano del secolo XVI*. Edited by Enrico Celani. Bologna: Romagnoli Dall'Acqua, 1891.

———. *Rime della signora Tullia di Aragona: et di diversi a lei*. Venice: Gabriele Giolito, 1547.

De Couessin, Charles. 'Le dessin sous-jacent de quelques tableaux de Raphaël des collections publique française'. *Raffaello, recenti indagini scientifiche*, 65–96. Milan: ICOM Comitato Nazionale Italiano, 1986.

De Frede, Carlo. 'Vittoria Colonna e il suo processo inquisitoriale postumo'. *Atti della Accademia Pontaniana* 37 (1988): 251–83.

De Holanda, Francisco. *Dialoghi di Roma*. Edited by Rita Biscetti. Rome: Bagatto Libri, 1993.

D'Elia, Una Roman. 'Drawing Christ's Blood'. *Renaissance Quarterly* 59.1 (2006): 90–129.

Della Latta, Alessandro. 'Storie di un imperfetto: Michelangelo, Plinio, Poliziano e alcune firme di fine Quattrocento'. In *Künstlersignaturen von der Antike bis zur Gegenwart / Artists' Signatures from Antiquity to Present*, 128–42. Edited by Nicole Hegener. Petersberg, Germany: M. Imhof, 2013.

De Man, Paul. *Allegorie della lettura*. Translated by Eduardo Saccone. Turin: Einaudi, 1997.

———. *Cecità e visione: Linguaggio letterario e critica contemporanea*. Translated by Eduardo Saccone. Naples: Liguori, 1975.

———. 'The Return to Philology'. In *The Resistance to Theory*, 21–26. Minneapolis: University of Minnesota Press, 1986.

De Tolnay, Charles. *The Art and Thought of Michelangelo*. New York: Pantheon Books, 1964.

———. *The Medici Chapel*. Princeton, NJ: Princeton University Press, 1948.

De Vecchi, Pierluigi. 'Ritratto di Baldassar Castiglione, 1514–1515'. In *Raffaello: Grazia e bellezza*. Edited by Patrizia Nitti, Marc Restellini, and Claudio Strinati. Geneva: Skira, 2001.

Di Filippo Bareggi, Claudia. *Il mestiere di scrivere: Lavoro intellettuale e mercato librario a Venezia nel Cinquecento*. Rome: Bulzoni, 1988.

Dionisotti, Carlo. *Gli umanisti e il volgare fra Quattrocento e Cinquecento*. Florence: 5 Continents, 1968.

———. 'Per la data dei Cinque canti'. *Giornale storico della letteratura italiana* 137 (1960): 1–40.

Doglio, Maria Luisa. 'L'occhio interiore e la scrittura nelle "Litere" di Vittoria Colonna'. In *Omaggio a Gianfranco Folena*, vol. 2, 1001–13. Padua: Editoriale Programma, 1993.

Dolce, Lodovico. 'Ai Lettori' [1560]. In *L'Amadigi*, 1–6. By Bernardo Tasso. Venice: Fabio e Agostino Zoppini fratelli, 1581.

———. 'Apologia contra ai detrattori dell'Ariosto' [1535]. In *Orlando furioso di Messer Ludovico Ariosto*, 1–9. Venice: Gabriel Giolito, 1536.

———. 'Dialogo della pittura intitolato L'Aretino' [1577]. In *Trattati d'arte del cinquecento fra Manierismo e Controriforma ed Paola Barocchi*, 140–206. Bari: Laterza, 1960.

———. *Dialogo di M. Lodovico Dolce, nel quale si ragiona delle qualità, diversità, e proprietà de i colori*. Venice: Gio. Battista et Marchio Sessa et fratelli, 1565.

———. *I quattro libri delle Osservationi nella volgar lingua* [1550]. Venice: Gabriel Giolito, 1558.

———. *Modi affigurati e voci scelte et eleganti della volgar lingua, con un discorso sopra a' mutamenti e diversi ornamenti dell'Ariosto*. Venice: Gio. Battista et Marchio Sessa et Fratelli, 1554.

Ebreo, Leone. *Dialoghi d'amore*. Edited by Santino Caramella. Bari: Laterza, 1929.

Eisner, Martin G. 'The Return to Philology and the Future of Literary Criticism: Reading the Temporality of Literature in Auerbach, Benjamin and Dante'. *California Italian Studies* 20.1 (2011): 1–20.

Elias, Norbert. *The Civilising Process*. Oxford: Blackwell, 2000.

Emison, Patricia. 'Grazia'. *Renaissance Studies* 5.4 (1991): 427–60.

Erasmus. *Opera Omnia*. 9 vols. Edited by Jean LeClerc. London: Gregg Press, 1962.

Equicola, Mario. *Libro de natura d'amore di Mario Equicola di nuovo con somma diligenza ristampato e corretto da M. Lodovico Dolce* [1525]. Venice: Gabriel Giolito, 1554.

Ernout, Alfred, and Alfred Meillet, eds. *Dictionnaire étymologique de la langue latine: histoire des mots*. Paris: Klincksieck, 1959–1960.

Fahy, Conor. *L'Orlando furioso del 1532: Profilo di una edizione*. Milan: Vita e Pensiero, 1989.

Ferrero, Ermanno, and Giuseppe Müller. *Carteggio di Vittoria Colonna, marchesa di Pescara*. Turin: Loescher, 1892.

Ferroni, Giovanni. 'Bernardo Tasso, Ficino, l'Evangelismo. Riflessioni e materiali attorno alla *Canzone all'anima* (1535–1560). In *Rinascimento meridionale: Napoli e il viceré Pedro de Toledo (1532–1553), Atti del convegno internazionale: Napoli, 22–25 Ottobre, 2014*, 253–319. Edited by Encarnación Sánchez Garcia. Naples: Tullio Pironti editore, 2016.

Feuer-Tóth, Rózsa, *Art and Humanism in Hungary in the Age of Matthias Corvinus*. Budapest: Akadémiai Kiadó, 1990.

Ficino, Marsilio. *Commentaire sur le banquet de Platon, de L'amour / Commentarium in convivium Platonis, De amore* [1484]. Edited by Pierre Laurens. Paris: Les Belles Lettres, 2002.

———. *Commentary on Plato's Symposium*. Translated by Jane Sears Reynolds. Columbia: University of Missouri Press, 1944.

———. *Three Books on Life (De vita libri tres)* [1489]. Translated by Carol V. Kaske and John R. Clarke. Tempe, AZ: Renaissance Society of America, 2002.

———. *The Letters of Marsilio Ficino*. Translated by Language Department, London School of Economics. London: Shepherd Walywyn, 1978.

———. *Opera omnia*. Basel: Petri, 1576. Edited by Marco Sancipriani. Turin: Bottega d'Erasmo, 1962.

———. *Sopra lo amore—ovvero convito di Platone*. Edited by Giuseppe Rensi. Milan: ES, 1992.

Firenzuola, Agnolo. 'Dialogo delle bellezze delle donne, intitolato Celso' [1541]. In *Opere di Agnolo Firenzuola*. Edited by Delmo Maestri. Turin: UTET, 1977; ebook Rome: Biblioteca Italiana, 2003, http://www.bibliotecaitaliana.it.

Firpo, Massimo. 'Vittoria Colonna, Giovanni Morono e gli "spirituali"'. *Rivista di Storia e Letteratura Religiosa* 24 (1988): 211–61.

———. *Inquisizione romana e Controriforma: Studi sul cardinal Giovanni Morone e il suo processo d'eresia*. Bologna: Il Mulino, 1992.

Firpo, Massimo, and Dario Marcatto. *I processi inquisitoriali di Pietro Carnesecchi: 1557–1567*, 2 vols. Vatican City: Archivio Segreto Vaticano, 1998–2000.

Flaminio, Marcantonio, and Benedetto da Mantova. *Il beneficio di Cristo*. Edited by Salvatore Caponetto. Turin: Claudiana, 2009.

Foister, Susan. 'Lucas Cranach the Elder, Cupid Complaining to Venus'. In *National Gallery Catalogues: The German Paintings before 1800*, 1–10. London: National Gallery Publications, forthcoming. http://www.nationalgallery.org.uk.

Forcellino, Antonio. *Michelangelo: A Tormented Life*. Cambridge: Polity Press, 2009.

Forcellino, Maria. *Michelangelo, Vittoria Colonna e gli 'spirituali': religiosità e vita artistica a Roma negli anni Quaranta*. Rome: Viella, 2009.

Fornari, Simone. *Spositione di m. Simon Fornari sopra l'Orlando furioso*. Florence: Lorenzo Torrentino, 1549.

Fragnito, Gigliola. 'Vittoria Colonnna e l'Inquisizione'. *Benedictina* 37 (1990): 157–62.

Freedberg, David. 'Iconography between the History of Art and the History of Science: Art, Science and the Case of the Urban Bee'. In *Picturing Science Producing Art*, 272–96. Edited by Peter Galison and Caroline Jones. London: Routledge, 1998.

———. *The Power of Images: Studies in the History and Theory of Response*. Chicago: University of Chicago Press, 1989.

Freedberg, David, and Vittorio Gallese. 'Motion, Emotion and Empathy in Aesthetic Experience'. *Trends in Cognitive Sciences* 11 (2007): 197–203.

Furey, Constance. '"Intellects Inflamed in Christ": Women and Spiritualized Scholarship in Renaissance Christianity'. *Journal of Religion* 84.1 (2004): 1–22.

Gallese, Vittorio, and Michele Guerra, *Lo schermo empatico: Cinema e neuroscienze.* Milan: Raffaello Cortina Editore, 2015.

Garin, Eugenio. *Italian Humanism: Philosophy and Civic Life in the Renaissance.* Translated by Peter Munz. New York: Harper and Row, 1965.

———. *L'umanesimo italiano: filosofia e vita civile nel Rinascimento.* Bari: Laterza, 1952.

Gaylard, Susan. 'Silenus Strategies: The Failure of Personal Emblems'. In *Hollow Men: Writing Objects and Public Image in Renaissance Italy*, 227–86. New York: Fordham University Press, 2013.

Geertz, Clifford. *The Interpretation of Culture.* London: Fontana Press, 1993.

Gilson, Simon. 'Vernacularizing Meteorology: Benedetto Varchi's Comento sopra il primo libro delle Meteore d'Aristotile'. In *Vernacular Aristotelianism in Italy from the Fourteenth to the Seventeenth Century*, 161–80. Edited by Luca Bianchi, Simon Gilson, and Jill Kraye. London: Warburg Institute, 2016.

Giovanozzi, Delfina. 'Leone Ebreo in Tullia d'Aragona's *Dialogo*. Between Varchi's Legacy and Philosophical Autonomy'. *British Journal for the History of Philosophy* 27.4 (2019): 702–17.

Giovio, Paolo. *Dialogo dell'imprese militari et amorose con un ragionamento di M. Lodovico Domenichi.* Lyon: Guglielmo Rouillo, 1574.

Girard, René. *Mensonge romantique et vérité romanesque.* Paris: Grasset, 1961.

Goffen, Rona. *Renaissance Rivals.* New Haven, CT: Yale University Press, 2004.

Golzio, Vincenzo. *Raffaello nei documenti, nelle testimonianze dei contemporanei e nella letteratura del suo secolo* [1936]. Westmeand: Gregg, 1971.

Grazzini, Anton Francesco. 'Le rime burlesche edite e inedite'. In *Nuovo rinascimento*. Edited by Carlo Verzone. Banca Dati 'Nuovo Rinascimento', 2015. http://www.nuovorinascimento.org/N-RINASC/testi/pdf/grazzini/rime.pdf.

Gurd, Sean, ed. *Philology and Its Histories.* Columbus: Ohio State University Press, 2010.

Hankins, James. *Plato in the Renaissance.* 2 vols. Leiden: Brill, 1990.

Harpham, Geoffrey Galt. 'Roots, Races, and the Return to Philology'. In *The Humanities and the Dream of America*, 1–34. Chicago: University of Chicago Press, 2011.

Hegener, Nicole. 'Faciebat, non finito und andere Imperfekte Künstlersignaturen neben Michelangelo'. In *Künstlersignaturen von der Antike bis zur Gegenwart / Artists' Signatures from Antiquity to Present*, 188–232. Petersberg, Germany: M. Imhof, 2013.

Hempfer, Klaus. *Diskrepante Lektüren: Die Orlando-Furioso-Rezeption im Cinquecento.* Stuttgart: Steiner, 1987.

Hirst, Michael. *Six Lectures.* Oxford: Clarendon Press, 1978.

Holland, Anna. 'Early Modern Swansongs'. In *Pre-Histories and Afterlives: Studies in Critical Method*, 61–81. Edited by Anna Holland and Richard Scholar. London: Legenda, 2009.

Horace. *The Complete Odes and Satires of Horace.* Translated by Sidney Alexander. Princeton, NJ: Princeton University Press, 1999.

Jaeger, Werner. *Paideia.* Oxford: Basil Blackwell, 1994.

Javitch, Daniel. 'Cantus Interruptus in the Orlando Furioso'. *Modern Language Notes* 95 (1980): 66–80.

——. *Proclaiming a Classic: The Canonization of Orlando Furioso*. Princeton, NJ: Princeton University Press, 1991.

Jedin, Hubert. 'Il cardinal Pole e Vittoria Colonna'. *Italia francescana* 22 (1947): 13–30.

Jones, Ann Rosalind. *The Currency of Eros: Women's Love Lyric in Europe 1540–1620*. Bloomington: Indiana University Press, 1990.

Jossa, Stefano. 'Entertainment and Irony: The *Orlando furioso* from Modern to Postmodern'. In *Ariosto, the Orlando furioso and English Culture*, 286–307. Edited by Jane Everson, Stefano Jossa, and Andrew Hiscock. London: British Academy, 2019.

Juřen, Vladimir. 'Fecit—faciebat'. *Revue de l'art* 26 (1974): 27–29.

Kárpati, Zoltán. *Raphael Drawings in Budapest*. Budapest: Museum of Fine Arts in Budapest, 2013.

Kelly, Donald R. *Renaissance Humanism*. Boston: Twayne, 1991.

Kenny, Neil. *Curiosity in Early Modern Europe: Word Histories*. Wiesbaden: Harassowitz, 1998.

——. *The Uses of Curiosity in Early Modern France and Germany*. Oxford: Oxford University Press, 2004.

Klein, Robert. 'Pensée et symbole à la Renaissance: spirito peregrino'. *La forme et l'intelligible*, 31–64. Paris: Gallimard, 1970.

Kleist, Heinrich von. 'The Puppet Theatre' [1801]. In *Selected Writings*, 411–17. Edited and translated by David Constantine. Indianapolis, IN: Hackett, 2004.

Kraye, Jill, ed. *The Cambridge Companion to Renaissance Humanism*. Cambridge: Cambridge University Press, 1996.

Kristeller, Paul O. *The Classics and Renaissance Thought*. Cambridge, MA: Harvard University Press, 1955.

——. *Studies in Renaissance Thought and Letters*. Rome: Edizioni di Storia e Letteratura, 1956.

Landino, Cristoforo. *Comento di Cristoforo Landino Fiorentino sopra la Comedia di Dante Alighieri poeta Florentino*. Florence: N. Di Lorenzo, 1481.

Langer, Susanne. *Philosophy in a New Key: A Study in the Symbolism of Reason, Rite and Art*. Cambridge, MA: Harvard University Press, 1979.

Lavin, Irving. 'Divine Grace and the Remedy of the Imperfect: Michelangelo's Signature on the St. Peter's Pietà'. In *Künstlersignaturen von der Antike bis zur Gegenwart / Artists' Signatures from Antiquity to Present*, 150–88. Edited by Nicole Hegener. Petersberg, Germany: M. Imhof, 2013.

Lee, Rensselaer W. 'Ut Pictura Poesis: The Humanistic Theory of Painting'. *The Art Bulletin* 22 (1940): 197–269.

Leeman, Frederik W. G. 'A Textual Source for Cranach's "Venus with Cupid the Honey-Thief"'. *Burlington Magazine* 126 (1984): 274–75.

Lewis, C. S. *Studies in Words*. Cambridge: Cambridge University Press, 1960.

Liburnio, Niccolò. *Le tre fontane* [1526]. Venice: Marchio Sessa, 1584.

Lippincott, Kristen. 'Gli dei-decani del Salone dei Mesi di Palazzo Schifanoia'. In *Alla corte degli Estensi: Filosofia, arte e cultura a Ferrara nei secoli XV e XVI*, 181–97. Edited by Marco Bertozzi. Ferrara: Università degli Studi, 1994.

——. 'The Iconography of the *Salone dei Mesi* and the Study of Latin Grammar in Fifteenth-Century Ferrara'. In *La corte di Ferrara e il suo mecenatismo 1441–1598*, 93–109. Edited by Marianne Pade, Lene Waage Petersen, and Daniela Quarta. Modena: Edizioni Panini, 1990.

Lisska, Anthony J. *Aquinas's Theory of Perception: An Analytic Reconstruction*. Oxford Online Scholarship, 2016.

Lockhart, James. *Nahuas and Spaniards: Postconquest Central Mexican History and Philology*. Stanford, CA: Stanford University Press, 1991.

Lomazzo, Giovan Paolo. *Idea del tempio della pittura*. Milan: Paolo Gottardo Ponto, 1590.

——. *Trattato dell'arte della Pittura, Scoltura, et Architettura*. Milan: Paolo Gottardo Pontio, 1584.

Londen, Lynn M. 'Sprezzatura in Raphael and Castiglione'. *Art Journal* 28 (1968): 43–49, 53.

Luna, Fabricio (da). *Vocabulario di cinquemila vocabuli toschi*. Naples: Giovanni Sultzbach, 1536.

Luzi, Joseph. *Romantic Europe and the Ghost of Italy*. New Haven, CT: Yale University Press, 2008.

Lyotard, Jean-François. *The Postmodern Condition: A Report on Knowledge*. Translated by Geoff Bennington and Brian Massumi. Manchester: Manchester University Press, 1984.

Mac Carthy, Ita. 'Ariosto the Lunar Traveller'. *Modern Language Review* 104.1 (2009): 71–82.

——. 'Fiordispina's English Afterlives: From Harington to Ali Smith'. In *Ariosto, the Orlando Furioso and English Culture*, 125–45. Edited by Jane Everson, Stefano Jossa, and Andrew Hiscock. London: British Academy, 2019.

——, ed. *Renaissance Keywords*. Oxford: Legenda, 2013.

Mack, Charles. *Looking at the Renaissance: Essays towards a Cultural Appreciation*. Ann Arbor: University of Michigan Press, 2005.

MacLachlan, Bonnie. *The Age of Grace: Charis in Early Greek Poetry*. Princeton, NJ: Princeton University Press, 1993.

Maffei, Sonia. 'La fama di Laocoonte nei testi del Cinquecento'. In *Laocoonte, fama e stile*, 98–230. Edited by Salvatore Settis. Rome: Donzelli, 1999.

Maier, Bruno. *Il cortegiano, con una scelta delle opere minori di Baldesar Castiglione*. Turin: UTET, 1955.

Maldina, Nicolò. 'Ariosto, l'ingratitudine di Orlando e gli amori di Sansone nel *Furioso*'. *Studi e problemi di critica testuale* 88 (2014): 127–74.

Manca, Joseph. 'Francesco Del Cossa's Call for Justice'. *Notes in the History of Art* 12.3 (1993): 12–15.

Martinez, Rinaldo L. 'Two Odysseys: Rinaldo's Po Journey and the Poet's Homecoming in Orlando furioso'. In *Renaissance Transactions*, 17–55. Edited by Valeria Finucci. Durham, NC: Duke University Press, 1999.

Masi, Giorgio. 'I segni dell'ingratitudine: Ascendenze classiche e medioevali delle imprese ariostesche nel *Furioso*'. In *Albertiana* 5 (2002): 141–64.

——. ' "Un uomo in una donna". Le rime michelangiolesche per Vittoria Colonna'. *Humanistica* 12 (2017): 131–53.

Mauss, Marcel. *Essai sur le don: Forme et raison de l'échange dan les sociétés archaïques*. Paris: Presses Universitaires de France, 2007.

Mazzocco, Angelo. *Linguistic Theories in Dante and the Humanists: Studies of Language and Intellectual History in Late Medieval and Early Renaissance Italy*. Leiden: Brill, 2013.

Mazzucchelli, Gianmaria. 'Notizie sulla vita di Tullia d'Aragona scritte dal conte Giammaria Mazzucchelli'. In Tullia D'Aragona, *Il Meschino detto il Guerrino*, 22–23. Venice: Giuseppe Antonelli Editore, 1839.

McGrath, Alister E. *The Intellectual Origins of the European Reformation*. Oxford: Blackwell, 2004.

———. *Reformation Thought: An Introduction*. 2nd ed. Oxford: Blackwell, 1993.

McHugh, Shannon. 'Rethinking Vittoria Colonna: Gender and Desire in the *rime amorose*'. *Italianist* 33.3 (2013): 345–60.

McLaughlin, Martin. *Literary Imitation in the Italian Renaissance: The Theory and Practice of Literary Imitation in Italy from Dante to Bembo*. Oxford: Clarendon Press, 1995.

Migliorini, Bruno. *Storia della lingua italiana*. Florence: Sansoni, 1960.

Minerbi, Lucilio, 'Il vocabulario del Decamerone'. In *Decamerone*, by Giovanni Boccaccio. Venice: Bernardino Vitali, 1535.

Monfasini, John. 'The Renaissance Plato-Aristotle Controversy and the Court of Matthias Rex'. In *Marilio Ficino: His Theology, His Philosophy, His Legacy*, 179–202. Edited by Michael J. B. Allen and Valery Rees. Leiden: Brill, 2002.

Monk, Samuel Holt. 'A Grace Beyond the Reach of Art'. *Journal of the History of Ideas* 5 (1944): 131–50.

Moriarty, Michael. 'Grace and Religious Belief in Pascal'. In *The Cambridge Companion to Pascal*, 144–61. Edited by Nicholas Hammond. Cambridge: Cambridge University Press, 2003.

———. 'Malebranche and the Laws of Grace'. In *Chance, Literature and Culture in Early Modern France*, 141–52. Edited by John D. Lyons and Kathleen Wine. Farnham, UK: Ashgate, 2009.

Moroncini, Ambra. 'La poesia di Michelangelo: un cammino spiritual tra Neoplatonismo e Riforma'. *Italianist* 30.3 (2010): 352–73.

Moss, Ann. *Printed Commonplace-Books and the Structuring of Renaissance Thought*. Oxford: Clarendon Press, 1996.

———. *Renaissance Truth and the Latin Language Turn*. Oxford: Oxford University Press, 2003.

Moussy, Claude. *Gratia et sa famille*. Paris: Presses Universitaires de France, 1966.

Muzio, Girolamo. 'Alla molto eccellente signora Tullia D'Aragona, il muzio iustinopolitano'. In *Dialogo d'amore del Cinquecento*, 245–47. Edited by Giuseppe Zonta. Bari: Laterza, 1912.

———. *Lettere: ristampa anastatica dell'ed. Sermartelli, 1590*. Edited by Luciana Borsetto. Ferrara: Arnaldo Forni Editore, 1985.

Nagel, Alexander. 'Gifts for Michelangelo and Vittoria Colonna'. *Art Bulletin* 79 (1995): 647–68.

———. *Michelangelo and the Reform of Art*. Cambridge: Cambridge University Press, 2000.

Natale, Mauro, ed. *Cosmè Tura e Francesco del Cossa: L'Arte a Ferrara nell'età di Borso d'Este*. Ferrara: Ferrara Arte, 2007.

Natali, Guido. 'Ancora del non so che'. *Lingua nostra* 19 (1958): 13–16.

———. 'Storia del non so che'. *Lingua nostra* 12 (1951): 45–49.

Nauert, Charles G., Jr. *Humanism and the Culture of Renaissance Europe*. New Approaches to European History 6. Cambridge: Cambridge University Press, 1995.

Neagu, Christine. 'The Power of the Book and the Kingdom of Hungary during the Fifteenth Century'. In *Humanism in Fifteenth-Century Europe*, 145–75. Edited by David Rundle. Oxford: Medium Aevum Monographs, 2012.

Niccolini, Benedetto. 'Sulla religiosità di Vittoria Colonna'. *Studi e materiali di storia delle religioni* 22 (1949): 89–109.

Nichols, Stephen G. 'Introduction: Philology in a Manuscript Culture'. *Speculum* (special issue: *The New Philology*) 65.1 (1990): 1–10.

Nitti, Patrizia, Marc Restellini, and Claudio Strinati, eds. *Raffaello: Grazia e bellezza*. Geneva: Skira, 2001.

Panofsky, Erwin. *Renaissance and Renascences in Western Art*. New York: Harper and Row, 1972.

Pasnau, Robert. *Thomas Aquinas on Human Nature*. Cambridge: Cambridge University Press, 2002.

Paton, William Roger, trans. *The Greek Anthology*. Loeb Classical Library. Cambridge, MA: Harvard University Press, 2014.

Patterson, Lee. 'The Return to Philology'. In *The Past and Future of Medieval Studies*, 231–45. Edited by John van Engen. Notre Dame, IN: Notre Dame University Press, 1994.

Perotti, Niccolò. *Cornu copiae seu Linguae latinae commentarii* [1489].Venice: Johannes de Tridino, 1508.

Pickens, Rupert T. 'The Future of Old French Studies in America: The "Old" Philology and the Crisis of the "New"'. In *The Future of the Middle Ages: Medieval Literature in the 1990s*, 53–86. Edited by William D. Paden. Gainesville: University of Florida Press, 1994.

Pico della Mirandola, Giovanni. *Commento sopra una canzone d'amore*. Edited by Paolo de Angelis. Palermo: Novecento, 1994.

Pittaluga, Stefano. 'La restaurazione umanistica'. In *Lo spazio letterario del Medioevo*, 191–217. Edited by Guglielmo Cavallo, Claudio Leonardi, and Enrico Menestò. Rome: Salerno, 1984.

Pliny, *Natural History*. Translated by H. Rackham. London: Loeb Classical Library, 1952.

Plutarch. 'Life of Antony'. In *Plutarch's Lives*, vol. 9. Translated by Bernadotte Perrin. Cambridge, MA: Harvard University Press, 1920.

Pope, Alexander. *Pastoral Poetry and an Essay on Criticism*. Edited by E. Audra, John Butt, and Aubrey Williams. London: Methuen; New Haven: Yale University Press, 1961.

Prosperi, Adriano. 'Michelangelo e gli "spirituali"'. In *Michelangelo Buonarroti: storia di una passione erotica*, 9–37. Turin: Einaudi, 2002.

Pseudo-Bonaventure. *Meditations on the Life of Christ*. Translated by Isa Ragusa and Rosalie Green. Princeton, NJ: Princeton University Press, 1977.

Putnam, Michael C. J. *Artifices of Eternity: Horace's Fourth Book of Odes*. Ithaca, NY: Cornell University Press, 1986.

Quint, David. 'Astolfo's Voyage to the Moon'. *Yale Italian Studies* 1 (1977): 398–409.

Quintilian. *Institutio oratoria*. Translated by Donald A. Russell. London: Loeb Classical Library, 2002.

Ragn Jensen, Hannemarie. 'The Universe of the Este Court in the Sala dei Mesi'. In *La corte di Ferrara e il suo mecenatismo 1441–1598*, 111–27. Edited by Marianne Pade, Lene Waage Petersen, and Daniela Quarta. Modena: Edizioni Panini, 1990.

Ranieri, Concetta. 'Vittoria Colonna: dediche, libri e manoscritti. *Critica letteraria* 13 (1985): 249–70.

————. 'Premesse umanistiche alla religiosità di Vittoria Colonna'. *Rivista di Storia e Letteratura Religiosa* 32 (1996): 531–48.

————. 'Descriptio et imago vitae. 'Vittoria Colonna nei biografi, letterati e poeti del Cinquecento'. In *Biografia: genesi e strutture*, 123–53. Edited by Mauro Sarnelli. Rome: Aracne, 2003.

————. 'Vittoria Colonna e il cenacolo ischitano'. In *La donna nel Rinascimento meridionale. Atti del convegno internazionale: Roma, 11–13 novembre, 2009*, 49–65. Edited by Marco Santoro. Pisa: Serra, 2010.

Restall, Matthew. 'A History of the New Philology and the New Philology in History'. *Latin American Research Review* 38.1 (2003): 113–34.

Ricci, Maria Teresa. 'La grazia in Baldassar Castiglione: un'arte senz'arte'. *Italianistica: Rivista di letteratura italiana* 32.2 (2003): 235–45.

Richardson, Brian. 'The 1516 Edition of Ariosto's Orlando furioso: The Opening'. *Modern Language Review* 113.1 (2018): 80–106.

Rosand, David. *Drawing Acts: Studies in Graphic Expression and Representation.* Cambridge: Cambridge University Press, 2002.

————. 'The Portrait, the Courtier, and Death'. In *Castiglione: The Ideal and the Real in Renaissance Culture*, 91–129. Edited by Robert W. Hanning and David Rosand. New Haven, CT: Yale University Press, 1983.

Rosenberg, Charles. 'The Sala degli Stucchi'. *Art Bulletin* 61 (1979): 377–84.

Rossi Monti, Martino. *Il cielo in terra: la grazia fra teologia ed estetica.* Turin: UTET, 2008.

Saccone, Eduardo. '*Grazia, Sprezzatura, Affettazione* in the *Courtier*'. In *Castiglione: The Ideal and the Real in Renaissance Culture*, 45–67. Edited by Robert W. Hanning and David Rosand. New Haven, CT: Yale University Press, 1983.

————. *Il 'soggetto' del* Furioso *e altri saggi tra quattro e cinquecento.* Naples: Liguori, 1974.

————. *Ritorni: La seconda lettura.* Naples: Liguori Editore, 2010.

Said, Edward. *Humanism and Democratic Criticism.* New York: Columbia University Press, 2004.

Salani, Teresa Poggi. 'Venticinque anni di lessicografia italiana delle origini (leggere, scrivere e 'politamente' parlare): Note sull'idea di lingua'. In *The History of Linguistics in Italy.* Edited by Paolo Ramat, Hans-Josef Niederche, and E. F. K. Koerner. Amsterdam: John Benjamins, 1986.

Salviati, Leonardo. *Risposta al libro intitolato: Replica di Camillo Pellegrini.* Florence: Anton Padovani, 1588.

Sangirardi, Giuseppe. 'Trame e genealogie dell'ironia ariostesca'. *Italian Studies* 69 (2014): 189–203.

Sanzio, Raffaello. *Scritti Letterari.* Edited by Mauro Sinigaglia. Bari: Acquaviva, 2002.

Scala, Mirella. 'Encomi e dediche nelle prime relazioni culturali di Vittoria Colonna'. *Periodico della società storica comense* 54 (1990): 95–112.

Schiller, Friedrich. 'On Grace and Dignity' [1793]. In *'On Grace and Dignity' in Its Cultural Context: Essays and a New Translation.* Translated by Jane V. Curran, edited by Jane V. Curran and Christophe Fricker. Rochester, NY: Camden, 2005.

Scholar, Richard. *The Je-Ne-Sais-Quoi in Early Modern Europe: Encounters with a Certain Something.* Oxford: Oxford University Press, 2005.

——. 'The New Philologists'. In *Renaissance Keywords*, 1–9. Edited by Ita Mac Carthy. Oxford: Legenda, 2013.

Segre, Cesare. 'Studi sui Cinque canti'. In *Esperienze Ariostesche*, 121–77. Pisa: Nistri-Lischi, 1966.

Seneca. *Ad Lucilium epistulae morales*. Translated by Richard M. Gummere. London: Loeb Classical Library, 1930.

——. 'De beneficiis'. In *Moral Essays*, vol. 3. Translated by John W. Basore. London: Loeb Classical Library, 1935.

Settis, Salvatore, and Walter Cupperi, eds. *Il Palazzo Schifanoia a Ferrara*. Modena: Panini, 2007.

Shearman, John. 'Le portrait de Baldassare Castiglione par Raphaël'. *La revue du Louvre* 29 (1979): 261–72.

——. *Only Connect . . . Art and the Spectator in the Italian Renaissance*. Princeton, NJ: Princeton University Press, 1992.

Smarr, Janet L. 'A Dialogue of Dialogues: Tullia d'Aragona and Sperone Speroni'. *Modern Language Notes* 113 (1998): 204–11.

Speroni, Sperone. *Dialogo d'amore*. Edited by Pierre Martin. Poitiers: La Licorne, 1998.

Strozzi, Tito. 'In amorem furem'. In *Strozii Poetae Pater et Filius*, 90. Venice: Aldo Manuzio, 1513.

Summers, David. *Michelangelo and the Language of Art*. Princeton, NJ: Princeton University Press, 1981.

Talbot, Charles. 'Central Europe, 15th and 16th Centuries'. In *The Robert Lehman Collection: Fifteenth to Eighteenth-Century Paintings*, 29–60. New York: MOMA, 1998.

Targoff, Ramie. *Renaissance Woman: The Life of Vittoria Colonna*. New York: Farrar, Straus and Giroux, 2018.

Tasso, Bernardo. *L'Amadigi*. Venice: Fabio e Agostino Zoppini Fratelli, 1581.

——. *L'Amadigi di Gaula di S. Bernardo Tasso*. Venice: Gabriel Giolito, 1560.

Tavoni, Mirko. *Latino, grammatica, volgare: Storia di una questione umanistica*. Padua: Antenone, 1984.

——. *Storia della lingua italiana: Il Quattrocento*. Bologna: Il Mulino, 1992.

Terpening, Ronnie H. *Ludovico Dolce: Renaissance Man of Letters*. Toronto: University of Toronto Press, 1997.

Therault, Suzanne. *Un cénacle humaniste de la Renaissance autour de Vittoria Colonna*. Florence: Sansoni, 1986.

Thomas, Ben. '"The Art Consists of Hiding the Art": Castiglione and Raphael'. In *Image and Word: Reflections of Art and Literature from the Middle Ages to the Present*, 134–50. Edited by Antonella Braida and Giuliana Pieri. Oxford: Legenda, 2003.

——. 'Raphael and the Idea of Drawing'. In *Raphael the Drawings*, 43–55. Edited by Ben Thomas and Catherine Whistler. Oxford: Ashmolean, 2017.

Thesaurus Linguae Latinae. Munich: Walter de Gruyter, 1900–.

Toscanello, Orazio. *Le bellezze del Furioso*. Venice: Pier de' Franceschi, 1574

Tura, Adolfo. 'Jean Lemaire de Belges tra le letture di Ariosto?'. *Studi medievali e umanistici* (2014): 239–48.

Ugolini, Paola. 'Self-Portraits of a Truthful Liar: Satire, Truth-Telling, and Courtliness in Ludovico Ariosto's Satire and Orlando Furioso'. *Renaissance and*

Reformation / Renaissance et Réforme (Special issue: *Comedy, Satire, Paradox and the Plurality of Discourses in Cinquecento Italy*) 40.1 (2017): 143–60.

Valdés, Juan de. *Le cento e dieci divine considerazioni.* Edited by Edmondo Cione. Milan: Fratelli Bocca, 1944.

———. *Lo evangelio di San Matteo.* Edited by Carlo Ossola. Rome: Bulzoni, 1985.

Valla, Lorenzo. *Collatio.* Edited by Alessandro Perosa. Florence: Sansoni, 1970.

Varchi, Benedetto. 'Discorso della bellezza e della grazia'. In *Opere*, vol. 1, 293–96. Edited by Giovanni Batista Busini. Milan: Bettoni, 1834.

———. *Due lezioni di M. Benedetto Varchi, l'una d'amore e l'altra della gelosia, con alcune utili e dilettevoli quistioni da lui nuovamente aggiunte.* Lyon: Guglielmo Rovillio, 1560.

———. *Due lezioni di M. Benedetto Varchi nella prima delle quali di dichiara un sonnetto di M. Michelagnolo Buonarroti, nella seconda si disputa quale sia più nobile arte la scultura o la pittura, con una lettera d'esso Michelagnolo et più altri eccellentissimi pittori, et scultori, sopra la quistione sopradetta.* Florence: Lorenzo Torrentino, 1550.

———. *La prima parte delle lezioni di M. Benedetto Varchi nella quale si tratta della natura, della generazione del corpo humano e de' mostri, lette da lui pubblicamente nella Accademia Fiorentina.* Florence: Giunti, 1560.

———. *Sonnetti spirituali.* Florence: Giunti, 1573.

———. 'Sopra alcune quistioni d'amore'. In *Opere*, vol. 1, 198–202. Edited by Giovanni Batista Busini. Milan: Bettoni, 1834.

Varese, Ranieri, ed. *Atlante di Schifanoia.* Modena: Pacini, 1989.

———. 'Novità a Schifanoia'. *Critica d'arte* 17 (1970): 49–62.

Vasari, Giorgio. *Le vite de' piú eccellenti architetti, pittori, et scultori italiani, da Cimabue insino a' tempi nostri.* Edited by Luciano Bellosi and Aldo Rossi. Turin: Einaudi, 1986.

———. *Le vite de' più eccellenti pittori scultori e architettori* [1550, 1568]. 6 vols. Edited by Paola Barocchi and Rosanna Bettarini. Florence: Studio per Edizioni Scelte, 1988.

Vidal, Denis. 'The Three Graces, or the Allegory of the Gift: A Contribution to the History of an Idea in Anthropology'. *Journal of Enthnographic Theory* 4 (2014): 339–68.

Vocabolario degli Accademici della Crusca [1611]. Accademia della Crusca, Scuola Normale Superiore. http://vocabolario.signum.sns.it/.

Wallace, William. *Michelangelo: The Artist, the Man and His Times.* Cambridge: Cambridge University Press, 2010.

Wang, Aileen June. 'Michelangelo's Signature'. *Sixteenth Century Journal* 35.2 (2004): 447–73.

Warburg, Aby. *The Pagan Renewal of Antiquity.* Los Angeles: Getty Research Institute, 1999.

Watelet, Claude-Henri. 'Grace' [1757]. In *The Encyclopedia of Diderot and d'Alembert Collaborative Translation Project.* Translated by Silvia Stoyanova. Ann Arbor: Michigan Publishing, 2015. http://hdl.handle.net/2027/spo.did2222.0003.100.

Weinberg, Bernard. 'Quarrel over Ariosto and Tasso'. In *A History of Literary Criticism in the Italian Renaissance*, 954–1073. Chicago: University of Chicago Press, 1961.

Wilde, Johannes. *Michelangelo: Six Lectures*. Edited by John Shearman and Michael Hirst. Oxford: Clarendon Press, 1978.

Williams, Raymond. *Keywords: A Vocabulary of Culture and Society*. London: Fontana Press, 1988.

Williamson, Edward. 'The Concept of Grace in the Work of Raphael and Castiglione'. *Italica* 24 (1947): 316–24.

Winckelmann, Johann Joachim. 'On Grace in Works of Art' [1759]. In *Johann Joachim Winckelmann on Art, Architecture, and Archaeology*, 137–42. Translated by David Carter. Rochester, NY: Camden, 2013.

Wind, Edgar. *Pagan Mythologies in the Renaissance*. London: Faber and Faber, 1958.

Wittkower, Rudolf. 'Genius: Individualism in Art and Artists'. In *Dictionary of the History of Ideas*, 293–312. Edited by Philip Weiner. New York: Scribner, 1973.

Yates, Frances Amelia. *Giordano Bruno and the Hermetic Tradition*. London: Routledge, 1964.

Zilioli, Alessandro. 'Breve vita di Tullia d'Aragona tratta dalla storia dei poeti italiani di Alessandro Zilioli con note di Giammaria Mazzucchelli'. In *Dialogo della infinità d'Amore*, v–xviiii. By Tullia d'Aragona. Edited by Carlo Téoli. Milan: G. Daelli, 1864.

absence, 85–88; of grace, 92, 145, 190n14
Accademia Fiorentina, 96. *See also*
 Florentine Academy, the
Accarisio, Alberto: 46–47, 48
Achilles, 32
Aesop's fables, 130, 209n36
aesthetics, 18, 28, 61, 70–71, 96, 173, 179,
 181–82, 201n34; of difficulty, 148,
 150–51, 167
affectation, 52, 53, 76, 77, 192n5
affettazione, 46, 53, 55, 61
agape, 4
agility, 52
Aglaia, 1, 42, 48, 111
Alberti, Leon Battista: 196n11
alchemy, 166, 202n36, 217n63
Alciati, Andrea: 135, 136
Alcinous, 31
Alexander the Great, 33
Allegory of April. See Palazzo Schifanoia:
 Salone dei mesi
Allen, Michael J.B., 193
altruism, 66
Altschul, Nadia, 20
Alunno, Francesco, 47–48, 49
ambition, 61, 64, 85, 101–2, 106, 121, 139;
 of the vernacular, 47, 49
Anacreon, 135
andiriviene, 122
Andreoni, Annalisa, 97, 202n41
angels, 169–70, 220n94
anger, 124, 125, 137, 159, 163, 216n50
anxiety, 64, 75, 78, 127–28, 167, 179
Apelles of Cos, 33, 55, 126, 144, 196n15
Apollo, 3, 39, 43, 102, 118, 127
appearance, 54–55, 57–59, 61, 76, 89, 158,
 184, 193n24; of virtue, 153; of women,
 27, 76, 95, 101, 108, 112, 186
appreciation, 2, 25, 52, 65, 151, 179
Apuleius, 69, 205n65
Aquinas. *See* Thomas Aquinas, Saint
archaism, 45–46, 168, 217n66
areté, 53, 196n9
Aretino, Pietro, 109, 205n64

Ariosto, Ludovico, 28, 114–40, 183–84,
 206n9 and 12, 207n23, 209nn36,
 40 and 41, 210n51, 211n54; *Cinque
 canti*, 130, 208nn32 and 33, 210n44;
 'De lupo et ove', 131, *141*; *Orlando
 furioso*, 114–28, 130, 132–33, 135–36,
 140, 206n6, 208n29; *Orlando furioso*
 1516 emblem, 115, 128–33, *129*,
 136, 138–40, 152, 208nn 31 and 33,
 209n42, 210n44; *Orlando furioso* 1532
 emblem, 140–41, *141*, 208n31, 210n44,
 212n61; *Satires*, 115, 128, 131, 136
Aristotle, 41, 90, 93–94, 96, 99, 173,
 202nn36, 39 and 41; *Nicomachean
 Ethics*, 7, 32, 60, 66; *Poetics*, 206n12
Arma Christi, 154–58
art, 127, 143, 145, 151, 156, 160, 166–67,
 171–72, 179–80, 183; that conceals
 artistry, 57, 109, 126, 139, 144–47,
 151, 158, 184–85; criticism, 54–55,
 145, 179; history of, 145–46, 181, 182,
 190n14, 198n42; that reveals artistry,
 148, 157 (*see also* aesthetics: of
 difficulty)
artistic grace, 25, 144, 167, 171, 183
arts, the, 5, 11, 53, 118, 137, 144, 212n6
attraction, 3, 71, 79
Augustine, Saint, 25, 37, 41

Bal, Mieke, 191n25
Beatrice, 41, 91, 218n67
beauty, 1–4, 8, 11, 18, 39–41, 52, 54, 66–69,
 102, 105, 107, 112, 180, 186, 196n12;
 inner, 101, 187; uncoupled from grace,
 78–79, *79*–92, 92–100
Beauvoir, Simone de, 91–92
bees, 118, 128, *129*, 131–41, *134*, *136*, 206n9,
 208nn31 and 33, 209n42, 210n44,
 211nn52, 53, 54 and 59
bella presenza, 27
Bembo, Pietro, 28, 46, 80, 88, 102; in
 Castiglione, 59, 78, 82–84, 87–90; *Gli
 Asolani*, 82, 88, 90; *Prose della volgar
 lingua*, 45, 123, 126, 128, 206n6

benefits, 17, 48, 98, 104, 109, 135–36, 121, 174; circulation of, 2, 6–9, 49, 69, 96, 115, 131; market of, 66, 109–10

benevolence, 1, 17, 103; cycle of, 19; sacred, 163

Berger, Harry, Jr., 190n14

biblical exegesis, 34, 36, 38

Biondo, Michelangelo: *Angoscia, Doglia e Pena*, 109

Blunt, Anthony, 22, 54, 212n6

Boccaccio, Giovanni, 8, 45, 47–49, 205n65

body, 39, 68, 70, 82–83, 89–91, 98–99, 176, 187, 193n24; absence of, 85, 86, 200n13; decorporealization/disembodiment, 85, 87, 89, 98, 99, 101–2; and soul, 77, 94, 98, 176, 203n48, 219n90

body loop, 176–77, 199n42, 219n89

bonum and *malum*, 129, 132–33, 135, 136, 139–40, 211n51

book trade, the, 115–16

Botticelli, Sandro: *Nascita di Venere*, 68; *Primavera*, 2, 9, 66

Brose, Margaret, 87

Brundin, Abigail, 85

buon fine. See good end

Buonarroti, Michelangelo, 19, 28, 55, 91, 142–60, 166–72, 178, 180–83, 215n44, 217n66, 220n94; *Christ of Santa Maria sopra la Minerva*, 154–60, *155*, 167, 214nn30 and 36, 215nn40 and 41; and Colonna, 143, 166–173, 178–79, 217n63, 220n94; *Colonna Crucifixion*, 170–73, *171*, 179, 220n94; *Colonna Pietà*, 160–61, *161*, 167–69, 171, 173, 218n71; *Last Judgement*, 161; Medici chapel of San Lorenzo, 143, 154; *Pietà*, 148–52, *149*, 154, 156, 167–70, 213n24; *Pietà* signature, 148–50, 213nn21 and 25, 218n71; other *Pietà*, 179; and Raphael, 143, 151–52, 160; Tomb of Julius II, 152, 159

Burke, Peter, 53

Burkhardt, Jacob, 14

Canigiani, Bernardo, 88–91

care, 18, 33, 46, 53, 66, 69, 126–27, 146

Casadei, Alberto, 130, 139–40

Castiglione, Baldassare, 19, 27, 46, 66, 74, 80, 88, 113; *Il Libro del cortegiano*, 27,

45, 50–55, 57–61, 65, 75, 76–78, 82–83, 91, 105, 144, 147, 150, 152–53, 184–85, 190n14, 196n11, 197n18, 200n6; portrait by Raphael, 55–57, *56*, 62–65, 75, 197n18

Catherine of Siena, Saint, 90, 175–76, 200n21, 220n94

charis, 4, 31–34, 44, 46, 60, 209n40

charisma, 2, 66

charismata, 178

charity, 2, 4–6, *6*, 8, 31, 36, 163, 178

charm, 17, 32–34, 95, 103, 107, 110–11

chastity, 85, 87–88, 91–92, 200n13, 211n53, 213n24

Christ, 19, 36, 49, 85, 92, 151, 154–77, 179–80, 213n24, 217n66, 219n90

Christian classicism, 4–5, 30, 38–44, 80

Christian doctrine, 39, 148, 151, 154

Christian Platonism, 39

church fathers, the, 4, 32, 34, 36, 39, 41, 199n6

Cicero, 4, 34, 49, 116, 127, 206n6

circularity, 3, 7, 40, 67, 81

circulation. *See* benefits: circulation of; exchange

civilised society. *See* society: civilised

classicism, 150, 158, 183

Clement VII (pope), 85, 160

Cleopatra, 107–8

close reading, 22–23, 34, 195n2

clothing, 56–57, 77, 197n18; sumptuary laws, 103, 204n54

Colonna, Vittoria, 19, 27, 78–80, 85, 89, 92, 97–98, 101–3, 107, 112–13, 143, 160–67, 170, 178–80, 186, 199nn2 and 6, 200nn13 and 21, 201n24, 215n45, 216nn51 and 59, 217nn60 and 63, 219n90; and Michelangelo, 166–73, 178–79, 217n63, 220n94; *Pianto*, 90, 173–76, 200n23, 219n90; *rime amorose*, 80–90, 162, 173, 175, 199n4; *rime spirituali*, 28, 90, 102, 162–66, 175–76

commerce, 62, 91, 103, 105, 108–10

compliments, 58, 104, 106, 108, 147

concealment. *See* art: that conceals art

conciliatory doctrine, 162–63, 165–66, 217n60

Condivi, Ascanio: *Vita di Michelagnolo*, 145–47, 148, 153, 170, 179–80, 212n12, 213nn17 and 24, 217n66

conduct manuals, 78

confidence, 61, 139–40, 144, 185; in God's grace, 163–65

connoisseurs, 60, 61, 64–65, 115, 183

Contarini, Gasparo, 165, 217n60

conversation, 27, 77, 80, 91, 107, 112

Corsi, Rinaldo, 88–89

Council of Trent, 38, 96–97, 100, 113, 162, 164–66, 184, 207n12, 217n60

Counter-Reformation, the, 14, 28, 96, 100, 119

court(s), 58–59, 66, 74–75, 91–92, 115, 128, 147–48, 153, 161, 184–86

courtesans, 24, 79, 92, 98, 103–4, 108, 112, 204nn54, 56 and 60

courtiers, 11, 19, 25, 117, 120, 124, 140. *See also* Castiglione, Baldassare: *Il Libro del cortegiano*

court ladies, 19, 27, 59, 76–79, 91, 137. *See also* women

Cranach the Elder, Lucas: *The Honey Thief*, *134*, 135–36, 210n50

creativity, 111, 118, 127, 138, 151

crisi, 202n41

crisis, 82, 97, 162

Crucifixion, the, 151, 154, 156, 160, 163, 165, 168, 173; depiction by Michelangelo, 170, *171*, 172, 179. *See also* the Passion

Cummings, Brian, 38

Cupid, 69, 73, *134*, 135–36, *136*

Da Canossa, Ludovico (in Castiglione), 46, 51–55, 57, 58, 61, 150, 184

Damasio, Antonio, 176–77

dance. *See under* Graces, the three

Dante, 13, 45, 47, 87, 90, 91, 194n42, 218n67; *Divina Commedia*, 119; *Inferno*, 41; *Purgatorio*, 168

D'Aragona, Tullia, 27, 78, 79, 92–93, 99, 104–12, 204nn54 and 57; *Dialogo dell'infinità d'amore*, 27, 92–93, 97–98, 100, 113, 184, 186, 201n28, 202n42; *Rime di signora Tullia di Aragona*, 27, 100–106, 111–13, 204n52

deceit, 9, 32, 109–11

De Holanda, Francisco, *Dialoghi di Roma*, 166

Del Cossa, Francesca, 9–11. *See also* Palazzo Schifanoia: *Salone dei mesi*

D'Elia, Una Roman, 168, 218nn67 and 72

delight, 24, 37, 48, 89, 109, 203n48, 207n15

D'Este, Alfonso, 136, *137*, 210n51, 211n52

D'Este, Alfonso II, 182, 185

D'Este, Borso, 2, 4–6, 8–11

D'Este, Ippolito, 131, 209nn38 and 41

De' Medici, Cosimo, 103, 204n54

De' Medici, Giuliano, 53, 76–77, 83

desacralization, 95, 96

desire, 41, 60, 68, 82–83, 87–89, 95, 98, 101–2, 119, 164, 191n34, 203n48

De Vecchi, Pierluigi, 62

Diana and Acteon, 87

Diet of Regensburg, 165–66, 217n60

difficultà, 54, 55, 157, 172

difficulty, 126, 139, 148, 150–51, 156–57, 172, 182; aesthetic of, 148, 150–51, 167

dignity, 49, 52, 204n56; of vernacular, 15, 45, 47

diligence, 33, 53, 55, 144, 146, 196n15

diplomacy, 42, 77, 185

disgrazia, 78

dispositio, 116, 120–22, 126, 196n14, 206n6

Dolce, Lodovico, 28, 115–23, 125–28, 138, 205nn3 and 5, 206nn6, 9 and 12, 207n23, 211n54; 'Dialogo della pittura intitolato L'Arentino', 54–55, 144, 147, 196nn14 and 16, 198n33

doubt, 97, 113, 185, 203n43

drawing, 71, 172

ears, 39, 99, 193n24

ease, 19, 54–55, 57, 61, 144, 148, 150–51

Ebreo, Leone, 95, 99, 201n33; *Dialoghi d'amore*, 92–93

ecclesiasticism, 157

effort, 19, 37, 45, 53–55, 57, 61, 115, 123, 144, 146, 149–54, 156–59, 164, 171, 180

eironeia, 60

Eisner, Martin, 20

elect, the, 35, 40, 151, 176. *See also* predestination

election. *See* predestination

elegance, 52, 56–57, 182

Elias, Norbert, 15

Eliot, George: *Middlemarch*, 50–51

elocutio, 116, 122–28, 196n14, 206n6

eloquence, 29, 31, 35, 44, 45, 49, 81, 87, 107, 111, 132

emanatio, raptio, remeatio, 40, 81

emanation, 82, 169

emblems, 115, 128–33, 135–41, 152, 184, 208nn31 and 33, 210nn42 and 44, 211nn52 and 54, 212n61
embodied cognition, 68, 198n36
embodied experience, 79
embodied simulation, 177, 198n36, 219n89
Emison, Patricia, 195n2, 197n17
encounter, 11, 15, 23, 64, 139, 179, 181
enemies, 42, 77, 140, 152
envy, 132, 139, 147, 184–85, 211n54
Equicola, Mario: *Libro de natura de amore*, 98–99, 203n48
Erasmus, 35, 192n14
eroticism, 66, 73, 87, 104, 200n13
Este court, the, 8, 9
Este family, the, 3, 6, 131. *See also individuals under* D'Este
Euphrosyne, 1, 42, 48, 111
Eurymone, 41
evangelism, 18, 154, 162, 167, 178, 200n23
exchange, 2, 7–8, 24, 31–33, 49, 59, 64, 91–92, 96, 106, 108, 129–30, 147; three-way, 61
exclusion, 65, 92, 156
experience, 2, 5, 24, 39, 91, 98–99, 119, 177; aesthetic, 179, 182, 219n89; embodied, 79; religious/spiritual, 28, 90, 168, 173, 176, 179, 219n89
eyes, 39, 88–89, 94, 99, 107, 172–76, 193n24, 199n42; absence of, 82–84, 175; depicted in art, 65, 168; depicted in poetry, 105

facilità, 54, 55, 58, 61, 126, 128, 144
Fahy, Conor, 140, 209n40
failure, 16, 61, 62, 75, 84, 107, 114, 127
faith, 4–5, 6, 36, 100, 102, 130, 140, 148, 151, 162–66, 171, 173–75, 177–78, 217n66, 220n94. *See also* justification by faith; *sola fides*
Fates, the, 40, 117, 118, 120
fatica, 61, 157
favour, 51, 59–62, 65–66, 69, 77, 91, 103, 114, 139, 152–53, 164, 184; divine, 17, 156, 165
favours, 61, 64, 75, 92, 104, 147, 186; poetic, 108; sexual, 104, 108
female models, 91, 106, 138, 167, 201n24, 204n60. *See also* women
feminine grace, 27, 78, 103, 105–6, 109, 112–13. *See also* women: and grace

femininity, 76–78, 81, 85, 87, 92, 190n14. *See also* women
feminist lens, 24
Ferrara, 2–5, 128, 131, 185–86, 211n52
Ficino, Marsilio, 38–40, 42–43, 44, 95, 96, 193n23, 196n12, 199n6, 200n9; *De amore*, 40, 81–82, 193n24; commentary on Plato's *Symposium*, 80, 92
Firenzuola, Agnolo, 95–96, 109–10, 201n34
flatterers, 60, 164, 117, 120
flattery, 42, 43, 62, 64, 128, 147, 153
flirtation, 68, 101, 122
Florentine Academy, the, 88, 91, 96
Fonte, Moderata: *Il merito delle donne*, 29, 186, 187
Forcellino, Antonio, 160
forgiveness, 16, 17, 36
form, 45, 94, 102, 123
formal analysis, 23
freedom, 37–38, 72, 100, 154, 185–86
free will, 38, 41, 203n51
Fregoso, Federico (in Castiglione), 56, 59–60, 63, 197n23
Fregoso, Ottaviano (in Castiglione), 60, 212n15
friendship, 15, 23, 27, 42, 59, 63; instances of, 51, 55, 64 146, 160
Furey, Constance, 91, 201n25

Geertz, Clifford, 43–44
gender, 24, 76, 80, 81, 90–91, 99, 112, 186, 190n14
genius, 18, 33, 146, 148
Ghiberti, Lorenzo: *Commentarii*, 196n11
gifts, 2, 5, 9–10, 85, 110, 141, 178; circulation/exchange of, 2, 7, 32, 35, 115, 178; divine, 2, 4–5, 80; of God, 2, 4–5, 12, 24, 28, 35–38, 40, 43, 47–48, 79, 146, 148, 151, 170, 178–79; of nature, 18, 52, 144, 186; nonreciprocal, 178; specific, 118, 160, 166–67, 178–79
Giles of Viterbo, 80, 199n6
Giolito, Gabriel, 116
Giovio, Paolo, 132, 195n1, 209n42, 211n54
giving, 7, 8, 66, 131, 140–41, 178
gloria, 85, 89, 91
God, 40, 91, 98, 113; relationship with, 35, 78, 163, 177; infinity of, 203n42. *See also* gifts: of God; grace: God's; love: God's/divine

golden mean, the, 33, 78
Gonzaga, Cesare, 52, 58
good end, 60, 61, 64
good looks, 27, 51, 52, 58, 60
good works, 35, 37, 162–63, 164, 178
Gospel, the, 38, 121, 218n67
grace: avoidance of, 93, 99, 106, 109
 (see also absence: of grace; beauty:
 uncoupled from grace); as generative,
 25; God's, 25, 35–37, 41, 46, 48–49,
 79, 82, 90, 97, 120, 146, 148, 156–58,
 162–64, 167–71, 173–74, 178–79, 180;
 as substance, 35, 61; as word, 12–14,
 17–20, 23–24, 27, 30–31, 42–43, 46, 49,
 51–52, 58, 100, 143–46, 181–82, 196n11,
 212n12.
See also artistic grace; feminine grace;
 literary grace; poetic grace; universal
 grace; women: and grace
Graces, the three, 1–9, 32, 39–44, 47–49,
 69, 81, 96, 111, 178, 200n9; dance of,
 1–3, 7, 9, 40, 66–69, 73, 81; depicted
 by Raphael, 65–75; names of, 42, 48,
 111–12
gratia, 8, 18, 32–34, 44, 47–49, 103–5, 131,
 140–41, 191n34, 209n40
gratioso, 49
gratuity, 32
gravità, 45, 123
gravitas, 57, 77, 78, 123, 125, 128
grazia, 8, 44–45, 60, 85, 89, 91, 94, 95,
 123, 126, 184, 191n25, 196n16
grief, 16, 80, 85–90, 92, 151, 154, 162,
 168–70, 174–77, 199n4, 218n72
guidance of princes, 60, 77, 153, 185, 213n15
Gurd, Sean, 21

happiness, 18, 36–37, 40, 42, 47–49, 52,
 84, 164, 186
harmony, 3–5, 45, 52, 69, 89, 90, 93, 120,
 122
hearts, 18, 94; and the divine, 25, 36, 80,
 84–85, 87–88, 101–2, 163–65, 173–76;
 of lovers, 68, 82, 89, 95, 97, 105, 110;
 predisposed, 16, 25, 80, 131
Hesiod, 7, 41–42, 120–21
High Renaissance art, 15, 70, 144–46,
 197n17
Homer, 7, 31, 120–21; Odyssey, 31;
 Iliad, 32

honour, 76, 78, 102–4, 138, 166, 204nn56
 and 60
hope, 4, 5, 6, 104, 119, 169, 177–78
Horace, 23, 34; Odes, 3–4, 120–21, 127,
 139, 141, 211n58
humanism, 8, 13, 20, 38; and questione
 della lingua, 44; revival of classical
 antiquity, 30–35; revival of Latin, 15,
 34–35, 49
human nature, 37, 186
humility, 66, 139, 140, 150, 174

idolatry, 167
Il beneficio di Cristo, 162–63, 165, 216n48
image. See word and image
imago pietatis, 167
imitatio, 206n6
imitation, 132, 138–39, 146, 183, 206n9,
 211n58
immateriality, 79, 85, 88–89, 90, 173
immortality, 101–2, 117–18, 121, 128, 130,
 151. See also posthumous renown
imperfection, 53, 150
ineffability, 2, 87, 95, 191n34
infidelity, 104, 110
ingenium, 33, 140
ingratitude, 7, 11, 115, 128–33, 139–40,
 208n31, 209n41
inspiration, 95; artistic/creative, 24, 43,
 171; divine, 82, 91, 167, 171, 180
intellect, the, 29, 39, 41–42, 89, 101, 106,
 119, 164, 185, 187, 201n24, 219n86
intellectualism, 79, 92, 105, 112, 173, 174,
 182, 183
inventio, 116, 118–20, 126, 138, 196n14,
 206n6
invenzione, 55, 64, 118, 119, 198n33
Italianità, 13–14
Italian Renaissance, the, 2, 12–15, 28, 51,
 55, 181, 183
Italy, 13, 14, 15, 28–29, 42–43, 77–78,
 189n2

je-ne-sais-quoi, 26, 95, 126, 202n34. See
 also non so che
Jesus. See Christ
Jews, 5, 8, 36
joy, 31, 37, 47–48, 81, 107, 109, 164, 186
judgement, 33, 38, 52, 57, 59, 61, 71, 75, 77,
 111, 144, 157

Julius II (pope), 147, 152, 159, 214n34; tomb of, 145, 159
Julius III (pope), 147
Jupiter, 39, 40, 41, 43, 81
justice, 5–6, 9–10
justification by faith, 36–38, 162. See also *sola fides*

kinesic intelligence, 68, 198n36, 219n89
knots, 177, 219n90
knowledge, 41, 97–99, 169, 178; of subjects, 34, 57, 103, 126, 157, 184, 185

labour, 28, 45, 102, 106, 139, 148–49, 152, 156–57, 180. *See also* work
ladders, 82–84, 92, 98, 101, 105, 112, 162, 177–78. See also *scala amoris*
Landino, Cristoforo: *Commentary on the Divine Comedy*, 41–42, 44, 81, 91
language, 4, 8, 106, 122, 125; deficiency/indeterminacy of, 86–88, 94, 95, 97, 106, 174. See also *elocutio; questione della lingua;* vernacular, the
Laocoön Group, the, 158–60, *159*, 214nn37 and 38, 215nn39, 40 and 42
Laura, 81, 84, 86, 91, 99, 106, 112, 200n8
Lavin, Irving, 213nn21 and 25
Lemaire, Jean: *La Légende des Vénitiens*, 208n31
Leonardo da Vinci, 144, 146, 183, 212n1
Leo X (pope), 64, 142–43, 147, 152, 154, 214n36
lexicography, 46–49
liberality, 5, 8, 11, 81
light, 43, 80, 82, 85–88, 91, 98, 102, 163–64, 172, 175–76; depicted in painting, 54, 57, 62, 70
literary grace, 28, 103, 111–12, 115–16. *See also* poetic grace
literature, 13–15, 18, 25, 28, 31, 38, 44, 99, 114, 146, 167; and art, 55 (*see also* word and image)
logic, 99
Lomazzo, Paolo, 69–72, 74, 183, 198nn36 and 42
love, 1–4, 8, 11, 41, 66–70, 78, 88–89, 92–106, 118, 133, 163, 174, 178, 186; celestial, 82, 84, 88; chaste, 85; gendered perspective on, 99; God's/divine, 100, 165–66, 216n51, 217n60;

ineffability of, 87, 100; inner, 177; pain/bittersweetness of, 133, 135–36; self-, 203n48; theories of, 80–82, 88, 97; tripartite division of, 81
loyalty, 132, 137, 152–53, 211n52
Lucia, 41
Luther, Martin, 37–38, 162, 165–66

MacLachlan, Bonnie, 32, 189n6
Malebranche, Nicolas, 25
Manelli, Piero, 102
Mannerism, 15, 182–83, 215n41
manners, 12, 15, 24, 27, 29, 31, 33, 38, 50, 62
Man of Sorrows. *See* Buonarroti, Michelangelo: *Cristo di Santa Maria sopra la Minerva*
Marguerite de Navarre, 201n24
markets, 66, 75, 91, 109, 147
marriage, 77, 85, 91, 186–87
Mars, 1, 3–4, 166
Martelli, Ugolino: 'Ben sono in me', 111
Martial, 211n59
Mary (mother of Christ), 35–36, 41, 49, 90–91, 151, 168–70, 173–77, 180, 201n24, 213n24, 218n72, 219n90
masculinity, 78, 81, 92, 190n14
Masi, Giorgio, 130, 209n36, 210nn44 and 47
materialism, 157–58
Matthias of Hungary (king), 42–43, 194nn36 and 37
McHugh, Shannon, 87, 200n13
Meditationes vitae Christi, 174–75, 176
mentors, 102, 106, 112, 166, 201n24
metaphor, 24–25, 26, 138, 163
Michelangelo. *See* Buonarroti, Michelangelo
mind, 39, 68, 99, 193n24; and body, 176–77
minds, 25, 68, 84, 86, 106, 112, 147, 164, 187
misogyny, 109–10
modesty, 66, 68, 73, 77, 139, 150, 198n38, 199n46, 201n28
Monk, Samuel Holt, 18–19, 196n12
moral lessons, 116, 119–20
Moriarty, Michael, 37
Moss, Ann, 49
motion. *See* movement
Moussy, Claude, 32, 49, 191n34

movement, 2–4, 25, 40, 66–68, 71–73, 77, 122, 157, 159–60, 169, 215n41
Muses, the, 69, 103, 111–12
music, 1, 3, 11, 18, 25, 53, 69, 150, 182, 193n24
Muzio, Girolamo, 101–2, 105–6, 108, 111–12, 201n28, 204n52
mystery, 91, 148, 169, 172–74
mysticism, 90, 175, 200n21, 201n25, 220n94

Nagel, Alexander, 168, 169, 217n66
nakedness, 2, 9, 32, 33, 66, 71, 135, 154
narratives, 19–21, 26–29, 73, 145–46, 181, 191n36, 195n2
naturalism, 167, 182
nature, 3, 18, 25, 45, 52–54, 104, 122, 146, 148, 211n58
Neapolitan Accademia Pontaniana, 80, 200n21
Neoplatonism, 38–41, 80–93, 100–101, 105, 176, 200n21, 214n26
new philology. See philology
New Testament, 36, 163
nobility, 31, 38, 51–52, 57, 76, 77, 98, 190n14, 197n18
non so che, 55, 68, 95, 126, 201n34. See also je-ne-sais-quoi

Obama, Barack: Charleston eulogy, 16–17, 18
obedience, 37, 98, 162–63, 174
Ochino da Siena, Bernadino, 200n23, 217nn59 and 60
Odysseus, 31
Old Testament, 163–64
onestà, 106, 118–19, 204n56
onomatopoeia, 125
opposites, 11, 132–39, 210n51
Orpheus, 193n24
Orphic theology, 40–41

painting, 23, 54–55, 57, 62, 71, 151, 157, 172
Palazzo Schifanoia: Sala delle virtù, 5, 69; Salone dei mesi, 1–5, 8–11, 19, 69, 114, 118, 127, 127, 152, 187, 194n40
Panofsky, Erwin, 14
paragone, the, 53, 157
passion(s), 59, 81, 83–85, 88, 98–99, 105, 119, 203n48
Passion, the, 154–56, 160, 166–69, 179–80

patronage, 13, 62, 103–4, 112, 131, 152–53, 167
patrons: general, 103–4, 121, 128, 147, 151, 158; specific, 9–11, 64, 103, 130–31, 139, 142, 147, 152–53, 160
Paul, Saint, 4–5, 36–38, 39, 41, 46, 90, 140, 142, 166, 178
peace, 136–37, 163, 174, 211nn51 and 52; inner, 104–5
Pelagian controversy, 37
perfection, 41, 98, 126–27, 143, 150, 172
Perotti, Niccolò: Cornu copiae, 48–49
persecution, 147, 156
persuasion, 12, 14, 34, 42
Petrarch, 13, 45, 47–48, 79–80, 87, 90, 99, 106, 110, 200n8; 'Ascent of Mt Ventoux', 90; 'S'i' 'l dissi mai', 104; 'Tacer non posso', 81, 84, 86–87
Phaeton, 3, 211n59
philology, 20–22, 36, 38, 190nn17 and 20
philosophy, 31, 39–40, 81, 103, 173
piacevolezza, 45, 109, 123
Pico della Mirandola, Giovanfrancesco, 206n6
Pico della Mirandola, Giovanni, 40–42, 43, 44, 81–82, 95, 200n6
piety, 36, 79, 85, 90, 157, 168
Piles, Roger de, 18
Pinckney, Clementa, 16–17
Pindar, 4, 139, 211n58
Plato, 39, 42–43, 80, 90, 92–96, 192n20; primary hypostases, 39–40, 193nn21 and 23
pleasure, 2, 24, 30–31, 37, 66, 70–72, 75, 88–89, 95, 136, 173, 184, 187
Pliny (the Elder), 18, 33, 60, 150, 214nn37 and 38
Plotinus, 39, 94
Plutarch, 107–8
poetic grace, 102–3, 115, 122, 130. See also literary grace
poetry, 1, 3–4, 11, 83, 87, 101–3, 106, 111, 116–21, 124, 127–28, 138, 206nn9 and 12, 208n31
poets, 103, 105–6, 108, 112, 115, 117–21, 123, 127–28, 131, 133, 138–40, 207n27, 214n25
Pole, Reginald, 162, 166, 200n23, 217nn59 and 60, 219n90
Politi, Ambrosio, 166

Poliziano, Angelo, 21, 83, 90, 150
Pope, Alexander, 18
popularity, 59, 65
portraiture, 55, 62, 65, 157, 198n38
posthumous renown, 102, 116, 127–28,
 207n27. *See also* immortality
predestination, 35, 37, 100, 163–65,
 192n17, 203n51
presence: divine/spiritual, 78, 87, 179;
 physical, 82, 85–86, 88
princes, 19, 59–61, 65, 77, 117, 120, 147–48,
 152–53, 184–85; guidance of, 60, 77,
 153, 185, 213n15
Prisciani, Pellegrino, 4, 8–9
proportion, 3, 39, 70–71, 89–91, 93–95,
 193n24; inverse, 115
Protogenes, 33, 55, 192n5, 196n15
prudence, 29, 76, 137, 184–85, 211n54

questione della lingua, 13–14, 30, 44–49.
 See also vernacular, the
quintessence, 95, 98, 202n36
Quintilian, 4, 33–34, 46; *Institutio orato-
 ria*, 34, 116

rainfall, 25, 35, 148, 162, 163
Raphael, 19, 27, 50, 54–55, 62, 114, 118,
 126, 142–47, 151–52, 153, 160, 181–83,
 195n1, 196nn16 and 17, 198nn36 and
 42; *Allegory*, 69; Castiglione portrait,
 55–57, 56, 62–65, 75, 197n18; *Judge-
 ment of Paris*, 73; *La Fornarina*,
 73, 74, 199n46; *Study for the Three
 Graces*, 65, 69–75, 70; *The Three
 Graces*, 65–69, 67, 71, 73, 75; *Venus*,
 73, 73; *Wedding Banquet of Cupid and
 Psyche*, 73, 75
Rapin, René, 18
reason, 18, 41–42, 81, 94–95, 99, 125, 173,
 177; confounded, 172, 179; lost, 83, 120
receiving, 7–8, 131, 163, 178
reception, 22, 47, 58, 130; Ariosto and, 28,
 115–16, 140
reciprocity, 3, 32–33, 58–59, 62–64, 67,
 96, 104–5, 130, 147–48, 178. *See also*
 exchange
recognition, 59–60, 62, 64, 66, 101, 114,
 131, 141, 173, 180, 185
recompense, 9–10, 59, 62, 64, 66, 141. *See
 also* repayment

reconciliation theology. *See* conciliatory
 doctrine
redemption, 35–37, 102, 156–58, 165–66,
 169, 170, 180
reform, 162, 165–68, 178
Reformation, the, 14, 15, 28, 30, 35, 38,
 162, 178, 180, 207n12, 214n26. *See also*
 Counter-Reformation, the
religiosity, 157, 213n16, 214n36
religious experience. *See* experience:
 religious/spiritual
remuneration. *See* repayment
Renaissance, the, 13–15, 23. *See also* Ital-
 ian Renaissance, the
Renée of France, 185
repayment, 32, 64, 108, 128, 209n38. *See
 also* recompense
representation, 157
reputation, 59–60, 101, 107–8, 112, 121
resurrection, 36, 151, 156, 168
rhetoric (classical), 31, 34, 46, 116, 196n14
Roman Inquisition, the, 96, 163, 185,
 216n51
Rucellai, *Le Api*, 136–38

Saccone, Eduardo, 19–20, 21, 60, 122, 132,
 210n44
Said, Edward, 20–23
salt. *See* seasoning
salvation, 12, 14, 35–38, 41, 151, 162, 170
Sanzio, Raffaello. *See* Raphael
Saturn, 40
scala amoris, 88, 95. *See also* ladder
Scholar, Richard, 21, 202n34
sculpture, 23, 53–54, 150–51, 157–58,
 168, 172
scuola religiosa, 80
seasoning, 33–34, 45–46, 50, 52, 58
secular, the: mixed with the divine,
 38, 49
secularization, 167
Seneca, 8, 49, 109, 138; *De beneficiis*, 7, 9,
 32, 66
senses, the, 84, 94, 99–100, 125, 173–74,
 176, 183, 219n86; higher, 88, 94, 101;
 inner, 176; lower, 84, 88, 203n48
sensuality, 2, 66, 71, 90
serpentine curve, 71, 74, 158, 160, 170, 183,
 215nn40 and 41
serpents. *See* snakes

Servius Honoratus, Maurus: *Commentary on the Aeneid of Virgil*, 8–9, 32, 66, 109

Shearman, John, 62, 197n18, 198n31

sight, 89, 99, 125, 173–76, 220n94. *See also* eyes; senses, the

simulation, 75, 153; embodied, 177, 198n36, 219n89

sin, 35–38, 163

Sistine Chapel, the, 142, 146, 152, 161

snakes, 128, 130, 135, 140, 159, 167, 211n54

sociability, 1, 7, 11

social hierarchy/status, 52, 58, 59–60

social order, 1–2, 5, 8, 58

society, 7, 12, 15–17, 27, 32, 137, 182; civilised, 2, 15, 17, 32, 69, 131

sola fides, 100, 165–66, 216n51, 217n60. *See also* justification by faith

Son of God. *See* Christ

Sophocles: *Ajax*, 31

soul, 4, 82–84, 87–90, 94–95, 98–99, 101–2, 106, 112–13, 162, 164, 175–76, 187, 211n52

spectators, 3, 10, 61–65, 68, 72, 148, 150, 172

Speroni, Sperone: *Dialogo d'amore*, 92, 99, 109

spiritual guides, 78, 85, 175

spirituality, 27, 79, 84, 100, 105, 160, 162, 181, 214n26; and art, 143, 158, 167, 151, 156, 173–74

splendour, 42, 49, 52, 77, 94–95, 110, 123

spontaneity, 25, 53, 144, 146, 150, 173

sprezzata disinvoltura, 53, 60, 64, 150

sprezzatura, 45, 52–53, 55, 58, 60–61, 65, 128, 141, 147, 150, 184, 190n14, 195n2

Strozzi, Tito: 'In Amorem Furem', 133, 135

study, 9, 31, 35, 53, 122, 126, 144, 146–47; self-, 167

success, 58, 61–62, 75, 102, 153

suffering, 36, 154, 156–59, 168, 170, 174, 177, 180, 187

swans, 1, 3–4, 117–18, 120, 124–25, 127–28, 139, 207nn14 and 27

synchronicity, 3, 66–67, 69, 74

talent, 51, 61, 65, 103, 117, 119, 143, 146, 148, 180, 184–86

Tasso, Torquato: *Il malpiglio*, 29, 184–86, 187

taste, 23, 33, 46, 57, 75, 115, 121, 183, 197n18

Taurus, 1, 11

terribilità, 144–45, 148, 196n17, 213n18

Thalia, 1, 42, 47–48, 111–12

theatre, 182

Theocritus, 133, 135

theology, 25, 35–41, 79, 100, 162, 165, 167, 202n42

Thomas Aquinas, Saint, 90, 175, 219n86, 220n94

Thomas, Ben, 195n2

threes/triads/trinities, 4–5, 39–40, 69, 81, 193n23

Toledo, Eleonora di, 103, 204n54

Torrello, Ippolita, 63

Toscanello, Orazio, 138, 211n54

touch, 73, 172–73, 176, 203n48, 219n86

transformation, 36, 102, 163, 180

transgression, 70–71

transubstantiation, 169

triads. *See* threes

triangulation, 60, 65, 197n23

trinities. *See* threes

trinity, hypostatic. *See under* Plato

Trinity, the Christian, 39–40, 96

universal grace, 11, 59–60

Urbino, 51, 185

Valla, Lorenzo, 35, 192n14

Varchi, Benedetto, 96–97, 157, 201n33, 202nn38–41, 204n54; as character in d'Aragona, 92, 93, 97–100, 184; 'Della bellezza e della grazia', 93–95, 96

varietà, 118

Vari, Metello, 154

Vasari, Giorgio, 15, 198n36, 213n21; *Le Vite*, 54, 143–47, 149–50, 196n11, 212nn6 and 12

Vatican, the, 13, 148, 158, 160

Venere pudica, 66, 68, 72–74, 198n38, 199n46

Venice, 186–87, 215n44

Venus, 6, 8, 32, 39, 40, 43, 47, 81, 96, 110–12, 200n8; depicted in art, 1–4, 73, *73*, 135, 198n38

Venusian attributes, 66, 67, 71, 74, 199n46

venustà, 49, 126, 196nn16 and 17

venustas, 18, 32–34, 49, 50, 60

vernacular, the, 13, 15, 34, 44–49, 50. *See also questione della lingua*

vessel, 36, 91, 176, 180

victory, 3, 32, 33, 154, 160, 168, 170

viewers. *See* spectators

Virgil, 121, 206n6; *Georgics*, 136–38, 211n52. *See also* Servius Honoratus, Maurus: *Commentary on the Aeneid of Virgil*

virtue, 37, 51–52, 60, 76, 87, 91, 102, 148, 152–53, 164, 186, 198n38; inner, 78, 187

virtues, the three theological, 4–5, 69, 178

vision, inner, 84, 175–76, 220n94

visual arts, the, 14–15, 38, 44, 54, 116, 144, 145

Viterbo circle, the, 80, 162–66, 168, 199n6, 200n23, 217n60, 219n90

Vulgate, 35

war, 3–4, 42–43, 77, 136–37, 211n52

Warburg, Aby, 3

widowhood, 80, 85, 87, 89, 90, 199n4

Williams, Raymond, 21, 23, 191n25

Winckelmann, Johann Joachim, 182–83, 215n42

Wind, Edgar, 40

witchcraft, 110

women, 76–79, 91, 95, 99, 106–9, 112, 137–38, 186–87, 201n24, 211n53; criticism of, 109–11, 113; described by men, 112–13; facilitating men, 77–78; and grace, 24, 27, 186 (*see also* feminine grace); suspicion of, 107–9. *See also* court ladies; feminine models; femininity

wonder, 57, 150, 172–73, 179

word and image, 23, 28, 51, 132

work, 19, 127–28, 139, 146–48, 153, 171–72; concealed, 53, 55, 75, 144. *See also* labour

writing, 61, 102–3, 119

Yates, Frances, 40

Zilioli, Alessandro: *Storia dei poeti italiani*, 107–9